9/12

The Serpent
&
the Lamb

STEVEN OZMENT

The Serpent & the Lamb

CRANACH, LUTHER, AND THE MAKING OF THE REFORMATION

Yale UNIVERSITY PRESS New Haven and London

Yale University Press books may be purchased in quantity for educational, business, or promotional use. For information, please e-mail sales.press@yale.edu (U.S. office) or sales@yaleup.co.uk (U.K. office).

Designed by Mary Valencia.
Set in Minion type by Keystone Typesetting, Inc.
Printed in the United States of America.

Library of Congress Cataloging-in-Publication Data
Ozment, Steven E.
The serpent and the lamb : Cranach, Luther, and the making of the Reformation / Steven Ozment.
 p. cm.
Includes bibliographical references and index.
ISBN 978-0-300-16985-0 (alk. paper)
 1. Cranach, Lucas, 1472–1553—Criticism and interpretation. 2. Cranach, Lucas, 1472–1553—Friends and associates. 3. Luther, Martin, 1483–1546—Friends and associates. 4. Reformation and art—Germany. I. Cranach, Lucas, 1472–1553. II. Title.
ND588.C8O96 2011
759.3—dc23 2011027308

A catalogue record for this book is available from the British Library.

This paper meets the requirements of ANSI/NISO Z39.48–1992 (Permanence of Paper).

10 9 8 7 6 5 4 3 2 1

Contents

CONTENTS

For Susan

Acknowledgments

It takes a team of experts to make a book, and this one was blessed with the best. Among the sovereign historians in the field, Joseph Leo Koerner, Mitchell B. Merback, and David H. Price offered generous advice.

Next came the advanced Cranach buffs, who joined the author in framing the story, Margaret ("Maggie") Arnold and Doris Finley. They sought out the copyright holders of the eighty-plus Cranach paintings and illustrations that appear in the book.

On the German scene, Frau Dr. Eva Löber, director of the Cranach Foundation in Wittenberg, was a kind hostess and shrewd adviser to my entourage during a week's sojourn in Cranach's refurbished house. Frau Marlies Schmidt, art historian at the Cranach Foundation, worked tirelessly to supply leads to the sources. And uncountable others selflessly joined in the hunt.

Christopher Rogers, editorial director of Yale University Press, and Phillip King, senior manuscript editor, served the author well, as did also Laura Davulis and Christina Tucker, who collectively turned a manuscript into a readable book.

Glen Hartley and Lynn Chu, my loyal and long-standing book agents, proved themselves again to be swashbucklers and guardian angels for authors in distress.

Also serving were those who waited and watched through the years of research and writing. Adam Beaver and Erik Heinrichs observed the blood and tears on the floor of their mentor's office, as did also George and Doris Finley in their dwellings in Schwäbisch Hall and St. Andrews.

Susan Schweizer rather saw less and less of her husband, often asking: who are these distant figures my husband spends more time with than he does with me?! Now, however, she, my children, and grandchildren may know what the author was doing all of those years.

Introduction

What's in a Coat-of-Arms?

THE SERPENT

In 1508, three years after his hiring as court painter to the electoral Saxon dynasty seated in Wittenberg, the thirty-six-year-old painter Lucas Cranach received a wondrous coat-of-arms from his lord, Elector Frederick the Wise of Saxony. Honoring his good services, the eye-popping shield displayed a mesmerizing winged serpent endowed with awesome life-giving powers, much as its human bearer would become known for.

The recipient, an early admirer of Albrecht Dürer in the contemporary art world, was a rising star among the best German Renaissance painters who recorded the age's religious reforms and confessional wars for posterity. Open-minded and ecumenical in an age that was not, Cranach and his workshop supplied both Rome and Wittenberg with their preferred religious artworks. At the same time he counted among his closest friends two clerics who became lethal rivals: Cardinal Albrecht of Mainz, the most powerful cleric in European Christendom after the pope, and Martin Luther, the monk who turned the religious world upside down.

A renowned court painter by the early 1520s, Cranach would become the Saxon court's de facto mentor and "handler" of Luther, an undertaking that positioned him also to become the painter of the Protestant Reformation. Although he scoffed at the myth of the vaunted "Renaissance man," Cranach came as close to exemplifying such a person as any other

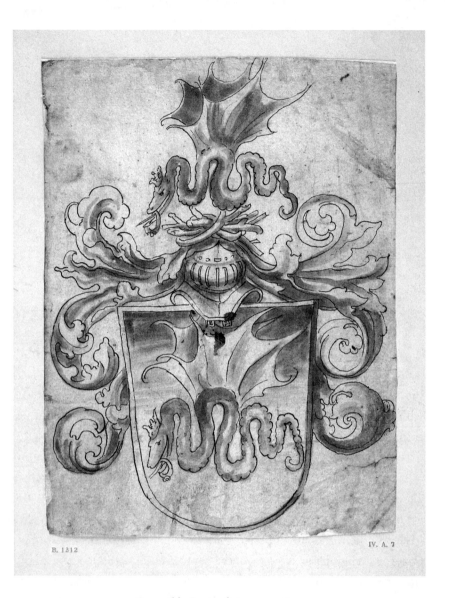

B. 1312 IV. A. 7

Cranach's Coat-of-Arms, 1506–9

(Photo: By kind permission from Handschriftenabteilung, Graphische

Sammlung, Universitätsbibliothek Erlangen-Nürnberg)

giant of the age. A natural diplomat and clever entrepreneur, he became the confidant of each of the three Saxon electors he served life-long.

An impresario of lucrative businesses, Cranach accumulated more real estate than any other burgher in the city by the late 1520s. Elected to Wittenberg's city council in 1519, he served thirty-plus years, nine of them (three full terms) as bürgermeister. Among the profitable enterprises that made him rich and powerful were the city's only publishing house and a full-service pharmacy. Here, indeed, was a keen man who was not to be trod upon.

His primary professional world was that of Greek mythology, the humanistic world of classical antiquity, that of Venus, but not initially of Eve. Cranach was the creator of an unredeemed, seductive world of beautiful women and powerful men, who shared fleeting pleasures and mixed messages. Among the reigning deities who governed that mythological world was Chronos, the Greek god of time and speed. With Düreresque pride, Cranach adapted the name for himself and his art world. Old and New Testament snake lore also ran through that world. These various mythological and Christian associations pointed to an artist who wielded a "fast-striking paint brush," whose images survived time and outlived posterity, a kind of biblical "serpent venom" that saved life as well as took it away.

THE LAMB

In 1524, at the peak of the Reformation's birth pains, Martin Luther also created a family shield of his own. It was occasioned by the success of foreign booksellers who had pirated the manuscript of his revised Latin Bible before it could be printed by the Cranach-Döring press. In response to the incident, Luther and Cranach manufactured a protective seal, henceforth to be embedded in future works as they came off the press. The seal became the authenticating trademark of the reformer's works wherever they appeared.

Juxtaposed to Cranach's Serpent, the Lutheran Lamb of God came from another world and culture. Unlike the fearsome figure of the Cranach

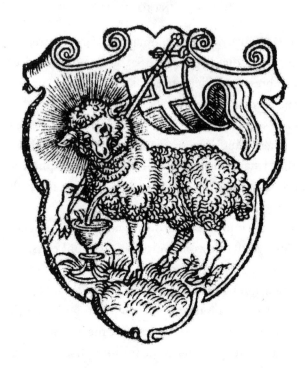

Luther's Coat-of-Arms, 1524
(© The British Library Board)

serpent, a creature quick to strike and to kill, Luther's sacrificial Lamb was neither designed for nor bestowed upon the reformer by reigning political authority. It was Luther's and Cranach's protective measure, undertaken in the name of a greater power: that of the servants of God Almighty.

The message of the Lamb was not a threatening "Don't Tread On Me." It was a bright, assuring, transparent statement of forgiveness and salvation. Attractive, even charming, the Luther trademark or seal presented the Lamb of God in the figure of the crucified Christ. In a counterintuitive gesture, the Lamb holds up the flag of the cross with his right leg, while his bloodstream erupts from his wounded heart filling the chalice of salvation for all eternity—a redemptive washing of the sinner in the blood of the self-sacrificial Lamb of God.

In purely pragmatic terms the Lutheran seal was a none too assuring hedge against recurrent piracies of the reformer's books, pamphlets, and

4

broadsheets. During the early 1520s and still two decades later Luther's books made up one-third of all German publications, a precious cache for both honest publishers and thieving pirates.

With the passage of years the figure of the Lamb was joined by a second Luther trademark that became a second family shield: the multilayered Lutheran White Rose. Unlike the sacrificial lamb, the White Rose, accompanied by a matching signet ring, was presented to Luther in around 1530 by the new elector, John Frederick. Intended to be an abstract or summary of Luther's theology, it displayed a black cross within a blood-red heart in the middle of which lies a "heavenly" colored blooming white rose, a symbol of joy, comfort, and the peace of faith on earth and in the afterlife.

It was not until after 1517 that the two men got to know each other well. In 1520, Cranach was forty-eight and Luther thirty-seven, both men in their remarkable prime. In the same year, Cranach, at the Saxon elector's bidding and Albrecht Dürer's urging, engraved an official court portrait of the emerging reformer while Luther himself stood as godfather to Cranach's lastborn child—a merging of their two families as well as their talents in the cause of reform.

Cranach's portrayals of "Luther the monk" made the reformer's name and face a household word and image throughout Saxony. Already a condemned heretic of the Church, Luther now became an outlaw of the Holy Roman Empire by the imperial decree of the Diet of Worms in May 1521. In that same year, he and Cranach answered back with their first collaborative blast against Rome: twenty-five irreverent pamphlet pages depicting and declaring the Holy Father to be the "Anti-Christ."

By this time both the "Serpent" and the "Lamb" were moving up to the front lines for the great battle with Rome. Each brought his special talents and top-of-the-line weapons to the battlefield, where a war like no other would be waged in European Christendom. Although coming from distant worlds strange and far apart, like the blood of the Lamb upon the curse of sin, the venom of the Serpent would also prove to be effectively life-giving, each, so to speak, "poisoning to save."

1

Cranach in History, Art, and Religion

TAKING THE MEASURE OF CRANACH

Recently Germans, Europeans, and connoisseurs of fine art around the world have been rediscovering the most prolific artist of the European Renaissance and the Reformation: Lucas Cranach the Elder (1472–1553), court painter to the electoral Saxon dynasty seated in Wittenberg, then a center of German Renaissance art and the birthplace of the Protestant Reformation. There have been five exhibitions of Cranach's works from almost as many collections and in almost as many years (January 2005 through October 2010).[1]

Worldwide, roughly one thousand surviving Cranach paintings exist today, four hundred authenticated to Cranach alone, the other six hundred attributed to his workshop. This family of artists included Cranach's sons, Hans and Lucas Jr., and the workshop's roughly fifteen apprentices, journeymen, and hired specialists in the decorative arts. Because the artist's materials were corruptible over time, the bulk of this artwork has long since been reduced to dust and ashes. Only a fraction of what then existed, perhaps 10 percent, survives today.[2]

While the Cranach fans abroad flock to the exhibitions, most Americans scratch their heads at the mention of his name. Among those who blink, a great many, unawares, have seen at least one Cranach painting numerous times. In the opening credits of the American soap opera *Desperate Housewives,* one of Cranach's twenty-plus paintings of Adam

and Eve (1513–15) briefly appears: a five-second cameo showcasing an Apollonian Adam and a Venus-like Eve.

The comparative absence of Cranach from the modern American mind is a lamentable deficit of historical knowledge of Europe and of Germany's cultural and political role within it. Given all of the Cranach artworks that once were, the artist left a lasting mark not only on European and world art, but also on German and European history as well. Without him, German Renaissance art might well have remained a pale imitation of High Italian, and the German Reformation have died aborning in the 1520s, so vital was Cranach to both.

The best explanation of his present-day resurgence is the successful roles he played as one of the age's most versatile artists and successful entrepreneurs. A truly "ecumenical" German, he joined Martin Luther in shaping a modern Germany in the sixteenth century. His position as court painter, which he held from 1505 to 1547, was a "*Novum,* something new in the sociology of the modern artist."[3] Few other painters of the age enjoyed the degree of freedom and privilege, proximity to and intimacy with noble patrons, that were Cranach's, not to mention the fortune he amassed and its influence on the times.

As gifted a diplomat as a painter, Cranach came to hold a special place at the court of Saxon elector Frederick the Wise, Germany's most powerful prince during the first quarter of the sixteenth century. The title "elector" traces back to 1356, when a weakened German emperor created an electoral college, a body of hand-picked electors who henceforth chose the "Holy Roman emperor of the German nation." Seven reigning princes from Germany's most powerful states became "imperial electors," four of them secular and three ecclesiastical.

In 1485, one of the electoral states, Saxony, was partitioned to end a lethal rivalry between the two male heirs, brothers Albert and Ernest. In an agreement known as the Leipzig Settlement the brothers divided and independently ruled what previously had been a united Saxony governed by the reigning Wettin dynasty. By that division, the brothers became the heads of new, independent states: Ernestine Saxony, which kept the

"electoral" title, and Albertine Saxony, which became a duchy, henceforth to remain kindred rivals.[4]

At some point after 1517, as the Reformation began greasing its wheels, the wily, pragmatic Cranach became the de facto mentor of the highly principled Luther. Luther had been a person of interest to Cranach because of the growing iconoclastic sentiment in the budding Protestant movement, then threatening to strip decorative art from Wittenberg's churches and the painters' livelihood along with it.

Around 1520, the electoral Saxon court thrust the two men together in the common cause of reform. It was the beginning of a shared, dangerous life that mixed their professional worlds and young families together. Accompanied by a growing loyal following, the two of them began to shake the foundations of their immediate world, henceforth to be joined together as one in life, death, and history.

PAINTER AND ENTREPRENEUR

Recent exhibitions of Cranach's artwork in Europe and Great Britain have made the sixteenth-century painter something of an icon, as large numbers of viewers fell in love with the classical and biblical stories his paintbrush told. His gifted partner in reform, Luther, frowned on art that made too much of itself, fearing the religious images might be taken as the divine realities themselves. Cranach rather feared contemporary theologians who made too much of themselves, particularly Luther's senior associate, Andreas Bodenstein von Carlstadt, who denounced decorative art in the churches as "painted idols" to be removed and destroyed.

Agreeing that religious images in churches should not be confused with the divine realities themselves, Cranach treated such reverence as a false and presumptuous perspective on art. Early on he and Luther addressed the problem with "idol resistant" sermons and art, that is, self-denying oratory and images that knew their proper place and limits before God.

Although Cranach had fixed responsibilities as court painter, he was also given artistic freedom and opportunity beyond the court's immedi-

ate commissions and requests. He was limited neither in the artwork he created nor in the business ventures he independently pursued. As court painter, he was quickly drawn into the orbit of society's powerful and wealthy, a long line of princes, nobility, humanists, self-made burghers, and high clergy hoping to acquire "a Cranach." Here was a money stream that allowed the court painter to become an impresario of new businesses of his own, as well as the director of his art workshop.[5]

Over his lifetime, Cranach served thirty years on the Wittenberg city council, including three separate terms (nine years) as bürgermeister. He became one of the city's two or three richest burghers and was its leading real estate developer and property owner. For quite a few years, he also owned the city's only publishing house and full-service pharmacy, which operated out of his mansion on Market Square.

Beyond his native talents as court painter, he also had the divine gift of a long lifespan. Living to be eighty-one, he worked to the very end, a remarkable advantage in longevity and productivity that translated into roughly sixty-plus years of active professional painting. No other European artist, neither Dürer in the sixteenth century nor Picasso in the twentieth, who lived to be eighty and had all the technical advantages of the modern world, created as much original art in as many genres and with such novelty as did Cranach and his workshop over the artist's lifetime.

In presenting Cranach to the twenty-first century, the modern biographer's challenge is not accessibility to his artwork, nor any lack of scholarly analysis to guide the uninformed. Over centuries, historians and art historians have staked out their own areas of interest and competence within the sizable Cranach corpus. Today, that research resembles the fragmented, unwieldy German empire during Cranach's lifetime: a torrent of images and commentary begging to be unified and integrated into the story of the artist's life.

The continuing mystery of the Cranach story is the man behind the celebrated paintings and the opulent bank accounts. The imperative is to connect, in historical place and time, the artist with the entrepreneur and the artworks with the business ventures. The story is a thoroughly human one set within the new world of the German

Renaissance and Reformation. In the recovery of the man and his works, one hopes also to rediscover the epoch as well.

"MOST GERMAN OF THE GERMANS"

"Lucas von Kronach" was born in 1472, his Christian name taken from the Apostle Luke, a regional patron saint of artists in and around the Franconian town of Kronach, near Bamberg, from which came his surname. Thirty-two years later, professionally prepared and freshly returned from a three-year tour of the great cities along the Danube, time spent mostly in Vienna, he was called to be the court painter of electoral Saxony, itself a new political regime of even fewer years than Cranach's life then to date.

The invitation was extended to Cranach only after the Saxon elector's scattered brain trust of humanists and artists assured him that Cranach, among all the available candidates, was the closest to Albrecht Dürer in talent and style, which was just the "magical" word the elector needed to hear! A year later, in 1505, Lucas von Kronach, having earlier accepted the Saxon elector's invitation, reported to Wittenberg.

The position was a challenging one. The greater part of the court painter's day was devoted to designing and decorating, furnishing and refurbishing the five castle residences of the princes. He planned the royal festivals and celebrations in the castles and created and decorated the altarpieces for the churches. It also fell to the court painter and his workshop to prepare City Square for the princes' jousting tournaments, also to outfit and accompany them on their seasonal hunts in the royal game preserves, their brushes and palettes at the ready to record "kills" in both arenas.[6]

The mandatory chores entailed endless smaller tasks, such as the design and procurement of wall hangings and frescoes, regalia for horses and carriages, new fall and summer uniforms for the court servants. On one occasion, Cranach was asked to create a gingerbread mold for Elector John Frederick's eight- and nine-year-old sons![7]

Historians have long divided Cranach's sixty-plus years of active painting into periods that exhibit markedly different styles and qual-

ity of artworks. Depending on time and place, those works have been described as hasty and expressionistic (early), humanistic and realistic (middle years), and mannered and mechanical (late). Yet a distinct and abiding core of professional values and a signature style have persisted over his lifetime.

Nineteenth-century art critics described Cranach's early artworks, those before Wittenberg (1505) and Luther (1517), as created "out of pure feeling alone," a conceit of artists and art historians both past and present. From such endowments the Italian masters and their northern peers came to believe, with not a little hubris, that gifted artists could improve on man and nature as almighty God had created both.

Cranach was no slave to symmetry and pattern, anatomical correctness, or extraterrestrial perfection when inventing his subjects. The same critics looked on his irrepressible mannerism and nonconformity, which increased with age, as an "inability" to transcend his early Gothic style.[8] Also taking account of his devotion to medieval popular culture, another critic dubbed him "the Hans Sachs of painting," a reference to the famous shoemaker-poet of Nürnberg, whose verses celebrated everyday life and manners.[9]

Of all his artworks, the altar paintings have received the highest marks for consistency and have been favorably compared to those of the altar master Matthias Grünewald.[10] Earlier generations deemed his woodcuts to be "the most engaging" of all of his artworks, able to "rivet [the viewer] with a swift strike and keen observation, or charm him with a pleasing summary, or naïve fantasy."[11]

But there were unkind critics who abounded as well. They saw his early talent "sinking" long before age became a factor, and dismissed his later works as "quirky."[12] For art historian Wilhelm Worringer his artworks were "conventional and purposeless, no match for Dürer . . . laborious allegories of the Protestant faith," and, most wounding of all: "forerunners of the fascistic cult of the Nordic man."[13]

Cranach's harshest critics turned out to be also among the most influential. Leading the pack was Max J. Friedländer, director of Berlin's Kaiser-Friedrich-Museum in the 1930s. Bridging nineteenth- and twentieth-

century assessments of Cranach, he panned most of the artist's post-1505 artworks and virtually all post-1525, doing so as only a master curmudgeon might. Assessing his later collaborative works with Luther, Friedländer saw only "assembly-line altars for Lutherans . . . jaded, unfeeling, non-sensical . . . shoddy works of the worst kind . . . sixteenth-century kitsch."[14]

In the end, however, the great critic went a stroke too far. In one of the boldest misjudgments in the history of art criticism, Friedländer proclaimed a selection of twenty-two Cranach drawings, woodcuts, and paintings created between 1501 and 1504 to be the artist's supreme "master-works." Yet, in 1504, Cranach was only thirty-two years old, with roughly fifty years of active painting still before him. Surveying the artworks of those later years, Friedländer again found few worthy works to compare to those Cranach had created around the turn of the sixteenth century, moving him famously to conclude:

> Had Cranach died in 1505, he would have lived in our memory as an artist charged with dynamite. But he did not die until 1553 and instead of watching his powers explode, we rather watched them fizzle out.[15]

Mercifully, a popular writer and Cranach admirer, Richard Muther, came on to the scene with some much needed critical balance and levity, praising the painter as "practically the only German artist who did not make the 'Italian pilgrimage.'" In his resistance to the Italian masters, Cranach was for Muther and other critics "the most German of the Germans," by which they meant an artist who did it his way with "Germanic pigheadedness, speaking from his heart without giving it a second thought." Caught up in what Muther called "a crazed age," Cranach, to his credit, escaped artistically into a kinder, gentler, romantic world of German landscapes and popular folk culture.[16]

Never one to believe that art could trump God or nature, Cranach presented his figures for the most part just as he perceived them to be: sometimes patching them up and ennobling them, or darkening them by elaborating on their flaws. To illustrate how "literal" Cranach could

be, Muther seized upon his portrayal of the archetypal German maiden, St. Barbara, whom he described as a "lyrical veal chop"![17]

Much as the medieval artists had treated figures from the Bible and Greek mythology as their contemporaries and kin, Cranach, too, bestowed full Saxon citizenship on the figures he resurrected from antiquity and the Gothic Middle Ages.[18] Far from the marks of a reactionary, his retroactive style and fond use of Gothic rather suggest defiance of the Renaissance juggernaut in an effort to preserve for the waxing modern world some hearty slices of the waning medieval.

The controversy over Cranach's artworks and the new art world they helped to create still continues. From his first reviews in the early sixteenth century, the critics measured Cranach against the consensus best of the age (Dürer), and with few exceptions found him wanting.[19] Modern *art historians* from Friedländer to Joseph Leo Koerner still position Cranach behind Dürer, Matthias Grünewald, Albrecht Aldorfer, Hans Baldung Grien, and the young Hans Holbein. In stark contrast, modern *artists* have embraced Cranach's works as special for his age and their own, having succumbed to the "musical character" of his art and the "variations and diverse treatments" of his subjects.[20]

A scholarly consensus holds that it all began to happen for Cranach in the late 1490s after Dürer's work caught his eye. Still it was not until his turn-of-the-century tour down the Danube that he wholeheartedly engaged the great Nürnberger. That journey took him through the culturally rich cities of Bamberg, Nürnberg, and Linz before finally depositing him in Vienna, where he apparently resided for the better part of three years (1501 through 1504). Home to a flourishing, infectious German culture on display in its art and literature, Viennese humanism remained a force throughout Europe and later played a role in the successful emergence of the first Protestant cities: Nürnberg and Wittenberg.[21]

Swept up in the Viennese art world, Cranach fell easily into the footsteps of Dürer, whose mixture of traditional iconography and modern style was now the cutting edge of northern Renaissance art. Vienna was the first large stimulus to Cranach's budding career, and just the

challenge he needed. Having sworn to himself as early as 1504–5 that he would paint in his own eclectic and expressive way, he now found himself measuring Dürer's shoes and beginning to step on his toes.

Although Cranach and Dürer share many artistic skills, and Dürer remained the towering artist of the century, their differences are far greater, so much that the two men may be said to anchor the opposing ends of the spectrum of German Renaissance and Reformation art. At the one end is Cranach's "fantasy and charm" (delicate lines and willowy bodies), and at the other, Dürer's "seriousness and power" (bold lines and weighty bodies). Already in the pre-Dürer years (1501–4) the core features of Cranach's mature style were visible in his "expressive line play, powerful coloring, and romantic tone." This artful combination created a lighter and freer counter-world to Dürer's tightly controlled, deeply analyzed, and comparatively ponderous universe.[22]

In Cranach's flexible iconography and adaptive style the Reformation found an artist for all sensibilities, one able to leap from vulgar woodcut exposés of the pope in Rome to soul-lifting altar panels that reprise Old or New Testament stories for the worshiping laity of Wittenberg.

ART AND HISTORY

When addressing the relationship between art and history, the art historians and art critics trend strongly toward the professional development of the artist in search of a distinctive style that sets his works apart. In gathering up the sources of artistic influence and identifying the direct borrowings from other artists, the "real story" of the artist's life and times is said to be found. Arguably, art without deep historical roots and an immediate context is not an expression of genius, but more a figment of the artist's imagination, be it ever so novel and bright. The ongoing scrutiny of Cranach's artworks in the ever-present shadow of Dürer is a case in point.

Interpreting art one-sidedly within the artist's "frame" confuses art and history by giving too much to the artist and too little to the world from which he and his artworks come. There is no artist without a

political culture, a literate audience, and generous patronage, all inform-
ing and shaping a work of art. As in life, so in art, civilization is the horse
and the artist only a temporary rider. Every artist lives and works in a
place and time not of his own choosing and can only record what is given
him by his surroundings. From a strong historical point of view, a work of
art is more a reflection of what the age makes of the artist rather than the
artist's response to the age. To interpret a work of art with an eye pri-
marily on artistic precedent and pedigree threatens to shrink art by rob-
bing it of its vital historicity, which is its only immediate substance.
Cranach's Germany is not just about Cranach and the artworks he created
there: it is a narrative of an epoch that, like all other epochs, calls forth
and empowers its own artists.

When in the early 1520s Cranach and Luther combined their skills to
give biblical stories an artistic and Lutheran interpretation accessible to
the masses, it was impossible to keep the pressing social and political
issues of the day out of their heads, broadsheets, sermons, and altar
panels. That was particularly so at a time when the German peasants on
the land and artisans in the cities were preparing for the largest popular
revolt in Europe before the French Revolution. In early Protestant broad-
sheets and pamphlet propaganda targeted at popular audiences, "honest"
peasants were prominently held up to "dissembling" Roman clerics.

Although the reformers intended their broadsheet propaganda to be
a tacit, wait-and-see sanction of the common man's cause, the aggrieved
peasants on the land and the poor artisans in the cities interpreted the
Protestants' broadsheet art as an enthusiastic "go-ahead!" Thereby the
reformers, led by Luther and Cranach, gained at one and the same time
not only the fervent support of the common man, but also the close
scrutiny of skeptical German princes. The result was a peasantry eager to
take their destiny into their own hands, and quite a few knightly princes
more determined than ever to give the common man a lesson he would
never forget.[23]

In the aftermath of World War II a brain trust of Cold War East
German scholars, then the modern residents of Cranach's native land,
became the authoritative biographers of their famous countryman.

Reflecting the concerns of the modern era, these scholars eulogized Cranach as a precocious, socially conscious "freedom-fighter" on behalf of the common man. These same scholars also saw in Cranach's artwork the promise of an "early modern burgher movement" that would free the "simple folk" from their feudal lords in both city and countryside. Contrary to art historian Friedländer, who pegged the peak of Cranach's creative career in 1502–4 (!), the East German scholars, led by Heinz Lüdecke, capped Cranach's effective career in the mid-1520s, the years in which they believed Luther and Cranach delivered the German peasants into the hands of the princes' armies.[24]

More recently, Harvard art historian Joseph Koerner has picked up Friedländer's and Lüdecke's shared torch. In its light Cranach's artwork is seen steadily diminishing throughout the 1520s, as the once great painter "surrendered" his talents to Luther in what these historians and artists viewed as unforgivable subservience of art to theology.

In making a positive case for Cranach, these same scholars had earlier seized upon one of his most popular paintings, entitled *Christ Driving the Money Changers Out of the Temple* (1510–11). Therein they saw and praised their hero's perceived original "socialism."[25] In this emotional scene, the viewer beholds a savior who was as devoted to the material well-being of his followers on earth as he was to their post-mortem spiritual lives in heaven.

Cranach's enraged Jesus was celebrated as a "burgher Apostle" striking out against *Fuggerei,* a reference to the financier Jacob Fugger, who presided over an Augsburg-based trans-European banking empire. Here, the Fugger name is taken in vain, deployed as an epithet for the netherworld of contemporary commercial greed.[26] In Christ's righteously raised whip hand, the coming moral-social wrath of the German peasants is said to be foreshadowed a full fourteen years before their grievances were contested with blood and iron on Saxon and Hessian battlefields.

At a later date (1524), Luther also attacked the "market spirit" of the age, condemning usury in the secular world and simony in the ecclesiastical.[27] Simony here refers to church trafficking in "spiritual goods," such as church offices and marriage licenses (that is, the church's fee-based

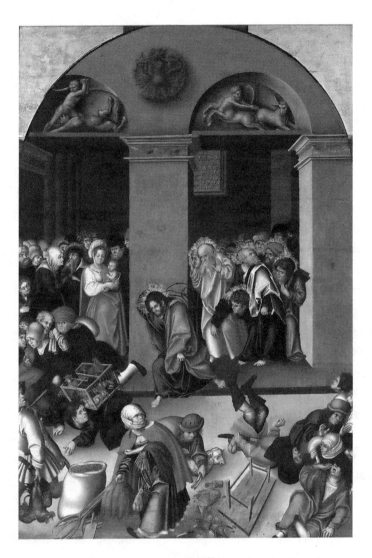

Lucas Cranach the Elder (1472–1553), *Christ Driving the Money Changers Out of the Temple,* 1510–11

(Photo: With kind permission from Gemäldegalerie Alte Meister, Staatliche Kunstsammlungen, Dresden, Germany)

cancellations of acclaimed marital impediments) and, not least, indulgences.[28] By his use of brute force to evict the money-lenders from the Temple, Cranach's Jesus appears as an emancipator of the poor and on the side of peasant rebellion against their lords.

After 1517, Dürer, Cranach, and other German artists began to fear the radical voices in the emerging Reformation. Foreseeing a Protestant stripping of decorative art from the church altars, a serious threat to the artist's livelihood, Cranach and other painters had begun to prepare for the worst. Three years before his death, a pessimistic Dürer wrote and bequeathed a "primer in art" to a new generation of artists, whom he believed would have to relearn basic skills before art could return to the churches in a more enlightened age.[29] Looking forward, the unflappable Cranach prepared for the great recession in art (which, it should be noted, never materialized) by acquiring new skills and mastering new trades that would assure him a comfortable livelihood.

Convinced that art was "a powerful shaping force in history," the post–World War II generation of East German scholars reacted strongly against what they believed to be a narrow, summary treatment of Cranach's artwork, one lacking a proper historical context. Determined to save their great ancestor and his art from perceived theory-driven, ahistorical art studies, contemporary art historians and critics were urged to quit the museums for the archives and the libraries! There, it was argued, they would find not only Cranach's contributions to art, but also the impact of his art on history. Despite the prominent ideological bent, the work of these scholars was a timely, provocative, and refreshing critique of the role of artists and art in history.[30]

To give Cranach his due place in history, those same scholars wrote chronological biographies that went well beyond his graphic art works and paintings. Working outside as well as inside the painter's "frame," they addressed his patrons, family, political life, business careers, relationships with princes, bishops, and reformers—altogether an attempt to present a rounded picture and appreciation of their great ancestor. One lasting result of this "big picture" research was a timeline narrative of Cranach's Germany.

Unfortunately, these laudable efforts to historicize Cranach's life and work and celebrate the man behind the pictures were shot through with the ruminations of Karl Marx and Friedrich Engels on human nature and the class struggle, the high price of doing history in the German Democratic Republic (DDR) between 1945 and 1990. In the end, the kettle was calling the pot black. Having berated contemporary art historians and art critics for alleged "ahistorical" studies, the Cold War East German historians were themselves no less enslaved to their own ideological reading of history.

The received ideology notwithstanding, the East German scholars succeeded in recasting the German Renaissance and Reformation as a prescient sociopolitical humanist-progressive "burgher movement" (*die frühbürgerliche Bewegung*), one that began to move Germany and Europe out of the Middle Ages and into an early modern world. The intertwined religious reforms and social revolts that became the Protestant Reformation and the Peasants' War in the mid-1520s are still today referenced in the speculative annals of Marxist-Leninist philosophy. In the hands of East German historians, the rebellious Protestants and peasants became the first of three great popular uprisings against European despotism, later to be followed by the kindred English (1649) and French (1792) revolts.

In Cranach's and Luther's era, the greater German states seized the opportunity to subordinate self-governing towns and villages to higher, territorial law, thereby depriving the artisans in the towns and the peasants on the land of their local freedoms. While no friend of revolutionaries, a self-interested Luther initially supported peasants in their grievances against oppressive overlords, treating the conflict as a cut and dry matter of precedent and law. As Luther put it:

> Since there is nothing Christian on either side and nothing Christian at issue between you, both lords and peasants are dealing with worldly right and wrong and temporal goods. And, moreover, since both parties are acting against God and are under his wrath . . . let yourselves be advised and attack these matters with justice, not with force or strife, and do not start an endless bloodshed in Germany.[31]

Ignoring Luther, both sides plunged into just such a bloodshed. When the carnage ended, Cranach, and arguably Dürer as well, fully shared Luther's condemnation of the peasants, who had drawn the first blood. Luther also cursed the landlords and the princes as "tyrants." In the aftermath of war the painter and the monk beseeched the princes to show clemency to noncombatant peasants caught up inadvertently in the fields of battle.

Still hewing closely to Marxist ideology, the Cold War East German historians blamed the massacre of the peasants on a dithering, cowardly bourgeoisie. The "proletarian cause" was lost in the sixteenth century at the moment the self-serving middle classes, led by Luther and Cranach, caught sight of the Saxon and Hessian armies arrayed against the revolutionaries. For the middle classes, that sobering specter ended both the old dream of an egalitarian society and the new dream of a just one. In the eyes of the masses, Cranach and Luther had ceased to be the god-sent "burgher Apostles" and "honest men of God" for whom they had waited. In Friedrich Engels's nineteenth-century history of the German Peasants' War, the "Serpent" and the "Lamb" became "the age's bootlickers of established political power."

In proposing to his age a comprehensive moral-religious, civic reform, Luther never insinuated that the assets and privileges of princes and landlords could become the deprived peasant Christian's bounty for the taking. The German peasants were legally bound to deliver contracted goods and services to their lords. The New Testament was no "communitarian manifesto," nor did it sanction a dictatorship of the aggrieved common man.[32] On the eve of the Peasants' War, Luther declared that the most a poor artisan, or peasant, might expect religiously from God and legally from his landlord was the mutual keeping of their faith with the one and their contracts with the other. The only resolution for both sides was a stand down and return to the status quo ante.

On the brighter side, Luther stressed the freedom of both peasants and lords, as believing Christians, to love and make sacrifices for the other. Stopping short of disobedience to political authority, the new Lu-

theran gospel cited a standing lesson of history and Holy Scripture: "tyranny begets anarchy and anarchy, tyranny." Neither prince nor rebel, Luther preached, escapes that terrible cycle that punishes both the guilty and the innocent alike.[33]

For all the ink the post–World War II East German Cranach scholars spilt in the rediscovery of their famous ancestor, their last words on Cranach and Luther were utterly dismissive and unforgiving, a dark historiography that still hangs over the famous pair. Lüdecke declared their partnership to be "more financial than artistic" and the artworks manipulative and exploitive. In this interpretation, Cranach's art and Luther's theology succumbed utterly to the political control of the Saxon regime, narrowing the vision of both men. To drive home his point, Lüdecke juxtaposed Cranach's early Leningrad *Venus* (1509) with his later Frankfurter *Venus* (1532): the first said to be a true "confession of Humanism," the latter, merely "a cavalier's amusement."[34]

For the Lüdecke school of history, the "retrenchment of the class struggle" in the aftermath of the Peasants' War sullied any promise the German Renaissance and Reformation might have extended to the common man. In this dark scenario, Luther's theology was said to have corrupted Cranach's art, which in turn betrayed the common man, while the great Protestant reformer himself salvaged his religious reforms by rushing into the bloody arms of the princes. Pamphleteering against "the murderous, robbing peasants" in the aftermath of their revolt, in 1524, Luther's reforms and peacemaking efforts became just another stab in the common man's back.

Compromised by his long association with Luther, neither Cranach's previous condemnations of greedy merchants and corrupt clergy nor his sympathetic portrayals of the common man's plight could buffer and redeem his reputation in the eyes of the unforgiving historians. The situation was also not helped when in the place of his early, admired artworks came new portrayals of the age's alleged "tyrants" and erotic renderings of nude heroines drawn from classical and biblical antiquity.

The most offending of these works for contemporaries may well have

been Cranach's painting of the new elector, John the Constant, the brother and successor of Frederick the Wise, whose portrait at Cranach's hand bore the title: "Savior of Germany."[35] The timing was unfortunate for both painter and new elector. John the Constant was by this time best known to contemporaries as the prince who had slaughtered more peasants on the battlefields of Saxony than any other.

DISMAL ANALYSIS

Despite the twentieth-century collapse of Communism and the end of the Cold War, the postwar era's ideological approach to history has been only slightly chastened by new criticism and the passage of time. Rephrased and fine-tuned by recent generations of historians, new versions of that ideology still remain at the center of a deconstructive history of the German Renaissance and Reformation. In the late 1970s, East German historians still harked back to Marx and Engels to define a proper histori-cal framework for the period. Werner Schade, then the dean of German Cranach studies, blamed the century's failings on a middle-class rejection of "the insurgents who persisted longest in revolutionary thinking."[36] By insurgents, he meant the leaders of the German peasants and in their wake (after 1529) the outlawed Anabaptists, yesteryear's acclaimed prole-tarians and righteous victims of the age.

Today many historians portray Cranach's Germany as a hegemonic era of despotic rulers and domestic patriarchs, one that was more the last hurrah of the Middle Ages than any foreshadowing of an enlightened modern world. In present-day Anglo-American scholarship extending from Thomas A. Brady's *Religion and Regime in Strasbourg* (1978) to Diarmaid MacCulloch's best-seller, *The Reformation* (2003), the decades of the German Renaissance and Reformation present a divisive and corrupt-ing era of patriarchy, religious persecution, and endemic warfare, to which present-day German failings are still confidently traced.[37]

At the end of a long survey that gives the fewest pages and the unkind-est cuts to the German Reformation, MacCulloch proclaims sixteenth-century Anabaptists and Erasmians (Pentecostals and Humanists) to be

the true bearers of a *worthy* modern Protestant legacy.[38] "Losers" in the age of Cranach and Luther, they are today joined in modern imagination with the martyred peasants: yesteryear's true champions of modern freedom and equality.[39] Unlike the Anabaptists, the Erasmians were more effective in fighting off the follies of the age. Their greater learning and eloquence, bolstered by wit, carried their wishes to fulfillment, allowing them to die more often than not peacefully in bed.[40]

Against such negative analysis of Germany's most formative century before the nineteenth, it is imperative to remember what was at stake for conflicted German lands and European civilization. Freely and fully conscious of their peril, separatist Anabaptists and skeptical humanists rejected both Rome and Wittenberg, denying and challenging the latter's most sensitive beliefs. Yet, unlike the Lutherans, neither had a ghost of a chance of succeeding against the religious-cultural-political monolith that was still then the Church of Rome.

For their part, the Anabaptists, both by choice and Roman-Protestant pressure, chose a segregated life in exclusive, regimented communities of their own creation and rule. For all the humanists' witty criticism of Rome and Wittenberg, the cautiously dissenting Desiderius Erasmus and his brainy followers were no better equipped than the Anabaptists to engage, much less defeat, the unsentimental, non-egalitarian Roman Catholic world of the sixteenth century. Like their namesake, the Erasmians were ambitious "soft-power" advocates in a world that could be changed only by brute force, a vital option their pacifism, like that of the Anabaptists, forbade them even to consider, much less forcefully pursue.[41]

Consider, for example, Erasmus's operational plan for pacifying the then menacing Turks:

> The most efficacious way of overcoming the Turks would be if they beheld that which Christ taught and exemplified shining forth in our own lives, if they perceived that we do not covet their empires nor thirst after their gold nor seek their possessions, but rather strive for nothing except their salvation and Christ's glory.... If only we act thus, Christ himself will be with us.[42]

Again, unlike the Anabaptists, the Erasmians possessed critical linguistic skills that enabled them to make explosive, historical knowledge available to the reformers, who, in turn, had no qualms about turning such knowledge into weapons of political and religious deconstruction in the war against Rome. To succeed against the entrenched powers of the Middle Ages, the early modern world required religious and political "swashbucklers" like Luther and Cranach.

These two men discerned the vital needs of the times and addressed them with confidence and force beyond reedy ridicule, wit, and abject pleading. It took a Luther to turn Erasmus's Greek edition and Latin translation of the New Testament into a readable German vernacular Bible the masses could grasp and wield like a sword against Rome's ever-encroaching encyclicals. And it took a painter of Cranach's force and subtlety to dramatize, on countless church altars and single-leaf woodcuts, the heartfelt jeopardy created in the souls of contemporaries by the abiding issues of sin and redemption, Armageddon and Apocalypse, resurrection and life eternal.

CRANACH AT THE GATE:
BREAKING THE RENAISSANCE MOLD

Before Cranach and Luther joined forces against Rome, the German humanists had adopted Erasmus's light and humorous, clever and witty exposés of the pope. Truth be told, those exposés were literary birdshot rather than heavy cannonballs. In raising the bar, the reformers' first collaborative work of religious propaganda set its sights directly on the Holy Father in Rome. Entitled *Christ and Anti-Christ* (1520), it was a bludgeoning, twenty-six-page block-printed pamphlet that enumerated the many reasons why the "Holy Father in Rome" deserved the Protestant cudgel.

By comparison, the humanists' approach to reform paled as effective criticism. The reformers' broadsheets proved to be the more powerful weapons in the confessional wars that were to follow. Backing them up

behind the lines, Cranach created his own "light cavalry" designed to demoralize the enemy in heart and mind, while cheering on the faithful. Disarmingly, he enlisted infants and children into Protestant broadsheet propaganda against Rome and the sectarians.

A popular example from the late 1520s was taken from the gospel story in which Jesus commands his disciples to clear the way for the little children so that they may come directly to him. Entitled *Christ Blessing the Children* (1504), its message accused the papists and Anabaptists of not having humility and trust enough to enter the kingdom of God by the faith of a child.

Over the years, this novel, riveting scene appeared in twenty-plus versions highlighting the gospel message and admonishing the Wittenberg faithful to heed the words of Jesus: "Whoever does not receive the kingdom of God like a child shall not enter it" (Mark, 10:13–16, Matthew 19:12–15, and Luke 18:15–17). In the background of this popular painting, the enemies of salvation by faith alone and infant baptism are seen scoffing and grumbling as Jesus welcomes a throng of new mothers, who caress, kiss, and commend their babies to God in holy baptism. Here the grim, ascetic religious mindset that rather chose chastity, repression, and the single life over God-ordained marriage, sex, and family met its "betters" in the army of happy mothers and contented infants directly blessed by their Savior. In this familial setting, the viewer is reminded of God's commandment to live together in the divine estate of marriage, there to become "fruitful and multiply," and thereupon also to build the kingdom of God in and through disciplined children and loving families.[43]

Throughout the Middle Ages, church restraints and guild regulations inhibited artistic freedom and experimentation, limiting the variety and quality of the artist's work. Treating contemporary artists as monastic scribes with paintbrushes rather than quills in their hands, Rome dictated subject matter and style, obliging artists to present anomalously jaded iconography and a questionable doctrine of the church.

By the late Middle Ages and High Renaissance, artists empowered themselves by gaining new technical skills that allowed them to expose

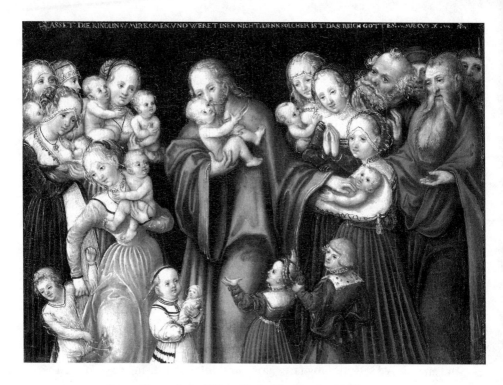

Lucas Cranach the Elder, *Christ Blessing the Children*, 1535.
Oil on wood, 6½ × 8¾ in.
(The Jack and Belle Linsky Collection, 1982 [1982.60.36],
The Metropolitan Museum of Art, New York;
Image copyright © The Metropolitan Museum of Art/Art Resource, New York)

multiple layers of contemporary life heretofore hidden or passed over. With such skills came also the freedom to chose their own subjects, render them in their own style, and put their own names on completed works.

By the time Cranach became the Wittenberg court painter, the problem of the artist was no longer a lack of artistic freedom, but rather the authoritarian nature of Renaissance art itself. When the masters of the Renaissance transcended Romanesque and Gothic art, their skill level was so high that many believed the new art to be the only art hence, the "end of art."

With few artists and even fewer patrons daring to step out of the new art's orbit, High Renaissance art threatened to become monolithic art.

The greater its success the greater the difficulty for artists to paint in ways other than those of the Italian masters and their northern peers. At its highest levels, Renaissance art was the new orthodoxy, and departing from it proved to be no less difficult than breaking with Romanesque and Gothic.

In both art and religion the German Renaissance and Reformation is the story of besting the old authorities and empowering the new. Before artists could choose their own subjects, put their own name, initials, or markers on a work of art, recruit their own patrons and customers, and run their workshops, they first had to become independent of the restraints placed on their craft by the church and the artisan guilds. When Cranach became the Wittenberg court painter, the Italian and German masters had long since triumphed over medieval art and High Renaissance art was believed to be as perfect as art would ever be.

Cranach responded critically to the Italian masters and also to Dürer by integrating expressive, nonconforming elements of Gothic art into his own well-absorbed Danube and developing Wittenberg style. Over roughly the same period, between 1505 and 1517, Luther independently challenged the leading lights of his profession. At this time he was rediscovering the original Christian gospel and by its light exposing the unbiblical teachings and practices of the medieval church.

Over the next three decades (1517–47) small, rustic Wittenberg would shake the foundations of both established religion and established art. That shaking, in turn, started the division of Western Christendom and the proliferation of new Evangelical confessions. Like the changes in the churches, that of the traditional art world also made room for new ventures. The art that came off Cranach's assembly line was refreshingly innovative in both iconography and style, drawing numerous new patrons to his art and Luther's sermons.

In contrast to the alternating realism, idealism, and heroism of High Renaissance art, Cranach's art world drew admirers into a kind of "twilight zone" where previously commanding orthodoxies no longer held great sway.[44] To break out of the Renaissance mold and gain his cutting edge, Cranach had also to master fully the skills and techniques of the

new Renaissance art world, which served him well. Although the regnant style of the Italian and German masters was not his preferred way to represent the world around him, in adapting to the competition in his own way, he positioned himself to take from, improve upon, and ultimately bring the most appealing features of contemporary art into his own developing art world.

An educated borrower with the talent to improve upon what he took from others, Cranach targeted established subjects in the graphic arts and paintings, as he proceeded to develop them in ways the original artists had not imagined. While embracing modern artworks, he also held tightly to old Gothic style, preserving the one as he mastered the other. Thus did the borrower learn what the lender knew, while the lender discovered his debt to the past and to the borrower.[45] In this way Cranach steered a sizable part of the contemporary art world away from a glorious, but often all too rigid and triumphant, High Renaissance orthodoxy.

To the great war with their times, Cranach and Luther brought genius, stamina, novelty, and derring-do. Both embraced popular and middling culture along with elite, Cranach preserving truth in art, while Luther sought it out in religion. Despite their different professions and temperaments, they became the best of friends and collaborators, bound together in a common cause that reshaped their world in the peak years of the German Renaissance and Reformation.

2

Chasing Dürer

FROM KRONACH TO WITTENBERG

Kronach was not Nürnberg and Cranach's origins were not Dürer's. He was born in the small, unwalled Upper Franconian town of Kronach in 1472, his mother the daughter of a shoemaker and his father a Bavarian immigrant. Hans Maler ("Hans the Painter") is remembered today as the founder of three generations of Cranach family painters, although he appears to have been rather more a craftsman than an artist himself.[1] There are few undisputed facts in the first thirty years of Cranach's life, starting with the date of his birth.[2] Not until the turn of the sixteenth century, after he had toured the southern German cities along the Danube and taken up his service as court painter in Wittenberg, did a broad, reliable account of his life begin to appear.[3]

In 1500, his hometown was approximately the size of Luther's Wittenberg, both cities showing roughly twenty-five hundred inhabitants. Although internally governed by a native city council and an elected bürgermeister, Kronach was under the political jurisdiction of the Bishopric of Bamberg. A bishop's appointee presided over the city council, ensuring the church's prerogative in city debates and legislation. Because those same church authorities were also the patrons of his father Hans Maler's workshop, Cranach grew up a firsthand witness to town-church, lay-clerical conflicts not unlike those that later framed the Protestant cities and brought him into Luther's camp.[4]

Cranach's parents and siblings were not immune to local conflicts. Toward the end of the fifteenth century, when Lucas was in his mid-twenties, his family surfaced both notably and ignobly in the city's legal records. On one hand, the professional services of Hans Maler's omnibus workshop kept the family in good standing. Those same services also brought it wealth, which was on display in the family compound on Market Square. There was, however, a dark side: feuding with a rival family of good standing brought unwanted notoriety on to the Malers.[5]

In March 1495, Hans Maler filed the first of several lawsuits against city councillor Kunz Donat, who two years later would become Kronach's bürgermeister. The first suit accused a Donat daughter, wife, and mother-in-law of slandering the Maler family name and physically abusing two of the Maler children: a five-year-old daughter was allegedly beaten and her fifteen-year-old sister pushed to the ground while carrying a sibling in arms. Young Lucas appeared in one of the Maler–Donat lawsuits, apparently after having stood shoulder to shoulder with his sister in meeting Donat aggression with Maler force. In their self-defense, the Donats accused the Malers of encouraging their children to attack the Donat children in a sinister belief that their children, being minors, could wreak havoc on the Donats with impunity.

By the end of the year the Donats had been fined and the Malers absolved. The judgment was not, however, a clear and settled victory for the Maler family. Continuing animosity on both sides kept the feud alive for two more years, leaving embarrassing descriptions of the Maler children's behavior in Kronach's criminal ledgers.[6]

In the second half of the fifteenth century, wall and altar decorations flourished in German churches, making those decades good ones for local painters, engravers, and stonemasons. In the large urban parish churches clerics and artists had their hands full. The artists retold popular biblical stories to the congregation in numerous altar panels, while the number of memorial services for deceased members of church families, guilds, and confraternities received the services of scores of clergy.[7] Kronach, being a small town with too few churches and cloisters to support its skilled

artists, did not share in the boom in decorative church art. Nor was there any great wealth in the surrounding countryside for its work force to tap.

For a gifted young artist, Kronach was a town to leave, and for those willing to pick and go its geography made the decision easy. A trade route hub connecting to the Middle Rhine, Danube, and Elbe rivers, the city gave its talented native sons and daughters in search of broader horizons the one thing they needed most: convenient access to grander cities and the workshops of true masters. In 1491–92, upon turning twenty, Cranach made his "bachelor's journey" (*Wanderjahr*) through the southern German cities, expanding his skills and developing a style of his own by close observation of, and liberal borrowing from, the competition.

Previous generations of scholars had long believed that the dukes of Coburg, an electoral Saxon town, were the first to discover and broadcast Cranach's talents throughout the region. Sited twenty-five kilometers west of Kronach, Coburg had long been a popular rest stop for travelers going to and from Nürnberg. One envisions a young, wandering Cranach making just such a trek and discovering, wide-eyed, the artworks of Dürer and other Nürnberg masters.

After Wittenberg and Torgau, Coburg was the favored residence of the Saxon electors. With its great mineral wealth and work opportunities, the city could entice the best painters, goldsmiths, and wood- and stone-cutters for the projects in and around the castles, churches, and cloisters.[8]

The discovery of Cranach's wall paintings in Fortress Coburg moved earlier generations of scholars to place the artist there at the turn of the century. At this time (1501), Coburg was rebuilding and refurbishing its fortress, which had recently been destroyed by fire. Those same scholars also placed Duke John the Constant, the younger brother of Elector Frederick the Wise and heir apparent to the electoral Saxon crown, in a semi-permanent residence there. The difficulty of establishing Cranach's whereabouts and activities in the last decade of the fifteenth century can be seen in recent studies that deny that Duke John and Cranach lived and worked together in Coburg at the turn of the sixteenth century. Those studies argue that the "Lucas Maler" who appears in the Coburg

archives in 1501 was rather the son of another Coburg painter, Hermann Tötzel, who, like Hans Maler, had also named his son after St. Luke.[9] Sited twenty-five kilometers away from his hometown of Kronach, Coburg had great appeal to regional artists. It is conceivable that Cranach had gone there at some early date, perhaps on the eve of his journey down the Danube to Vienna, although presently the sources have yet to document that.[10]

While such findings, or failure to find, seem only to diminish and confuse our knowledge of Cranach's career, they actually help us keep the historical record straight. Cranach *was* indeed active both within and around Fortress Coburg, but the year was *1505*, after he had become the electoral Saxon court painter, not 1501, when he was just getting started with his career. Reporting for work in Wittenberg in the summer of 1505, he found himself soon on the way to Coburg, and from there back and forth to other electoral Saxon residences. On April 14, 1505, he received his first recorded payment as court painter: "40 Gulden for services rendered at Castle Torgau."[11]

The extended stays in the royal residences were not always devoted to maintenance and decoration. Cranach and his journeymen also accompanied the elector's royal entourages on their seasonal hunts in the rich game preserves that surrounded the dynasty's castle residences. There, they prepared the grounds for the hunts and the hunters for the kill, handicapping their prey by herding them into cul-de-sacs and breaking their flight paths with water traps and heavy nets. In the aftermath of such hunts, Cranach and company recorded the carnage for posterity: wild game (deer, boar, and bears) were taken by the scores and fowl in even greater numbers.[12]

In 1506, Cranach traveled with his lords to Coburg Castle for just such a hunt. Later in that year he would create his first major painting as the Wittenberg court painter: *The Martyrdom of St. Catherine*. In that artwork he remembered the Coburg hunt by inserting a background scene in which the torsos of Elector Frederick and Duke John, both in their hunting garb, dash past the distant Fortress Coburg shining high above their heads as if it were a great, heavenly crown.[13]

FRIEDLÄNDER'S "TWENTY-TWO":
WERE CRANACH'S FIRST WORKS HIS BEST?

After departing Kronach at the turn of the century, Cranach traveled through the southeastern German cities of Bamberg, Nürnberg, Regensburg, Passau, and finally to Linz, where he embarked down the Danube en route to Vienna. There, he beheld the residence of the imperial Hapsburg dynasty, home to Emperor Maximilian's new College of Poets and Mathematicians (founded in 1501). No cosmopolitan yet, the Kronach native must have thought he had wandered into a fantasy land.[14]

In Vienna, he became acquainted with two crowned poets laureate: the German humanist and university professor Conrad Celtis, and the university rector (dean), Johannes Cuspinian, successor to Celtis in 1493. By the good graces of those two famous men, Cranach was introduced to the world of Viennese humanism and art, both of which he devoured. The years in Vienna opened wide the doors to classical antiquity, henceforth to inform both his secular and religious artwork.[15]

In 1932, a well-known modern art connoisseur, Max J. Friedländer, selected twenty-two of Cranach's artworks completed during his Danube-Vienna period and proclaimed them "a self-contained group," distinct from and superior to all of his artworks before and after.[16] Named the "Vienna Group," these "incunabula of the Danube style" have been described as "fantasy realism: artworks that are hugely spontaneous, complex, intense, and mysterious."[17]

Taken together, "Friedländer's twenty-two" reveal a gifted artist caught up in both the pleasures and the throes of his creativity. Striking out in both new and contradictory directions, Cranach's early artworks present an inspired spectrum of gory crucifixions of Christ, grotesque martyrdoms of saints, and playful putti, who share strawberries with baby Jesus, and escort Mary Magdalene to heaven on their tiny, batting wings.

The imagery for the woodcut series of Christ's Passion, particularly the crucifixion scenes, would later become a staple of the new Protestant artwork. Other standouts in the group of twenty-two are secular-profane works that showcase his own Christian-humanist interests. In early sets of

"pendant" paintings he presents two notable Viennese couples, inaugurating a new genre of portraiture: so-called pair paintings. They too became staples of Protestant art, often presenting the era's most watched couple: Martin Luther and Katherine von Bora, whom Cranach celebrated throughout the mid-1520s and '30s.

In an artistically unremarkable pen-and-ink drawing dating from this same period, Cranach surprisingly presented among his Vienna works a completely different kind of couple: anonymous lovers in an impassioned tryst. This work appears to be a first surviving artistic expression of his interest in illicit sexuality, a subject he would later pursue in his classical nude repertoire.[18] Seemingly counterintuitive, those same Cranach nudes would loom large in Luther's domestic and social reforms.

In an effort to contextualize the artwork of Cranach's "Danube period," Friedländer invoked Dürer to explain Cranach's early, rapid success.[19] According to Friedländer, Dürer was the not so invisible hand guiding Cranach's career from the 1490s through the highly productive Vienna years (1501–5). "Discreetly, but constantly," so Friedländer, Cranach "assimilated" Dürer's art to the fullest, taking in as much of it as time and talent allowed.[20]

Inspired and emboldened by Dürer's example, the still somewhat rustic and hesitating Cranach put his initials on one of his own artworks for the first time. That select work was *The Schleissheim Crucifixion* (1503), also known as the *Lamentation Under the Cross,* and praised by many as the best of the Vienna Group's crucifixion scenes. In putting his signature on his artworks, Cranach did not yet act so boldly as Dürer, who early marked his artworks with large, free-standing capital initials "A.D.," sometimes intertwining them, at other times arranging them side by side. By contrast, Cranach boxed up one of his early, if not first, autographs by putting his initials safely in a cryptogram.[21] This was a generic marker like those of handworkers and stonemasons, a still humble medieval gesture that put craft before the craftsman and artwork above the artist, thereby crediting the finished product to a higher power than the artist himself.

Some years later, after Frederick the Wise endowed his court painter with a spectacular bat-winged, serpentine coat-of-arms (1508), Cranach

put all such modesty behind him. In his post-1508 artworks he displayed a new serpent shield with Düreresque panache, sometimes showing initials, and sometimes not. Henceforth, the new coat-of-arms became the official signature of Cranach, his workshop, and his family.[22]

In these early years, there was no denying Dürer's preeminence in the contemporary generation of artists. Cranach became intimately acquainted with Dürer's artworks, and he quietly paraphrased them whenever the opportunity was there. By the time he departed Vienna to return to Kronach in late 1504, he was a renowned, near peer of Dürer in certain humanistic circles. In terms of skill and popular appeal, whatever he borrowed and adapted from contemporary artists, the result retained the quality of the original source and often transcended it.

Examples of such borrowing and bettering appear throughout the first decade of the century not only in the Vienna Group, but also in the fourteen sheets of Cranach's completed *Passion of Christ* (1509–10). Comparing the latter with Dürer's unfinished *Albertina Passion* and *Large Passion,* Cranach scholar Werner Schade allowed that Cranach had both matched and excelled Dürer's renowned *Apocalypse* and *Large Passion* series. As Schade put it: "Their roles seemed now (1509–11) to have been reversed. Dürer, the great giver, falls behind the eagerly receptive Cranach, no doubt because of the latter's greater dexterity and adaptability."[23]

Dürer, kind soul that he was, praised Cranach's renderings of classical (mythological) women as the "best in genre among all artists of the era." In the same vein Wittenberg's professor of Greek, Philipp Melanchthon, a besotted Dürer admirer, juxtaposed Cranach's "beguiling restitution of simple ordinary life" favorably with Dürer's grand artworks.[24]

Arriving in Vienna in 1501 full of raw talent and eager to learn from the masters there, Cranach's intense encounter with Dürer's work made him a worthy peer and rival by the end of the decade. In the most inflexible artistic medium of them all, Dürer had been the unquestionable "king of the woodcutters." Yet, in woodcuts and engravings of his own, Cranach's early efforts (1501–4) reveal a rare ability to create scenes of "heightened excitement and string-tight frenzy," suggesting a Dürer "contender" in this medium as well.

To become a court painter anywhere was a great achievement for an artist, and to be that of the electoral Saxon court was a rare leap. However, before Cranach's art would change his times, his times would change the artist and his art.[25]

THE DIFFERENCE TIME MAKES:
TREKKING TO SCHLEISSHEIM

Friedländer hailed several of Cranach's Vienna artworks as being "completely independent" of Dürer's influence and that of all previous artistic tradition and convention. That was a high tribute to Cranach's early attempts to infuse new life into traditionally prized but often time-worn iconography and style. From his select twenty-two, Friedländer singled out three works to represent the painter's excellence and variety. They were: *The Schleissheim Crucifixion,* a new kind of crucifixion scene; *The Cuspinians* and *The Reusses* (1502–3), novel "pair" paintings of newlyweds; and last, but not least, *The Holy Family Resting on Its Flight to Egypt* (1504), the latter a fantasy portrayal of the family of Jesus and some of its friends.

A scant three years before any of these masterpieces existed, the twenty-eight-year-old Cranach painted what is today his oldest surviving artwork: the little known and perhaps best forgotten *Schottenstift Crucifixion* (1500). Its name was taken from the Benedictine abbey of Schotten, where it was originally displayed. By comparison with scores of Cranach crucifixions running through the first half of the sixteenth century, this seeming "cartoon" gives the modern viewer a baseline for the artist's skills on the eve of his three-year "Danube period." Placed side by side with *The Schleissheim Crucifixion,* the Schottenstift may attest the shortest learning curve in a Renaissance artist's career.

Undertaken in 1500, *The Schottenstift Crucifixion* shows Christ hanging between the two thieves who accompanied him to his death on Golgotha. Sketchy and pox-marked, an agonizing Christ spills a seeming river of blood down the sides of a rough-hewn pole on which he was crucified. With the exception of the horses and their riders, the attending figures

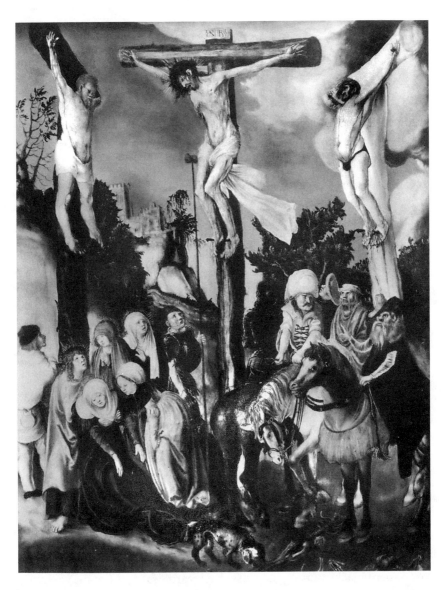

Lucas Cranach the Elder, *The Schottenstift Crucifixion*, 1500.

Oil on wood, 23 × 17¾ in.

(Kunsthistorisches Museum, Vienna, Austria;

Photo: Foto Marburg/Art Resource, New York)

remain indistinct and give the appearance of having been hastily mustered onto the scene.

On the left, four women clad in bright red or black velvet join a midget-sized John the Baptist and the centurion in comforting the swooning Mother of God as she witnesses the scene. Whatever impression the sight may have made on contemporaries, the modern viewer beholds a scrum of distorted figures bracing for the Savior's death.

On the right of the cross three roguish and grotesque riders sit compactly on their mounts in a row. Clothed in bright, contrasting colors, they are a far cry from the three kings who visited Jesus on his first birthday. To all appearances they are a contingent of Ottoman Janissaries, soldiers or mercenaries, who first appeared in western Europe in the fourteenth century and are seen here extending their protective services. Reading from left to right, the three of them sit respectively on dark, gray, and bay mounts.[26]

Given the gravity of the event, they seem crudely comedic and undermine the sanctity of the occasion. That they steal the scene is no compliment to the artist, nor any reassurance of the viewer's salvation. The first rider wears an outsized turban, the second a diminishing straw or canvas hat, while the bearded third rider, to all appearances the leader of the pack, sports a wide-rimmed, red and black conical hat angled over his right ear. In apparent sympathy with the confused viewer, his perky bay horse cocks its head and sends a knowing wink to him.

In the artistic mixing and matching that is the *Schottenstift*, the turbaned rider gives every appearance of having mounted his horse (the prominent black abutting the cross) backward! If that is not the case, then the armored black knight under the cross has managed to take the turbaned rider's mount out from under him unawares, leaving the poor rider sitting in thin air and holding on for dear life.

In the confusion, the gray mount joins a dog in pawing through the human remains of previous crucifixions, another display of Janissary nonchalance in a scene of Christian tragedy. Striking and unusual is the dark humor that Cranach seems to have injected into a traditionally

mournful scene. As if wanting to change the subject, the plucky bay struts in her bright red fringed apron!

Cranach was always eager to freshen and reanimate clichéd iconography, whomever the figure, or whatever the subject. His early *modus operandi* was to ennoble old icons by presenting them in a more appealing medium, while at the same time improving the traditional story line. Confronted by a time-worn woodcut topic, or a dull engraving of a well-known figure, Cranach's instinct was to turn both into colorful, captivating paintings, which occurs repeatedly in the crucifixion scenes.

In creating his first Passion story (*Schottenstift*), replete with Janissaries, Cranach was testing the possibilities of the genre and responding to a contemporary masterpiece, Dürer's *Apocalypse* (1498). If, as it seems, he took on the *Schottenstift Crucifixion* prematurely and unprepared, he also dutifully did the hard work of raising his skill level for the future *Schleissheim Crucifixion* to come three years later.

From Dürer's works and those of others he had borrowed and learned from, Cranach's goal was not to duplicate, or copy, but to improve upon the reigning "exemplars," thereby enhancing both his own and his lender's skills. For Dürer, a true work of art was always a new creation, and any borrowings from ancient or present-day artists should be seamlessly assimilated and ennobled within the final work.

Throughout his Danube years, Cranach took full advantage of the resources of humanistic-Christian Vienna.[27] Those learning years shaped the so-called "Danube style," which in the 1520s would become a composite of the "Wittenberg style." Altogether, the latter was a lighter, ascetic art form searching for the defining core of a figure, or a subject, while leaving nothing precious behind.[28]

In overhauling well-established subjects, Cranach put far more of himself into his artworks than ever he did borrowings from other artists. As for the final result, he left it to the viewer to decide what was creatively added and what was simply borrowed, trusting the viewer to discern the difference between an artwork creatively transformed and a simple copying. Given the variety and novelty of his early artwork it contradicts

the eyes and falsifies artistic endeavor to describe Cranach's early art as "knock-offs" of idealized Dürer figures and compositions.[29]

Three years after the seeming fiasco of the *Schottenstift Crucifixion*, Cranach radically rearranged the dramatis personae of the traditional crucifixion scene, this time to lasting applause. The resulting, masterly *Schleissheim Crucifixion* was a successful effort to show faithful Christians a new way to behold and worship their Savior, and as such it became the watershed painting that climaxed the so-called Vienna Period.

Cranach approached that grand finale by a deep study of Dürer's *Large Passion*, after which he created a complete Passion of his own. If up to this time he had been standing on Dürer's shoulders, with the completion of his *Schleissheim Crucifixion*, it was Dürer's turn to kneel before Cranach's finished work.

One of the early scenes was a woodcut titled *The Mount Calvary Crucifixion* (1502), a work of distinct figures and restrained brutality, knit together in an artistic unity Dürer would have approved. The foreground scene shows John the Evangelist and three unidentified women comforting the Mother of God, who has collapsed to the ground after beholding her son upon the cross. Although described by some as an elaboration on Dürer's *Mourning of Christ* (1496–99), Cranach's intention was more likely to give Dürer another art lesson in human emotions.[30]

Cranach's imagination made this work a model for all of his future crucifixion scenes. He girded Christ in an outsized, billowing loincloth, henceforth to become a Cranach signature of hope beyond tragedy, peace of mind everlasting. While firmly tethered to the Savior's body, the animated loincloth takes on a life of its own as the dying Christ surrendered his. Free-floating and kite-like, the loincloth became an agile guardian of the sacred space around the Savior, and a protector of all the holy dead. Holding tightly to the Son of God, both in his death throes and after his life was gone, the faithful, feisty loincloth stands an unstinting vigil, its ethereal folds suggesting smoke and the beating of angel wings. It reminds the viewer of the staying power of the Holy Ghost and the Gospel message of eternal life after all else is irretrievably gone.

Building again on the loincloth motif, another artwork anticipates

Lucas Cranach the Elder, *The Mount Calvary Crucifixion* (The Crucifixion;
Calvary), 1502. Woodcut, sheet: 16 ⅛ × 11 ½ in.
(Harris Brisbane Dick Fund, 1927 [27.54.2], The Metropolitan Museum of Art, New York;
Image copyright © The Metropolitan Museum of Art/Art Resource, New York)

the *Schleissheim Crucifixion*. It is a naive colored woodcut titled *The Crucified Christ with Mary and John* (1502–3). Here, in a symmetrical gesture, the combative powers of the maverick loincloth extend to John's great red mantle. Like Christ's protective loincloth, a piece of which Mary still grasps in her hand, John's mantle personifies the living Spirit of God that surrounds and protects the Savior both in peace and in extremis. Firmly anchored to the base of the cross, John's mantle connects him directly to the blood flow of the Savior, as he and Mary grapple for their own lives by holding fast to the life that is left in Christ.

A final woodcut scene from the Vienna Group, titled *Christ on the Mount of Olives* (1502–3), depicts a frightened Jesus down on bended knees as he implores his heavenly father to stay his approaching death. Overhead a great wind-whipped tree provides a tenuous shelter against the racing storm that hastens forth to snatch the life of Jesus away. Reassuring the viewer, the Apostles who accompanied Jesus to the mountaintop now lie upon the ground, lost in the deep sleep of the faithful, or that of the cowardly uncaring. Borrowing much of the scene from Dürer's *Apocalypse* and *The Mourning of Christ,* Cranach's wood-cutting speed outpaced the great artist in the medium he had long owned.[31]

Here one is reminded that new Cranach wine was now filling the old Dürer bottles. If, as some believe, Dürer was turning away from the woodcut medium at the time Cranach was making it his own, the woodcuts of the Vienna period suggest not only heightened competition between the two men, but also a sharing of the guard in the woodcut medium.[32] The unusual energy in these woodcuts resulted from the speed and intensity of Cranach's diagonal strokes, the so-called fast style that was also carried over into his paintings ("fast brush"). Although others also mastered this style, Cranach's application of it ushered in a new "expressionism" in Christian iconography.[33]

At the end of a long evolution of Passion scenes, *The Schleissheim Crucifixion* finally appears. It presents a completely novel scene occurring on Golgotha. Rotating the three crosses out of their traditional alignment, Cranach reduced the number of mourners to two and gave the viewer a new angle on the crucifixion scene. The two thieves who had previously

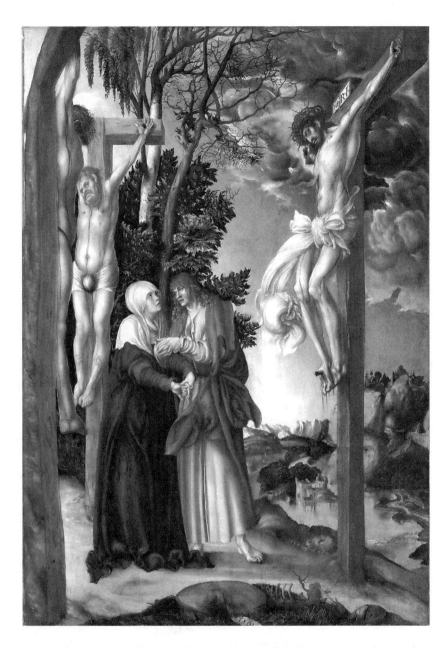

Lucas Cranach the Elder, *The Schleissheim Crucifixion* (Lamentation Under the Cross), 1503. Oil on pine wood, 54⁵⁄₁₆ × 39 in.

(Alte Pinakothek, Bayerische Staatsgemäldesammlungen, Munich, Germany; Photo: Bildarchiv Preussischer Kulturbesitz/Art Resource, New York)

framed Jesus are now seen pushed deep into the left margin of the frame. Filling the generous foreground and right margin is a very handsome, muscular Christ! He is packaged and bound up with the most perfect bow-ribbon loincloth Cranach could create, a redemptive gift of salvation laid out appealingly for the viewer.

The animated loincloth now appears as a cataract radiant with sunlight, both the Savior's life support and his protection from the lethal thunderclouds that rush over and against him, as he dies the death he had lived for. Bathed in the warm sunlight, the Son of God passes away, taking death with him as he redeems the world with his last breath.

Cranach's improvisation also puts Mary and John the Evangelist at ground level gazing up at their Savior, who looks back at them, leaving the eager viewer to watch from the edge of his chair. In this arrangement the viewer sees and internalizes the crucifixion not only through his own eyes, but also vicariously in and through the anguished faces and twisting hands of the two people on earth who loved Christ most.[34]

BEAUTIFUL PEOPLE: THE CUSPINIANS AND THE REUSSES

Although religious subjects dominated the Vienna Group, secular subjects also had a place there and were pursued with no less imagination and originality. Among Friedländer's "unprecedented twenty-two" were two of Cranach's oldest surviving pair paintings. The first commemorates the marriage of a prominent Viennese couple: the twenty-nine-year-old crowned poet laureate Johannes Cuspinian and his well-to-do wife, Anna Putsch.

In his earlier artworks, Cranach favored a configuration of man and nature that left human figures dwarfed against imposing landscapes. In his representation of the Cuspinians, husband and wife sit on a hillock in a another completely novel art scene. Here, humans appear to be larger than all other earthly life—a compact scene of a rare Cranach Renaissance moment.

A trained physician, Cuspinian was also a gifted poet, scholar, and rector of the University of Vienna. When in 1502 Cranach fell ill in Vi-

enna, it may have been Cuspinian who brought him back to good health and also the beginning of a lasting friendship. If so, the artist's portrait of the handsome visionary and his fair wife was a gift in return: the perfect couple perfectly integrated into the perfect grassy knoll! Frau Cuspinian appears every bit as introspective as her husband is transcendental, each silently pausing with the viewer, as if they were waiting in concert to hear the proverbial tree fall in the forest beyond.

Following Friedländer, modern critics claim to see in *The Cuspinians* an alleged "graphic-intellectual richness that Cranach never again attained."[35] An aura of genius radiates from Cuspinian's face, heightened by nature's tranquil background and the bliss of a perfect match. Yet, in their surrounding world, alarms are everywhere being sounded, as dark powers shift about portentously in the background.

Hanging over Cuspinian's head the bright, redemptive star of Bethlehem portends either deliverance or punishment. It is not the only sign of trouble in the background sky. An ominous, pop-eyed owl returns home with a fresh kill clutched in its claws. Above the head of Frau Cuspinian, a hawk-like bird carries home its prey, while in the far distant forest plumes of fire and smoke interrupt the peaceful landscape.

Three months after painting the Cuspinians, Cranach used the same formula to present another successful Viennese couple: the forty-one-year-old jurist and university rector Stephen Reuss and his wife.[36] From their portraits the Reusses appear to be more bronze than golden, and Cranach's representation suggests a contrast with the Cuspinians. As a couple, they do not radiate the brightness and warmth of the Cuspinians. With his turned-down mouth and sour blank stare, jurist Reuss looks like a man who has just read a prophecy of doom from the book on his lap. A possible good omen in the background is the drifting white cloud that forms a distant nimbus around Herr Reuss's head, another ambiguous sign of hope, as was the star of Bethlehem for the Cuspinians. If the outside world's message to *The Cuspinians* is any guide to the fate of *The Reusses,* there may be good news for both couples.

However, the cautionary signs are more threatening for the Reusses than for the Cuspinians. On the surface, the couple seems to be

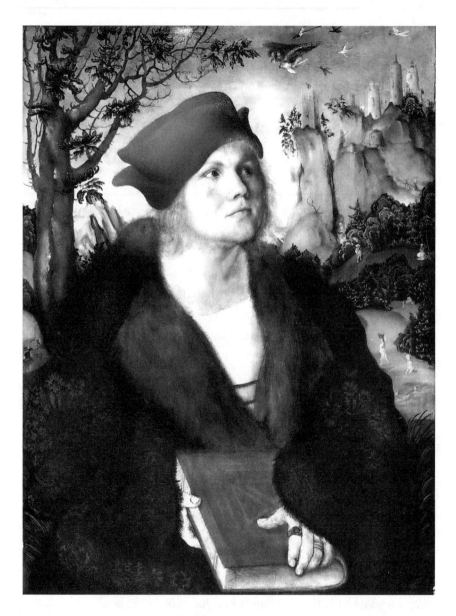

Lucas Cranach the Elder, *Johannes Cuspinian,* ca. 1502–3.
Oil on wood, 23⅝ × 17¾ in.
(Collection of Oskar Reinhart, Winterthur, Switzerland;
Photo: Foto Marburg/Art Resource, New York)

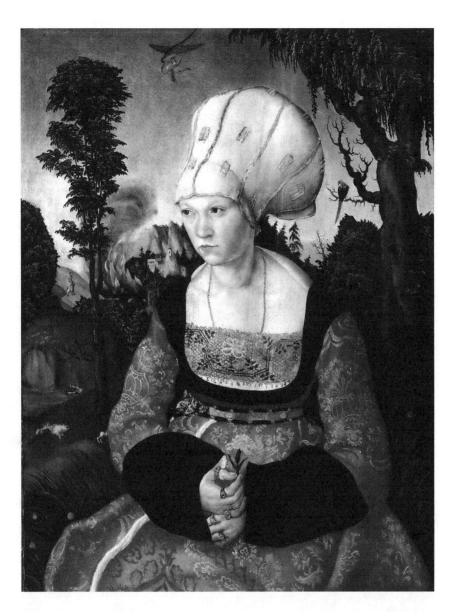

Lucas Cranach the Elder, *Anna Cuspinian,* ca. 1502–3.
Oil on wood, 23⅝ × 17¾ in.
(Collection of Oskar Reinhart, Winterthur, Switzerland;
Photo: Foto Marburg/Art Resource, New York)

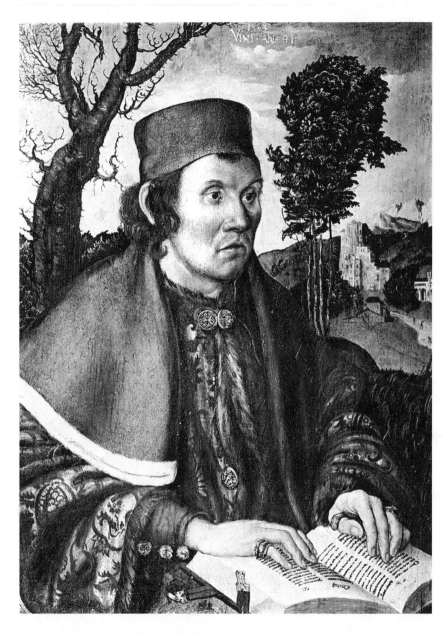

Lucas Cranach the Elder, *Chancellor Stephen Reuss*, 1503. Painting, 21¼ × 19¼ in.
(Germanisches Nationalmuseum, Nürnberg;
Photo: Foto Marburg/Art Resource, New York)

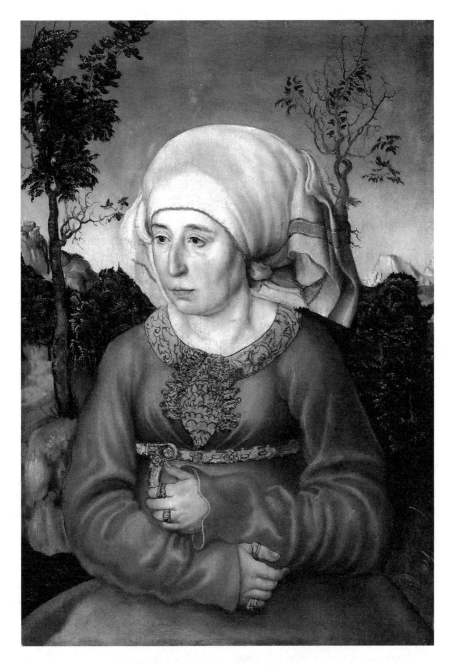

Lucas Cranach the Elder, *Portrait of a Woman (Frau Reuss)*, 1503. Oil on wood,
20 $^{11}/_{16}$ × 14 $^{3}/_{8}$ in.

(Gemäldegalerie, Staatliche Museen, Berlin, Germany;

Photo: Bildarchiv Preussischer Kulturbesitz/Art Resource, New York)

discomforted in body and mind, a toll not yet taken on the Cuspinians. Given the seeming melancholy of *The Reusses,* their promising white cloud could turn out to be an ill-forming nimbostratus, which, although white through and through, eventually brings a dark rain.[37] Still another cautionary sign for the Reusses is their framing between two background trees, one clearly dying, or already dead, the other a brilliant, leafy green, heralding the full promise of life.

Yet, again, the accent is not on the positive. Both husband and wife stare blankly at the world around them, unlike the bright-eyed Cuspinians. Frau Reuss fidgets uncomfortably with her arms, and seems not quite to be the watchful, bejeweled "mother-hen" Friedländer would have the viewer believe.[38] To all appearances she is not her husband's alter ego as Frau Cuspinian is to her handsome Hans.

Although each spouse mirrors the other, the Cuspinians do so brightly and optimistically, the Reusses dimly and gloomily, although with a ray of hope. In an apparent commentary on the predetermined character of life, Cranach has here painted "counter-couples," pairs that are made for each other only and cannot be otherwise. A palpable tension between felicity and vulnerability, freedom and bondage, pervades both scenes, reflecting contemporary debates in religious and humanistic literature on the freedom and power of the human will, a subject soon to explode in the confessional debates of the 1520s among Catholics, Humanists, and Protestants.[39]

Although soft-pedaled by *The Cuspinians,* both couples deliver the same somber message about human life. No matter how high and mighty, attractive and accomplished, or perfectly meant for one another, men and women must be ever mindful that their lot in life is always a struggle that ends in death.[40] Cranach portrays the Cuspinians as coping far more successfully with that dark, inescapable truth than do the Reusses.

The painter may also have been intuitively judging both couples by their respective professional worlds: Cuspinian, the literary humanist, and Reuss, the practicing jurist. In the age in which they lived, the humanists were warmly embraced, while the jurists were bitterly decried.[41]

In the end, what sets the Cuspinians apart from the Reusses is their

greater imperturbability. While all four are equally mortal, a spiritual aura of serenity surrounds the Cuspinians, but eludes the Reusses. On the edge of life's pitfalls, the Cuspinians project confidence, which, Cranach is saying in his dueling portraits, is a redemptive gift received by those who believe and trust in God, a message consistent with the Vienna Group.

Modern historians have interpreted these portraits as commentaries on the different lifestyles of gifted, protected intellectuals in contrast to needy, simple folk. While the beautiful people are equipped to penetrate the higher realms and plumb life's deeper secrets, the common man may glimpse such wonders only by the courtesy and generosity of his betters.[42]

Given the fear and caution surrounding both the elite Cuspinians and the Reusses, Cranach drew a more modest sociological moral from their stories. If there is something beyond the fortunes of the golden Cuspinians and the bronze Reusses that Cranach wants to impress upon the viewer, it is a sympathetic demythologizing of the educated and the privileged, or, in a word, of people like Cranach himself. Despite their learning and earnings, their esoteric visions and Dionysian joys, the beautiful people, when closely observed, are no less vulnerable to the threats of nature and the whims of the fates than are the needy, simple folk, a recurring theme throughout Cranach's artwork.

THE BODY ASCETIC AND EROTIC

In the Vienna years, Cranach addressed ascetic and erotic subjects in artworks that were few in number but rounded out the range of his artistic interests on the darker and lighter side of life. In new "fleshy" renderings of traditional religious subjects, he presents a grizzled, stigmatized St. Francis (1502–3) and a semi-nude, penitential St. Jerome (1502–3).[43] His *Martyrdom of St. Stephen* (1502) provided still another opportunity to plumb the painful depths of man and nature. The soon-to-be-martyred saint appears incarcerated within a twisted arbor inhabited by monsters and bratty putti, who poke their faces in and out of the vines in gloating peek-a-boo torment![44]

Both fascinated with but also put off by the expansive, extraterres-

trial, impossibly beautiful heroic figures of the Italian masters and their German peers, Cranach gained fame and popularity by making room for lighter, down-to-earth, modestly endowed yet no less engaging human figures. He engraved or painted them from imagined biblical and classical models, and also from well-known Wittenberg neighbors, all with a riveting story to tell.[45]

A sketchy early example of the erotic is a pen-and-ink drawing adorned with a fraudulent Dürer monogram attributed to Cranach. Entitled *Seated Lovers,* it presents an anonymous couple engaging in impulsive sex in an open setting.[46]

This rough drawing shows a pair of lovers locked together under a commanding tree flanked by two pooling fountains. The soon to be receiving woman lies flat on her back, her shoes kicked off. The trunk of the tree hides her face and upper torso, while her extended right arm blocks the view of her lover's face. The scene catches the moment in which a visible, moving lover's hand lifts the hem of her dress over her knees. Unbeknown to the preoccupied pair, they are being stalked by death, who emerges from behind the fountains in the garb of a pint-sized grim reaper mightily offended by the lovers' behavior. He confronts them with a scythe far larger than himself before inflicting a terminal punishment upon their carnal sin.

Based on a cautionary story popular among the clerics, the scene of flaring passion climaxed by the appearance of the figure of death may be another of Cranach's "firsts" in the history of art. Traditionally, in medieval art and literature, death, being mightier than life, did not take its victims surreptitiously, but stepped forth in full view, towering over its helpless prey before calmly striking it dead.[47]

Throughout Cranach's Vienna period grotesque scenes of crucifixion and bright portraits of the beautiful people project a dialectical world alternating between faith and despair, life and death, heaven and hell. That is seen here again in *Seated Lovers,* where sin, death, and the devil straightforwardly assail the life of the body as well as that of the soul. These themes in Cranach's early religious art would find a cautionary match in Luther's formulations of faith.

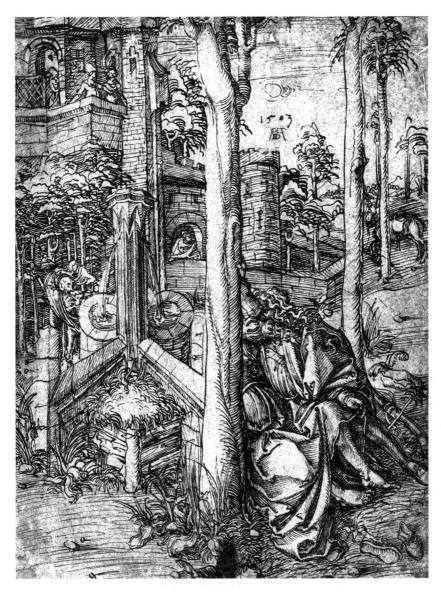

Lucas Cranach the Elder, *Seated Lovers,* 1503. Pen and ink.
(Photo: With kind permission from Herzog-Anton-Ulrich-Museum, Braunschweig,
Kunstmuseum des Landes Niedersachsen, Museumsfotograf)

ON THE SUNNY SIDE

Among Cranach's early works, *The Holy Family Resting on Its Flight to Egypt* (1504) has the reputation of being both the last work of his early Danube-Vienna period and the first of his new career as electoral Saxon court painter.[48] An original reading of Christian iconography, this painting has been his most popular work with the general public and also greatly respected by the critics. It is also the first painting he signed solely with his own free-standing initials (an interlocked "L" and "C"), suggesting that he also thought it to be a milestone in his career.[49] When contrasted with *The Schottenstift Crucifixion* (1500), painted on the eve of his departure from Kronach, this charming, sparkling fantasy of the baby Jesus and his parents illustrates again how rapidly his artistry had developed in just four years.

Set in a lush forest and meadow landscape, where Joseph, Mary, and the infant Jesus have paused on their flight to safety in Egypt, the viewer beholds the Christ child as eight accompanying angels entertain and serve him. Five are precocious naked putti roughly the age of Jesus, and the others are well-clothed adolescents, two girls and a boy.[50] Sheltered from the surrounding forest by a great spruce tree, they play around an oasis and gather wild strawberries. A towering white birch guides the viewer's eye to the bright distant light of eternity that watches over the scene.

Joseph gestures toward Mary and Jesus with an upraised palm, as if introducing them to the viewer: "Here they are," he seems to be saying, "the Mother and Son of God, my wife and your Savior." A barely visible halo radiates from Mary's forehead as she sits before her husband balancing Jesus on her lap, who stands and reaches out to receive the gifts of the angels. Slightly startled by the unexpected company, the earthly mother and father of Jesus cast their eyes pleadingly toward the viewer as if to ask for a bit of privacy before they journey on.

The scene around the family group is pure mirth. The adolescent angels hold flutes and pages of musical scores in their hands. A putto fills a flask with water from a nearby brook to refresh the troupe. A second stretches himself over a moss-covered boulder, sleeping like a rock. A

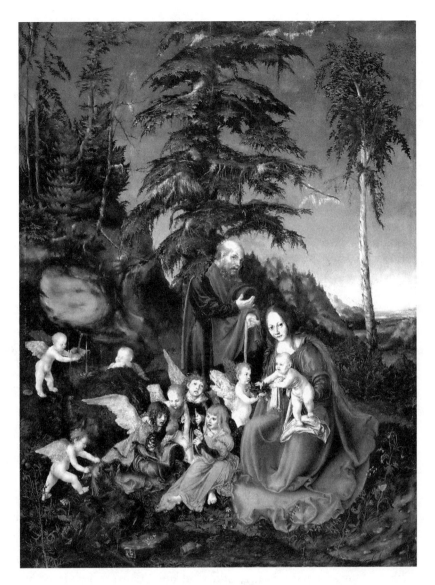

Lucas Cranach the Elder, *The Holy Family Resting on Its Flight to Egypt* (Rest on the Flight into Egypt), 1504. Oil on limewood, $27^{13}/_{16} \times 20^{7}/_{8}$ in.

(Gemäldegalerie, Staatliche Museen, Berlin, Germany;

Photo: Jörg P. Anders, Bildarchiv Preussischer Kulturbesitz/Art Resource, New York)

third has his arm around the neck of one of the musical angels, as if entranced by her singing. Still another frog-marches a parrot, a symbol of innocence and hope, toward the infant Jesus so that he and the bird may examine one another. The last putto, standing between Joseph and Mary, offers leafy ripe strawberries to the Madonna and Child. Because the strawberry plant flowers and bears fruit at the same time, it became a symbol of the Mother of God. Strawberries were also believed to be the compensatory food of the blessed dead in heaven, particularly the prematurely deceased.[51]

Looking back at Cranach's artistic production during his four-year Danube-Vienna period, historians Dieter Koepplin and Tilman Falk see the unity of his Viennese works in what they call a "Düreresque" tension between freedom and bondage, acuity and torpor. Human life alternates between "boiling motion and matching calm," they tell us, inferring human subjection to and unending struggle with higher powers, both divine and devilish.[52] That dialectic reflects a biblical and classical "anthropology" that was fully shared by Dürer and Cranach long before Luther deepened it theologically for them both.

Such dialectical thinking pervades the Vienna period and the pair portraits of the Cuspinians and the Reusses, but it has no place in *The Holy Family Resting on Its Flight to Egypt*. The latter's innocence and joy conveys a message of transcendent peace and eternal security. It is a scene suffused with the assurance that God is in his heaven and all is right with the world. Unlike the many scenes of his Viennese works, no alarms are sounding in the background. Here, there is only the golden moment in which heaven and nature sing, and God and man are blissfully one, interrupted only in passing by the viewer.

Despite Cranach's infatuation with Dürer's artwork over the Vienna years, his artistic goals lay well beyond Dürer's analytical and systematized world. Where Dürer displays idealized human forms with scholastic precision, Cranach captures the transient moments of everyday life, ranging from the grotesque and erotic to the naive and fanciful. The difference between these two great men was as wide, and as narrow, as that between the Renaissance and the Reformation.

3

The Compleat Court Painter

WITTENBERG CALLING

By the time he left Vienna, Cranach had mastered Dürer and discovered himself as an artist.[1] Although their rivalry continued until Dürer's death (1528), Cranach had convinced leading German humanists, the Saxon elector Frederick the Wise, and, most importantly, himself that he had the promise of Dürer's artistry. Thereafter, he tackled a Dürer subject only to please a Dürer-smitten patron, or to improve on a Dürer artwork, but no longer to stay abreast of the great Nürnberger.

While en route to Vienna in 1501, and again upon his return home in late 1504, Cranach must have sojourned in Nürnberg. In those years he would have made the proper contacts with the city's prominent patricians and humanists who a decade later, in 1516, made up the brain trust of the so-called Staupitz Society. Previously known as the Pirckheimer Society after Nürnberg's leading humanist, Willibald Pirckheimer, the society's new name was taken from Johannes von Staupitz, the vicar-general of the Augustinian Observants. More pertinent to our story, Staupitz had been Martin Luther's mentor and confidant during their years together in Erfurt's Augustinian cloister.

An elite lay-religious dinner-discussion group, the Staupitz Society met regularly to address the pressing problems of the age, particularly those of religious and political reform. Among its dozen members were such notables as cloth merchant Anton Tucher, painter Albrecht Dürer,

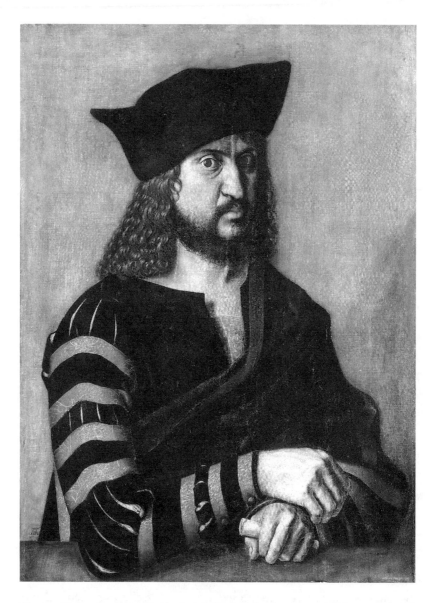

Albrecht Dürer (1471–1528), *Frederick III the Wise (1463–1525), Elector and Duke of Saxony*, 1496. Oil on canvas, 29 15/16 × 22 1/16 in.

(Gemäldegalerie, Staatliche Museen, Berlin, Germany;

Photo: Jörg P. Anders, Bildarchiv Preussischer Kulturbesitz/Art Resource, New York)

and city jurist and diplomat Christoph Scheurl. The Nürnberg sodality also maintained a sister-city relationship with Wittenberg, and between the two of them a powerful lobby existed for religious, political, and educational reforms.[2]

Cranach's post-1504 paintings suggest that he had carefully studied Dürer's artworks in these years and was also well acquainted with other Nürnberg masters. Among them were Michael Wohlgemüt, Dürer's teacher; Martin Schongauer, master painter and engraver of Passion scenes; and Hans Baldung Grien, a Dürer student and rival, who from time to time caricatured the artworks of his master.

While in Nürnberg, Cranach would have studied a special work of Dürer's: the *Paumgartner Altar*. A magnificent nativity scene in the city's Dominican Church of St. Catherine (1502–4), the altar panel features the shepherds' adoration of the Christ child at his birth. The work was commissioned by city attorney and recorder Stephan Paumgartner following his safe return home from a pilgrimage to the Holy Land. In the wings of the altar, he and his brother, Lucas, appear as St. Eustachius and St. George.

Within a year of its completion, in 1505, Cranach engraved his own expressive image of St. George, which he reiterated a year later in another engraving of the great biblical dragon slayer. Both works were inspired by the *Altar*, giving Cranach new opportunities to demonstrate his signature ability to turn parts of Dürer's masterpieces into original works of his own.[3]

If, as many scholars believe, Cranach received his call to Wittenberg in late 1504 while traveling home to Kronach, Dürer would surely have been one of the elector's referees. The two men had been in contact with each other since 1496, when Dürer painted the young Frederick's portrait. Looking back on it as a connecting point for the three men in the coming years, the portrait was also an omen of Cranach's future as the Saxon court painter. The viewer beholds a work of art that has more in common with Cranach's freestyle expressionism than with the impeccably measured and belabored Dürer masterpiece. Thereafter, Dürer continued to

receive commissions from Frederick, and each man remained the elector's close friend and adviser.[4]

Assuming that the aforementioned conjunctions between the two artists did occur, each had the opportunity to become well acquainted with the other's work. For Cranach, the sojourns in Nürnberg opened the most important doors of his career.[5] Dürer's helping hands were not, however, the only ones pushing Cranach to the top of the contemporary art world. Among his new friends and admirers in Vienna, the poet Conrad Celtis is most likely to have sung Cranach's praises to the Saxon elector in advance of Dürer.[6] Frederick the Wise and Celtis had known each other since the 1480s, and early in his rule (1487) Frederick persuaded Emperor Maximilian to crown Celtis "Imperial Poet Laureate," the first German poet to receive that high honor. In the year before, Celtis had dedicated his first published work, *The Art of Verse and Poetry* [Ars Versificandi et Carminum] (1486), to his great patron.

Another prominent scholar who helped align Cranach's stars favorably in Wittenberg was Konrad Mutian of Gotha. Revered as the leader of the Erfurt humanists, Mutian was often in the august company of Johann Reuchlin, Erasmus, and Luther. In 1505, he became a key link between Cranach and the elector as Cranach assumed the position of court painter. Later, Mutian would introduce Cranach to the family of the woman he would marry: the patrician Brengbiers of Gotha.[7]

When in 1508, Frederick the Wise went in search of a tutor for his eight-year-old nephew, John Frederick, the future Saxon elector, Mutian recommended the Erfurt Augustinian, Georg Spalatin, who became Frederick's court secretary, historian, and spiritual adviser. With those two recommendations, Mutian had given the Wittenberg court its two most prized members during Frederick's reign (1485–1525): Cranach and Spalatin.

Spalatin's position made him the elector's key adviser in all matters historical and political. The court secretary was also an effective advocate for his humanist friends. With the settlement of the theologians in reform-minded Wittenberg, it was not surprising to see Martin Luther

arrive there for good in 1511, to be followed in 1518 by Philipp Melanch-thon, around whom the Lutheran brain trust now gathered.

Art, culture, and history played a vital role in safeguarding the late medieval German states. A connoisseur of contemporary art and collector of antiquities and relics, Frederick surrounded himself with the best talent of the age. The mere presence of such gifted men kept Saxony's enemies at bay, knowing the cleverness of its court, its awesome political power, and its proven military might. Messages subliminal and explicit gave pause to Frederick's rivals, not least among them Emperor Maximilian I and the dukes of Albertine Saxony.

As for the distinguished artists who received commissions from the elector after Dürer and before Cranach, one counts the well-reputed Michael Wohlgemüt, Hans Burgmair, and Conrad Meit. Cranach's immediate predecessor in the court painter's job was the Italian Jacopo de' Barbari (1503–4), a Venetian painter and printmaker who moved to Wittenberg after a stint in the imperial court.[8] The Germans called him Jacopo "the Italian," while in Italy he was known as Jacopo "the Barbarian," a wry comment on each culture's standing in the eyes of the other.[9] Like Jacopo, Cranach gained the post only after Frederick's advisers assured him that Cranach more than any other available artist approximated the Dürer style.[10] In 1505, again in the shadow of Dürer, Cranach took up his courtly duties.

At this time, the devout elector was celebrating the annual All Saints' Day exhibitions of his prized and ever growing relic collection, a labor of piety made possible by a network of agents and buyers within and beyond Europe. Upon Cranach's arrival, the collection contained five thousand pieces. In the religious culture of the age relics were both a species of medieval art and highly revered objects. By 1517, Frederick's collection was northern Europe's largest, exceeding nineteen thousand pieces, all ominously housed in the building adjoining the church in which Luther was beginning to preach the new Protestant gospel of faith alone.[11]

As with the favored poet (Conrad Celtis), Frederick's long friendship with Dürer deepened over the years. Had the evangelically sympathetic

Dürer indicated the slightest desire to leave Nürnberg for Wittenberg, the position of court painter would have been his for the asking. Historians have speculated counterfactually on how history might have been changed if Dürer, rather than Cranach, had been Frederick's new court painter in 1505, and fifteen years later, the artist and religious spokesman for the Saxons in the revolutionary year of 1520. Would Dürer have replaced Cranach's popular gospel stories with comparatively heavy, intellectual dissertations for a more select and elite audience? Would the Reformation have become a more difficult and shorter-lived reform? Or might the great artist who revered Luther so much, and was a great friend of the Saxon princes, have chosen a more secular reform than that of Luther and Cranach?

THE NEW JOB

United by both professional and personal bonds, Elector Frederick, poet Celtis, and artist Dürer reigned over late medieval Saxony's cultural world. Early in Cranach's tenure Dürer had reminded the connoisseurs of German art and politics of that trio's special relationship. The reminder came in the form of a painting titled *The Martyrdom of the Ten Thousand Christians* (1507–8). Deep within that busy painting the figures of Dürer and Celtis, the latter resurrected from the dead for the scene, stand robed and larger-than-life among the Christian survivors, as they salute their great patron, Frederick.[12]

Despite the challenge before him, Cranach had much to recommend himself to this select circle. Reputed to be an artist in the mold of Dürer, he already had the "upper brush," some thought, on select subjects and desired art media. The strictly artistic side of the court painter's job may have been made easier because Frederick's interest in art was cut and dry, pragmatic and political. The court painter, like the court poet and the court historian, existed to document and showcase the pedigree and achievements of the electoral Saxon regime, whether the event in question might be a marriage, a celebration of a joust, a wild game trophy, or the

gilding of a relic. No other court painter had more varied and challenging duties than Cranach. Nor did any of his counterparts across Germany leave behind a greater record of documented service, not to mention a far more original archive of new, innovative artworks. Under Spalatin's direction Cranach's job was twofold: to document and retrieve Saxony's origins in biblical and classical antiquity, and to record the present-day activities of the court at both work and play.

Tracing the regime's historical origins back to ancient Greece and Troy, Cranach's art claimed those distant lands and their achievements as the true lifeblood of the mighty electoral Saxon family tree. Putting forth such claims lent authority to the regime in its present-day land disputes.[13] Still more taxing for Cranach was his charge to keep an artistic record of annual courtly events. That record encompassed the upkeep, repairs, and decoration of the regime's castles and residences, not to mention the preparations for royal celebrations, funerals, tournaments, and hunts.

Having chosen an artist praised by Germany's leading humanists, Frederick had every reason to be confident of his choice. As for the court, it treated its new members well, meeting all of Cranach's personal and professional needs. In addition to a salary of one hundred gulden per annum, a horse was also put at his disposal. Both man and beast received shelter, food, and clothing. To his furnished apartment in the castle, whose exact location apparently still remains a mystery, a workshop was added in 1507. Upgraded in 1509–10, the apartment remained his home until 1511–12, at which time he bought a great house in the city, the first of several Cranach mansions.[14] With his peers serving the Saxon elector, he also wore the official summer and winter court uniforms that became his responsibility to design and distribute.

His annual salary was double that of his predecessor Barbari, and equal to Dürer's imperial pay and Martin Luther's annual salary. Frederick the Wise paid his court painter more reliably than ever Emperor Maximilian did Dürer, thereby making the court painter a man of surer means and greater peace of mind than an imperial retainer.[15] In addition

to salary, horse, board, and clothing, Cranach received all the supplies, tools, and workshop assistants needed to fulfill the royal commissions. In addition to his salary and professional support, a broad artistic and entrepreneurial freedom was also bestowed upon the court painter.

This bright beginning was interrupted by a lingering summer plague that put the elector in his bed and forced the University of Wittenberg's faculty and student body to move their studies to plague-free Herzberg. Extending a friendly hand to his stricken neighbors, newcomer Cranach demonstrated his civic loyalty by creating a traditional crucifixion scene bearing the title *A Christian Heart* (woodcut, 1505).[16]

This multilayered artwork encloses the crucified Christ within Mary's divided heart, an ensemble affixed to a shield that bears the appearance of a coat-of-arms. The configuration hangs over the city, courtesy of indefatigable *putti*. Mary's pierced and bleeding left ventricle exposes her suffering with and for her son, while the intact right ventricle attests her unfailing faith in the power of God.

Mary and John the Evangelist join the plague saints Sebastian and Rochus on their knees before the city, as the four of them make a protective holy wall with their own bodies. Aligned with them in the immediate foreground corners, the two Saxon coats-of-arms create a princely bastion for the saints and the martyrs. In the middle foreground, Cranach's interlocked initials display the date, confirming both the new court painter's arrival in the city and his sharing in its travail.[17]

Driven from the city by plague, Cranach spent his first Wittenberg spring and summer in Torgau and his first fall and winter in Coburg. At this point in his tenure the records contain orders and invoices documenting past and present commissions, with occasional pleas for payment of services rendered and materials bought out-of-pocket.

Whereas a merchant's account book might provide information of a personal or familial nature, Cranach's business mail remained just that: strictly business.[18] Unlike Dürer, who left behind personal diaries and correspondence, essays and books, Cranach's archives contain no deep information about his plans, concerns, opinions, or personal behavior. For so important a historical figure, his private world can only be inferred

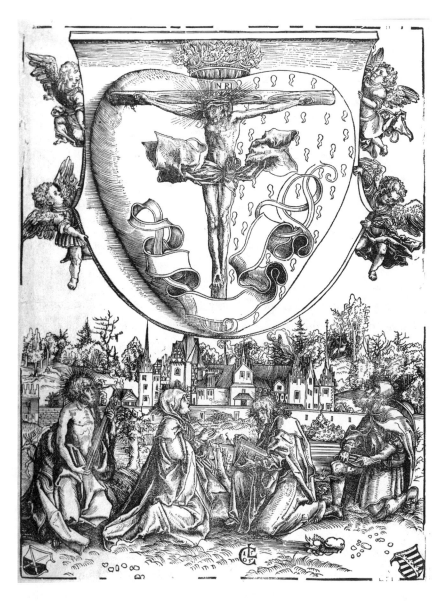

Lucas Cranach the Elder, *A Christian Heart*, 1505
(Photo: By kind permission from Klassik-Stiftung Weimar, Herzogin Anna-Amalia
Bibliothek, Germany)

and reconstructed contextually by drawing on known associations with patrons and rivals, court commissions, public activities, state and business travel, and above all, the surviving artworks.

CHANGING STYLES: THE ST. CATHERINE ALTAR

Cranach's first large commission was an altar for Wittenberg's Castle Church, and the riveting story it tells is that of the eastern martyr St. Catherine of Alexandria, who appears in two separate versions in as many years: *The St. Catherine Altar* (1505) and *The Martyrdom of St. Catherine* (1506).

The artists who see farthest are those who don't quite yet know where they are going, and that disposes them to wander and pause, sample and ponder. In the bright new world of the Renaissance and Reformation nothing seems too much for the artist. We find Cranach in these same two years scooping an appealing woodcut of *The Rapture of St. Mary Magdalene,* an acclaimed work that was both Cranach's and the contemporary art world's first portrayal of a biblical nude.

Cranach, who was early known as "fast brush," seized upon Dürer artworks because they were the best of the times and Cranach never doubted that he could make them better. He took Dürer's St. George and the Dragon from the *Paumgartner Altar,* and turned the pair into a brilliant, self-standing chiaroscuro.[19] Here was an artist ready to paint the epic St. Catherine. Dürer's small portrayal of St. Catherine so captivated Cranach that he rendered the scene of her martyrdom twice. The magnificent 1506 version "stands stylistically alone, a work full of inner contradictions and a wealth of new features never before, nor since, seen in a Cranach work of art."[20]

According to legend, Catherine was a brave and gifted fourth-century noblewoman who, at eighteen, challenged the Roman persecution of Christians in the reign of the tyrant Emperor Maxentius. Having sensed in her a troublemaker, the intellectually outmatched emperor summoned a body of scholars, fifty in all, to expose her as an apostate. However, in the ensuing debates she proved her brilliance, winning her pagan opponents

Lucas Cranach the Elder, *St. Catherine Altar,* 1506. Oil on limewood.
(Gemäldegalerie Alte Meister, Staatliche Kunstsammlungen, Dresden, Germany;
Photo: Bildarchiv Preussischer Kulturbesitz/Art Resource, New York)

over to Christianity by dint of her cogent and eloquent argument. Among the notable new converts were the commander of the Roman garrison and the empress herself. In the aftermath, the emperor ordered her to be executed on a revolving, spiked wheel, an instrument designed to inflict a slow and painful death, henceforth known as the "Catherine wheel." According to legend, the moment the wheel touched her body it shattered into pieces, and the heavens rained fire and brimstone down upon the scene. Anticipating her escape, the determined executioner stepped forth and decapitated her with one swing of his great sword.[21]

At the height of the retaliatory moment, the all-consuming wrath of God cascaded down and around a background mountain, piling fiery debris right up to the executioner's long stocking feet: a frenzied scene reminiscent of Cranach's earlier portrayal of *Christ on the Mount of Olives.*[22] The interior wings accompanying the scene frame the centerpiece in which the execution occurs. Already garnishing the scene in the wings are three female saints. Looking forward, these ladies will later become the famous women who appear in Cranach's nude repertoires and semi-nude lineups. They are the artist's classical, biblical, and present-day women who entertain Saxon gentlemen and liberate celibate clerics, who have

67

turned their backs to the divine sex drive that is the foundation of marriage, progeny, society, and states.[23]

In *The Martyrdom of St. Catherine* the energy radiates from the bodies and costumes of the executioner and his hapless victim, the one outsized and overwhelming, the other compact and crystalline. In Cranach's first rendering of her, the *St. Catherine Altar,* the executioner is a great bear of a man: thick, twisted, ugly from feet to face, a clumsy, smashing savage. By contrast, the svelte ballet legs and cold, pasty face of the 1506 executioner present a snake of a man, poised to deliver a quick, hypnotic, terrifying death. Neither one of them is a match for the still, constant face of the saint.

In both artworks Cranach propels the towering, chiseled executioner toward the courageous victim with a contrapuntal force that blurs and reduces the two opposed figures to one. In the cold face of the executioner and the silent panic of the future saint, we see again Cranach's early fascination with predatory violence and grotesque executions.

Yet, for all the one-sided physical force arrayed against Catherine, the executioner does not truly hold the upper hand, which is the scene's arguable giveaway clue. The right arm of the executioner that reaches for the great sword to strike her dead is measurably stunted and deformed, too weak to wield so great a sword against so godly a soul. There are also physical cracks in his body suggesting deceptive strength and promising a Pyrrhic victory in this flawed, momentary triumph.

In contrast to the executioner's foreshortened, withered arm, Catherine's disproportionately elongated arms join her clasped hands in a mighty reach of heavenward prayer. In this moment she is embraced by a transcendent power and certain of her salvation beyond her imminent death. Strewn about the scene are the human faces and body parts of people Cranach and his patron may have known well both at court and beyond, a novel scene that has been called "the first modern montage."[24]

In this gathering of silhouetted figures larger than the surrounding landscape, Cranach may have been anticipating the Burgundian-Netherlands' style he would encounter and absorb two years later during a diplomatic mission to the Netherlands.[25] That style combined a flat, pasty

realism with a commanding, ethereal human presence. Compounding coincidences, it also resembles the style Luther would urge Cranach to pursue in the new Reformation art, particularly the crucifixion scenes. Luther liked that style because it was "minimal art," self-denying representations that knew their place in the presence of the holy. The slim, stylish figures Cranach introduces in *The Martyrdom of St. Catherine* also found a place in the hybrid "Wittenberg style" that would carry forward the reformers' new theology and no less ambitious social-domestic agenda.[26]

PRAISING CRANACH IN WORD AND DEED

Kilian's Fly

In 1507 Georgius Sibutus Daripinus (called Sibutus), a student of the poet laureate Conrad Celtis, published a collection of poems and orations under the title *Kilian's Fly* [De Musca Chileanea]. The title poem of the collection was a witty, impromptu piece about a fly sketched by a university colleague of Sibutus, one Kilian Reuter. Reuter's fly had been inspired by Dürer, who famously painted a hyperrealistic, blemishing fly on a commissioned Venetian canvas titled *The Celebration of the Rosary* (Venice, 1506). Since antiquity the measure of a true master artist had been the ability to fool the eye of the viewer. Rumors had it that passersby, upon seeing Dürer's fly, moved impulsively to swat it, while birds flying overhead dropped from the sky to snap it up.[27]

As co-workers at the electoral Saxon court, Sibutus and Cranach collaborated on royal and noble commissions, Sibutus writing the verses, Cranach painting the images. It was thus appropriate for Cranach to decorate the cover of *Kilian's Fly*. In doing so, he supplied not one but two images. On the upper half of the book cover a large fly sits on a scrap of paper, while on the lower half a warbler holds the same fly, now twitching in its beak. This was a scene of consecutive action twice deceiving the viewer's eye, an early animation technique.

Thus did Sibutus celebrate his colleague and friend as Germany's compleat painter. Mixed in among the poems in *Kilian's Fly* were lines of high

praise for "our painter Lucas," whom Sibutus proclaimed to be a master artist beyond Dürer at a time when only Sibutus and Cranach believed it.[28]

A Cranach Coat-of-Arms

If the praise of Sibutus suggests Cranach's popularity among the court humanists, the Saxon elector's bestowal of a coat-of-arms on him the following year attests the admiration and respect of royalty as well. Awarded on January 6, 1508, during the imperial diet in Nürnberg, the new shield recognized Cranach's valued services at court, but did not, as some have inferred, lift him into the hereditary nobility.[29] The de facto honor did, however, empower Cranach to move about more freely and intimately in the world of the aristocracy, another boon to his self-esteem and his artistic career. The coat-of-arms was a "privilege for eternity" because it ensured the painter and his family the respect of every rank of royal servant and kin, including prelates, freemen, lords, knights, and counts.[30]

In a world of novel coats-of-arms Cranach's shield was truly enigmatic and bizarre.[31] It set a black, bat-winged serpent against a bright yellow shield, its wings shooting skyward. Wearing a red crown on its head, the serpent bites down on a ruby ring set in gold. Atop the ensemble sits a blue and gold warrior's helmet capped with green thorns, above which the serpent replicates itself.

Interpretations of the shield are varied and not a few impenetrable. The winged serpent signifies Chronos, the Greek god of time, a name Cranach occasionally applied to himself in an apparent humanistic embrace of antiquity.[32] In classical mythology, a snake biting down on a golden ring represented eternal life, and bat wings were associated with dragons. In contemporary German folktales, both crowns and rings, as those seen here, conveyed magical powers.

The tribute was to Cranach's ability to paint remarkably fast, creating images of the present that would keep for posterity, hence, an artist whose work was both plentiful and enduring. Adorning the shield are the traditional black and yellow Saxon colors of a loyal Saxon vassal.[33]

As in yesteryear, still today the talents of gifted artists and the knowl-

edge of learned scholars are believed by the Church to have a divine origin. By the turn of the fifteenth century Renaissance artists, solely by their manifest talent, had the freedom to choose their patrons, the subject matter of their art, and the style in which they would render it. Their own names, initials, or "logos" identified not only their artwork but themselves as well. From their increasing freedom to set their own boundaries and celebrate themselves in their own artwork, the creative, independent, opinionated artist of the European Renaissance was born.[34]

Between 1504 and 1508 Cranach, diffidently at first, also signed his works. By 1505, his court-commissioned artwork was authenticated by the Saxon coats-of-arms, both that of the original Wettin dynasty and that of the new electoral Saxon regime.[35] Although his initials continued to appear, the shield he received in 1508 progressively eclipsed them all. By 1514, it stood alone as the artist's and his workshop's legal signature and guarantee of quality.[36]

Having certified the artworks of Cranach and his workshop for twenty-nine years, the proud serpent seal would later be cropped by a mournful father commemorating the life and work of his eldest son (Hans), who died in 1537 while traveling in Italy. At the time, Cranach blamed himself for having given his son permission to undertake such a dangerous journey. In commemoration of his loss, the two extended bat wings on the Cranach shield became a single retracted crow wing. In the aftermath, the surviving younger son, Lucas Jr., also a gifted artist in the mold of his father, became the sole heir to the Cranach legacy. In 1544, he succeeded his father as director of the workshop.[37]

Pictor Celerrimus: "Fast Brush"

On December 16, 1508, still another accolade graced the court painter when the distinguished Nürnberg jurist and diplomat Christoph Scheurl delivered a tribute to Cranach on behalf of the Nürnberg and Wittenberg humanists.[38] Residing in Wittenberg at this time, Scheurl seized upon the occasion of a university graduation address to sing the rising Cranach's praises.[39]

In classical eulogistic style he subjected Cranach's work to peer review, comparing it with that of his fellow Nürnberger, Dürer. Like Dürer, so Scheurl, Cranach was a "friendly, communicative, generous, obliging, and pleasing personality." "Often and happily," Elector Frederick and Duke John visited the Cranach workshop to behold its "many monuments to his genius." Professing "love, esteem, marvel, and reverence" for Cranach's artwork, Scheurl declared him to be "the first among contemporary painters *after* the undoubted genius, Albrecht Dürer."[40]

The talents Scheurl had in mind were, first, Cranach's aptitude for deceiving the viewer's eye. "Although you are a completely honorable man," he said of Cranach, "you may deceive others at your pleasure and do so as often as you wish."[41] Like Kilian Reuter, he cited examples of Cranach's wall decorations in the ducal apartments in Coburg, visible to passersby in the world outside. Birds, Scheurl claimed, attempted in vain to perch on Cranach's painted stag horns, while magpies attacked a delectable depiction of grapes on a table at their peril. So realistic was a Cranach painting of a wild boar that approaching hounds begin to bark and run upon seeing the work. In the princes' residence at Lochau it was said that a portrait of Prince John, visible through an open window, brought unsuspecting villagers coming upon it to fall respectfully to their knees!

Such deceits fooled not only the simple folk. When the visiting Graf von Schwarzburg arrived for a stay at the electoral residence in Torgau, he reportedly mistook Cranach's wall paintings of rabbits and birds in his apartment for live ones. Rushing from the apartment, he ordered his retinue to shoo them away before they fouled the floor and the air. Later, when he was ridiculed for thinking them real, the flabbergasted graf scoured the scene in his defense, claiming that he had found an incriminating duck feather.

Scheurl also reminded his audience of Dürer's ability to paint realistically by retelling the well-known story of Dürer's dog. Mistaking his master's freshly painted self-portrait for the master himself, the dog raced up to the canvas and gave it a friendly lick! Dürer liked to tell this story to visitors as he pointed out the smudge left on the portrait by the affectionate hound.[42]

Cranach's other celebrated talents were an ability to paint quickly and to stay long on the job, traits also acknowledged in the symbolic figures on his coat-of-arms. Scheurl dubbed him *pictor celerrimus,* "the swiftest of painters," an accolade one may read today on his gravestone in Weimar. As for his due diligence, whenever the princes played and hunted at their retreats, the court painter stood ready with palette and brush to record their feats.[43]

Two other contemporary commentators had less exuberant but perhaps more insightful assessments of Cranach's artwork. In 1538, Johannes Strigel, a Wittenberg humanist, poet, critic, and Cranach admirer, reported Dürer's private description of Cranach's mythological women, whom he found to be charming and agile [*Anmut und Leichtigkeit*], indeed "the best in the genre among all the artists of the age."[44] High praise from Dürer!

The other notable commentator was Philipp Melanchthon, also a Cranach colleague and sometime collaborator. Although a well-known Luther colleague, he did not to all appearances share Cranach's high degree of intimacy with Luther. Nor was he as vital to the success of the Reformation, a factor that may have alienated the famous Greek professor from both men.[45]

Yet Melanchthon's commentaries on the artwork of Dürer and Cranach were penetrating and fair. Expressing admiration for both, he saw the full spectrum of contemporary German art in their combined artworks. Like most of the sages of the era, scholastic and humanistic, he placed the more cerebral and academic Dürer at the top, but not necessarily as his personal favorite, or best loved, artist. He saw in Cranach's art "a beguiling restitution of simple ordinary life," whereas Dürer "painted everything in a complex and grandiose style, differentiated by diverse guidelines," a ponderous art exploiting all the tricks of the trade.[46]

The Elector's Diplomat

In the late 1490s Frederick the Wise had served Emperor Maximilian in Mechelen as counsel and master of ceremonies (1494–96), thereafter to

become senior counselor (1497–98). Their relationship soured, however, after the emperor diminished Frederick's imperial position and withdrew a promise of marriage to his daughter Margaret, an alienating experience for the Saxon elector and his youthful regime.[47]

Over the next decade (1498–1508), electoral Saxony became the most powerful German state, raising again the question of a marriage alliance with the Hapsburgs. Promoting Saxony's historical pedigree and culture was Frederick's preferred way of increasing political capital, an approach far more effective, he believed, than rattling the sword at the overwhelmingly powerful Holy Roman emperor.

When a new opportunity for a Saxon-Hapsburg marriage alliance arose, the big question within the court was: who among the elector's confidants had the intelligence and charm to represent the regime in the wider European world? To all appearances, the court painter's name made all the lists! It was no accident that Cranach, clad in a brand new tailored Netherlands' summer coat, accompanied the Wittenberg delegation to Mechelen in 1508.[48]

In presenting himself to the emperor on his first diplomatic mission, Cranach carried with him a trophy painting of a great boar Frederick had killed. It was a symbolic gift from electoral Saxony's "First Hunter" to the Holy Roman Empire's "First Hunter." In both Innsbruck and the rich Saxon game reserves, the two men had stalked beasts and fowl together since 1497. Accompanying that gift was still another: a small-format depiction of Cranach's *Judgment of Paris,* in which the Trojan warrior Paris is greeted by the three Greek goddesses upon his return home from the wars—altogether the most "manly" of gifts.[49]

From the moment of their arrival Cranach's art and conversation did more to gain the good will and favor of the emperor than the two rulers' previous marriage diplomacy had done. According to Scheurl's chronicle of events, Cranach's first action upon entering the delegation's lodging was to take a piece of coal from the fuel bucket and draw a likeness of Emperor Maximilian on one of the walls: an immediately recognized image that left everyone marveling.

Saxon-Hapsburg politics did not, however, exhaust Cranach's mis-

sion to the Netherlands. There, he also devoted much of his time to studying the artworks of the Burgundian-Netherlands masters, which incorporated the best features of the Italian school. The combination of styles was congenial to both his previous Vienna artwork and his evolving, hybrid, Danube-Wittenberg style. In the Netherlands, his every artistic wish seemed to be fulfilled. He met the reigning Dutch masters, Hieronymus Bosch and Quentin Massys, studied their artwork, and later was moved to create his own version of a Bosch-like *Judgment Day Altar*.[50]

Cranach seized the opportunity to develop a lasting relationship with the then eight-year-old Archduke Charles, future heir to the Spanish crown as King Charles I, and also destined to succeed his grandfather to the imperial throne as Emperor Charles V (1519). Making the most of his opportunity, Cranach painted the boy's portrait in an impromptu sitting during which a lasting bond was created between them. That bond would be remembered by the principals thirty-nine years later, after the imperial army defeated the Protestant League and occupied Wittenberg in the darkest days of the Reformation. Despite Cranach's personal success in Mechelen, the second Saxon mission also failed to unite the two royal houses, leaving the Saxon dream of a royal marriage with the Hapsburgs moribund.

After the passage of another decade, the newly crowned Holy Roman emperor, Charles V, took the initiative to propose yet another Hapsburg-Saxon alliance by offering the hand of his sister, Catherine, to Frederick the Wise's nephew and future Saxon elector, John Frederick. This time, it was the Queen Mother who rudely scuttled the new marriage plan, declaring that she would not have her daughter live in "that land" (Germany).[51] Between the new insults to Saxon diplomacy and the progressive Saxon embrace of Protestant reforms, the future held strife and war, not union and peace, for electoral Saxony and the Holy Roman Empire.

SELF-ASSERTION

While in the Netherlands, Cranach's approach to the artworks of others was to borrow, scrutinize, and boldly redevelop, thereafter to integrate

Lucas Cranach the Elder, *The Holy Kinship* (Torgau Altarpiece), 1509.

Oil on wood, 47⅝ × 39⅜ in.

(Photo: © Blauel/Gnamm/ARTOTHEK)

what he fancied most. Because contemporary Burgundian-Netherlands art was so strongly influenced by the Italian masters, the discovery of the one was also the assimilation of the other.

Upon his return to Wittenberg in mid-December 1508, Cranach's new artwork reflected the influence of fashionable Netherlands art. It was seen first in his re-creation of *The Holy Kinship* [Die Heilige Sippe], a popular portrayal of Jesus' earthly relatives and extended family.[52] Therein he allowed full-sized human figures to dominate the scene rather than dwarf them against towering landscapes, as he had done so often in his earlier works.

Originally displayed in the Church of St. Mary in Torgau, this triptychon is also known as the *Torgau Altarpiece* and *The St. Anne Altar*. In the wings, Frederick the Wise appears as Alphaeus, the father of the Apostle James, while brother John the Constant takes the role of Zebedee, the father of the Apostle John. A figure with the features of Emperor Maximilian sits above them on the parapet, his hand raised as he converses with a saintly figure bearing the features of his imperial counselor.

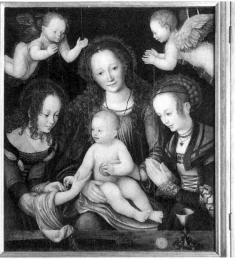

Lucas Cranach the Elder, *Dessau Altarpiece* (Fürstenaltar), 1508. Left panel, the Elector Frederick the Wise of Saxony (1463–1525) and St. Bartholomew; center panel, Virgin and Child with Sts. Catherine and Barbara; right panel, John the Constant, Elector of Saxony (1468–1532) and St. Jacob the Elder.

(Gemäldegalerie, Dessau, Germany; Photo: Foto Marburg/Art Resource, New York)

Some speculate that the man he is speaking to on his left is Cranach. In the foreground, future Saxon elector John Frederick, the son of John the Constant, makes his debut in the main panel as the eight-year-old boy he then was.[53]

A scant year later, another full-sized portrayal of the elector and his brother filled the wings of the *Dessau Altarpiece,* also known as the *Fürstenaltar* [Princes' Altar], Frederick now being accompanied by St. Bartholomew and his brother John by St. James. In the middle panel of the scene the Madonna and Child are being served by both angelic and saintly attendants. Claiming the altarpiece to be both his "best painting and a challenge of Dürer," art historian Werner Schade saw Cranach here giving Dürer an art lesson in the Nürnberger's own style.[54]

Because the Wittenberg court painter held his position at the pleasure of his princely patron, a certain subservience of craft to politics remained a fact of Cranach's life and the raison d'être of all who served the court. Still, the master painters of the German Renaissance and Reformation

were no longer obliged to surrender their input and control over their artworks. Talent now had its privileges as well as its patronal requirements. Court painters not only signed their works, they also put themselves and other select family members in central biblical and classical roles previously reserved for royalty.

For Cranach, the empowering events of 1508 were the receipt of a family coat-of-arms and his huge diplomatic success in the Netherlands. Those achievements emboldened him both as a man and as an artist. Attesting this change was his first portrayal of Venus and Amor. Appearing in a commissioned woodcut of Mother and Child created in 1509, Venus became Cranach's first classical nude, and her son's appearance with her was also an artistic first for Cranach.

The scene in which the two of them appear documents Saxony's historical connection with classical Rome. On a plot of land that would later become the German city of Magdeburg, Julius Caesar had erected a shrine to Venus. In his rendering of this sacred scene, Cranach prominently attached his new coat-of-arms to the so-called Magdeburg "Foundation Tree." In doing so he positioned his shield just below and between the two historical shields of electoral Saxony, thereby enshrining himself with the Magdeburg Venus: the beginning of a relationship that deepened with time.

Throughout his career Cranach always looked for ways to refresh and magnify the regime's authenticating biblical and classical stories.[55] The positioning of his coat-of-arms within a shield's length of those of his lords was a bold statement of who he now thought he was: Lucas Cranach, court painter—like the Saxon princes a mighty pillar of the Saxon regime! Such boasting, both by Cranach and his new "escort," Venus, was not far off the mark. The two of them were now destined to become electoral Saxon "stars."

Reclaiming the best of his Danube techniques and integrating them with those he had learned in Wittenberg and the Netherlands, Cranach capped his first five years as court painter with a dazzling fourteen-page woodcut titled *The Passion of Christ* (1509–10). Inspired by Dürer's *Large Passion* (1496–97), Cranach's completed Passion was a fusion of acquired

artistic styles. Taking note of its superior pacing, composition, and narrative development, it has been called a "personal triumph over Dürer."[56] In viewing it, Dürer must surely have recognized how worthy a competitor Cranach had become in a very short time.

ANTICIPATING LUTHER

While the princes were quick to embrace their court painter throughout the 1510s, they were not so eager to reach out to the Augustinian monk, Luther. Cranach freely associated with his noble betters, in whose company he was treated as one of their own. Luther by contrast was looked upon by wary court politicians as a true lightning rod. Increasingly after 1517, his ambitious reforms threatened the wrath of rival states upon the electoral Saxon regime in the guise of papal edicts, peasant rebellions, and imperial inquisitions. For such reasons, Luther served the regime at a distance in the years leading up to the Reformation.[57] Yet, throughout the 1510s and long before he and Luther knew each other well, Cranach gave striking signs of becoming a reformer in the mold of Luther.

His career soared as his reputation as court painter, diplomat, and entrepreneur spread throughout Saxony. By 1510–11, he was a Renaissance artist of the highest rank, an appealing, effective painter confirmed by the praise of his peers and the awards of his lords. But with that success came heightened stress (the ever-present, magisterial shadow of Dürer); new professional barriers (a limited, claustrophobic castle workshop); and incessant demands on the workshop (growing lists of chores and favors beyond core, creative artwork).

After becoming court painter Cranach endured a hard existence of long workdays with little play and relief. He was constantly going back and forth to decorate and make repairs on the castle residences of his lords, while at the same time orchestrating the annual jousts, hunts, and private celebrations. Not to be anachronistic, but to all appearances, the demands of the workplace joined with the loneliness of a mid-thirties bachelor to trigger rounds of dissatisfaction and much worse: melancholy, a kind of sixteenth-century midlife crisis.

A near decade would pass before Cranach and Luther became allies and collaborated on the reforms that would enshrine the Protestant Reformation. At a time when neither man knew the other well, roughly throughout the 1510s, each was casting about for something missing in his life. Almost exclusively that "something more" was profane rather than spiritual for Cranach. From beginning to end, his own talents and personal interests were directed to the Reformation's *second* front, its moral-secular, domestic-social agenda rather than the theological-ecclesiastical battles. Those battles drew his interest only as they threatened his independence and livelihood.

Within Luther's new gospel of faith lay a strong moral-secular foundation for a full, earthly life of charity and service to one's fellow-man centered around marriage, progeny, and a sovereign family life. It was to that side of the reformers' table that Cranach brought greater, hands-on experience than Luther then could do. In Cranach, Luther gained a worldly wise, down-to-earth mentor with strong political connections throughout Saxony and beyond, to which he also brought his own solid record of success.

Cranach's emotional needs at this time may be seen in numerous portrayals of St. Mary, Jesus' mother, and St. Anne, his grandmother. Mother Mary was the Christian face of consolation in Saxony, and Anne the patron saint of travelers in distress, whom Luther famously invoked in 1507 during a violent thunderstorm while on the back roads to school in Erfurt.

In the decade before the Reformation, Cranach painted numerous youthful and attractive Madonnas. Their numbers and quality suggest a longing within the artist for the solace and devotion that only a mother or a wife might give. He portrays a grown-up Jesus and a youthful Mary side by side, roughly the same age, looking more like brother and sister, or boyfriend and girlfriend, than Holy Mother and godly son. The beautiful and vibrant, soon-to-be "Mother of Sorrows" appears shoulder to shoulder with the handsome, soon-to-be "Man of Sorrows," a new rendering of the Madonna and Child in Christian iconography.[58]

The popularity of such images made Cranach's name a household

Lucas Cranach the Elder, *Christ and Mary,* 1516–20
(Photo: By kind permission from Stiftung Schloss Friedenstein,
Schlossmuseum Gotha, Germany)

word in Saxony long before Luther's became such. In such images and
their progeny, the viewer may behold Friedländer's prolific Cranach at the
top of his religious artwork.[59]

On April 8, 1510, Cranach's images of St. Mary and St. Anne received
an unexpected commendation from the Holy Father in Rome. On that
day Pope Julius II endowed the Saxon elector's relic collection with a most
generous indulgence. Displayed on All Saints' Day, the collection, num-
bering five thousand pieces, was endowed with the power to shorten the
faithful Christian's path to heaven. Penitent sinners who venerated those
relics by invoking St. Mary and St. Anne to save their own and the Saxon
elector's soul were promised relief from punishment in the afterlife.

That indulgence foreshadowed two more famous ones. The first was
the notorious St. Peter's indulgence sold throughout ducal Saxony by
John Tetzel at the instigation of Cardinal Albrecht of Brandenburg, which
prompted Luther's *Ninety-five Theses* (1517). The second indulgence was
also instigated by the cardinal for any and all who revered his relic collec-
tion displayed in his residence in Halle (1522). At that time the cardinal's
had become the largest collection in Europe, eclipsing that of Frederick
the Wise and prompting still another condemnation from Luther.[60]

Upon receipt of the 1510 indulgence, the Saxon elector commissioned Cranach to create a sampler of his relic collection. He selected a hundred and twenty pieces from the five thousand that were there and turned them into woodcut images that were published and displayed collectively in Leipzig in 1511. It is revealing of the pressures Cranach labored under that his lord, Frederick, was at this same time trading Cranach paintings for new relics from the collection of the king and queen of France, a negotiation that could not have been flattering to his court painter.[61]

On the very last page of the published *Relic Sampler* Cranach apparently expressed his unhappiness, not only with the mercenary religious practices of the age, but also with the social-moral-spiritual tenor of the times. One medium he chose to deliver his message of discontent was the saddened face of his courtly colleague Sibutus, the Wittenberg court poet, who had assisted the *Sampler* project by providing poetic commentaries for the chosen relics.

Cranach presents his colleague as a panicky man, puzzled and distraught, a wild laurel wreath askew on his head, his hair unkempt, his lips tightly sealed, his hands gesticulating nervously rather than going to the point: a doubting narrator out of sync. This was no flattering image of a crowned Imperial Poet Laureate reading his poems, but rather an orator in deep doubt of himself and his times.[62]

That such an image concluded the *Sampler* cannot be accidental. One may speculate that Cranach wanted to get something off his chest. The perceived confusion and torpor of his colleague gave him a safe opportunity. More than a snapshot, Cranach catches the imperial poet laureate in an unheroic moment, not the man one would expect, given his exalted position and title. Sibutus shows none of the clarity, manliness, and "effortless superiority" (*sprezzatura*) of the fabled "Renaissance man." He is rather a man who knows not what he wants nor can he grasp what he wills—a mortal soul in deep jeopardy.[63]

Cranach biographers Koepplin and Falk see in this image a naive Cranach character trait of great importance. In dealing with proud, confident, humanistic figures, Cranach confronted them directly with the

112 L. Cranach d. Ä., 1511
(Nr. 159)

Lucas Cranach the Elder, *Sibutus*, 1510–11
(Photo: © The British Library Board Source)

true human condition, which is the bondage of the will, "the stirring helplessness of human endeavor" this side of eternity. In the tormented face and searching hands of the famous orator the viewer beholds only *Angst*. The representation of Sibutus is an unexpected discrepancy in an expected role, a jarring message delivered by the figure's own body

language. He appears as the medieval pilgrim (*viator*) who stands at the crossroads of heaven and hell groping for the meaning of life. Only his recognition and acceptance of the human condition will bring him back to his true, mortal self.[64]

The big question is whether Sibutus was at this point in his life really in such a precarious state of mind. Had Cranach projected his own somber view of the human condition onto Sibutus, thereby telling the viewer more about himself than about his esteemed colleague?[65] If so, it was an awareness he appears to have carried nonchalantly for the greater part of his life.

Circumstances play a role in reactions. After having spent a tedious year poring over the elector's relic collection, both Cranach and Sibutus might well have concluded that there was no "Renaissance man" at the Saxon elector's court. Watching for years the most powerful and respected German prince devote his faith and wealth to thousands of relics allegedly bearing Rome's indulgences, how easy must it have been for the two to question the judgment of all human authority?

Here in the portrait of Sibutus, years before Luther addressed such matters theologically with his new reforms, Cranach was artistically undermining the twin myths of the power of relics and the vaunted Renaissance man. His *Sibutus* was a true statement of human nature as one finds it in history and Holy Scripture. Although a wondrous creature, man remains inconstant and unreliable, unsure of what he wants and stymied when he gets it, altogether his own worst enemy and by no means any prescient, Renaissance "lord over all."[66]

Although the art Cranach created in his early Danube (1501–5) and Netherlands' (1508–9) periods exhibited the strong influence of the High Renaissance, he already knew that the grandiosity of the Italian masters and the elevated, heroic style of Dürer did not portray humankind and the world as he saw them. Cranach rather portrayed man in nature simply, but truly, as a creature charitably ennobled, yet always far from human and divine perfection, a child more of the "Reformation world" than of the "Renaissance world." Yet these twain did meet theologically and existentially in a paradoxical Lutheran formula that declared the

Protestant Christian to be *simul iustus et peccator:* at one and the same time totally righteous by his faith in Christ and utterly sinful when left to himself.

Regarding the sources of that formula East German historian Ernst Ullmann believed he had discovered a true, early Protestant mindset in two Cranach paintings well before Luther's theology and religious reforms gained traction. The first was a portrait of John the Baptist preaching in the wilderness (1516), a scene that "conjured the image of a new socio-religious people's movement."

The other painting, titled *The Dying* (1518), presented a more distinct Lutheran message. It depicts the "Wrath of Hell" that awaits the delivery of a dying man's soul, whose failings over a lifetime are tallied by background monsters who wait to devour him. On one side, a "devil bird" tells the dying man that there is no hope, that he must die because he has transgressed God's commandments. On the other side, an angel of God urges the poor man to repent, seek forgiveness, and ask for God's mercy, a reminder of the gospel message that Luther was now (1518) preaching in Wittenberg.[67]

Whether Cranach depicted Sibutus as he really was, or chose his image to represent the human condition, this minor work delivered a mighty punch to High Renaissance humanists and Roman theologians. By concluding the *Sampler* with the image of a Renaissance poet laureate, who to all appearances was confused in mind and bound in will, Cranach directly questioned in a work of art the *bona fides* of the great idol and fiction of the age: the divinely gifted, ever effective Renaissance man, whom he exposes in the figure of Sibutus as only a tormenting fiction enveloping the best of humankind and leaving melancholy behind.

Although Cranach's criticism was directed more at humanistic concepts of human nature than the teachings of the Holy Father in Rome, his portrayal of Sibutus was a prescient, quasi-theological step into the world of Luther in the late 1510s and the early 1520s. Already in 1510–11, he was raising in his artwork the anthropological and soteriological questions of the coming Reformation.

Looking back from 1511 to 1505, when he became the electoral Saxon

court painter, Cranach may well have begrudged the years he had spent on menial decorative arts, lethal jousts and hunts that passed for courtly "play," not to mention the commissions that were not to his liking, or choosing. Certainly his ego was no smaller than Dürer's, nor did he value his artistic freedom any less.

The *Relic Sampler* project was only one of many distasteful, obligatory chores expected of the court painter. His frustration with them may well date back to 1505 when his first royal commission put "silk strings" on his hands, binding him to a surfeit of tasks well short of great art. At the turn of the first decade of the sixteenth century, those strings must have seemed more like "golden handcuffs," limiting his work and constraining his artistic soul.

By greatly increasing the number of pilgrims henceforth to visit Wittenberg on All Saints' Day, Pope Julius II's 1510 indulgence actually made the celebration of the elector's relics a more arduous task for Cranach and his workshop. Concurrent with the religious celebrations were the jousts at Market Square and the hunts in the princes' game preserves. Throughout Europe jousting and hunting had for centuries been incorporated into lay Christianity. By sharpening warrior skills, tournaments and hunts readied knights to defend Christendom against Muslim Turks and other foreign invaders. For that reason, the Church embraced such activities as meritorious, even worthy of a spiritual reward. Here was still another contorted way the laity might atone for unconfessed and unrepented sins and thus enter heaven directly as pious warriors who had also earned salvation.

On both of Wittenberg's real battlefields, the annual jousts at City Square and the animal hunts in the surrounding forest preserves, the number of unseated knights and the slaughter of game and fowl had always to be counted and depicted. Those chores required the constant presence and rapt attention of the court painter's team, no matter the folly of the deed or the tedium of the work. Beyond the decoration of the churches, the pope's 1510 indulgence created more new tournament spaces and shelters for the Cranach workshop to build, not to mention

the carriages and battle-wagons to outfit, and the horses, armor, and weapons to festoon. And if these were not labors enough, the high noble lords and princes who gathered there annually in ever larger numbers also expected to be sketched in a triumphant moment by the court painter's workshop.

Against the background of a pervasive, mercenary church and court, we find a disenchanted Cranach complementing his exposure of the fictive "Renaissance man" with a blast at the greed of merchants and the simony of clerics, in still another critical artwork against the Roman church. The work bore the title *Christ Driving the Money Changers Out of the Temple* (John 2:13ff). This commentary on the events surrounding All Saints' Day conjured a scaly, devilish tail of mercenary piety winding its way through Wittenberg and its environs. A full decade later, in 1520–21, the same scene appears again in Cranach's first collaborative work with Luther under the title *The Passion of Christ and Anti-Christ*, a powerful propaganda piece that juxtaposes thirteen woodcut images of Christ and Anti-Christ (the Pope), all to the detriment of Rome.[68]

A decade earlier, Cranach was an angry artist reprising an angrier Christ, who again drives the money changers out of God's Temple, now with a long finger pointed at the greatest swindler of all: the Unholy Father in Rome. In the later scene, the viewer beholds the pope and his bishops as they transgress the laws of God and Scripture by peddling indulgences directly to laymen and laywomen.

With the passage of a decade, Cranach's early protest became all the more Luther's. Both the money changers' sales of sacrificial animals in God's Temple and the pope's auction of letters of indulgence in Rome are now exposed as the same falsely promised papal protection of Christian souls.

Contrary to the post–World War II East German scholars' fond remembrance of these artworks as strictly secular briefs against economic and social injustice, Cranach's and Luther's contemporaries rather believed Christ's outrage targeted Rome's trafficking in *spiritual* goods as well. Hence, the prominent display of "Pfennigs *for* heaven" in the cropped

version of *Christ Driving the Money Changers Out of the Temple*, which presents the pope selling indulgences red-handed directly across his desk (1520–21)![69]

Like the transitional figure of Sibutus, Cranach was fundamentally no Renaissance man. He, too, had been burdened in these years by professional frustration, existential doubt, and loneliness. His need to take flight from the oppressive atmosphere of the castle and the court is confirmed and illuminated by the fact that he was, at this same time, actively becoming acquainted with the family into which he would soon marry (in around 1512): the Brengbiers of Gotha. With the passage of time, the intimacy of marriage, and the joy of work and family, Cranach would give every appearance of having resolved his nagging discontents, and even put them completely out of mind.

4

Workshop Wittenberg
Cranach Domestic and Entrepreneurial

OLD HOUSE, NEW HOUSE

etween 1510 and 1512, the well-established court painter was gaining the fame of the ancient masters, wealth beyond his needs, and the good company of the Saxon court. Such bounty, however, was no longer what his soul desired. After an eventful six years as court painter, his demanding work and often unchallenging commissions had taken a toll on the artist and the man.[1] Between 1506 and 1510, the workshop hired as many as ten assistants, both apprentices (*Lehrlinge,* young men in training) and journeymen (*Gesellen,* advanced artists). With the increased demand for Cranach art came the hiring of ancillary gold-platers, illuminators, cabinetmakers, glaziers, goldsmiths, silk sewers, cloth weavers, and tailors.[2]

For Cranach, Inc., the workshop's multidirectional growth both challenged and threatened to consume the court painter. One suspects that life within the castle workshop had become confining and monotonous, moving him to seek new challenges beyond the court retainer's well-scripted workdays. Whatever the discontentment, Cranach's reaction was drift and flight. By 1512 Cranach had moved out of the castle and into the town, where he purchased real estate in the city's posh center. The two properties he acquired at this time were worn and neglected yet sound, magnificent "great houses." His purchases were reminiscent of his professional approach to the creation of new artworks. There, one had also to borrow and salvage, innovate and decorate. In both cases he started with

something worthy and well-established, and progressively subjected it to a new, superior medium: for example, a fading wooden house rebuilt as a stone mansion, or dark etchings, redone in bright new colors.

In home construction as in decorative art, the task for Cranach was always to ennoble what he beheld. This he did by adding new elements not necessarily associated with the particular object or structure that stood before him. The result was a surprising renovation, both in substance and style, giving new life to tired but worthy figures and subjects, whether persons or great houses. In such undertakings, he knew how to select wisely, analyze thoroughly, demolish gently, and boldly re-create.[3]

The tax rolls of 1512–13 show Cranach owning two great houses in the heart of the city: one at 4 Market Square and another, a corner house, at the intersection of 1 Castle Street and Elbe Way, also on Market Square. These were homes for the upper crust. When, in 1523, King Christian II of Denmark failed to establish the Reformation in Scandinavia, he found a welcoming refuge from his enemies at home in a Cranach mansion.[4] After roughly four years of tearing down and building up, 1 Castle Street became a combined family dwelling and professional workshop like no other in Saxony and beyond. Thereafter it remained Wittenberg's premier great house well into the seventeenth century.[5]

Cranach's marriage in 1512 brought him another house, this one safely in the city of Gotha, a Wittenberg protectorate. Not until 1518 was it delivered into Cranach's hands.[6] The new house in Gotha joined with the two great houses in Wittenberg, not to mention newly acquired small dwellings in Wittenberg that Cranach rented out or sold. His real estate ventures also acquired numerous gardens, courtyards, meadows, and tillable fields. The new properties he rebuilt on Market Square turned a prominent segment of the city into his own domain. Surviving records attest both the new homeowner's resolve and the extent of the reconstruction. In 1512, he placed orders for 11,500 bricks, 6,000 roof tiles, and 40 wagonloads of limestone, to which 1,300 tiles and 30 wagonloads of lime were added between 1513 and 1517. When the new construction began in earnest, the treasurer's office exempted Cranach from a general tax of twenty groschen, then being levied on Wittenberg citizens to finance the

The house at 1 Castle Street [Schloßstrasse 1], eighteenth-century engraving
(Photo: By kind permission from Städtische Sammlungen Lutherstadt,
Wittenberg, Germany)

construction of the Elbe Gate bastions. Although a modest sum for Cranach, the city's forfeiture acknowledged, per city law, the great outlays he had made to improve his properties, which in turn benefited the economy of the entire city.[7]

The mansion at 1 Castle Street had previously been owned by city councillor and recorder Caspar Teuschel. Having purchased the property unfinished in 1506, Teuschel did little to complete it within the city's five-year tax-free grace period for new housing starts. As this example suggests, the city's tax incentive did not always achieve the goal of timely, high quality, finished construction. Help, however, was on the way. The new owner of 1 Castle Street was a man quick to please: Cranach built his properties to completion in an orderly and timely way, exceeding everyone's expectations.[8]

Cranach rebuilt the house at 1 Castle Street in stone, then the fashion throughout the city. During his forty-five-year residence, almost as many great houses (forty-six) were built, none more magnificent than Cranach's. To maximize the footprint for his new, expanded mansion, he demolished an anterior house on the property along with sizable portions of the original house.[9]

During the building years (1513–17) Cranach lived in his other great house at 4 Market Square, which also underwent significant renovations. The previous owner, Martin Pollich von Mellerstadt, had been the personal physician of Frederick the Wise and also served the city as the first rector of the university. During the years he had lived there, Mellerstadt negotiated a lucrative electoral privilege that permitted him to own and operate a pharmacy on the premises. Ever vigilant, Cranach took note of that precedent when he and his business partner, goldsmith Christian Döring, conjointly purchased the house. Later, in December 1520, the special privilege was restored, much to the Cranach family's profit well beyond the sixteenth century.[10]

When readied for occupancy in 1518, the Cranach mansion on Castle Street presented eighty-four rooms and sixteen kitchens, each with heating capacity. For over a century, it remained Wittenberg's largest dwelling-workshop complex, and over his lifetime it gave Cranach the

distinction of paying the city's highest real estate taxes.[11] Thus did the court painter plant himself squarely on Wittenberg's most prestigious real estate.

Henceforth Cranach lived among the city's most affluent burghers, while progressively serving its citizenry throughout the 1520s and '30s in official roles as painter, politician, publisher, and apothecary. By 1528, he owned nine properties, more real estate than any other Wittenberger, and his liquid assets were estimated at 4,016 gulden, placing him among the city's three richest burghers. He was also a close friend of one: Electoral Chancellor Gregor Brück.[12] As these two titans watched their families grow up together, it surely passed through both of their minds that marriage alliances would one day be in order.

BARBARA BRENGBIER CRANACH

By the time Cranach moved out of Castle Wittenberg, his motives for doing so had broadened well beyond any professional discontents. His flight had become a happy one now that it was aimed straight into the arms of his Gothan wife. Approaching forty and in his prime, he was now thoroughly gripped by the desire to marry and raise a family. Behind all of the speculative buying, demolishing, and rebuilding of stressed real estate there lay the vision of an extended Cranach family: husband, wife, and children living, working, and playing together in the great house at 1 Castle Street. Whether that mansion was acquired before, upon, or after the marriage is unknown. What is undisputed is the fact that he was now a man of such fame and wealth that he could live wherever he wanted, and share his new dwelling with any partner he chose.[13]

In searching through his bachelor years, one finds scant evidence of any deep love interests. Yet rumors of intimacy with a mysterious "Anna" do exist. She was the subject of an epigram in a lost Cranach painting (ca. 1510). Written in "the playful, poetic, humanistic spirit of flirtation," the epigram suggested that she was a Cranach lover ("Geliebten Cranachs").[14]

Increasing the intrigue, the epigram indirectly connected Cranach

with still another woman who was the subject of yet another epigrammatic Cranach painting. Her name was Gesa Bloch, the well-known consort of university rector Dietrich Bloch. That Gesa and Dietrich were not married was a direct consequence of his university position. His appointment had been made under a strict rule of celibacy. Here he faced a "relic" of centuries-old church domination, one that denied marriage to faculty ranks and high administrative officials like him. If that were not barrier enough to their marriage, Dietrich to all appearances had also taken religious vows at a younger age.

In the face of such clerical harassment and public disapproval, the couple ended their pretense in 15ll. Dietrich resigned his position and the two of them departed the city to take up a new life elsewhere as man and wife. By doing so they escaped a harsh Roman rule that Luther in his gospel sermons, and Cranach in his religious paintings, would see banished from the new Protestant faith.

Taken together with the linked epigrams, Cranach's paintings of these two women suggest the court painter's lively interest in the opposite sex throughout his bachelor years. One epigram evokes the following erotic passion:

"They call me lovely Anna. A second Apelles painted me. And just as [I] have a reversible name, anyone can turn my body heels over head."[15]

If Gesa's story evinces a freer spirit, her abiding relationship with Dietrich leaves Anna as Cranach's only known girlfriend before his courtship and marriage to Barbara Brengbier. These early dalliances also raise the question of female models and love interests in the Cranach workshop. As has been observed, Cranach's interest in the female body, emergent in the mid-decade of his appointment as court painter, grew steadily thereafter and would completely occupy him in his later years.

Mary Magdalene was Cranach's first biblical nude and Venus his first classical.[16] Together these two Cranach women foreshadowed what, after 1525, and well into the 1540s, became a varied and sophisticated repertoire of nude heroines and female victims snatched from biblical and classical

times. One wonders whether Anna and Gesa might have modeled such roles in the privacy of the artist's workshop.

At some unknown point between 1511 and 1512 Cranach met and courted the woman who would become his wife. After Anna and Gesa there was the Gotha patrician Barbara Brengbier, to whose town Cranach traveled back and forth for reasons of both business and pleasure. Long before Fraulein Brengbier quickened his pulse and pace to Gotha, he had come to know her hometown and fellow citizens, including members of her family, with whom he frequently crossed professional paths.

Apart from his new love interest, Cranach still had good reason to be in regular contact with the city's famous humanist Konrad Mutian. In 1504–5, Mutian had been both referee and go-between in Cranach's successful appointment as the Wittenberg court painter. A decade later he was an obliging contact for the courting Cranach, extending a helping hand throughout each visit to his beloved Fraulein Brengbier. Mutian's diary entries comment favorably on her father, who was a patrician counselor who became Gotha's bürgermeister. Mutian also recorded some of the dates on which Cranach was in town, including one in 1512 very close to the time their nuptials were most likely occurring.[17]

Like her husband-to-be, Barbara Brengbier also had a "past," one far stranger than epigrammatic flirtations. She was engaged to a boarder who lived in her father's house and died there before their planned marriage could occur. Martin Luther was the source of this information, inclining some scholars to argue that Brengbier was an older bride. Some see her approaching forty, the age of her husband, not the young woman many believed her to be from her husband's post-nuptial portrayal in *The Holy Kinship,* a work celebrating their wedding day.[18]

In the absence of reliable records, or surviving wall flies from sixteenth-century Gotha, the modern historian has little context and even less information about the Cranach-Brengbier nuptials. The ever secretive Cranach gives every appearance of having succeeded in making his marriage a strictly private affair in the bride's hometown. Later, he commemorated the event with an endowed midsize altar panel arranged in a private setting strictly for family eyes only.

Earlier (in 1509), Cranach had given leading roles in biblical scenes to his Saxon patrons. He likened Jesus' extended family to the Wittenberg princes (the three Saxon electors): Frederick the Wise, his brother Duke John the Constant, and future heir apparent John Frederick. Frederick the Wise appeared as St. Alphaeus, Duke John as St. Zebedee, and John Frederick as the playful six-year-old boy he then was. Also sharing in this royal flattery was the emperor, Maximilian I, who makes a cameo appearance on a parapet above the scene.[19]

The three electors also appeared in Cranach's *Dessau Altarpiece* (Fürstenaltar). Here, Elector Frederick and Duke John filled the wings and framed the Madonna and Child, who were joined in the centerpiece by the same serene saints, Catherine and Barbara.[20]

A similar and grander presence of family appeared in Cranach's first rendering of *Venus and Amor*. At that time, he hung his recently received coat-of-arms as close to the electoral Saxon shields as he dared. Members of his extended family can be seen mingling with the biblical dramatis personae, privately sharing the lineages of the saints just as the royals were so fond of doing! On the heels of such princely flattering, Cranach, soon to be a proud *paterfamilias,* wasted no time in recruiting major figures from the new Cranach-Brengbier clan into the roles of Jesus' biblical kin.

Here Wittenberg's royal family is privately preempted by Cranach's own family aspirations. Presenting himself in patrician attire, he appears in the left background scene as a handsome St. Alphaeus. In bringing his new bride into the picture, Cranach shrewdly left it to the viewer to resolve the issue of her age and bearing on her wedding day. If one assumes Barbara Brengbier was at this time a woman in her early twenties, then the youthful face and features of Mary Cleophas, sitting center-left and suckling her infant child, must be the new bride, Brengbier. For those who theorize that Cranach's bride was already into her thirties, then the visibly older Maria Salome (center-right), who also holds an infant in her lap, must be the new Frau Cranach. Unfortunately, only the artist knew for sure, and he does not resolve it for the viewer.

As there are no known portraits of Barbara Brengbier Cranach, not

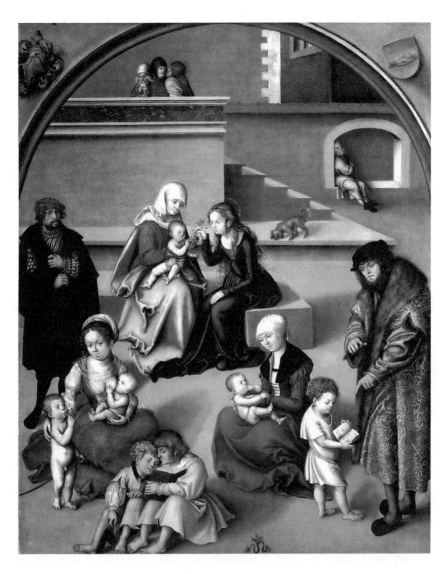

Lucas Cranach the Elder, *The Holy Kinship (With Self-Portrait of Cranach, Standing with Red Cap, Portraits of His Wife, Left Foreground, and His Parents-in-Law, Right)*, 1510–12. Limewood, 34⅝ × 27¾ in.
(Akademie der Bildenden Künste, Vienna, Austria;
Photo: Erich Lessing/Art Resource, New York)

even so much as a commemorative gravestone image, there is no way to confirm her real life appearance, much less authenticate it in a work of art. Scholars do, however, agree that his new bride *was* the model for one or the other female figure in the scene.[21]

As for history's *votum*, the sixteenth-century marriage market greatly preferred younger brides, which suggests that it is Mary Cleophas who wears the face of Barbara Brengbier. But was the artist on history's side in this matter? While that question cannot be answered definitively, it is well known that Cranach had a twinkle in his eye for luminous, youthful female beauty, and was also kind in his artwork to the vast majority of older women he painted (thin and pretty).

It is also likely that the rotating cast of characters in the iconography of *The Holy Kinship* is just harmless flattery and pride on the part of the principals portrayed: we have both royalty replacing the saints, and Cranach's new family replacing the royals *and* the saints! From this perspective, the youthful Mary Cleophas and the aging Maria Salome present the different features and qualities of the artist's perception of his new bride, whatever her exact age and bearing may have been.[22]

Beyond the above debate, two indicators within the scene of *The Holy Kinship* attest a true relationship of love and trust between Cranach and his bride upon their entrance into the estate of marriage. The first is the trustee emblem in the upper spandrel showing two hands tightly clasped ("the emblem of trust"), a symbol of deepest loyalty and fidelity.[23] The other indicator of a devout union is the center-stage appearance of St. Anne, whose blessing brings the promise of fertility and offspring to all newlyweds who revere her. And pointedly reinforcing her bona fides in the scene is the presence of seven children—infants, toddlers, and youth, mingling among the ten adults.[24]

Was Barbara Brengbier her husband's workshop model after their marriage? Some suggest that she not only modeled herself in *The Holy Kinship*, but thereafter appeared in various stages of undress for her husband's portrayals of Eve, Lucretia, and Venus, among other biblical and classical women. Does her sitting for her husband's nude repertoire suggest jealousy and self-interest on her part? By modeling for her hus-

band, she might prevent younger, sexier women from beguiling him, thereby safeguarding her own self-esteem and keeping her marriage intact, as God would have it be.[25]

For any or all of that to be true, however, Barbara Cranach would have to have been one of Wittenberg's most attractive, discreet, and resilient women. Regardless of her age, the bearing of five children over eight years (1513–20) would have taken a heavy toll on her body and her time. And beyond those barriers, one may suspect that her patrician status would have prevented her from giving such nudity any proper thought.

A better and more credible contribution to her husband's education in marriage and intimacy, sexuality and progeny, was the couples' own observation of their daily life together in the divine estate of marriage. Day by day marriage increased Cranach's knowledge of, and sensitivity to, female anatomy and disposition. Luther, believing marriage to be the parking place of the sex drive and the supreme school of the sexes, shared with him as he did with others the cardinal lessons of love and matrimony, which the following ode to marriage attests.

> At first [Luther warns] love is glowing hot (*fervidus*), an intoxicating love by which we are blinded and rush forth to grasp one another. But once married, couples soon grow tired of one another, confirming the old saying of Ovid: *praesentia odimus, absentia amamus:* "We hate what we have and we love what we have not." A wife is easily taken, but to have abiding love is the challenge. One who finds it in his marriage should thank the Lord God for it. Therefore approach marriage earnestly, asking God to give you a good, pious girl, with whom you can spend your life in mutual love. Sex [alone] accomplishes nothing in this regard. There must also be agreement in values and character (*mores et ingenium*) [as the two proceed with one another].[26]

Cranach's early nude portraits ignore anatomical features, gross physical traits, and superficial beauty. By comparison with his German rivals, Dürer and Hans-Baldung Grien, Cranach's "holistic" approach to the

female body gives the least attention to hard gender features, while awakening a certain eroticism in the slimmest of figures. Seldom does the viewer see an exaggerated breast or a heroic buttock on the Cranach woman. As a rule, Cranach's women are confident and convincing, curious and pleasing, and more often than not "on top." From the sensitivity of his portrayals and the comfort of his figures, whether dressed to the nines or totally nude, *what Cranach knew about women* came from his own respectful contacts and moments of intimacy with them, rather than reliance on professional models, or courtesans.

The artist and his women reflect the "gender zeitgeist" of the German Renaissance and Reformation. At this time contemporary humanists and reformers exalted marriage, sex, and family over celibacy, chastity, and the single life. In the war-ridden, plague-stricken, impoverished late Middle Ages, the shortage of eligible bachelors and the insufficient earnings of couples delayed or denied marriage and family for a great many. In the new era, however, the doors to courtship and marriage, progeny, and family opened wide.

In Luther's writings and Cranach's artworks, respect for the abilities of women found very positive expression. Industrious housewives and self-sacrificial mothers were compared to heroic biblical and classical women. Also high up on the reformers' social pedestal stood the self-reliant "housemother" who commanded the household, kept the accounts, and made the deliveries for the family business. Following the matriarchs in praise were the self-sufficient, in-and-out-of-house single women who spun cloth and prepared food for their own and other families. Last, but not least, were the women who in time of war or catastrophe stood shoulder to shoulder with their husbands in the trenches.[27]

Children

Between 1513 and 1520, Barbara Brengbier carried five pregnancies to term. Like the partial dating of the parents' lives, the dates of the children's births and deaths are the best guesses of historians.[28] In the mold of their father, the Cranach boys, Hans and Lucas Jr., grew up in their father's workshop, proving themselves early to be gifted artists as well.

While traveling through Italy in 1537 to meet, and to study the works of other artists, Cranach's eldest son, Hans, met a premature death in Bologna. In the aftermath of the tragedy, Lucas Jr. became his father's sole male heir and followed in his footsteps, both in the art workshop and as a city councillor, real estate developer, and bürgermeister.

Naturally gregarious, the senior Cranach made alliances with men of high social standing and success, doing so not least by marrying his children to theirs. All of his children married, three for a second time, and always with a substantial mate. In such match-making, the rich, burgher-class Cranachs were better positioned socially for success than most. However, their good matrimonial fortunes did not guarantee either the parents or the children a long and happy life.

Lucas Jr. and his middle sister, Barbara, married into one of Wittenberg's most esteemed and wealthy patrician families, that of the imperial electoral counselor and chancellor, Gregor Brück. The elder Cranach had come to know him well during their years of joint service in the city council. Barbara Cranach married Gregor's son Christian in 1537, and her brother Lucas Jr. married Gregor's daughter Barbara in 1541. When she died, Lucas Jr. married well again, to Magdalena Schurff, the daughter of the university's professor of medicine and the niece of its Greek professor, Philipp Melanchthon.

The great wealth of the social circles the Cranach children grew up and married in is suggested by the five thousand gulden Barbara Cranach brought to her marriage to Christian Brück, who succeeded his father as city councillor and chancellor. Cranach's middle daughter, Ursula, an early widow, also remarried a very successful Würzburg jurist.[29] Cranach's youngest child, Anna, a god-child of Martin Luther's, was the long-lived wife of Caspar Pfreundt, her father's hand-picked pharmacist, who ran the co-owned Cranach-Döring pharmacy.

CRANACH AS TASKMASTER

Inside the art workshop, Cranach's reputation was that of a successful manufacturer of high-quality artworks with an impeccable skill in marketing them. In addition to his entrepreneurial spirit, two leadership

qualities stood out: a transparent approach to the workshop's production line and a mentor's keen eye on detail and process.[30] With such a master, the apprentices and journeymen always knew what was asked of them and could go confidently to their work.

Between the workshop's formulaic modeling and rapid assembly-line techniques, the result was high productivity and quality. For the workshop the reward was a continuing stream of new patrons and commissions, which translated into higher pay for his employees and greater wealth for the Cranach family.

By the second decade of the century, the workshop routinely mounted extravaganzas for both visiting royalty and the native population. In 1513, Cranach and ten journeymen spent seven weeks in Torgau preparing a three-day celebration in Castle Hartenfels. The occasion was the wedding of future elector Duke John the Constant and Margarete of Anhalt (November 12–15). The workshop adorned the bridal bed with popular classical fables impressive enough to move poet Philipp Engelbrecht to publish a Latin commentary on the decorations.[31] The result was as stimulating to the mind as it was striking to the eyes. The Wittenberg workshop manufactured and shipped the requested accessories directly to the scene: a collection of brightly decorated tournament tents, helmet plumes, tapestries, and coats-of-arms (large ones for hanging, and small ones for waving).[32]

In the following year (1514) the workshop prepared still another magnificent royal marriage: that of Katherine of Mecklenburg and Henry the Pious, another Saxon duke in the Albertine line. Cranach painted them as they appeared on their wedding day in what is reputed to be the earliest life-size painting of standing figures in the Renaissance, yet another Cranach standard for the age.[33] In the first half of the sixteenth century there were no brighter lights in the decorative arts than those that shone in the Cranach workshop. Nor was there another artist whose creations shaped the contemporary religious and political worlds more decisively for posterity.

Outside of the art workshop, Cranach began his ascent as a Wittenberg politician in the late 1510s and early 1520s. In the same year in which Charles I, king of Spain, became Emperor Charles V (1519), Cranach took

his seat in the twenty-one-member Wittenberg city council, the beginning of a thirty-year career in city politics. Since only one-third of the council members actively governed in annual rotations, the demands of the position did not inhibit his continuing direction of the workshop, or his new business ventures. In his first year on the council he and his partner, goldsmith Christian Döring, occupied the two offices of the treasury (*Kämmererei*), to which office Cranach would later twice return (1531, 1534).

A seasoned politician by the 1530s, he served three terms as the city's bürgermeister (1537, 1540, 1543).[34] Quick and strict in enforcing the legal process, he executed criminals and alleged witches on three occasions during his first term. In January 1537, he ordered the beheading of a burgher convicted of a premeditated murder. In June of the same year, he ordered a fifty-year-old woman, her two sons, and a compliant servant to be executed at the stake for the alleged crimes of sex with the devil (*Teufelbühlschaft*), poisoning of fertile fields, and invoking violent storms. Again, in October, he sent an accused witch to the stake on similar charges.[35]

As had always been apparent, the court painter's virtuosity was not confined to his paintings. Although his artistic skills put him at the top of the art world, in the eyes of his contemporaries he remained the city's consummate businessman. As a modern biographer put it: "[Cranach was] the most versatile entrepreneur of the German Renaissance."[36]

His intertwined artistic and marketing skills, the awesome ability to create and to sell, were symbiotic, complementary in the most beneficial ways. The artist and the artwork drew princes, noblemen, high clergy, humanists, self-made burghers, and the art brokers of Europe to Wittenberg. All came in search of a Cranach "connection," and those who could not make a purchase left contentedly with the fantasy.

Although a consummate insider at court and in the city council, Cranach never exclusively favored the royal-patrician world over middle-class society. As a recent critic put it: "By his proven art, business sense, and social activity, Cranach presented himself as a typical representative of the young middle class."[37]

In documenting the pedigree of Saxons all the way back to biblical

Eden and classical Rome, Cranach gave his Saxon lords the legacy and legitimacy they so desperately craved. As if in a distant mirror, the past was neither here nor there, black nor white, but a connected world that rang true to contemporaries at both ends. His great discovery from such raids on ancient civilizations was the latter's continuity with present-day life. In every age the past held the key to the present. Its dramatis personae counted craven tyrants and grotesque criminals, gouging merchants and papal mercenaries, lecherous old men and gold-digging young women. Yet, in that same history there was no shortage of brave heroines and righteous heroes, kindly saints and godly laymen, loyal husbands and honest wives.

Two dominating figures of Cranach's immediate world were Cardinal Albrecht of Mainz and the monk Martin Luther. These two great patrons and friends represented the contemporary warring sides of the crisis in European civilization. Although reading deeply the same biblical gospel and classical lore, each embraced a religious confession that canceled out the other: the one clinging to hegemonic Roman tradition, the other hanging everything on a new reading of the New Testament. Although Cranach assisted both of these titans with political advice and flattering portraits, he gave Luther more of each, which made all the difference.

Ruffians and Cronies: The Student-Burgher Wars

The academic year 1520–21 saw the student population of Wittenberg University soar to twenty-three hundred, roughly the same size as the city's non-student population. Coming from all over Germany to sit at the feet of Luther, the surge of noble-patrician students added new pressures and created sore feelings between town and gown. Quite a few of those students accused the burghers of scorning and harassing them, and they singled out the journeymen in Cranach's workshop as the most confrontational of all.[38]

At the top of the students' grievances was the burghers' refusal to honor the city's ban on deadly weapons (daggers), a law then strictly

enforced on the student population. By all accounts Cranach's journey-
men carried weapons in their clothing with both their master's knowl-
edge and impunity. On July 14, 1520, Frederick the Wise received a formal
complaint from the students, accusing ordinary burghers of "having it in
for them." They alleged constant, unprovoked "bullying, slander, and
[physical] attacks" upon their persons, citing as evidence the beating of a
Danish master, the flailing of a Franconian nobleman, and the dragging
of an innocent academic by his hair.

That Cranach and his journeymen were the main targets of those
accusations suggests that the altercations grew from class envy and resent-
ment. Although well-to-do and well protected by their immediate noble
allies, quite a few students, jealous of their own high station in life,
resented the "proud bearing" of Cranach's self-made journeymen.

Contributing to such suspicion and distrust was the prevalent belief
that dressing above one's social rank was a prelude to disobedience and
rebellion. Due to the workshop's success, Cranach's journeymen were
able to dress more like their betters and were not above flaunting it.
Therein, one also finds the students' resentment of the city's most promi-
nent, self-made burgher, Cranach himself.

As tensions increased, students demanded disciplinary action against
all court servants, painters, and burghers and the immediate disarming of
Cranach's journeymen.[39] Amid student cries for a "revolutionary cleans-
ing," a reportedly morose Cranach engaged the unpopular university
rector, whom both sides ended up blaming for the city's troubles. At this
time Luther also condemned rebellious students from his pulpit and
defended Cranach's actions against the rector, who thereafter (1521) re-
signed and moved to Ingolstadt. Before order was restored, however,
electoral troops had to be called into the city.[40]

Three years after this great uproar, a journeyman painter who had
participated in the student-burgher brawls of 1520–21 confessed to a
mentor that he had, at the time, delivered a death blow to a student,
and ever since had been living in the fear of discovery and punishment.
Upon hearing the painter's confession in early March 1523, Cranach asked

Luther to intercede with Spalatin on the guilty man's behalf, the two of them combining forces to obtain the elector's confirmation that the remorseful journeyman would not be punished.

Arguing that the student's death was unpremeditated, Cranach and Luther cast the incident as an accidental death, an act of self-defense on the journeyman painter's side. Both deemed the latter's guilty conscience to be punishment enough, Luther warning the elector that "Lucas Cranach will not tolerate any deceitful betrayal of the man, nor his imprisonment."[41]

Here we see Cranach looking out for his own, but now able to do so with such authority that the two most powerful men in the city, Frederick the Wise and Martin Luther, granted him his wish.

PUBLISHER

If the city council was Cranach's first "supplemental" career, the Cranach publishing house was the second. Together, these two new bases of political power sealed Cranach's position as the city's real estate king and one of its wealthiest citizens. Around 1520, he and Christian Döring, a fellow city council member and the elector's private goldsmith, entered into a partnership to create a publishing house with Cranach as the senior partner.

At this point both were novice politicians, having just served their first year on the council, as treasurers, helpful preparation for their imminent joint venture into the rewarding, but trap-laden, book business.

In his position as court painter Cranach had also often to confront his debtors. Over the years he acquired a list of powerful patrons who had become delinquent in paying their bills. Among the debtors were such heavyweights as the shoemakers' guild, Martin Luther, the city council, and even the Saxon elector himself!

Having purchased a printing press, Cranach and Döring persuaded the Leipzig printer Melchior Lotter, Jr., whose father had earlier published Luther's *Ninety-five Theses,* to join them in Wittenberg. Arriving in the city with molds of the famed Basel publisher Johann Froben's type, Lotter received lodging in Cranach's mansion and set up his print shop there.

Together, the Cranach-Döring-Lotter team had the technology and talent to mass-produce illustrated woodcuts, pamphlets, and books, while also profiting from the sale of print "accessories" (inks, pens, et cetera). They also had Martin Luther, Germany's best-selling author, in their stable. So long as the team held together, the new Cranach publishing house was poised to dominate the regional book market for the foreseeable future. During the 1520s the conjoined Cranach workshop and Lotter press laid a lasting foundation for the Reformation by distributing the staples of Evangelical protest and reform straight out the door at 1 Castle Street.[42]

In 1520, Lotter made his debut with three seminal tracts by Luther, each originally printed in Latin, but quickly translated into German and widely distributed by sympathetic humanists. The first urged the German nobility to seize the opportunity to reform Christendom, the second exposed the corruption endemic in the Roman Church, and the last summarized the new Lutheran theology of faith, freedom, and charity. Each treatise found an eager audience among the reading public and proved to be a bonanza for the publishers. Appearing in tandem with Luther's books was a potpourri of patriotic anticlerical writings directed against Rome from the hand of the popular German humanist and knight Ulrich von Hutten, another crowned German poet laureate (1517), and deeply devoted to Luther's reforms.[43]

Two years later, while Luther was in hiding at Wartburg Castle in the wake of the Diet of Worms (1521), the Cranach-Döring-Lotter team launched an even greater project. After three unbroken months of work (from mid-December 1521 to February 1522), Luther presented his German translation of the New Testament to Professor Melanchthon for a final proofreading. Three months later, in May, the manuscript went to press.

The result was the so-called "September Testament," a first run of three thousand copies, soon to surge to five thousand in the second edition, then known as the "December Testament." The selling price of an unbound copy was half a gulden, and bound copies sold for a full gulden, roughly the price of a slaughtered hog. All five thousand copies were sold

out within three months, during which the per copy price tripled to a gulden and a half.[44]

Between 1523 and 1526, the Cranach-Döring publishing house printed thirty-six other works by Luther. In the year the complete German Bible, both Old and New Testaments, became available in one volume (1534), the "September Testament" had run through fourteen German and seven Dutch editions.[45]

Luther immediately sent two copies of the "September Testament" to Frederick the Wise, who passed one copy on to the Nürnberg cloth-merchant Anton Tucher, whose modern descendants put their copy on display in Nürnberg's Tucher Museum. Contributing to its strong sales were Cranach's twenty-one original illustrations decorating the last book, *The Revelation of John* (a.k.a. *The Apocalypse*), a sustained prophecy of the events that were expected to befall the world in the last days before Christ returned in glory to gather up his saints.[46]

In addressing the topic of the "last days" it was commonplace for artists and workshops to borrow from Dürer's iconic Apocalypse illustrations dating from 1496–98, as Cranach did in his earlier Passion scenes. Perhaps reflecting his independence from Dürer and loyalty to Luther, his twenty-one Apocalypse illustrations were for the greater part straightforward and without embellishment, a "literal" rendering of the biblical text.

Consummate mentor that he was, Cranach also went out of his way to help Luther make the most accurate translation. Coming upon a list of precious stones in Revelation 21, not all of which were immediately identifiable in the Greek and Latin texts, a stymied Luther turned to Cranach for help.[47] To resolve the impasse, Cranach gave him access to the elector's gem collection, allowing him to identify the biblically cited stones by matching their shades of color.[48]

Whether in response to Luther's nudging or his own religious sensibility, Cranach boldly added a new feature to *The Book of Revelation*'s personification of the devil. He placed a papal tiara upon the head of the so-called Babylonian whore, thereby identifying, or at least associating, her with the Holy Father in Rome. According to prophecy, she was to rise up from the bottomless pit on the back of a beast and conquer the world

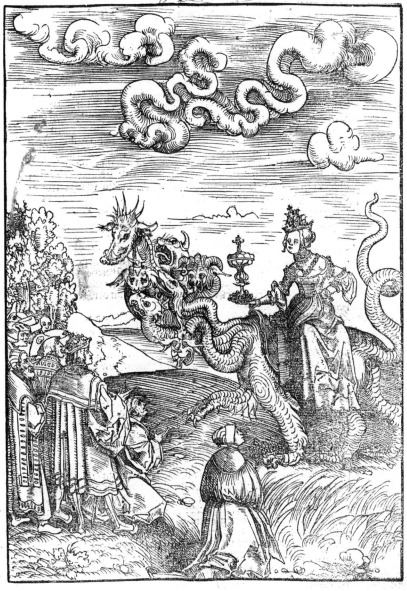

Lucas Cranach the Elder, *Babylonian Whore*, in *September Testament*, 1522
(Photo: By kind permission from Das Evangelische Predigerseminar Wittenberg,
Bibliothek, Germany)

in the "last days" (Rev. 17:1–8). Here again, now brightly illustrated within the German New Testament, Cranach and Luther repeated their earlier (1520) slander of the pope as Anti-Christ.[49]

That slander was, however, short-lived. Three months later, when the second edition, the "December Testament," appeared, the offending tiara was nowhere to be seen. In its place were blank white spaces, serving as the offender's flags of surrender, courtesy of the Saxon political censor. In the intervening months Duke George the Bearded, the new ruler of ducal Saxony and Elector Frederick's sworn rival, strongly condemned Cranach's blatant confessional parti-pris. Heeding the duke's warning, and probably also sharing his offense, the wise Saxon elector commanded the offending tiara to be stricken from the new edition.[50] Taken in the name of peace and order, the action was both prudent and another reminder to both sides that politics could still trump religion in the new age of reform.

With the completion of the translation of the New Testament, work on the Old Testament was also started in earnest. By 1523–24, Luther had completed three parts: the five books of Moses (1523), those between Joshua and Esther (1524), and the Song of Songs (1524). These chapters and verses laid a path to the completion of the German translation of the entire Luther Bible, the original Protestant goal that still lay a full decade away (1534).

Although the professional and personal bonds between Luther and Cranach strengthened in these years, this great feat of translation and publication sowed terminal discord among those who had accomplished it. The breaking up of the publishing team resulted from an unequal sharing of the profits between the publishers and the printers. Having begun with one press, at the peak of the workshop's productivity, Lotter ran three around the clock. His skill, diligence, and top-of-the-line technology had made the Protestant dream of a vernacular Bible come true and the publishers very wealthy.

The latter's largesse, however, was not shared among the owners and the printer, much less the clerical translators who, still at this time, had no legal claim to royalties, although they did receive bound copies of the Bible which they could sell, or barter. Although no religious scruples kept

printer Lotter from receiving a larger and more equitable share of the Cranach-Döring windfall, he was excluded by "legalities." To his misfortune, the salary agreement he had signed upon his hire confined him to a fixed sheet price for the duration of his employment, regardless of sales. The seeming unfairness of that stipulation grew with the project's revenues, leaving Lotter with an embittered sense of having been outmaneuvered and cheated.

Now completely alienated from his employers, he became sloppy at his work and struck out at his employees. Losing control one day in late 1523, he planted an awl in the nose of a slow-moving apprentice, which resulted in a legal sanction and a fine for the Cranach workshop. By such abuse of a worker, Lotter had damaged his professional reputation in Wittenberg irreparably. Seizing the opportunity, Cranach and Döring stepped in and fired him.[51]

Out of a job and denied lodging at 1 Castle Street, Lotter attempted to set up shop elsewhere in the city. Unfortunately for him, Cranach and Döring were not men to be crossed in Wittenberg, and they made it impossible for Lotter to restart his press there. Lacking an alternative, Lotter was forced to seek a living elsewhere, which over time he very successfully did.[52] A local printer, Josef Klug, while not as skillful as his predecessor, took Lotter's place and gave the Cranach-Döring press several more years of life.

Best-selling author Luther also lived under the rules and demands of his publishers, and from time to time he commented frankly on his relationship with Cranach "the entrepreneur." Bemoaning in a 1523 letter that he had become "a slave to the profit, or greed, of others," implying the Cranach-Döring publishing house and the Lotter press, Luther professed a fond wish "never to publish a book again." He went on, however, to explain that his "slavery" to Cranach was completely voluntary, something he did "because Lucas's press needed [his] support."[53] Confirming his continued devotion to his friend, Luther cited two new works he had recently finished, one political, the other biblical, both earmarked for Cranach's next press run.

In a deconstruction of Luther's side of this story, historian Heinz

Lüdecke, no fan of the reformer, reminded his readers that Luther had become a pamphleteering "Angel of Death" in 1522, thereafter cheering on Elector John the Constant's slaughter of the rebellious German peasants. The allusion was to a pamphlet in which Luther bluntly forewarned the peasants not to rebel against lawful political authority, promising that if they did so, he would not stand with them, no matter the injustices they had suffered. As far as Lüdecke was concerned, that statement sealed the German peasants' fate. As for Luther's description of himself as a slave of Cranach's profit and greed, Lüdecke opined that, in truth, Luther had been no more an enemy of profit and greed than he was weary of writing books.[54]

During the bitter breakup of the Cranach-Döring-Lotter team in the mid 1520s, the reformers were never more assailed and the Reformation more at risk. In May 1525, as the peasants attacked the castles of their lords, the reformers' protector, Frederick the Wise, was dying a slow and painful death from acute kidney failure.[55] Taking advantage of the chaos, foreign booksellers successfully pirated and printed the manuscript copies of Cranach and Döring's revised Latin Bible completed in 1524. Before the Cranach-Döring-Klug press could recover and become competitive again, the Saxon market was saturated with the Bible.[56] To help the reformers regain some of their footing, the new elector, John the Constant, gave the Cranach-Döring press sole and exclusive rights to print and sell copies of their Bible throughout electoral Saxony in the coming new year (1526).

Plagued by that pirating, Luther took protective measures by creating a book trademark, or seal, of his own in 1524. The trademark was an image of the "Lamb of God" holding up the flag of the cross, as his redemptive bloodstream filled the chalice of salvation. The bleeding lamb would later be joined by a second, preferred Lutheran trademark or seal: a layered White Rose that progressively became the Lutheran family coat-of-arms. Showing the reformer's initials in bold black letters, the new shield was bestowed on Luther by the Saxon elector John Frederick.[57]

Henceforth both seals, the bleeding Lamb of God and the heavenly White Rose, gave Luther a none too reliable hedge against further

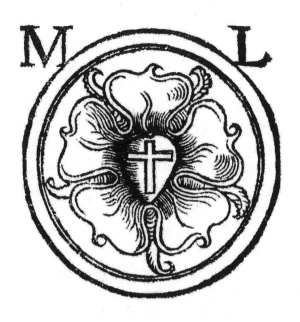

Luther's Coat-of-Arms, ca. 1530
(© The British Library Board)

pirating. At the conclusion of the second part of his then undated and unauthored Old Testament translation [*Das Ander teyl des alten Testaments*] both shields appeared with the inscription: "Let this symbol be proof that these books have passed through my hands, for many are today engaged in falsifying publications and ruining books."[58]

In the midst of three great events—the creation of the first vernacular Bible, the revolt of the German peasants, and the death of Frederick the Wise—Cranach and Luther met for still another history-changing event that arguably proved to be a greater milestone than any of the aforementioned. That event was the wedding of Martin Luther and Katherine von Bora on June 13, 1525.

The lawful marriage of a condemned, heretical monk and a renegade nun was a greater precedent and more fateful historical moment both for the age and for posterity. Although the marriage had little to do with the

reformers' Bible translations and ecclesiastical-theological reforms, it signaled a new domestic-social, moral-religious relationship between the sexes, one directly affecting the status of both genders forevermore. Great feats of scholarship, rebellions, and devastating wars had always existed, but never such a marriage as this. No longer an exclusive sacrament of the unified Western Christian Church, the estate of marriage would progressively fall under the jurisdiction of the secular state. As never before in the history of the Church, the conditions and regulations of *legal* marriage would henceforth be defined exclusively by secular authority rather than by clerical, this despite the latter's continued prominent role in the event.[59]

The small entourage attending the Luther–Von Bora wedding ceremony and feast in mid-decade consisted of the Cranachs, who were witnesses and stand-in family for Von Bora, Pastor Johannes Bugenhagen of Wittenberg, who conducted the unprecedented service, and local lawyer Johann Apel, who was there as a notary public for legal confirmation.[60] Uninvited, and reportedly unhappy about it, was the University professor of Greek, Melanchthon.[61]

Cranach actually played a larger role in that wedding than did Luther. He stood as both best man to the groom and the surrogate father of the bride, and in the aftermath of the marriage, he several times immortalized the famous couple in new "pair paintings." For this novice bride and groom, who throughout their adult lives had known only a single, religious, cloistered regimen, the Luther–Von Bora nuptials opened the door to a new world of companionship, intimacy, parenthood, and self-discovery, not just for themselves but for all clerical and lay lovers.

With their ecclesiastical and domestic reforms now well laid, after 1526 Luther and Cranach appear to have drawn back from each other, pulled apart by the powerful forces they themselves had set in motion. At the end of an intense five-year collaboration, western Christendom was becoming permanently divided into traditional Roman and new Evangelical Protestant confessions. At the same time and in the same places the Peasants' War left German peasants by the tens of thousands dead, and even more on the run in what became Europe's greatest popular uprising

against political authority before the French Revolution. These dual legacies also brought Cranach and Luther the enduring curse of Rome and the lasting distrust of the common man, powerful hatreds that are still palpable today among many historians who chronicle the era.[62]

For the remainder of his life Luther would henceforth be consumed by the oversight and defense of the new Lutheran Church. At the same time, the domestic, familial world he and Von Bora created in the cavernous "Black Cloister" that was their home gave them a welcome respite from the conflicted world outside, while bequeathing to posterity a true model of modern marriage. Also stung by the Lotter episode and the pirating of his Latin Bible, Cranach distanced himself from the publishing business and its consuming rancor. By 1528, he had largely withdrawn from the print business, leaving behind still another successful Cranach-Döring partnership.[63]

It is a commentary on an abiding travail of sixteenth-century court painters and entrepreneurs that Cranach had at this time increasingly to beg his royal patrons and remind the chronic art and book collectors to pay their lawful bills. Even Frederick the Wise required regular prodding throughout the 1510s.

A truly notorious tightwad was the powerful Duke Albrecht of Prussia, recently appointed grandmaster of the Order of the Teutonic Knights. An enthusiastic reader with whom the court painter had done business before, he wrote to Cranach in 1526 requesting that he send him "all the new and read-worthy books" recently released by Cranach-Döring and other publishers. Cranach collected and sent several barrels full, which were received in Königsberg in 1527 with an itemized bill for 183 gulden attached.

Two years later (April 1529) Cranach, then attending the Easter Fair in Leipzig, reminded the duke that his payment for the books sent was still overdue.[64] With the passage of still more years without payment, the duke nonetheless ordered and received books and paintings from Cranach without meeting any resistance.[65] Jumping ahead in this never changing story, in the year before Cranach's death (1552), the nonchalant Duke Albrecht, still greatly in arrears, requested that the son of his royal

trumpeter be admitted into the Wittenberg workshop for training as an artist. As Cranach was at this time in exile in Augsburg with Elector John Frederick, the request went to Lucas Jr. in Wittenberg, now the official owner and operator of the Cranach workshop. Although Lucas Jr. was well aware of the duke's dreadful history of unpaid bills, he nonetheless obliged the duke by granting the youth in question a three-year residency in the workshop![66]

The conclusion to be drawn from such patience and generosity is not Cranach indifference or cowardice. In both their billings and their artworks the Cranachs spoke truth to political power, but with measure. Behind the closed doors of the princes and the bishops, the option of blunt, brute force was always on the table. In the high end of the contemporary book and art worlds, entrepreneurial success required an indirect approach to the customer. In the court painter's world, all doors had to remain open, with patience, subtlety, and charm the only prods.

Whether it was Cranach Sr.'s drafting of the plans for Cardinal Albrecht's new foundation church and residence in Halle (1523–24) or the father and son's accommodation of Duke Albrecht's failure to pay his bills, the Cranachs instinctively knew there was little to be gained by breaking ranks and burning bridges with powerful princely and well-to-do customers.

In this regard, the Cranachs neither were, nor wanted to be, Martin Luther. In the unsettled religious world of the Reformation, church doors could not be left wide open. Together with Luther, but far more obligingly than he ever was, the Cranachs lived and prospered by their own pragmatic business calculus, which Luther understood but could not apply to the "business" he practiced. As he once put it, all one can do in an irreparably fallen world is to "darn and patch" the social and political fabric as best one can.[67] The world, he meant here to say, and all of human life within it, is inconstant and unreliable. For the Cranachs, weathering its vicissitudes was deemed to be the better and most viable course this side of eternity.

After the confessional battles of the 1520s, the Cranach workshop turned to mass-produced proven sellers, giving patrons and customers

exactly what they wanted. For the churches that meant familiar stories from the Old and the New Testaments; for well-to-do "gentlemen," classical and contemporary women in various stages of undress; and, for all ages and both genders, biblical stories and mythological tales.

THE CRANACH PHARMACY

In 1511–12, Cranach purchased his great house at 4 Market Square, where a pharmacy had earlier been operated. Around ten years later, in March 1520, he lobbied the elector to return the pharmacy permit to the present owner of the house, namely himself. On December 12 of that year the electoral court, then seated in Lochau, awarded ownership conjointly to Cranach and Döring. By that privilege they gained exclusive rights to sell a full array of widely demanded pharmaceuticals in both the city and its environs.[68]

For the owners, the privilege was an absolute windfall. Henceforth, they held a virtual monopoly on medications, from rare herbals and roots to an omnibus cure-all called tiriac. The privilege also licensed them to sell sugar, sealing wax, rat poison, beer, and sweet (that is, new) wine. Since the city's *Ratskeller* also sold wine in quantity, that item fell under city restrictions.[69]

The pharmacy quickly became the preferred supplier of prescriptions and provisions among the city's elites, beginning with the elector's family and court. It delivered its wares to customers daily throughout the year. By the legal constraints of the privilege, all other area merchants selling the same wares could market them only during the annual fairs and festivals in the city. Striking back at Cranach's monopoly, the merchants spread rumors of impure medications ("not concocted with the freshest ingredients") and accused the Cranach-Döring pharmacy of charging exorbitant prices.[70]

Although they were legal owners of the pharmacy, *lay* dispensing of pharmaceuticals was deemed a threat to the health of buyers and thus illegal. By being slow to hire a mandatory "university-trained and -sworn" apothecary to operate the pharmacy, Cranach and Döring also

invited more trouble for themselves. As the debate over the pharmacy heated up, Cranach asked the elector, to whom he was fortunately very dear, to investigate the allegations of mismanagement and unfair competition. With the elector responding quickly, a city-appointed committee gave the new pharmacy a clean bill of health.[71]

As with the art workshop and the publishing house, the new pharmacy expanded its product line to accommodate its customers' every taste and desire. It imported beers from distant regions, including a favorite from Coswig, near Barbara Cranach's Gotha home. After the death of her mother in 1541 and her father's exile from Wittenberg in 1550, the youngest Cranach child, daughter Anna, and her husband Caspar Pfreundt moved back into Cranach House at 4 Market Place. Taking the family pharmacy privilege with them, they continued to operate the pharmacy for twenty-seven years, to 1577, after which new Cranach generations took their place.[72] Through the female line, the Cranach pharmacy remained in the family until the nineteenth century![73]

Possessing so many useful skills and door-opening powers, Cranach would seem to have sat lifelong in the proverbial catbird seat. Unfortunately, in his own mind there were just too many clever "cats" stalking that bird. Like the predatory pirating of the Latin Bible, the attacks on the pharmacy were to him no less underhanded and invincible. In a bitter ending, he accused the city council of closing its eyes to the illegal poaching on his electoral book privilege.[74] Here, beneath the cold armor of the great artist and entrepreneur, one glimpses both his iron discipline and vulnerability.

5

Marketing Luther

Virtually from its start, the new University of Wittenberg (founded in 1502) was destined to become a powerful magnet for students and faculty across Germany. Among the new faculty recruits in its first decade was the novice Augustinian monk Martin Luther. Eleven years Cranach's junior and no less driven, he arrived in Wittenberg in 1508, the year in which Cranach garnered high praise from the art critics and received his serpentine family coat-of-arms from the Saxon elector. Lodging with the local Order of Augustinian Hermits, Luther taught Aristotle's moral philosophy in the university. By 1509, he had earned a bachelor's degree in Bible studies and become a *Sententiarius,* a master of Peter Lombard's twelfth-century *Book of Sentences,* the basic textbook for aspiring theologians.

In 1510–11, Luther sojourned with the Erfurt Augustinians before embarking with his brothers on an eye-opening journey to Rome. Returning to Wittenberg in the summer of 1511 more zealous than ever for reform, he earned a preacher's certificate, completed his doctorate (October 1512), and lectured on the Psalms. Armed with his new doctor's beret, he now put down roots in what he called "this little city in the wilderness."[1] In these same years (1511–12), Cranach was moving from *Schloss* to *Stadt,* also putting down roots in the city that still can be seen today.

During the early and mid-1510s, the two men were virtually isolated from one another, each single-mindedly pursuing his career in a different

venue, unaware that the hidden hand of history had put them on inter-secting paths. Not until later in the decade (1516–17) did the two men begin to seek each other out. By then, Cranach had moved himself and his workshop from the castle into the city proper, and Luther's early biblical commentaries and reform tracts had credentialed him as a theologian of the first rank. A possible early monument of their growing presence in the city, something each may have worked on at mid-decade independently of the other, is the striking *Ten Commandments Panel* (1516) that still reigns over the Wittenberg town hall.[2]

Whatever the bond between the two men in these early years, Cra-nach and Luther were not yet the brain trust that launched the Protes-tant Reformation. That history-changing union came in the wake of Emperor Maximilian's death in 1519, an event that created a dangerous, pan-imperial political climate for both religious and secular reformers. Moving to get his house in order, Frederick the Wise commissioned Cranach to create an official portrait of the rapidly emerging Luther, on whom the eyes of Saxony and its neighbors were turning. In 1520, three years after Luther's *Ninety-five Theses,* court secretary Georg Spalatin collaborated with Cranach to make their mutual friend, the now univer-sity professor Luther, a household face and name throughout the Holy Roman Empire of the German nation.

Both together and individually, directly and behind the scenes, these three gifted men would now set the agenda for the religious and political reforms so many were awaiting. On the contemporary political scene Spalatin was the elector's sharp eyes and ears. He conducted the regime's diplomacy, chronicled its past and recent history, and loyally acted as the elector's personal spiritual counselor.

Cranach was the oldest of the three and Spalatin (born in 1484) the youngest. By 1519, Cranach had served the court for fourteen years and Spalatin for seventeen. Although a comparative newcomer aloof from the court, the author of the *Ninety-five Theses* was the one Wittenberger the outside world longed to see, hear, and champion. To that end, humanistic scholarship and new art was put in the service of Protestant reforms. In the overlapping worlds of Cranach, Luther, and Spalatin, contemporaries

discovered the awesome enlightenment and powers of the German Renaissance and Reformation.

From the early years of their hires, Spalatin and Cranach had the ear of the elector, making them consummate court insiders. Although Luther was not directly privy to the court's goings-on, he, too, won the elector's respect and support, albeit at a distance. After 1517, Luther's attacks on the Roman Church put Wittenberg politically on a collision course with the papacy in Rome and the imperial Hapsburg dynasty in Vienna and Mechelen. His was the kind of fame that put a name on the elector's private watch list.[3] As a subject of a prince renowned for peace-making, the strident reformer was the city's, and increasingly the German nation's, lightning rod.

Between 1517 and his death in May 1525—the seven years that made the Reformation—a sympathetic but wary elector alternately reined Luther in and gave him his head. It was vital to the elector to keep the peace with his immediate subjects and surrounding neighbors, a great many of whom thought Luther to be a godsend and had embraced his reforms. Not a few of Frederick's most trusted advisers, Dürer and Spalatin, among others, believed with the German masses that Luther was "a true holy man of God." It was, however, also imperative that the Saxon regime maintain good relations with the Holy Father in Rome and the Holy Roman emperor in Vienna, both mighty European figures the emboldened Luther assailed at his own and the elector's peril.

Always cautious and credulous in religious matters, Frederick was quick to see the light of divine providence shining brightly in Luther. He was no less open-minded in dealing with other reputed men of God. In the mid-1520s, he would give a princely audience to the flamboyant radical Thomas Müntzer. On that occasion, Müntzer, then an early Luther follower, but soon to be the reformers' bête noire, presented his credentials to the Saxon princes as the *true* prophet of the age.[4]

After 1517 and throughout the early 1520s, Frederick became Luther's constant protector. He would not allow a foreign power—neither the Holy Father in Rome, nor the Holy Roman emperor—to harm his famous university professor. The wily elector knew instinctively that Rome's execution

of an extradited Luther, now a realistic papal scenario, would undermine his own authority and throw Saxony into civil strife, so strong had the appeal of Luther's reforms by then become. On the other hand, it was equally clear that a precipitous rejection of traditional church teaching and papal authority would also bring quick papal and imperial resistance.

Despite the difficulties Luther created for the elector, his intimacy with Spalatin and Cranach continued unabated, allowing the reformer to know virtually everything they knew. Strangely, the etiquette that governed their positions did not allow Luther to speak directly to the elector, even though each man was often on the mind of the other and occasionally directly in his eye. By protocol, Luther's communication with the elector went through Spalatin, while Cranach remained an informal go-between and protector of the interests of both. With such stellar support it was not surprising that the Wittenberg court, in 1518, made it clear to the outside world that it would not allow any harm to come to its famous reformer, nor would it stand in the way of his peaceful religious reforms.

As the storm clouds gathered over Luther, the court grappled with the best way to present the reformer to the surrounding Roman and imperial worlds. Much was now at stake. Throughout Germany and Europe the Saxon elector was recognized as the most powerful of German princes, also a man both the pope and the emperor relied on and were beholden to. Given the rumors about Luther, the great fear was that the outside world would conclude that the Saxon elector was blatantly sheltering a heretical movement. The situation also raised a big question for Luther: having roiled the Saxon waters with his stinging reformatory rhetoric and bold protestations, would the charismatic reformer now turn his hand to help his protectors calm them?

Although a celebrity since 1517, Luther's face did not make the cover of a German pamphlet until June 1519, and then only as an indistinct Augustinian monk swallowed up in his habit. The scene was taken from the Leipzig Disputation, where Luther defended himself against charges of heresy leveled at him by the Ingolstadt theologian John Eck. Fortunately for the

reformer, that less than flattering, cover image proved to be a true straw in the wind, anticipating Luther's debut on the larger European stage.[5]

THE ARTIST AND THE THEOLOGIANS

In the late 1510s and early 1520s, Cranach, more than any other colleague of Luther, understood in real-political terms what was required for a successful religious reform in present-day Saxony. Initially, Cranach distrusted the budding Reformation because of its infiltration by iconoclasts. The person he watched most closely was Luther's senior associate, the outspoken archdeacon of Wittenberg's Castle Church, Andreas Bodenstein von Carlstadt. Known in certain circles today as the "forerunner of the Protestant aesthetic," Carlstadt at this time led a successful movement to strip all decorative art and instrumental music from Wittenberg's churches. Mounting a pulpit steeped in traditional formality and doctrine, he preached wrecking balls to the congregation:

> Organs belong only in theatrical exhibitions and palaces of princes. Painted images hanging on the church walls are despicable. The idols painted on the altar panels are even more harmful and devilish.[6]

Before collaborating with Luther, Cranach had mentored Carlstadt in the art of religious propaganda, doing so with the intent of reducing his threat to decorative church art. Together, he and Carlstadt created the first Protestant broadsheet against Rome: a single-leaf woodcut titled *Chariots to Heaven and to Hell* (1519).[7]

Here, biblical Christians are seen obeying God's word as they travel steadfastly to heaven, while Roman Christians march pell-mell to hell under the guidance of papal decretals. This maiden theme became a staple of sermonic and artistic Protestant criticism throughout the 1520s. Following Carlstadt's and Cranach's lead, a generation of Protestant pamphleteers juxtaposed the pope and Christ, law and gospel, good works and grace, the bondage of the will and the freedom of faith, all to the detriment of the Holy Father in Rome.

Lucas Cranach the Elder, *Chariots to Heaven and to Hell*, 1519

(Photo: By kind permission from Das Evangelische Predigerseminar Wittenberg,

Bibliothek, Germany)

Cranach's first steps into Protestant propaganda reveal the crude extremes to which the reformers were prepared to go to win the hearts and minds of the laity. In earlier biblical artworks Cranach mustered charming, irrepressible putti to surround and protect faithful Christians. Under Carlstadt's "modern" influence, he literally barricaded the faithful with boxed, biblical verses. The goal was to seal all the open spaces into which a viewer's mind might independently stray and wedge an opinion of its own! The gospel of Christ was put forth solely for taking and believing, not for any lay discussion, debate, or challenge.

The specter of iconoclasm in the Wittenberg churches put the paint-
er's welfare more in jeopardy than the theologian's, as decorative church
art was a revenue stream for artists. Having reached out to Carlstadt,
Cranach also approached Luther strategically on the issue. He did so
because he knew better than both men that Frederick the Wise, a fabled
collector of art masterpieces and relics, was not about to allow Witten-
berg's altars to be stripped of their artworks. By raising the reformers'
awareness of the cultural and political fallout threatened by iconoclasm in
the churches, Cranach did both men a very large favor.

When in 1520 Cranach and Luther combined their talents in sup-
port of their overlapping causes, the initiative came from court secretary
Spalatin, who got the idea of bringing the two men together in common
cause from none other than Albrecht Dürer. Dürer had written urgently
to Spalatin expressing his fear for Luther's life, a looming problem since
Luther's *Ninety-five Theses* put Rome's inquisitors at his heels. From his
reading of Luther's writings, Dürer concluded that he was "a truly honest
man of God." He also found personal solace in Luther's writings after his
mother's death in 1514, and still again while coping with his delinquent
patron, Emperor Maximilian I, a prince who paid his art bills very slowly,
if at all. Upon his death in 1528, Dürer reportedly owned a copy of every
available, published work of Luther, not a few of them gifts from Spalatin.[8]

Dürer's letter to Spalatin lamented the absence of a public image of
Luther that justly acknowledged his life and work. Together with the
letter, Dürer included two copies of a recent copper engraving commis-
sioned by his patron and friend, Cardinal Albrecht of Brandenburg, a
work titled *The Little Cardinal* (1519). Dürer appears to have wanted to do
for Luther what he had done for the famous cardinal: namely, create a
positive image of the reformer for posterity.

Unfortunately, the cardinal was at this time persona non grata in
Luther's circle. The reformers never forgot that his was the hand behind
the marketing of the St. Peter's indulgence in Saxony, provoking Luther's
Ninety-five Theses and galvanizing the forces of reform in electoral Sax-
ony. As Dürer was preoccupied at this time and could not come to Wit-
tenberg to "immortalize Luther," Spalatin passed a copy of Dürer's *Little*

Cardinal on to Cranach. It was sent with the instruction to engrave an official court portrait of Luther, presumably one in the style of Dürer.

That "instruction" might well have raised Cranach's eyebrows. He had, after all, made copper engravings of the elector and other courtly worthies between 1506 and 1510, and was practiced enough in the medium, at least in his own mind, to be fully Dürer's peer. Also during the intervening years he had demonstrated his ability to improve upon figures borrowed from Dürer's artworks.[9] Add to those circumstances Cranach's growing friendship with Luther and the pair's bad memories of Cardinal Albrecht, and one finds a painter and a monk ready to act out.

In preparing for his portrait of Luther, Cranach first copied Dürer's portrayal of the cardinal in his own style, arguably doing so more from the spleen than from the heart. His 1520 pinewood panel of Albrecht did not project the manly Renaissance prince of the church that Dürer had etched the year before, in 1519. The viewer rather beholds "an apathetic youth" who, when placed side by side with Cranach's muscular, steely-eyed, angry monk Luther, appears to be the far lesser force.[10]

When in the nineteenth century Friedrich Engels viewed this portrait of Luther for the first time, he claimed to have seen in Luther's face "both the poet of the Marseillaise of the sixteenth century and the bloodthirsty enemy of revolutionary peasants."[11] Regrettably for the reformers this image of Luther was the very one Frederick the Wise could not authorize. Also at this time Frederick was in delicate negotiations with the emperor. All foresaw a royal disaster should the emperor catch a glimpse of so defiant a reformer.

Both rulers needed to see in the image of Luther a pliable spiritual leader, one the politicians could reason with and rely upon. Without such assurance, Luther's reforms were unlikely to gain the elector's support and take hold in Saxony. Nor would the Saxon and Hapsburg dynasties be able to live together in peace and trust.

Given the forces then at work, the court deemed Cranach's engraving of Luther too provocative for circulation. And by no means could it be showcased before the emperor at the upcoming imperial Diet of Worms (May 1521). Instructed to try again, Cranach did not disappoint his lord.

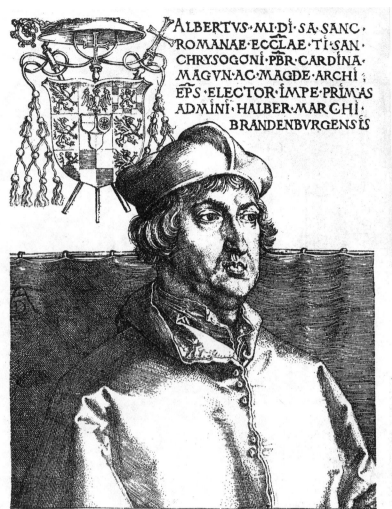

ALBERTVS·MI·DI·SA·SANC·
ROMANAE·ECCLAE·TI·SAN·
CHRYSOGONI·PBR·CARDINA·
MAGVN·AC·MAGDE·ARCHI·
EPS·ELECTOR·IMPE·PRIMAS
ADMINI·HALBER·MAR·CHI·
BRANDENBVRGENSIS

SIC·OCVLOS SIC·ILLE GENAS·SIC
ORA FEREBAT
ANNO ETATIS SVE XXIX
·M D X·I·X·

Albrecht Dürer, *Albrecht of Mainz*, 1519

(Staatliche Museen zu Berlin–Bildagentur;

Photo: Bildarchiv Preussischer Kulturbesitz/Art Resource, New York)

Lucas Cranach the Elder, *Portrait of Cardinal Albrecht von Brandenburg*, ca. 1520.
Painting, $19^{11}/_{16} \times 14^{3}/_{8}$ in.
(Mittelrheinisches Landesmuseum, Mainz, Germany;
Photo: Bildarchiv Preussischer Kulturbesitz/Art Resource, New York)

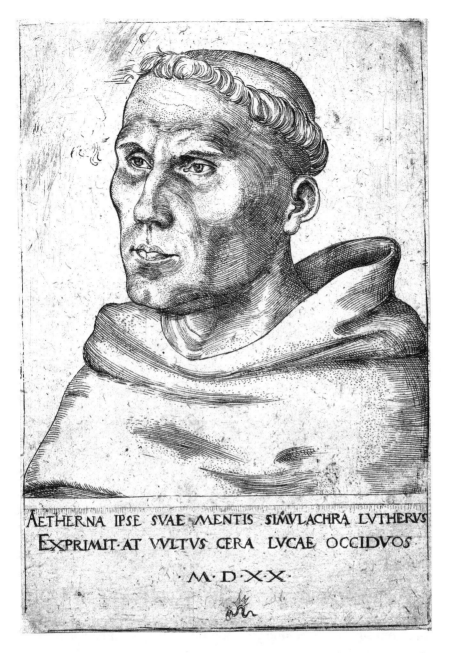

Lucas Cranach the Elder, *Martin Luther as an Augustinian Monk*, 1520.
Engraving, sheet: 6¼ × 4³⁄₁₆ in., plate: 5⅝ × 3¹³⁄₁₆ in.
(Gift of Felix M. Warburg, 1920 [20.64.21], The Metropolitan Museum of Art, New York;
Image copyright © The Metropolitan Museum of Art/Art Resource, New York)

In a second, "fail-safe" image, Luther appears confined within a traditional saint's niche, an open Bible in his hands, the image of a holy man with an open mind, obedient will, and god-fearing heart.

At the dawn of the Reformation, the above image became Luther's official court portrait. With its acceptance came a renewal of the elector's pledge to protect Luther and a cautious commitment to uphold his basic reforms. A year later contemporary artists Hans Baldung Grien and Heinrich Höpfer further softened the reformer's image by adding a halo and a dove to the niche motif.[12] Throughout the early 1520s, Cranach varied Luther's attire and multiplied his personae in an effort to enhance his safety. Profiling the reformer in an oversized, ballooning doctor's beret, he called attention to his learning and authority as a university professor empowered to interpret the Bible and fight heresy.

In a variety of representations, Cranach put forth a reformer for all seasons and social classes, while the slower responding Catholic apologists struck back with comparatively clumsy and overly subtle rebuttals in both words and images. An example is the artwork of Roman theologian Johannes Cochleaus and artist Hans Brosmer, who presented Luther to the Catholic faithful as a seven-headed false prophet.

Reading from left to right in this depiction, Luther wears (1) a doctor's beret, (2) a monk's cap, and (3) a Turkish turban, the last insinuating the false pretense of the first two. Moving on, he impersonates (4) a high churchman in a humble priest's cap. (5) A swarm of hornets crowns his fifth head, indicating a mentally ill or fanatical person. He next appears as (6) a jurist of the highest authority, while at the same time exposing himself as a complete fraud by presuming to judge the pope. (7) His final head is that of Barabbas, the convicted murderer whom the faithless mob at Gabbatha set free in the place of Christ.[13]

United by forces beyond their control, Cranach and Luther emerged from the early 1520s as close friends and colleagues in a common cause of reform. Having initially been attracted to each other by their complementary genius, their bond was deepened by new personal and familial ties. Cranach was quick to recognize in Luther the perfect ally for the coming confrontation with Protestant iconoclasm, while Luther was no less

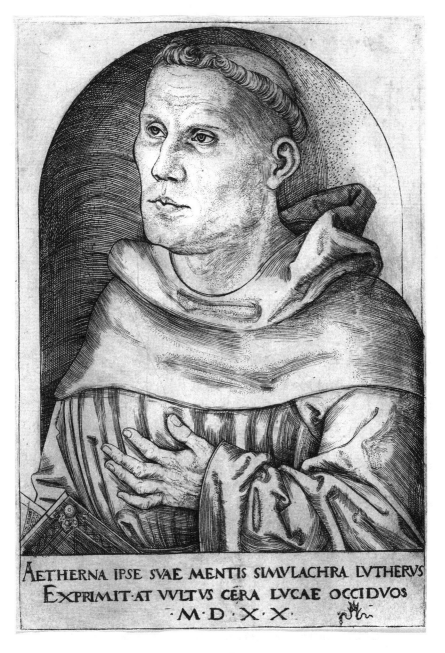

AETHERNA IPSE SVAE MENTIS SIMVLACHRA LVTHERVS
EXPRIMIT·AT VVLTVS CÉRA LVCAE OCCIDVOS
·M·D·X·X·

Lucas Cranach the Elder, *Luther in a Monk's Niche,* 1520

(Photo: By kind permission from Kunstsammlungen der Veste, Coburg, Germany)

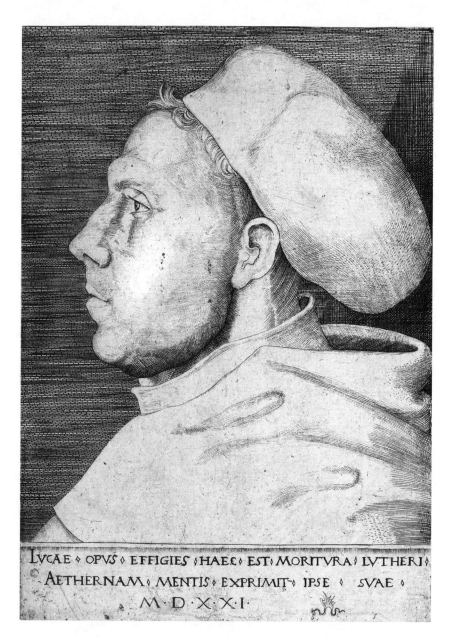

LVCAE ⋄ OPVS ⋄ EFFIGIES ⋄ HAEC ⋄ EST ⋄ MORITVRA ⋄ LVTHERI ⋄
⋄ AETHERNAM ⋄ MENTIS ⋄ EXPRIMIT ⋄ IPSE ⋄ SVAE ⋄
⋄ M·D·X·X·I·

Lucas Cranach the Elder, *Martin Luther (1483–1546) with Doctor's Cap*, 1521.
Engraving.
(Graphische Sammlung Albertina, Vienna, Austria;
Photo: Erich Lessing/Art Resource, New York)

prescient in picking Cranach as his secular guide and worldly mentor on the political fronts of Saxony, Rome, and Vienna.

Also pulling the two men together was their mutual skepticism and disillusionment with the received "wisdom" of reigning authority in the universities and churches. Long before Cranach collaborated with Luther, he independently exposed the icon of the "Renaissance man" to be a fiction, while Luther attacked scholastic and humanist notions of sovereign free will. Yet both men embraced the better works of Renaissance humanists and medieval scholastics, whose mastery of languages and philosophy opened new treasure troves of literature, theology, and art for the age's reformers.

After soundly condemning certain works of the scholastic philosopher William of Ockham, which taught salvation by good works, Luther still held to him as "my teacher." In doing so he was referring to Ockham's brilliant denunciations of reliance on reason's limited reach into the mind of God. Accusing Desiderius Erasmus, the acclaimed "prince of the humanists," of similar presumption and heresy, Luther went on to exploit his Greek edition and Latin translation of the New Testament, for his own rendering St. Jerome's Vulgate Bible into an eloquent German vernacular.[14] Along the same lines, Cranach recognized his debt to Dürer's religious art over a much longer and friendlier rivalry.

With regard to decorative art, Luther did not believe that images, whether painted on church walls or planted in human hearts and minds, possessed any intrinsic power to save or damn the human soul. He did believe that man was by nature an unrelenting image-maker, and to that extent religious images helped him receive and keep the faith. Suppressing the physical images only slammed a door on human nature, which was the surest way to turn previously harmless images into ungodly idols. Taken simply for what they were, religious artworks greatly aided Christian piety wherever they were displayed, and for that reason decorative art remained plentiful and prominent in Protestant churches and Luther's publications.[15]

When in 1534 the complete German Bible finally came off the printing press, 123 Cranach illustrations were integrated into its pages. As for his

own image, Luther allowed the court, through Cranach, to represent him as best served its interests. To make sure that such images did not stray far from the new theology, or become lost in a purely artistic medium, the two of them carefully collaborated on the new Protestant art.

Convinced that an imageless faith was impossible, a mere "self-effacing image" became the reformers' goal. By that was meant an image that repudiated both image worship and iconoclasm by directing the viewer to a transcendent reality no artwork could ever intrinsically be. What the eyes saw in religious art was not the divine reality itself, but the engagement of the viewer's heart and mind in visible, spiritual worship. Yet before the image was out of sight it helped the process along in the same way material, sacramental elements were believed to assist a more profound spiritual washing of the soul.

Thus did Luther and Cranach create an artistic style that allowed the congregation "to see through the image to its didactic charge," a transcendent experience of hearing and taking to heart unlike any other mundane oral, visual, or analytical process.[16] The reasoning here is that a proper religious image abides neither on wood nor on canvas, any more than the spoken gospel word remains on the lips of the priest. Working in tandem, Cranach's images and Luther's sermons conveyed the gospel message with immediacy, transparency, and power. And as they did so, the spirit-directed gospel message found a place within the faithful auditor-viewer, thereafter to become a living "frame" and a live "antenna" for the Word of God. It was from just such reasoning that Luther declared the ears to be "the organs of the Christian," and the mind and eyes true image makers.[17]

To the Reformation's great good fortune Cranach developed a flat, two-dimensional, ascetic image known as the "Wittenberg style." Its goal was to capture, barebones, the immaterial "aura" or inner "essence" of a subject beyond the visible, palpable "icon." Therein lay also the protection Luther sought for his gospel of faith. Adaptable to iconography as diverse as the nude body of Venus and the barely clad figure of the crucified Christ, the Wittenberg style conveyed painted images to the viewer with maximum effect, without either entrancement or image worship.

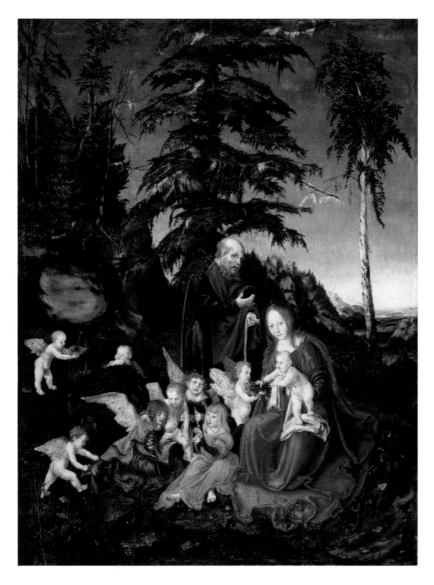

Lucas Cranach the Elder, *The Holy Family Resting on Its Flight to Egypt*
(Rest on the Flight into Egypt), 1504.
Oil on limewood, 27$\frac{13}{16}$ × 20$\frac{7}{8}$ in.
(Gemäldegalerie, Staatliche Museen, Berlin, Germany;
Photo: Jörg P. Anders, Bildarchiv Preussischer Kulturbesitz/Art Resource, New York)

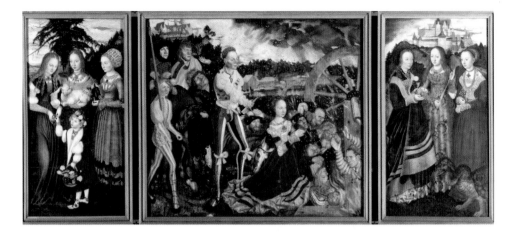

Lucas Cranach the Elder, *St. Catherine Altar,* 1506. Oil on limewood.
(Gemäldegalerie Alte Meister, Staatliche Kunstsammlungen, Dresden, Germany;
Photo: Bildarchiv Preussischer Kulturbesitz/Art Resource, New York)

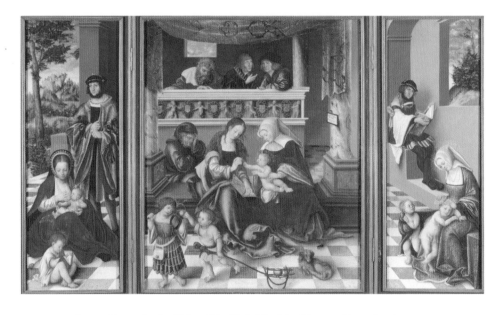

Lucas Cranach the Elder, *The Holy Kinship* (Torgau Altarpiece), 1509.
Oil on wood, 47⅝ × 39⅜ in.
(Photo: © Blauel/Gnamm/ARTOTHEK)

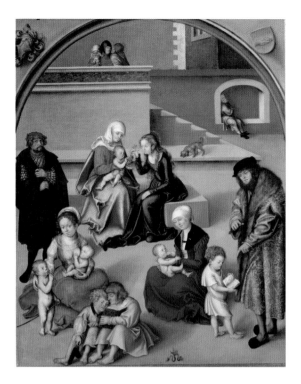

Lucas Cranach the Elder, *The Holy Kinship (With Self-Portrait of Cranach,
Standing with Red Cap, Portraits of His Wife, Left Foreground, and His Parents-
in-Law, Right)*, 1510–12. Limewood, $34^5/_8 \times 27^3/_4$ in.
(Akademie der Bildenden Künste, Vienna, Austria;
Photo: Erich Lessing/Art Resource, New York)

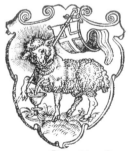

Dis zeichen sey zeuge / das solche bucher durch
meine hand gangen sind / deñ des falsche drucfēs
rnd bucher rerderbens / vleyssigen sich ytzt viel

Gedruckt zu Wittemberg.

Luther's Coat-of-Arms, 1524–30 (© The British Library Board)

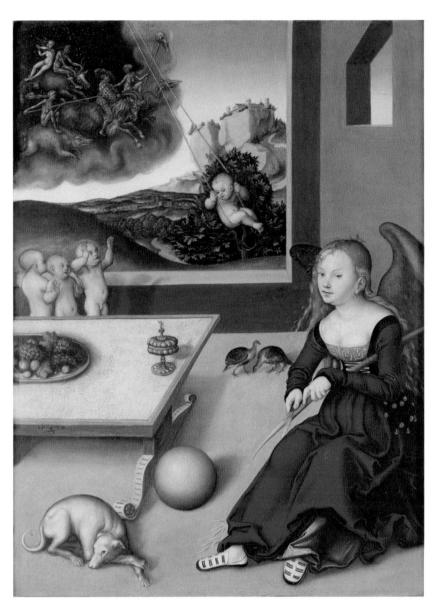

Lucas Cranach the Elder, *[Red] Melancholy*, 1532.

Oil on panel, $30\,1/8 \times 22\,1/16$ in.

(Musée d'Unterlinden, Colmar, France;

Photo: Bulloz, Réunion des Musées Nationaux/Art Resource, New York)

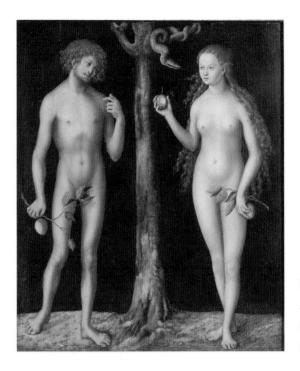

Lucas Cranach the Elder,
Adam and Eve, 1513–15
(Photo: Hans
Hinz/ARTOTHEK)

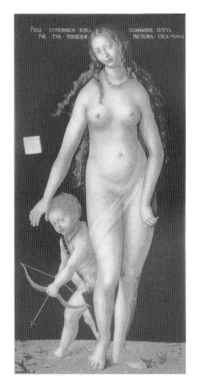

Lucas Cranach the Elder,
"Dark Venus" (*Venus and
Cupid*), 1509
(Hermitage, St. Petersburg,
Russia; Photo: Scala/
Art Resource, New York)

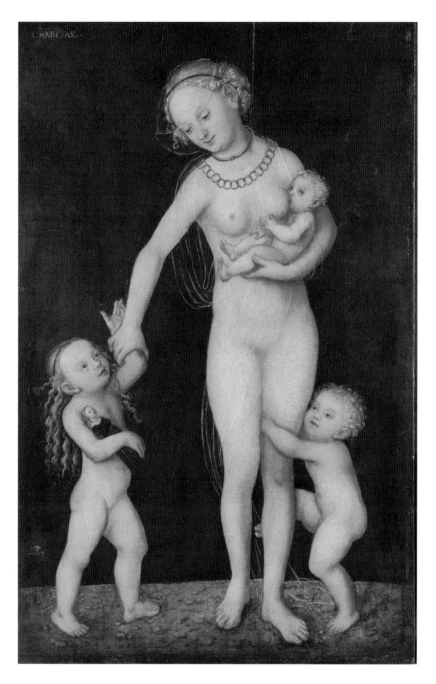

Lucas Cranach the Elder, *Charity*, 1537–50.

Oil on beech, 22³/₁₆ × 14¹/₄ in.

(Presented by Rosalind Countess of Carlisle, 1913, National Gallery, London, Great
Britain; Photo: © National Gallery, London/Art Resource, New York)

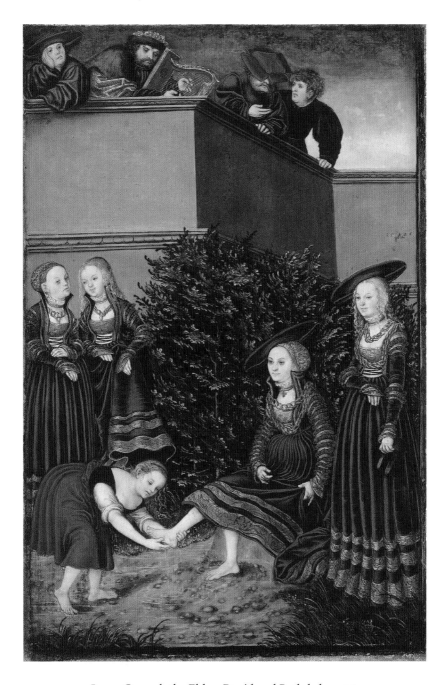

Lucas Cranach the Elder, *David and Bathsheba*, 1526.
Oil on red beech wood, 15 ¼ × 10 ⅛ in.
(Gemäldegalerie, Staatliche Museen, Berlin, Germany; Photo: Jörg P. Anders, Bildarchiv
Preussischer Kulturbesitz/Art Resource, New York)

Lucas Cranach the Elder, *The Wittenberg Altarpiece: The Last Supper and Scenes
from the Life of Martin Luther,* 1547
(Marienkirche [St. Mary's Church], Wittenberg, Germany;
Photo: The Bridgeman Art Library/Getty Images)

WORMS, WARTBURG, AND WITTENBERG:
LUTHER UNDER COVER

Although the posting of the *Ninety-five Theses* in October 1517 made Luther a man to be carefully watched, his life and reforms never hung more in the balance than in the years immediately following. Having survived potentially lethal interrogations in Augsburg (1518) and Leipzig (1519), he was summoned to the imperial Diet of Worms in 1521, there again to answer charges of heresy in the presence of the new Holy Roman emperor, Charles V. On April 17–18, 1521, after scrutiny of his writings, church authorities found him once again guilty as charged. When asked directly by the emperor to recant, he did not help himself: "My conscience," he said straightforwardly, "is bound by Holy Scripture and a captive of the Word of God. I cannot and will not recant anything . . . God help me."[18] On April 26 the emperor pronounced Luther, already a condemned heretic of the church, an outlaw of the empire as well, both capital crimes.

Having determined Luther's guilt, the imperial diet remained deeply split on the question of his fate, with no immediate decision emerging from the Imperial Cabinet. As the deliberations on the question proceeded, the emperor gave Luther a three-week safe conduct. The review of his release was Luther's enemies' way of buying time to arrange an assassination, which the wily Saxon elector interrupted with measures of his own before a plot could be hatched. Having received from Spalatin short notice of his impending "kidnapping" and "exile," Luther was soon in the hands of a friendly escort arranged by Frederick. At his first stop Luther sent an urgent message to Cranach: "I am letting myself be put away and hidden," although he did not yet know exactly where. The only other person immediately privy to the "abduction" was Wittenberg theologian Nicholas of Amsdorf, who had accompanied Luther all the way to the Wartburg.

Riding at full gallop into the unknown, a blustering Luther now contemplated his own martyrdom. He would later confide to Cranach that he would rather have died at the hands of "that tyrant Duke George"—the

rival Albertine Saxon ruler—than go secretly into hiding. However, once inside the doors of the Wartburg he made it his home for ten months (May 4, 1521–March 22, 1522), his every hour devoted to the translation of the Greek New Testament into German, not to return to Wittenberg until March 1522.[19]

Meanwhile in Worms, the Imperial Cabinet approved Luther's condemnation on May 8, 1521. By that date only a small minority of delegates were there to endorse it. On May 25, a rump of the original diet sanctioned the cabinet's unpopular judgment, which was now meaningless.[20] Still under both independent papal and imperial bans, Luther, at least on paper, was as imperiled as a person might be in the sixteenth century. Showing forth a faith and an ego as mighty as his God, he made light of his situation when opportunity allowed. Although the hearings in Worms had put him on death's doorstep, he jokingly blamed his predicament on the devil, finding consolation, as always, in dark humor and ridicule.[21] Asked how his interrogation before the emperor went, he presented the following summary.

> LUTHER: It was nothing more
> than this:
> EMPEROR: Are the books yours?
> LUTHER: Yes.
> EMPEROR: Will you recant them?
> LUTHER: No!
> EMPEROR: So get out![22]

With Luther now safe in the Wartburg, the Archdeacon Andreas Bodenstein von Carlstadt seized the opportunity to enact new, radical reforms in the Wittenberg churches. At this time all the reformers agreed that altar images were only painted wood, with no intrinsic powers over the souls of viewers. Carlstadt, however, dwelt on the danger such images posed to credulous simple folk, for whom he proposed a direct and draconian solution: perish all the idols in the churches and the souls of all the simple folk would be spared!

Foreshadowing the turmoil to come over decorative art in the

churches, Carlstadt conducted Holy Communion on Christmas Eve, 1521, and did so not in the prescribed clerical vestments, but in his everyday plain clothes. Instead of serving the consecrated elements of the Eucharist to the parishioners, he exhorted the congregation to "help themselves to the bread and the wine placed upon the altar."[23] A month later, to the surprise of many, the charismatic archdeacon persuaded the city council to remove sixteen of Wittenberg's nineteen decorated altars and strip the images from the remaining three.[24]

For Cranach, who had done his best to keep Protestant iconoclasts out the churches, it must have seemed as if one of Carlstadt's famous chariots had suddenly materialized in the city, broken loose, and gone careening through the streets straight to hell! A previous threat of iconoclasm now became harsh reality in Wittenberg, boding ill for the decorative arts and peaceful reforms in the churches.

Escalating the crisis was the arrival of three émigré preachers, the so-called Zwickau Prophets. In early December 1521, these roughhewn visitors from the revolutionary city of Zwickau joined Carlstadt in stripping Wittenberg's altars. By mid-December, Cranach was urging Luther to put his translation of the Bible aside, return to Wittenberg, and address the new turmoil Carlstadt was creating.[25] Although no transcripts of the ensuing discussions exist, one cannot doubt that Luther's eyes were now wide open to the peril iconoclasm posed to civic order and his own reforms. In earlier writings, calling for the end of monastic vows and private masses, Luther, too, had entertained a coercive cleansing of the churches, much as Carlstadt was now doing.[26]

Fearing for Luther's life once outside the safety of the Wartburg, Frederick denied him permission to return to Wittenberg under present conditions. Upon learning from Cranach the perilous state of his reforms there, Luther ignored the elector and returned to Wittenberg to join Cranach. For safety's sake during his days in the Wartburg, he had disguised himself as a *Junker* (a young nobleman), in which garb he also made his brief return to Wittenberg in mid-December 1521. There, in behind-the-scenes plotting with city council members, he and Cranach sowed the seeds of Carlstadt's removal.

When the two men met again in Wittenberg in early March 1522, it was to direct the city council in securing the churches from further iconoclasm. Between March 9 and 16, Luther addressed the crisis publicly and decisively in eight Lenten sermons. Taking to the pulpit, he accused the Wittenberg iconoclasts of "internalizing" idols in the heart by physically eradicating them from the eyes, thereby promoting the truest form of idolatry. Among the growing list of "idols" Carlstadt wished to remove were the traditional Mass, decorative art (painted panels and wall decorations), private confession, instrumental music and song, to which were added lay reception of the Eucharist in bread alone and the Friday ban on eating meat.

Luther deemed all of the above *adiaphora:* long existing, harmless practices that should be neither forbidden to nor forced upon Christians. These were "indifferent matters" to be acted upon freely as individual Christian conscience dictated. Unlike Rome's private, mercenary Masses for the dead, decorative art and instrumental music were not abominations unworthy of the churches. The present conflict thus called for persuasion, not compulsion, Christian freedom, not the forcible stripping of the altars.[27]

With the new year, Carlstadt left Wittenberg for Zurich, there to make common cause with a less controversial but equally fervent iconoclast: the Swiss reformer Ulrich Zwingli. Zwingli had stripped Zurich's Great Church of decorative art and whitewashed its walls. When the cleansing was done, only decorated glass windows and the portraits of worthy pastors interrupted the church's bare walls. Although a master of numerous musical instruments and unparalleled with the lute, the only "music" Zwingli would permit his parishioners to hear on the Sabbath was the congregation's recitation of the Psalms.[28]

After his stay in Zurich, Carlstadt gained a position in the tiny peasant parish of Orlamünde. There, in a grand iconoclastic gesture, he stripped *himself* of his "false images." Renouncing his professorial titles and privileges, he replaced his academic robes with peasant attire and led the life of a simple Christian layman addressed as "Brother Andreas."[29]

Carlstadt's expulsion from Wittenberg sealed the alliance between Cranach and Luther that had been evolving since 1520. In the aftermath of

victory, both men gained power, Cranach securing his professional stand-
ing as court painter, city treasurer, and freelance entrepreneur, while
Luther's authority over the churches only increased. For that success,
Luther owed much to Cranach, who throughout these dangerous years
kept the Reformation on a viable political course.[30]

Luther's powerful brief against the iconoclasts now targeted their
bullying of believers and usurpation of Christian freedom. A strong
Christian faith, he argued, could parry any immoral temptation an image
posed. By contrast, those who go about smashing paintings to escape
temptation only confirm their weak faith and the power images hold over
them. In a retrospective on the iconoclastic controversy written three
years later, Luther sided completely with the artists. He condemned the
iconoclasts for creating unnecessary disorder, threatening Christian free-
dom, and depriving weak Christians of the consolation of biblical images.
There is no such thing as an "imageless faith," he preached: "faith may,
will, and must have its images!"[31]

Among the age's image breakers, the continued presence of decora-
tive art in the churches attested the reformers' reluctance to speak truth to
power. Five centuries later, modern historians today still decry Luther's
and Cranach's "obsessive decoration" of the churches with the "icons" of
middling pastors and unworthy princes on the walls. Such artworks are
said to have fanned the fires of confessional rivalry, spawning religious
dogma, division, and wars, not to mention the wasting of Cranach's
genius on such trite political theater.[32]

As pedestrian and politicized as some of Cranach's court-
commissioned art may seem to be, that art's creation was the court paint-
er's main job. In tandem with the court historian and the court poet, his
raison d'être was to keep a current artistic record of Saxony's presumed
history dating all the way back to antiquity.

Far from lacking moral-political backbone in his dealings with the
court, Luther was arguably rather too quick to decry "bullying" rulers,
both princely and priestly, German and Roman. In letters, broadsheets,
and pamphlets he pummeled Frederick the Wise as bluntly as ever he did
the pope. In the early 1520s, he denounced the "tyranny" of the Saxon

princes in their buildup to the Peasants' War, and again for their failure to prevent Cardinal Albrecht of Mainz from endowing his great relic collection in Halle with still more godless, but lucrative, indulgences. At the time of the latter "obscenity" the cardinal's collection eclipsed Frederick's by roughly three thousand pieces. It displayed forty-two complete skeletons of saints and 21,441 separate saintly pieces, holy bones guaranteeing 39,245,120 years and 220 days of indulgence for all who venerate them and pray for the cardinal's soul.[33] As Luther deadpanned: "more godless idols for the simple folk!" When Frederick stepped in to impede Luther's denunciation of the cardinal's idolatry, Luther pulled no punches.

> I have hardly ever read a letter that displeased me more than your last. Not only did I put off my reply [to you], but I had decided not to answer you at all. To begin with, I will not put up with your statement that the "Sovereign Will" [the elector] will not allow anything to be written against Mainz, or anything that would disturb the public peace. I would rather lose you, [my] Sovereign, and the whole world with you than [to hold silence]. If I have resisted the creator [of these idols, meaning the pope], why should I now yield to his "creature" [in Mainz]? Your idea about not disturbing the peace is a "beaut," but will you also allow the eternal peace of God to be disturbed by the wicked and sacrilegious actions of that son of perdition [Cardinal Albrecht]. It's just not going to happen, Spalatin! It's not going to happen, Elector![34]

In December, with the sale of the plentiful Halle indulgence running apace, Luther wrote his forbidden letter to the cardinal, despite having been ordered by Frederick not to do so. In it, he denounces Germany's two most powerful electors: Frederick of Saxony and Albrecht of Halle, men second only in status and power to the Holy Roman emperor and the pope.

> If the "idol" [the new Halle indulgence] is not taken down, my duty toward divine doctrine and Christian salvation is a necessary, urgent, and unavoidable reason to attack Your Electoral Grace . . .[35]

As for showing backbone in response to Rome upon the publication of the papal bull condemning him as a heretic, Luther marched his students to the Elster Gate in Wittenberg and publicly burned it. In doing so he added to the fire the law books and decrees that had given the pope such powers.[36] Cranach also spoke truth to power by "painting power down"—putting tyrants in their place with pigment. His 1527 portrayal of John the Constant (Frederick's immediate successor) put an ugly face on a mean tyrant, a prince then popularly known best for his merciless treatment of peasants in both peace and war.

CRANACH IN HALLE, 1521–23: LUTHER BETRAYED?

By the early 1520s the Cranach workshop was a combined think tank and assembly line equipped to mass-produce artworks, religious and secular, for both sides of the growing confessional and political divide. Its largest commissions now came from Frederick the Wise and Cardinal Albrecht. A rival of the electoral Saxon dynasty and utterly loyal to Rome's agenda, the cardinal was the supreme secular-spiritual dignitary of the age. He ruled over the largest church province not only in Europe, but in the whole of Christendom. He was the consummate politician of the age, the most frequently painted prince of the century, with Dürer, Matthias Grünewald, and the Cranachs, Sr. and Jr., enlisted in his service. Despite his reputation as Luther's chief opponent, he proceeded cautiously against the popular reformer as he watched events unfold. Having given his permission to burn Luther's writings in 1520, he refused to put his signature on the Edict of Worms in 1521 that declared Luther an outlaw of the empire.[37]

Frederick the Wise was a match for Albrecht and other powerful rivals as long as he lived up to his name by confronting them wisely. That he was the most respected and able of the German princes became clear during the election of a successor to the imperial throne upon the death of Emperor Maximilian in 1519. Frederick chaired the seven-member electoral college and was also one of the leading candidates for the throne. After the first round of secret ballots, the electoral college

Workshop of Lucas Cranach the Elder, *John I (1468–1532), the Constant, Elector of Saxony,* 1533. Oil on paper, laid down on wood, 8 × 5⅝ in.

(Gift of Robert Lehman, 1946 [46.179.2], The Metropolitan Museum of Art, New York; Image copyright © The Metropolitan Museum of Art/Art Resource, New York)

reportedly chose Frederick by a four to three margin, his own vote putting him over the top.

Having thus proved his popularity in the confines of the electoral college, Frederick could not bring himself to accept the imperial crown. The reason was one all the electors knew before they assembled: Frederick, although ever so strong, simply did not command an army capable of enforcing peace and unity throughout the empire. Military strength was the sine qua non of imperial rule, and only the Hapsburgs could meet that imperative. In the end, Frederick and his fellow electors reported a unanimous vote for Charles of Spain, who succeeded his grandfather as Emperor Charles V.[38]

Just how different the course of German history and the Reformation might have been had Frederick become emperor is a story awaiting a good contrafactual historian. Upon Charles's ascension to the imperial throne German lands could draw two certain conclusions: the Hapsburgs' political streak as rulers over the empire was far from done, and traditional Roman Christendom would not be diminished without a war like no other.

In this electric atmosphere Cardinal Albrecht and Luther were fully aware of the consequences, yet each labored under the delusion that one side could still win over the other and preserve German and European unity. As late as 1525 Luther cherished the hope that Albrecht would join the Protestant reformers. To that end he wrote an open letter requesting that the cardinal take a wife, thereby embracing Evangelical reforms at least to that pleasant extent. For his part, the cardinal sent Luther and his bride a gift of twenty gulden on their wedding day, evidently stringing out his "courtship" of Luther.[39]

Cranach was a close friend and major influence on both men. He had taken commissions from each in previous years, fulfilling their wishes exactly as requested, no questions asked. To the extent that it worked, this triangulation owed everything to Cranach, who, unlike Albrecht and Luther, harbored no religious, artistic, political, or business "taboos."[40] From his choice of friends (Luther and Albrecht), confessional associations (Protestant Wittenberg and papal Halle/Rome), and commissions

(altarpieces and portraits per both confessions' wishes), Cranach was ever the willing, reliable middleman.

In the same years that Cranach and Luther worked hand in hand to implement Protestant reforms, Cranach was also developing master plans for the construction and decoration of Cardinal Albrecht's combined foundation church and private residence in Halle. The new construction was intended to be a "Roman castle built for siege . . . a mighty fortress to obstruct the spread of the Reformation beyond Wittenberg." Its creation made the cardinal and Halle greater threats to Saxony's confessional peace and reforms than the pope in Rome.[41]

Before taking his workshop to Halle, Cranach prepared 186 drawings for Albrecht's new church and residence, 142 of which were devoted to a Saints-and-Passion cycle, a great showcase of traditional piety for the Halle faithful. From those drawings Albrecht made the final selections and hired additional artists to assist the Cranach workshop's implementation of the plan. A senior Cranach protégé, Simon Frank, moved to Halle and directed the execution of the project, thereafter to remain in the city as the cardinal's new court painter.

Methodically, the Cranach workshop filled the new church's interior with traditional Catholic artworks and sculpture conforming to the cardinal's wishes. A recent exhibition (2007) of the remains of the original Halle collection has reminded viewers that the Reformation came powerfully to Halle in 1540, exposing Albrecht's "mighty fortress" as a paper bulwark. Forced at the time to flee the city, the remains of the cardinal's new art and sculpture found a safe home in Catholic Aschaffenburg.

Having personally drafted the Halle plans and overseen what has been called the largest new construction project in 1520s Germany, Cranach's presence in Halle was not as evident as that of his workshop. His artistic talents, however, can still be seen in the remains of the Halle-Aschaffenburg collection, particularly its *Magdalene-Altar.*

Despite Cranach's low profile in Halle, biographer Andreas Tacke found it remarkable that the cardinal was "helped by none other than Cranach," moving him to conclude that scholars should no longer speak of a "Lutheran," or a "Catholic" Cranach. Given the painter's ability to

accommodate patrons and projects on both sides of European Christendom, Tacke rather declared Cranach a true confessional hybrid, able and ready to create "artworks with a *reform* theme and artworks with a *traditional* theme."[42]

Other scholars have seized more critically upon what they perceive to be the painter's professional and confessional "promiscuity," for want of a better term. After viewing an exhibition at the Royal Academy in London, the historian of English Catholicism, Eamon Duffy, spoke for many viewers when he questioned the spiritual depth of the person he dubbed "Luther's PR Man." Cranach, he inferred, was a wobbly believer, a modern secular man, comfortable with any and all religious confessions, and, Duffy feared, a man who put credence in none of them at all.[43]

Ever dutiful to his craft and patrons, Cranach approached Albrecht's commissions strictly as a vendor, never as a catechumen. In the two opposed confessional venues, Protestant Wittenberg and Catholic Halle, Cranach and his workshop satisfied the demands of both sides without hesitation or demur. The new Halle church and residence was not Cranach's first commission undertaken solely on behalf of Rome, nor would it be his last. Another nearby Roman patron he obligingly served was Duke George of (Albertine) Saxony, acclaimed by some to be Luther's "most significant opponent" among the German princes.

After all was said and done the artist's traditional iconography in Halle was left to speak for itself. As intended, it contested Wittenberg's teachings and reforms, particularly Luther's signature theology of justification by faith alone. To the extent that the new Halle church and residence expressed the painter's true convictions, a low-profile neutrality appears to be as far as the so-called "Catholic Cranach" would allow himself to go.

As for Halle's new role as a Catholic bulwark against the spread of the Reformation from Wittenberg, that goal was entirely the cardinal's to pursue. For their part Cranach and Luther continued to publish artworks in the slanderous vein of their first (1520) pamphlet exposé of the pope as the Anti-Christ. However, nothing approaching that level of religious aggression emanated from the workshop's Halle project. If Cranach was a

"hybrid," or ecumenical, confessional artist, he was one with a very strong Protestant bias. Having earlier been party to vile attacks on Rome, his Halle commission did not in the aftermath answer Rome's continuing broadsheets against Wittenberg in kind. Both at the time and thereafter, the Cranach workshop took a strictly-business approach, one that attested his loyalty to Luther and arguably best served his reforms.

If the cardinal was able to contain his qualms about Cranach's advancement of Lutheranism in Wittenberg, and Cranach could accommodate the cardinal's traditional iconography in Halle, Luther was not about to join the two of them in the middle. However much he may have wanted the cardinal to join the Protestant camp, he always remembered that it was the cardinal's surrogate, John Tetzel, who had rushed the St. Peter's indulgence into Saxony in 1517. Three years later (September 1520), learning that Albrecht was offering a new indulgence to all who revered his relic collection in Halle, Luther howled his displeasure in a derisive, initially unpublished pamphlet titled *Against the "Idol" in Halle*.[44]

In the mid-1540s, the Cranach workshop created a near replica of the Halle Saint-and-Passion-cycle for Albrecht's nephew, Elector Joachim II of Brandenburg, whose royal residence was in Berlin. Before the cycle's completion, the success of the Reformation had forced Joachim to make concessions to the cure of souls within his lands. Unlike Albrecht's retrenched Halle church built in 1523, Joachim's new Berlin church accommodated the changing times by adopting an Evangelical order of worship. And on every Sabbath, surrounded by the old Roman iconography, he and his parishioners received the Eucharist in both kinds.[45]

Rather than setting confession against confession, as happened in early-1520s Wittenberg and Halle, the replication of the Halle Saint-and-Passion-cycle in Berlin was an example of the budding religious tolerance born *in*voluntarily from the Reformation's success. By the 1540s, numerous cities and lands were pragmatically making room for minority confessions. In doing so, they secured their communities' long-standing social and political unity, a bond at least as strong as the religious, which a majority of laity agreed should not be sacrificed simply because of new plural confessional loyalties. Here, long before the Enlightenment, in dis-

creet and transparent actions, minority Protestant congregations found ways to worship peaceably among majority Catholics, while the latter also discovered ways to accommodate their minority Protestant neighbors.[46]

In such displays of religious tolerance, the 1540s confessional and art worlds appear to have adopted Cranach's "hybrid approach" to religious art in the 1520s. By the 1540s not a few German cities were finding ways to present two kinds of religious services and accompanying religious art. From such religious tolerance modern political and social tolerance would progressively grow.

Although Cranach, the artist of the Reformation, walked prominently on the Roman side of the German confessional street in 1520s Halle, it is doubtful that such "ambidexterity" is any verification of a religiously "Catholic Cranach." Throughout the 1520s and into the 1540s, the Cranach workshop continued to produce Protestant altarpieces and portraits of Christian heroes and heroines, whose faith was firmly aligned with Luther's. Over a lifetime that artwork documented a definitive, Protestant history of salvation extending from the Garden of Eden to the Last Judgment, all clearly attested and viewed in artworks such as the Wittenberg and Weimar altarpieces.

Although Cranach's early artworks have been praised as his very best, when compared with his later Protestant and private-sector work (1520–47), they rather pale, not in quality, but in numbers, variety, and depth of engagement. It was in these middle and later years that Cranach and Luther seized the European stage by dint of their mixed artistic and theological "dynamite." The result was an enduring partnership of original art and sermonizing that blew apart the late medieval political-religious and domestic-social worlds. Whether or not Cranach believed with Luther that they were doing the Lord's work, their achievements over two-plus decades remain undiminished. For those who today love, or hate, either man, or both men, it neither exaggerates nor belittles Cranach's artwork to say that his intervention on behalf of the Reformation was the linchpin of both men's success and historical reputation.

6

Gospel Art

CIRCLING WAGONS

In the aftermath of the iconoclastic controversy, Cranach and Luther collaborated on the images that would fill the Protestant churches. Both men had an interest in keeping decorative art and portraiture prominently on display. For Cranach, church art was the painter's staple, while for Luther, art gave the gospel sermon immediacy and the church a captive audience. Addressing lay conscience in tandem, Cranach's images and Luther's sermons filled lay memory with the audio-visual experience of worship, thereafter to be reprised in the solitude of their own hearts and minds, after the eloquent words in church have fallen silent and the altar panels are out of sight.

As the congregation engaged the new decorative art, it ceased to be the idolatrous dead wood and canvas the iconoclasts decried. The integration of art, sermon, and song contextualized and softened the grizzled images of crucifixion that lay at the center of the Lutheran service of worship.[1]

From first portrait to last, Cranach endowed neither Luther nor any other worthies with superhuman traits or radiant divinity. One rather finds in his representations of Luther a non-heroic monk with a large chip on his shoulder, and a mission impossible barring divine help. The renderings of the other reformers reinforced the conviction that art cannot capture and convey the true essence of a human soul any more than it could convey the divine reality of God.

To make his point, Cranach embedded a "disclaimer" of the artist's powers in an early portrait of Luther. It read: "Luther himself [*Lutherus ipse*] projects the eternal image of his spirit; his mortal features are only the wax of Lucas [*cera Lucae*]."[2] Therein lay a lasting reminder of the limitations of artists and their art. The artist can make an impressive pigmented figurine, but only the living, human subject and his Maker know the true reality within. Despite the caution, Cranach's images gave art a powerful role in the promotion of the new gospel. In the history of Christianity religious images had a long, divisive run. While agreeing that artistic images were not the selfsame Holy Spirit bearing grace, Cranach's altar panels put the gospel message before the viewers' eyes as effectively as Luther's sermons planted it in their ears. With the coming of the Reformation, the majority of Protestant laity embraced images in the churches and vocal and instrumental music in the new service of worship.[3] Expanding with the age of print and commerce, the new art world was irresistible to the laity, despite brief spells of iconoclasm. The same laity who embraced religious art in the churches also welcomed music there. Other laity at this time were defiantly eating forbidden meats on certain days, and welcoming lawful wives into the parsonages of the new, non-celibate clergy. Always the bell-ringers of history, the laity kept the new faith alive and up to date.

Exonerated and secure, Protestant art found a safe haven in the Wittenberg churches. Convinced that Cranach's images opened wide the eyes and minds of the congregation, Luther made sure the artworks were plentiful and prominently there. Whether seen on altar panels and church walls, or racing through the streets and countryside on single-leaf broadsheets, Cranach's art reprised the old and new biblical world as that of no other. With such a great bounty of original religious art, the Cranach workshop resettled popular biblical figures into present-day Saxony as if they had always lived there and were soon to be joined by their counterparts from classical antiquity. With such resources Luther could appear at the Last Supper with all twelve Apostles, while Cranach Sr. and Jr. waited on the tables of the famous time-travelers.

The mixing of the biblical past and the Christian present bound

theology and history tightly together in an enduring Christian fantasy. This triumphant art had its humble beginnings in Cranach's and Carlstadt's 1519 traffic jam of wagons transporting Evangelicals back and forth on the road to heaven. Two years later (1521) it was Luther's turn to look over Cranach's shoulder as the two men prepared their second Protestant broadside for the pope in Rome: this time a twenty-six-page Passion pamphlet exposing the failings of the Holy Father in Rome, under the ominous title, *The Passion of Christ and Anti-Christ.*

In this, their first collaborative artwork, Cranach and Luther juxtaposed Christ's godly behavior during his brief years on earth with the ungodly behavior of Roman popes for over a millennium. Accompanying every scene are biblical and canonical commentaries, courtesy of Luther's colleagues, Philipp Melanchthon and Johannes Schwertfeger. Each scene presented the pope transgressing what Christ faithfully always observed, implying that the pope was not the self-proclaimed vicar of Christ on earth, but the Anti-Christ in a clever disguise.[4]

Throughout the 1520s, the chemistry between Cranach's art and Luther's theology succeeded beyond their fondest hopes. In Cranach, the reformers had an artist who could portray sin and redemption, death and the devil, hell and heaven, with the same force and clarity as Luther did from the pulpit. With his brilliant altarpieces, portraiture, and fantasy worlds came also raw gutter propaganda, hugely grotesque figures, and lethal beauty. From the start, the crude, the rude, and the nude were among Cranach's imagistic foot soldiers serving in the great confessional war against Rome. Cranach the businessman dispassionately pursued a client's cause, or painted a figure dear to his heart, even though that cause, or figure, was not always dear to himself. On the other hand, he could, with the same equanimity, defame a cause, or a person, despised by a patron, even though he did not find either the cause or the person odious to himself. That, too, was demonstrated at the times when he helped Luther craft damning woodcuts of the Holy Father in Rome.

Over a lifetime, no other painter of the age marketed product, material or spiritual, in greater volume, or with greater success than Cranach. He created novel artworks in virtually every genre and on subjects

Lucas Cranach the Elder, *The Passion of Christ and Anti-Christ*, 1521.

Woodcut, 8 × 11¼ in.

(Hamburger Kunsthalle, Hamburg, Germany;

Photo: Christoph Irrgang, Bildarchiv Preussischer Kulturbesitz/Art Resource, New York)

never, or seldom, seen before. In acknowledgment of those achievements, biographer Berthold Hinz, at his own initiative, bestowed upon Cranach "the crown of entrepreneurial versatility."[5]

For ambitious contemporaries seeking recognition in Saxony's "Who's Who," Cranach's sketchbook, or better still a painted Cranach canvas, were the places for one to be prominently seen. Compromised Catholic patrons such as Cardinal Albrecht and Duke George of (Albertine) Saxony were quick to contact the painter for just those reasons.

Although for many he was a lion of a man, Luther was also known to be putty as well as wax in Cranach's hands, an intimate who never passed up a court request for a Cranach "shoot." Such malleability blessed their bond of friendship and joint devotion to their common "liege lord,"

Frederick. Whether the pair's relationship was more happenstance than calculation, by going the full distance with the workshop, Luther entrusted his reforms to Saxony's most powerful public relations firm. In doing so, the great reformer gained in the bargain: a mentor who made all the difference in the Reformation's survival and success.

DISENCHANTED ART?

Between Cranach's 1520 etchings that introduced Luther to the greater European world and the completion of *The Wittenberg Altarpiece* twenty-seven years later (1547), celebrating Luther's career in the year after his death, Cranach had been an absolute godsend for the reformers. Those twenty-seven years were the Reformation's most formative and Cranach's most productive. Not everyone cheered them on or perceived in their success the birth of religious pluralism and individual freedom, the first and lasting steps toward modern tolerance and enlightenment.

In two mighty books separated by ten long years (1993–2004) of work, art historian Joseph Koerner subjected the art world of the German Renaissance and Reformation to what many believe to be its most incisive critique.[6] In both studies, the author juxtaposes Dürer with Cranach and Luther, and the European Renaissance with the German Reformation, celebrating the prescience of the former while arguing the backwardness of the latter. For both contemporary and modern art historians, Dürer's *Self-Portrait* (1500) has long been acclaimed as the artistic peak of the European Renaissance: "a kind of Copernican revolution of the image . . . a radical break from the past . . . a threshold of a new era . . . the epiphany of the artist at the start of our [modern] age."[7]

Like Dürer's Dürer, this romanticized Dürer is also larger than life. In sync with the famous transcendental portrait of the artist, Dürer is celebrated as the man who freed the contemporary art world from its long bondage to the church. From Hans Baldung Grien, who paraphrased Dürer's works to caricature them, to his persistent rival Cranach, who borrowed from those works to improve upon his own, all German artists of the era stood in Dürer's shadow and debt. As Koerner describes:

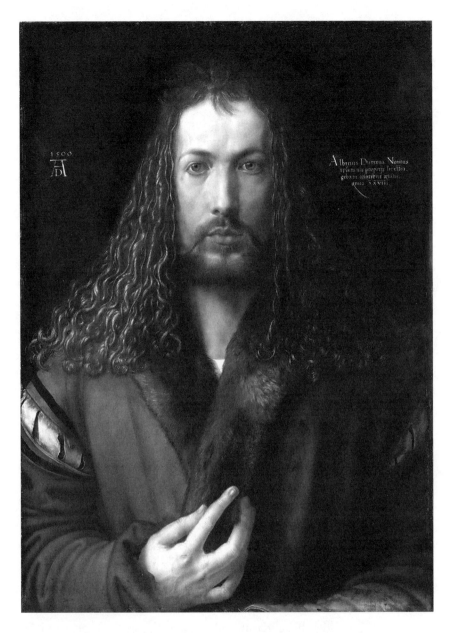

Albrecht Dürer, *Self-Portrait (in Fur Cloak)*, 1500. Oil on board, 26⁷⁄₁₆ × 19¼ in.
(Alte Pinakothek, Bayerische Staatsgemäldesammlungen, Munich, Germany;
Photo: Bildarchiv Preussischer Kulturbesitz/Art Resource, New York)

All the great German artists derived . . . their whole conception of what it means to be an artist from Dürer, who combined in his figures the most perfect elements from various classical and natural models, submitted them to strict canons of proportion and geometry, and perfected the result through a painstaking process of construction, simplification, and reconstruction. . . . Probing the nature and proportions of many people, Dürer took a head from one, a breast, an arm, and a leg from another, and so on through all the parts of the body, front and back, omitting none [thereby creating] a beautiful human figure. [As the first artist in Germany] to theorize and codify an ideal of the beautiful as the aim of art, his images affirmed the familiar [Renaissance] discourses on the dignity of man.[8]

Such praise suggests a Dürer who sounds more like the "Martin Luther" of the late medieval art world. Given Dürer's reverence for Luther, which was praise beyond anything Cranach left behind, Dürer, to all appearances, would have welcomed the association.[9] Making the case that individual artistic genius is the primal force in art, Koerner challenged what he calls "rigorously historicist art history." By those phrases he means the historian's one-sided interpretation of the artist and his art in strictly *historical* terms, an approach that is said to "rob art of its imagistic meaning" and the artist of his own god-given "self-fashioning."

The real worry here, however, is that the historian hogs the scene with his own rules of interpretation, and in doing so reduces the artist to a passive tool of the zeitgeist, a cipher of his age rather than profound, artistic genius preening. In the hands of the historian, according to Koerner, "the artist becomes just another sinner and his artwork a revelation of the age's dominant culture: a usurpation of the artist's freedom to behold and represent the world as he, and only he, sees and chooses to represent it."[10]

One may ask whether a rigorous "artistic" depiction of history could ever be as true to life as the historian's reconstruction of it from below. For all the blind spots of professional historians, they would still seem to hold an edge over the inspired artist. In the pursuit of a chosen subject the historian follows history's "hidden hand"—the larger collective forces

that create, shape, and dominate entire eras. By comparison, the lone artist's images are highly individual and subjective, powerful, but more narrowly framed. As Koerner puts it, "*art is an image of its maker* . . . [and] all images . . . are at bottom displays of the artist."[11]

Like genius itself, "great art" often eludes time, place, and a penetrating scrutiny, secure in a transcendent world of presumed rare breeds and high experiences. It was Cranach's abandonment of such presumption that moved modern critics to accuse him of committing a mortal sin against the Renaissance. A pragmatic artist deeply engaged in the workaday world, both his courtly and privately commissioned artworks served communication, education, entertainment, protest, propaganda, piety, and wealth creation. There are few signs that he ever viewed his artwork as being divinely inspired, or just confined to his own personal human world, although he was not above promoting himself in his artwork.[12]

Both contemporary and modern critics have portrayed Cranach as a man without a religious confession, or any other principled mission in life.[13] Yet his job as court painter was to celebrate the Saxon regime and inspire the cure of souls in Saxon churches, a dual political and "evangelical" calling, in which Cranach acquitted himself superbly and quietly. To fault him for "reworking art to make it fit the new faith of Luther" overlooks his reverence for Providence in history and nature, which always works in mysterious ways, underestimating the calling of the "handmaidens" whose work is also never done.[14]

Looking back to Cranach's first collaborations with Carlstadt and Luther (1519–20), the painter gives every appearance of having found in them a cause worthy of art's accommodation to history. By comparison with the stakes in the 1510s, those of the 1520s were far more challenging and consequential, the issues that truly changed the world. Yet, already in the early years, the maverick painter and monk confronted princes and popes, exposed mercantile and ecclesiastical greed, sifted critically through traditional church teachings and practices, and even deconstructed the vaunted "Renaissance man"!

So transparent were the new artworks that some came with embedded viewer instructions to aid and abet the winning of souls in the cities.

While the purpose of such "tutelage" was to gain the viewer's attention and inculcate a prioritized message, it also seemed perforce to deny the viewer the freedom of his own judgment and the joy of his own discovery. More interesting to contemporaries than to modern laity was this practice of embedding edifying messages in artworks. Modern critics saw immediately a medieval "sacrifice," or "deadening," of the image in an over-zealous attempt to capture wavering lay hearts and minds.[15]

In the aftermath of the iconoclastic struggle (1519–23) and the advent of new confessional divisions, mainstream artists survived their brazen-ness, bad taste, and zealotry; decorative art increased on both altar panels and church walls.[16] Betwixt and between the sermons, hymns, and sacra-ments, the personal lives of the needy in the congregation were woven into the service, there to be dramatized and resolved by the new art as well. *The Wittenberg Altarpiece,* Cranach's supreme achievement in the genre after thirty years of altar building, brought together a preeminent cast of biblical visitors, who joined in with the local worthies at the Last Supper. Such homespun cameos presented real-life dramas that were immediately embraced by the congregation. Assisted by these representa-tions, the congregants took comfort from and gave thanks to God for the kinder moments of life. In St. Mary's Church they listened to the sermon and meditated on the new art, as the congregation made peace with God on the Sabbath.

For the modern critics, the great offense was subjecting art to theol-ogy, or to any other discipline, altogether a rude constraint of the artist and his calling. When, under Luther's influence, Cranach bent his art-work to Protestant reforms in some of the best paintings of the age, can it really be said that Cranach was coercively "sacrificing his artistic persona" and turning his artworks into Protestant "billboards"?[17]

If Cranach ever begrudged his collaboration with Luther, there is precious little evidence of it. Compared with the discontent of his early courtly chores (1510–12), one finds scant dissatisfaction in his collabora-tion with his Protestant friends in the early 1520s. Given the many Cra-nach altarpieces that retold the stories of the Old and New Testaments, not to mention the portraits of revered rulers and clergy that hung on the

walls of St. Mary's Church, one can only conclude that the congregation believed that a select group of their contemporaries, like the biblical saints of old, had earned a rightful place in Wittenberg's house of worship. In such commemorative artworks the viewer reassuringly beheld the hidden hand of God and the visible brush of the court painter.

Far from being "despoiled" by Luther, Cranach was more his protector and mentor. That was especially the case in such life-and-death situations as the iconoclastic controversy, the Diet of Worms, and the Peasants' War. Throughout all three crises, Cranach kept Luther aware of history's tolerances and limits.

ART AND REVOLUTION

In the mid-1520s rumors of war between the "common man" and the princes replaced the fears of stripped altars in the churches, although the Reformation's growing success kept both specters alive throughout the century. In a bold move to broaden the authority, popularity, and civic scope of his reforms, Luther made overtures to two long-oppressed and powerful groups: the German peasants and the German Jews.[18]

Behind his olive branches the reformer's political calculation was patent. Beginning in 1520, Protestant propaganda juxtaposed the "honest peasant" to the "depraved priest." By such flattery Luther hoped to win the masses to his side in an alliance that promised greater leverage for his reforms. At the same time Luther took a hard line with the German princes and lords, whose oppressive treatment of the simple folk was visible to all. Having conceded to rulers their God-given sovereignty over bodies and properties, Luther condemned their law-breaking and "tyranny" and denied them any authority whatsoever over human minds and souls.[19]

In a more surprising overture in the same year Luther admonished lay Christians not to scorn the German Jews, but rather befriend them. That urgent request appeared in a pamphlet titled *Jesus Christ, Too, Was Born a Jew* (1523). Although unaccompanied by any credible plan, Luther had hoped to convert "some, perhaps many, Jews" to reformed Chris-

tianity. As with his endeavor to bring the peasant masses into the Protestant camp, any success in converting Jews to Christianity would have been interpreted by contemporaries as a providential vindication of the Protestant cause.

Luther's throwing of the dice, perhaps recklessly, was not successful. Contemporaries then and modern critics still today accuse him of raising peasant expectations to the point of revolt and Jewish hopes to the point of conversion, without having any true intent to stand in the trenches with them. Elsewhere authorities at this time were harshly punishing so-called godless artists who supported the peasants' revolt while trafficking in sexual artworks deemed pornographic for the age. There is, however, scant evidence that mainstream reformers suffered any great loss of freedom, income, or life by addressing the peasant cause.[20]

If anything, artists of the stature of Cranach and Dürer asserted their artistic freedom even more boldly in the aftermath of the Peasants' War. In addition to artworks in support of the common man, Cranach's nude repertoire featured alluring women from both classical and Christian antiquity, not to mention quite a few of Wittenberg's finest ladies and nymphs.

In the aftermath of the Peasant's War Dürer sketched and published in the year before his death (1527) a seemingly sympathetic memorial to the defeated peasants, accompanied by an implicit condemnation of their betters. Appearing in a primer on perspective in art, the scene presented an agrarian-themed column depicting a lone peasant sitting atop a chicken coop slumped over dead with a sword thrust prominently through his back in the classic iconography of betrayal.[21]

Modern scholars interpret Dürer's monument as wholly sympathetic to the peasants and condemnatory of the princes. A closer look, however, suggests a graphic version of both Luther's and Dürer's disgust with both sides of the conflict. When Luther warned the princes of the growing threat of revolt, he laid the blame directly at their feet, reminding them that tyranny always begets anarchy and anarchy tyranny—a vicious, but just, cycle of divine punishment for tyrants and anarchists.[22] Once

Albrecht Dürer, *Monument to the Peasants*, 1527
(Photo: By kind permission from Museen der Stadt Nürnberg, Germany,
Grafische Sammlung)

engaged in war, neither side was any longer open to advice. Washing his hands of both as it were, Luther left it to "divine justice" to apportion blame and inflict righteous punishment on those who defy the eternal laws of God and man.

Fortunately for Cranach and Dürer the Peasants' War was not an event one commented on at one's peril, and both presented their free and honest evaluations of the conflict with impunity, as Luther had done much earlier. As for the message of Dürer's "Memorial" to the peasants, it is to be noted that at this time, all of the artist's closest friends and associates emphatically rejected and condemned the peasants' war. During the months of the peasants' defeat, Dürer passed the time painting portraits of the Fugger family, Europe's renowned bankers, and also the ruling family of Margrave Casimir of Brandenburg-Ansbach, who blinded dissenting Anabaptists before exiling them from his lands.[23]

THE MALADY OF GENIUS AND THE REMEDY OF FAITH

From the works of ancient philosophers and medical authorities Renaissance humanists received the doctrine of the body's four ruling humors, or temperaments. According to that ancient lore, the human body was directly influenced by, and impulsively responsive to, the stars and the planets. A celestial-humoral conjunction was believed among the intellectuals to be responsible for health, illness, behavior, and also creativity. According to Italian authorities, all men of intellectual distinction suffered intermittently from the fourth humor, melancholy, also known as black bile. The fifteenth-century humanist Marsilio Ficino described the melancholic state thus: "While the rest of their body remains idle [melancholic persons] develop great cerebral and mental activity, for which reason those stricken are likely to produce mucous [phlegm] and black bile [melancholy]."[24]

Independently, Dürer (in 1514) and Cranach (between 1528 and 1532), created figures of melancholy based on such beliefs. They did so under the influence of humanism and Luther's new theology, asserting the roles of

God and the devil, astrology and the occult, in opposing artistic representations of the so-called "malady of genius."

Dürer followed the Italian humanists in believing melancholy to be a "divine pathos" visited upon gifted authors and artists. For the afflicted it was a tormenting "passage" that enabled genius to plumb new depths of knowledge and create profound works of literature and art. In 1512, Dürer, always ready to draw comparisons with the divine, praised melancholy as "an idea of spontaneous interior creation, almost comparable to divine creation." In the year of his death (1528), his long speculation on the subject ballooned into "a theory of selective [artistic] synthesis in which God played . . . the inspiring source [within the soul of the stricken artist]."[25]

Such theorizing was flattering for those who believed they were eligible for such divine attention, notwithstanding its accompanying pain and suffering. Dürer encouraged belief in a divine connection between God and melancholy when he insisted that future painters be "educated in the fear of God and the desire to receive grace and subtlety from the Divine."[26]

In stark contrast, Luther nowhere in his reading of the Gospel found the Christian God visiting such ungodly alienation from self, world, and deity upon his creatures, which melancholy was said to inflict. Rather than a divine pathos, Luther declared the "malady of genius" to be the devil's indiscriminate seizure of souls, both exalted and meek. An affliction like no other, melancholy filled the mind with a chorus of demons and witches, also grotesque human figures and beastly animals, a malady that tested the resilience of human will and faith in God.

Cranach painted his first personification of melancholy in the year of Dürer's death (1528), taking his departure from Dürer's 1514 engraving of the figure of melancholy. Entitled *Melencolia I,* the figure has every appearance of Dürer's own persona. Here again, we find Cranach reinterpreting, visually and philosophically, another Dürer artwork created fourteen years earlier.[27]

In the brooding face, blazing eyes, and stiffened body of Dürer's

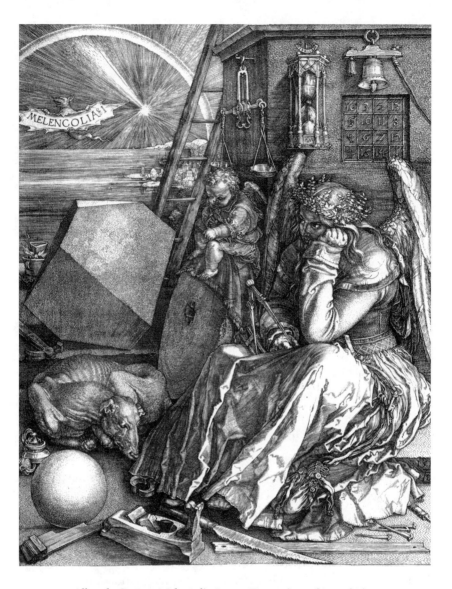

Albrecht Dürer, *Melencolia I*, 1514. Engraving, $9^{5}/_{16} \times 7^{3}/_{8}$ in.

(Kupferstichkabinett, Staatliche Museen, Berlin, Germany;

Photo: Jörg P. Anders, Bildarchiv Preussischer Kulturbesitz/Art Resource, New York)

figure, Cranach saw a snapshot of the great artist himself in the physical and spiritual throes of melancholy. As he studied the scene, his big question was also that of Luther: If such abandon and loss of self is the price of a work of genius, how can melancholy be the work of God? In Luther's theology, such cruel abstraction of the artist's inner self could not be traced to the true Christian God. Agreeing with Luther, Cranach traced melancholy directly to the netherworld of the devil, whose role in the scheme of things is always to stifle and destroy. In this case the target was human genius.

Dürer's figure of melancholy has also been said to resemble a pen-and-ink drawing of his young wife Agnes, sketched twenty years earlier when she was nineteen (1494). At first glance, the figure gives every appearance of being masculine, hence imprinting a self-portrait of the artist himself rather than the generic feminine figure contemporary artists depicted melancholy to be.[28] By contrast, all of Cranach's personifications remain emphatically feminine.

That Dürer engraved his representation in the year of his mother's death (1514) was no coincidence. At that time he was struggling to regain the meaning of life, which he claimed to have found in Luther's early theological writings.[29] The burdens he then carried may be seen in this dark portrayal. Encircling the feet of the hulking figure of melancholy is an array of weights and measures, instruments and charts, the tools of those adept in the sciences of math, geometry, architecture, and astronomy, in whose ranks Dürer had good standing. Every living creature in the scene is frozen in place. A seemingly serpentine sack of bones on the floor becomes upon closer inspection a large, sleeping hound. Overhead, a plump, winged putto sleeps upright on a stone wheel reiterating the figure of melancholy.

The scene suggests utter failure and the approaching pall of death. No longer are the towering wings and the laurel wreath of victory vital signs of the Renaissance man. The figure's wings are folded and tucked away as if never to take flight again. And the laurel wreath, no longer green, joins the residue of defeat.

One source of melancholy's plight is suggested by the ominous bat

that hesitates in the background sky, a classical oracle of punishment and despair born of pride. Waving a titled banner in midair, the bat identifies the scene as the "first stage of melancholy." Dürer's figure confronts his enemy only to find his own prideful self! Believing melancholy to be a divine state of genius, the self-assured could expect a safe outcome.[30] The comet shooting across the background sky, a classical omen of either imminent doom, *or* salvation, gave the gifted afflicted at least half a hope.

In the present moment of the scene the figure of melancholy is another stymied genius discovering the limitations of mortal humans. "Bondage of the will" is a subset of the malady, whether the stricken recognize it or not. The Renaissance debate over such bondage had begun in earnest after the new humanist image of man challenged the old biblical anthropology. In that confrontation, not a few humanists and scholastics rushed to affirm the freedom of the human will in both transcendent and mundane matters, including the individual's God-like ability, on his own, to defeat mortal sin and death, and command the divine reward of eternal life.[31]

Addressing the malady of melancholy fourteen years after Dürer's portrayal of it, Cranach presented three consistent figures over four years, two of them known as *[Orange] Melancholy* (1528) and a third as *[Red] Melancholy* (1532), the names taken from the ladies' attire. It was not coincidental that Cranach's first rendering of the figure was in the year of Dürer's death (1528).[32] These representations may be seen as Cranach's last confrontation with and farewell to Dürer, who, sadly, would never again challenge and thrill him with a new work of art.

Interestingly, three years earlier (1525), Luther also had made his peace with the man who had for so long cast a larger-than-life shadow over him: his earthly lord and master, Frederick the Wise. Political and religious barriers remained between the two men lifelong, and they apparently never conversed directly with each about the issues dividing them, even though each was often on the mind of the other, and occasionally directly before him. Protocol required all communication between them to be by mail and otherwise cleared by court secretary Spalatin.

On two special occasions, however, Luther did speak directly and clearly to his lord Frederick, who, however, at both times did not so much

as open his mouth. There was an acceptable reason for it: Frederick was now very dead. Luther first spoke directly to him in his funeral sermon in Castle Church, and thereafter spoke more words to him at the burial plot, when he read the last rites over the great elector's body.

CRANACH'S MELANCHOLY

Borrowing infrastructure from Dürer's 1514 figure of melancholy, Cranach re-created the scene in his own style and along the lines of Luther's theology. In an exchange with his brainy colleague Philipp Melanchthon, a man who embraced traditional astrology and the four humors' theory, Luther had looked him straight in the eye and proclaimed: "Your philosophy is crap."[33] For Luther and apparently Cranach too, the "science" of astrology was deemed to be a mask and rationalization for the devil's assault on faith in God, which Cranach, faithful to Luther's teaching, portrayed as wild, demonic hordes on night flights over the Saxon landscape in search of vulnerable Christians.

Cranach portrays his figures of melancholy as being trapped in a more ambivalent world and facing a more subtle and sinister enemy than does Dürer's comparatively passive and isolated melancholy figure. In Cranach's representations Dürer's dark, oppressive atmosphere is relieved by bright lighting and happy colors. Gone, by and large, are the ponderous tools and arcane symbols that surrounded Dürer's figure, now reduced to a playful, mobile, childish few. In the foreground the viewer beholds a scrubbed and tidy, almost antiseptic room cordoned off from the dangerous outside world. Beyond the rampart of the secure room in which the putti play, beastly animals and even beastlier humans fill the scene with the pagan lore of witches and warlocks. Outside the safe room, that terrible horde travels within a dark, billowing cloud that blights the landscape as it passes over. Before them in the distance is a desolate castle retreat that provides no safe haven from the galloping horde.

Cranach reinterprets and complicates Dürer's dramatis personae. Where Dürer's single putto is clothed, aloof, and tranquilly stretched out upon a millstone, Cranach's multiple putti run naked through the safe

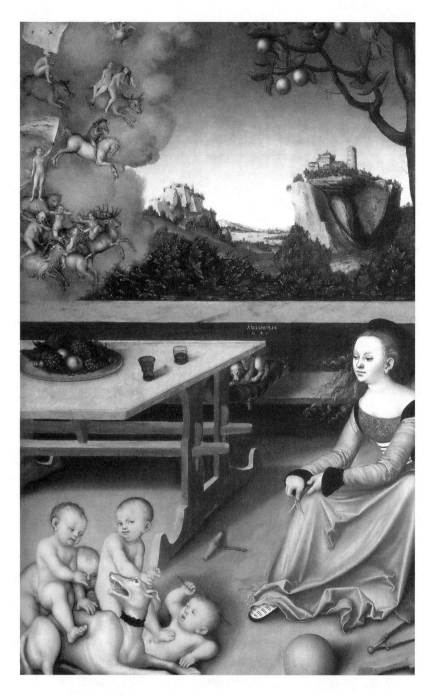

Lucas Cranach the Elder, *[Orange] Melancholy*, 1528.

Oil on panel, 44½ × 28⅜ in.

(Photo: © Hans Hinz/ARTOTHEK)

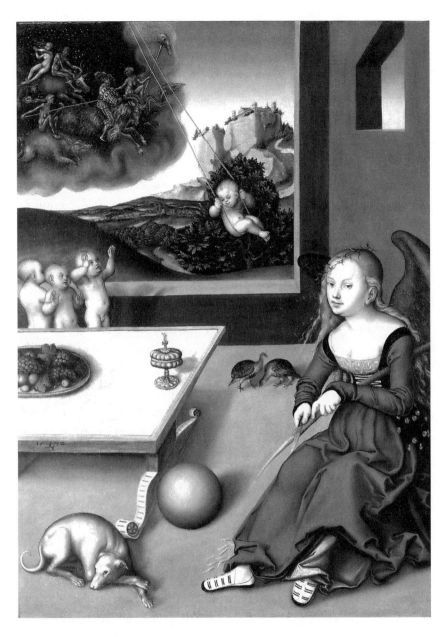

Lucas Cranach the Elder, *[Red] Melancholy*, 1532. Oil on panel, 30⅛ × 22 1/16 in.

(Musée d'Unterlinden, Colmar, France;

Photo: Bulloz, Réunion des Musées Nationaux/Art Resource, New York)

room, unencumbered and never spent. Composed and alert, brave and curious, inquiring and raucous, these zestful babes are immune to melancholy's inertia and gloom. Their comparative good cheer pervades and disinfects the safe room. Rebutting Dürer's sleeping hound, Cranach introduces a frisky, tail-wagging alternative who joins the infants in play as if the hound was one of them.

In all three renderings, the figure of melancholy is self-preoccupied and shows no interest in anybody or anything in the room—except for a curious pile of sticks. The putti come and go as they please, and remain as impervious to her as she is to them. She sits quietly and strangely alone, there, but not there. Dazed, aloof, and lost in a dream, she hangs on to reality by monotonously whittling away her mysterious stack of sticks.[34]

The 1532 portrayal of *[Red] Melancholy* displays a fetching young woman dressed in red velvet and wearing flat, white, seemingly "occult" slippers with curious black stripes. There is the suggestion of an entranced seer locked in a spell. Her neckline is cut low, showing cleavage, to which her bodice adds a flash of bright orange. Her long, golden, curly hair pulsates with a force of its own, tracing a halo around her face before cascading down her back. Like the "guardian loincloth" of the crucified Christ, Red Melancholy's hair animates an otherwise entrapped, motionless figure, suggesting that she still has the hope of redemption and salvation.[35]

Red Melancholy is also immersed in a life-and-death struggle. Her slanted and glazed-over eyes stare directly at the viewer, while partridges drill the floor with their beaks. At an immeasurable pace, a Christian heart is being coaxed by the Prince of Darkness into the netherworld. Whoever or whatever she may be, in this very moment, her mind, heart, and will are being bound over to the nefarious powers that have bewitched her. The fragile wreath of tiny, new-green, needlelike leaves that sit ajar on her head suggest a fraudulent crown of thorns: a mockery of Christ and a pretension to occult powers of her own. She is all dressed up, but has only one place to go, if she loses the present struggle for her soul.[36]

The clue to her true identity lies in the sticks she robotically shaves to a sharp, or vanishing, point. In the 1528 scenes the stick she holds in her hand has been whittled down to perhaps a foot in length, while the one

she holds in the 1532 scene is roughly her own height, suggesting that the original length of the sticks was spearlike.[37] Since none of Cranach's melancholy figures interact with the putti in the room, one may conclude that the sticks are there neither for discipline nor for play.[38]

Much longer sticks can be seen in the hands of the female creatures who have concealed themselves within the dark cloud visible from the inner room, as it drifts across the background sky. A bestial-faced noble-man dressed in black and gold (the electoral Saxon colors) and sporting a feathered crimson beret leads the malevolent horde on its wild ride. The "Prince of Darkness" sits astride a large goat flanked by two witches, one riding on a great serpent, the other a wild boar. Each holds a long wooden spear perhaps twice her height. Another holds high an impaled skull of a horse, as if it were the horde's banner or coat-of-arms. A pale young woman shares the back of a bull with a grotesque male figure, as the two of them bring up the rear: all lost souls bound for the netherworld.

Can we pinpoint the true identity of melancholy? Although Cranach's figures dress in the brightest and cheeriest of colors, their inner selves remain in the grip of the devil. None of these trapped souls are internally what they appear to be, which is also true of their infernal lord and master. The entranced, monotonous shaving of the witch's stick is a prep-aration for the day when she will join, or rejoin, the wild horde. Mean-while, the honing of her lethal skills keeps her captured mind fixed on her dark master.

For Luther, melancholy was the devil's wallow, his preferred medium for snatching honest souls: "a melancholy head is the devil's bath [and] the devil likes melancholic natures and makes good use of them."[39] Like the celebrated Renaissance man, the divine pathos of the gifted genius was for the reformers another false, flattering Renaissance fiction. Under their bright velvets and shiny silks, Cranach's figures of melancholy are souls in extremis, their only hope of release from such bondage the clarity of the Gospel and the stamina of their faith. Thus Luther's exaltation to the faithful: "No matter how artfully he dresses, to see through the devil is to defeat him."[40]

Luther opined about melancholy from his own personal experience,

recalling his own "great temptation and fright [*Anfechtungen*]" that once put him "beyond all consolation and leaving him barely able to breathe."[41] He describes his years as an Augustinian monk as having been trapped in a vocation of rote, monotonous actions similar to those of the figure of melancholy: the repeated phrases, circular gestures, self-preoccupation and scrutiny, the eyes and mind always glued to the "Leader": activities that, taken all together, make the human soul easy prey for the devil.

> Being a monk, I wished to omit none of the prayers and often overtaxed myself. . . . I assembled my hours for an entire week and sometimes even two or three. Sometimes I would lock myself up for two or three entire days at a time, with neither food nor drink, until I had completed my breviary. My head became so heavy that I could not close my eyes for five nights. I was in agony and totally confused. . . . So confined was I in this practice that the Lord God had to tear me violently away from self-torture.[42]

As Luther taught and Cranach illustrated, a melancholic soul is neither a free child of God, nor yet the devil's hopeless captive. It is a soul bewitched, hanging in the balance, soon to be given over completely to the devil, or to be set free by faith in the grace of God.

As for the best defenses and remedies once enticed and entrapped, Luther recommended a healthy diet, bright clothes, cheerful company, music, and song. How loyally Cranach took that advice may be seen in the fresh grapes and new wine decorating Frau Melancholy's table and the exuberance and security of the infants playing around it.[43]

For the brave at heart, Luther also recommended profane language and gestures against the devil, who, being a "proud beast," can be readily driven away by insult. For starters, the moment he tempts you, "fart in his face!" And if his "milk thieves" (*Milchdieben*, the devil's indentured witches) turn up at one's house and hex the butter churn so that they may steal the milk and make butter for themselves, one must immediately "drop one's pants and crap in the churn!" Luther credited this defense and remedy (that is, ridicule and a bold sense of humor) to Wittenberg pastor Johannes Bugenhagen, who claimed it had never failed him.[44]

HUMANKIND'S BEST FRIENDS

In some of his most original and endearing artworks, Cranach portrays children, both angelic and human, as the best companions and helpmates of God and man. In his painting titled *The Holy Family Resting on Its Flight to Egypt* (1504), angelic children serve up fresh-picked strawberries and spring water to the baby Jesus and his parents, while their adolescent counterparts serenade the holy family with pastoral music. A full three decades later, Cranach again assembled the infant children for another popular and novel scene: *Christ Blessing the Children* (1530), which made a serial run through the 1530s and '40s. The scene depicts a throng of infants and their older siblings as they wait patiently in line to be taken from the arms of their mothers and placed in those of their Savior, where they are blessed and clothed in the spiritual armor of God.

Between these two fabled artworks, Cranach again summoned the same children for his late-1520s and early-1530s *Melancholy* paintings, there to play the supporting roles in a scene of hellish evil. By comparison with the entrapped, melancholic adults and a Protestant laity grimly preparing for the confessional wars of the 1530s and 1540s, Cranach's infants show themselves to be resilient souls and the best tonic for adults. By dint of their innocence, curiosity, trust, and spontaneity, the infants elude the devil's wiles and dodge the tyrant's sword, as they nonchalantly find their place in the world. And they could do so, Luther believed, because, they were not yet consumed by selfish human reasoning: impulsive, yes, but not yet calculating only their self-interest. Their direct approach to life made them immune to both astrology and bewitchment. And unlike the adults on scene, the innocent babes know instinctively to keep their distance from sullen women who obsessively sharpened sticks!

At story's end, they line up fearlessly to take their turn swinging into the world of the wild horde, ignoring the encroaching dark cloud and its darker passengers. The bold putto in *[Red] Melancholy* swings ahead of the cloud, as if to challenge the bestial riders to a race. He has no intimations of peril, nor any eagerness to rush back to the safe room. Perhaps he senses the danger within to be just as great as that without. With their

hands raised high, the boys show their readiness to take a turn on the swing, devil take care! The sole girl in this foursome waits quietly behind the boys, her arms folded as she studies her options. Is this a moment of childish indecision, or one of prescient intuition? Or do her decisions perhaps suggest the caution and security of a confident, trusting faith?

7

Cranach's Women

THE MORAL-DOMESTIC FRONT

I n the aftermath of the Peasants' War social order was slowly secured and the reformers' long-debated theological agenda firmly set in place. In the churches altar panels were sharing the walls with new portraits of local authorities and other worthies. Luther's *Prayer Book* and *Catechism* gained high visibility in both church and home, henceforth to be the staples of new lay piety in the developing churches and households.

During the war and the postwar recovery demand for new altarpieces slackened. Addressing a declining revenue stream, the workshop increased its production of artworks popular with the laity in other genres. Modern scholars see the workshop's traditional theological-religious communication with the laity being overrun by secular-profane currents in both church and society. Was the house of Luther being built before its foundation had been laid? From another perspective, the drama in the air was playing directly into the reformers' new, prioritized moral-social agenda.

Placed in tandem with an already popular repertoire of classical, biblical, and contemporary women, the new artworks addressed urgent issues of moral-domestic-family life. Having long focused on the authority of the pope in Rome, the Protestant lights were now turned on the relationships between men and women, husbands and wives, parents and children, altogether the lay Christian's duty to town, church, and state. Therein, the domestic themes of love, courtship, and marriage, sex,

progeny, and family, were being thoroughly aired. At the same time the workshop's "nude repertoire," long popular with gentlemen, now gained traction with the lay viewing public at large.

With Luther launched on the new venture of Christian marriage, and Cranach's new art eager to oblige, the perfect match appeared at the perfect time: a whirlwind of complementary moral-religious, social-domestic, old-time sermonizing and lay truth-telling now settled upon Saxony. For four decades the laity were inspired by the reformers' sermons, pamphlets, and books, which were accompanied by the artists' woodcuts, engravings, and paintings, courtesy of the Cranach-Döring media mill.

Looking back to the late-fifteenth century when life began to bloom again after decades of pestilence and war, large numbers of celibate clergy and religious demanded the freedom to marry and raise families of their own just as the Christian laity had always done.[1] Pressured by the deep human need for companionship and intimacy, parenthood and legacy, both the laity and the clergy took matters into their own hands. The immediate result was increasing numbers of out-of-wedlock families and widespread clerical concubinage. When it could do so, the Roman Church averted its eyes from the dismal facts of domestic life, and when it could not, it punished lay cohabitation and out-of-wedlock births with penitentiary fines and public shaming.[2]

At the same time, Rome mercifully addressed the human need for intimacy and progeny among its celibate religious by allowing them to lead fictive married and familial lives within their cloisters. Nuns entering cloisters became "brides of Christ" and "mothers of God," while their male counterparts took the role of "stepfathers of Jesus," all in all, an ersatz, make-believe family life for the cloistered and confined.[3]

Neither fines nor role-playing were effective solutions for the celibate-religious and the single layperson's domestic plight. After assurance of salvation, the most vital need of the laity and the clergy was personal and domestic freedom in private, intimate relationships. Luther called the latter "the divine estate of marriage."

Although both men acted initially for strategic purposes, the alliance

174

between Cranach and Luther enabled each to gain his worldly goal. For Cranach, the goal was to expose and defeat the iconoclasts, and in doing so to secure decorative art in the churches and provide the artists with wealthy patrons and a livelihood. Luther's goal was even more ambitious. He foresaw the wholesale replacement of Roman authority and religious doctrine in the churches and a new Protestant gospel of faith alone taking their place. With those sweeping ends in sight, each grasped the other's hand and plunged back into Saxony's confessional wars.

After the ecclesiastical-theological reforms Luther unveiled in 1517 came his complementary civic-domestic reforms centered around marriage and family. That fond, dual vision was also enthusiastically embraced by Cranach, now a seasoned eight-year veteran of marriage and parenthood, with five young children underfoot to prove it.[4]

Luther prepared the way for his domestic reforms by exhorting the Saxon rulers to stay within the limits of the sovereign powers of a free Christian state. The regime's political dominion was to be strictly limited to body and property, and never asserted over conscience and soul.[5] Luther also pointedly reminded Germany's magistrates and councilmen of their human and godly duty to fund public schools for all children, boys and girls alike, while expanding and reforming the universities.[6]

Luther acted to make the care of the poor an organized civic obligation. He proposed a welfare ordinance that mandated a common chest to be put in every German town. Rather than skimp along with the traditional practice of almsgiving to the needy and deserving native poor, Luther proposed that they receive grants, or loans, from the common chest. Each recipient pledged to repay the borrowed amount after a timely recovery and return to self-sufficiency.[7] This was love of one's neighbor through shared civic responsibility, or in Lutheran religious terms, "faith begetting charity."

When in the late 1510s and early 1520s Cranach and Luther collaborated on the new reform agenda, Luther was a composite monk, university professor, Bible scholar, and famous author of the *Ninety-five Theses* (1517). Cranach, at this point, was the only senior member of the reformers' circle who had deep experience in everyday domestic life, household

economy, and the workaday Saxon world. From the operation of his workshop, knowledge of commerce, grasp of city government, and practiced diplomacy at home and abroad, Cranach was in a position to help his friends develop their ambitious reforms.

The reformers he mentored were committed to principled, pragmatic change in both secular and religious spheres. Having fought with Luther against Rome's unbiblical theological and religious teachings, they had a strong interest in the "big questions" of the era: Who is man and who is woman? How should they arrange their lives with respect to one another? What do they owe their fellow man and society? Should not all able-bodied men and women embrace God's command to marry, be fruitful, and multiply? Is raising up progeny in the way of the Lord not the best formula for creating a purposeful and prosperous society?

In the pursuit of their civic and domestic reforms the reformers assailed Rome's meddling in the intimate affairs of the laity, particularly those of the bedroom. At this time married couples might find their sex life the subject of a priestly interrogation, ranging from sexual "seasons" and "positions," to frequency and infidelity. A wife, or a daughter, might also receive a lewd clerical solicitation.[8] Condemning Rome's impediments to, and restraints on, lay marriage, the reformers turned this debate emphatically to the freedom of Christians to marry at will, and not least among them the long-suffering celibate clergy and religious. In their recasting the new moral-social-domestic unit in the early 1520s Luther and Cranach declared the Christian church and household to be coextensive, as were also Christian freedom and lay Christian secular life. Having fought Rome to a standstill, the reformers now put their hands to a new plough, one that would leave different furrows. At this time the monk Luther held forth on the subject of the "sex drive," which he describes as "a matter of [innate] human nature, not one of [free human] choice . . . there is no free will over sex . . . whatever is a man must have a woman and whatever is a woman must have a man."[9]

Displaying biblical and classical examples of womankind's sexual prowess over even the brightest and mightiest of men, Cranach joined Luther in pointing out the sizable numbers of clergy and religious who

could not, and did not, keep vows of celibacy and chastity. Both went on to eulogize the sex drive that is embedded in human nature, something both divine and ineradicable, the most invincible force in God's creation. By it, humans share in the divine power to create life, the human endowment closest to its Maker. And for that reason God created a special place for the sex drive in the firmament, a place where it would be properly exercised and held accountable, namely, the divine estate of marriage.

In that sacred setting, the companionship of spouses and the vigilance of parents harness and direct the sex drive, putting it to work in accordance with its God-given power and purpose on earth. From the first days in the Garden of Eden, that purpose had been to create new life and form godly families (Genesis 2:18), which in turn became the foundation stone of all societies and states, in and through which all rightful human endeavors spring.[10]

With the exception of eunuchs and celibates, Luther directed all able-bodied men and women into courtship and the estate of marriage. There, they were to bond, conceive, give birth, and rear children in the privacy, love, and discipline of a nurturing, sovereign family, now free from the intrusions of the Roman Church.[11]

As the Reformation's influence spread, Cranach's Wittenberg mansion became a proving ground for free, legal, secular marriages of recently emancipated religious women. In 1523, nine to eleven nuns emboldened by Luther's writings escaped from their cloister in Nimbschen near Grimma. In making their dash to freedom, they had the help of sympathetic man-servants, who concealed them in and around barrels of fish in a wagon bound for Wittenberg. Upon arrival, the women found a temporary lodging in Cranach's mansion and in other open homes, where they awaited Luther's fulfillment of his promise to find each nun an acceptable husband.[12]

One of those nuns, Katherine von Bora, would be the last to find a husband. During her two years of waiting in Wittenberg she received as many offers of marriage. The first one she would have accepted had the parents of the prospective groom not deemed her lacking. After refusing the second offer outright, she found herself left with a very desirable, but

not particularly love-stricken mate: Martin Luther himself. Between the freedom of the new Protestant world and the pressure Luther's followers put on him to marry, Cranach was soon (May 1525) standing as best man beside the twenty-four-year-old Von Bora and the forty-two-year-old Luther, as Wittenberg's Pastor Bugenhagen pronounced them man and wife. Although she was the "last" of the Nimbschen nuns to marry, Von Bora arguably got in Luther the "first" of the eligible husbands, as the history of their courtship and marriage suggests.

Modern scholars have speculated that Von Bora was the last available nun because she had her eyes fixed on Luther from the very beginning, suggesting a strong, clever "Cranach woman." In his role as matchmaker, Luther irregularly visited the waiting nuns to discuss their prospects. At some point in those deliberations, the idea of marrying Von Bora was planted in his mind. Many believed Luther's marriage was vital both for the taming of the masses and the popular reception of the new theology, not to mention Luther's own *bona fides*. Luther, after all, had long been the great advocate of universal marriage, both lay and clerical, and the time had come for him to act on what had been, since 1522, his own emphatic teaching. The match was of course unprecedented and raised the specter of a runaway nun successfully stalking a renegade monk.[13]

After the event, the court secretary of rival ducal Saxony sent Duke George's greeting to the newlyweds. It contained only three words: "Death to Whoring!" The reaction to the famous monk and the little-known nun living together and committing sex in legal wedlock was beyond rage and sent a shock wave through Roman Christendom.[14]

In supporting Luther's case for universal marriage, Cranach contributed his own artistic commentaries on gender and sexuality, drawing from Old Testament stories and classical mythology. The wisdom of the ancients gave both men a definitive "anthropology," a presumed timeless guide to the relationship between the sexes. In Cranach's painted stories women acquitted themselves brilliantly in mismatched confrontations with males. Pitting the power of male logic and brute strength against underdog feminine cunning and beauty, his gender conflicts more often than not ended with the ladies very much on top. From different, yet

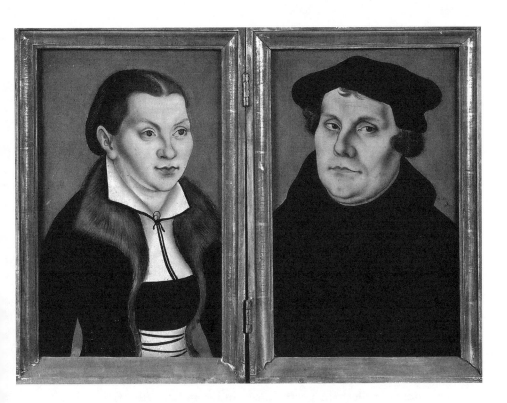

Lucas Cranach the Elder, *Dr. Martin Luther and His Wife Katharina von Bora*,
1529. Oil on beechwood, 14³⁄₁₆ × 9¹⁄₁₆ in.
(Hessisches Landesmuseum, Darmstadt, Germany;
Photo: Bildarchiv Preussischer Kulturbesitz/Art Resource, New York)

kindred sources, the painter and the monk presented "women's world" as
not only the more powerful, but also the more desirable and effective in
the development of human nature and civilization.

Cranach's engravings and paintings of female figures run a spectrum
from Greek and Roman antiquity to the Old and New Testaments, and
from there through the Gothic Middle Ages down to sixteenth-century
Saxony. His women appear as both heroines and victims, mature queens
and pre-pubescent princesses, saints and sinners, married and single,
well-matched and "ill-sorted."[15]

Whether ancient or contemporary, whoever they are and whatever
their status in life may be, as a rule Cranach's women appear in present-
day Saxon dress. At one end of the spectrum they are clothed in deep

velvets and shiny silks, while at the other, their nude or semi-nude bodies are concealed and revealed under fine translucent veils. In between, they stand before the viewer in various, pleasing stages of undress.

With the passage of time, the vitality and charm typical of Cranach's classical women—particularly in his soulmate, Venus—appears to flow from the painter over to the more somber biblical counterparts, especially the figure of Eve. His post-1525 "antiqued" Adam is Apollonian and Eve is exalted and Venus-like. The viewer sees the "woman deep within," the aura and essence of a beautiful body and soul, one beyond anatomical correctness. As one historian bluntly puts it: "Eve's sensual persona transcends any natural skin enhancement."[16]

As a rule, Cranach's portrayals of feminine physical beauty avoid dominant, or gross, sexuality. His portrayals of the first humans combine a light, native Gothic with imported Italian features, and a touch of the naturalistic North Alpine silhouette. The resulting feminine figure is an antitype of the outsized heroic women one finds among the Italian masters and their German peers Dürer and Hans Baldung Grien. In this breakthrough Cranach simply found a lighter, brighter way to present women, regardless of subject matter and whether clothed or nude.

Within the prevailing Saxon culture, Cranach's patrons and private customers as a rule commissioned artworks that indulged the eyes and aroused the senses. He and his fellow artists mixed and matched past and present as they found them, and none were prudish when it came to nudity and sexuality. Contemporary artists and patrons wholly embraced classical antiquity's ideal of physical beauty, accentuating and celebrating the human body and its sexuality tenderly.[17]

The art inventories of North European courts confirm broad ownership of Cranach's mythological nude paintings not only among royals and noblemen, but also in the homes of well-to-do burghers. Presented in his own "antique-contemporary" mix, his classical myths have moved a subset of modern art historians to salute him as "the alpine Botticelli."[18]

Although no classical nudes decorated the altar panels of Wittenberg's churches, one may detect in the painted faces of Cranach's Eve,

Mary, and the Magdalene bright traces of his painted Venus.[19] As one would expect, Cranach's classical nudes are more sensuous and aggressive than his biblical nudes. In his late portrayals of *The Judgment of Paris* (1530s) the three nude goddesses may be seen casting about gamely for the viewer's eye, ready to throw themselves at the vulnerable and responsive.[20]

As he had done with Cranach's early Viennese artworks (1502–5), Friedländer also scrutinized his portrayals of women over a decade and a half, from 1505 to 1520. Finding these images "brighter, warmer, and more trusting" with the passage of years, he joined the critics' universal praise of a new figure of Venus: the so-called "Dark Venus" (1509).[21] The reader would like to think that Friedländer's effusive praise for her also expresses second thoughts about his declaration of Cranach's premature artistic demise in 1505!

Sadly for both, Friedländer concluded that "Dark Venus" was the exception that proved the rule. Cranach's ability to portray women in a complex, interesting way had also run its course, peaking and expiring prematurely in the bright light of "Dark Venus."

Friedländer reached that conclusion after discovering Cranach's "intense interest in the naked [female] form." He describes the artist as constantly "scouring the Bible, history, and myth for any opportunity to portray a nude." Going out on still another limb, Friedländer also ascribed Cranach's infatuation with the nude female body to a deleterious middle-age "obsession" with sex, which he blamed on the secular spirit of the Renaissance.[22]

As there is little hard data on such matters, one may simply guess that Cranach's interest in women as *objets d'art* originated in his youthful associations with models in the workshops of his father and other Kronach painters. The women who appear in his early Viennese and Wittenberg artworks can be somewhat rough-hewn. Not until 1510 do we find known "girlfriends" he portrayed and was evidently infatuated with.[23] Most likely he came to appreciate womankind in deeper and more lasting ways after his marriage in and around 1511–12. Thereafter, Cranach's women do not appear, if ever they did, as soulless "art

objects." They rather present themselves as believable persons in their own right, some more complex than others, but none refuting Friedländer's imprimatur on Cranach's upbeat portrayal of women throughout the 1510s.

No less an appreciation of women was shared by Cranach's new friend and colleague, the great patriarch Luther, with whom Cranach joined in advancing the social-domestic reforms of the Reformation. Like Cranach, Luther, too, belatedly discovered in his own marriage the talents, pleasures, and high-quality companionship that came with the opposite sex and bound a marriage together. Thereafter, he progressively spoke of womankind in a warm and trusting way, despite some irrepressible gender jokes that went awry. To cite only four of Luther's hundredfold amiable comments on the opposite sex collected in his *Table Talk* is to convey the upbeat tenor of them all. In 1531, after six years of marriage:

> I would not give up my Katy [Katherine von Bora] for France or for Venice—first, because God gave her to me and gave me to her; second, because I have often observed that other women have more shortcomings than my Katy (although she, too, has some shortcomings, they are outweighed by many great virtues); thirdly, because she keeps faith in marriage, that is, fidelity and respect. A wife ought to think the same way about her husband.[24]

In 1536, after eleven years of marriage:

> It seems to me that it is the most pleasant kind of life to have a moderate household, to live with a compliant wife, and to be content with little.[25]

In 1542, after seventeen years of marriage:

> Imagine what it would be like without the female sex. The home, cities, economic life, and government would virtually disappear. Men can't do without women. Even if it were possible for men to beget and bear children, they still could not do without women.[26]

In 1543, after eighteen years of marriage:

> Marriage does not consist only of sleeping with a woman—everybody can do that! But keeping house and bringing up children must also be considered by anybody who intends to take a wife. . . . There's more to marriage than a union of flesh. There must be harmony with respect to patterns of life and ways of thinking. The bonds of matrimony alone won't do it.[27]

FASCINATING WOMEN

By the late 1520s, the Cranach workshop had its own "beauty formula" for the production of classical, biblical, and contemporary Saxon women, whose composite best figures were interchangeable within different genres. Like the workshops of other artists, Cranach's also had an ample repository of female body parts, faces, and poses to keep the workshop fully operative.[28]

From such reserves came playful, mythological goddesses, vengeful, biblical femmes fatales, and sleek, patrician beauties, quite a few of them dressed to the nines, while many more appear in varying stages of undress. The Cranach nude engaged willing viewers with enticing stares and well-practiced body language. Despite the eroticism of the scenes, contemporary records report no outraged customer returns, or condemnations of the workshop. Cranach's upscale nudes met the community standards of the Saxon court.

Those same mischievous "ladies" contributed to Cranach's reputation as the "fast painter," and they still did so long after he ceased to be such. Thanks again to them, the workshop had delivered a remarkable spectrum of Cranach women by the 1540s.[29] Looking back and forth, the viewer beholds his religious women, from the martyred St. Catherine to the score-settling Salome; his classical women, from the bright-eyed Venus to the morbid Lucretia; and his contemporary Saxon women from royalty's gilded queens to the plain wives of the humanists and the reformers.

Other contemporary artists were not so fortunate. The so-called "god-less painters" of lesser reputation and lower social standing who made their living by milling and selling rank, erotic art risked being driven underground, there to forfeit their livelihood and occasionally their lives.[30] More recently, modern critics have accused Cranach and Luther of betraying art and the common man—art, by subjugating it to theology, and the common man by leaving him to the mercy of his landlord. Invoking their close association, modern critics also saddle Cranach and Luther with dreaded patriarchy and sexism as well.[31]

Appearing at first sight to be launching a rescue mission of Cranach's art and reputation, Australian art historian Michael Carter invoked the historically elusive nature of the classical nude in Cranach's defense.[32] He reminds the reader that nude Greek goddesses and heroines have always been free to "move back and forth on the boundary of public and private use." By straddling the line between reason and eroticism, the Greek nude has eluded a fatal censure simply by virtue of Greek classicism's long, public respect.

Unfortunately for Carter's argument, Cranach's art, like Luther's sermons, address a far deeper fault in human nature than that between reason and emotion. The subjugation of emotion to reason neither frees the will nor saves a mortal soul. The fatal impasse is that between sin and redemption, death and eternity, nothingness and everything live. There, the human will meets more than its match. Even with the emotions suppressed, the will still remains bound, and no soul can set itself free.

Compared with the struggle between righteousness and sin, the triumph of reason over emotion and of knowledge over ignorance still leaves the dire human predicament in place. At the end of an impossible argument, Carter reduces Cranach and his nudes to "voyeuristic pornography for gentlemen," a short-lived diversion of the issue and a true dead end.[33]

In a more thoughtful discussion of the Cranach nude, historian Berthold Hinz points out that Cranach, unlike Da Vinci, Dürer, and Michelangelo, was never "a fanatical student of the nude." Over his long career, he actually painted more wild game and animals than classical and

biblical nudes. And when he turned his hand to those subjects, he completely ignored the guiding principles of the genre.

After his first renderings of Venus in 1508 and 1509, Cranach never again created an outsized heroic nude. Nor did he ever reduce nude figures to their primal genitalia as did Nürnberg's contemporary "godless painters," and, five centuries later, Pablo Picasso in his brutal paraphrases of Cranach's Venus. In the history of the nude, Cranach presented a perfect-imperfect figure, both ethereal and erotic, chaste yet worldly-wise, fetching but also lethal. His portrayals of Venus made her the high-end item on the sixteenth-century adult art scene, a compliment she returned manifold by making Cranach and his workers the "most successful nude specialists of the age."[34]

In a recent monograph, Hinz joined the three great twentieth-century Cranach critics (Max J. Friedländer, Heinz Lüdecke, and Joseph Koerner), all of them besotted Dürer fans. Romanticizing Dürer as a disciplined, modern, scientific artist with a compass in one hand and a ruler in the other, he reveled in his ability to draw human bodies, and also rabbits, that some believe to be more perfect than any to be found among the actual living species. Dürer, in a word, and perhaps even in his own words, was the proverbial artist whose talent trumped God and nature.

As for Cranach, Hinz reduces his assets to "a personal penchant, refined and hardened in response to [customer] demand," by which he means an intuitive artist, subject to whims, and showing a mercenary streak. In a tour-de-force deconstruction of Cranach's assembly-line nudes, he pokes fun at the "offspring" of the workshop's "model female," asking of the artist: "Are not all of these [Cranach] women the same shiny, diminutive, svelte child-woman showing tiny breasts, small derrieres, willowy appendages, and a large, white girl's head delicately placed upon her shoulders?"[35]

Rather than the "King of the Nudes," Hinz exposes Cranach as the court painter who has no clothes. Try as he might, Hinz could find no good *artistic* reason for Cranach's success. Barring his artistry, what accounted for the wide appeal of his women? For Hinz it was the combination of the artist's cleverness and the age's backwardness. As if trimming a

Christmas tree, Cranach heightened the sensuality of his nudes by drap-ing them with select accessories: necklaces, chains, and feather hats. And beyond that winning move, he excited the viewer with counterintuitive "Gothic throwbacks," creating otherworldly experiences that beguiled a thoroughly gullible age.[36]

Venus Steals the Scene

It is a telling commentary on their different interests and temperaments that Dürer, having sketched hundreds of nudes over his career, neither drew nor painted an openly sensuous female nude of the caliber of Cra-nach's classical goddesses. Over his lifetime, Cranach created twenty-plus Venuses and thirty-plus Eves, quite a few of them knock-down gorgeous. Given the artist and the two women he favored, the Mother of God had little chance of winning the competition with Venus. Despite the numbers of their portrayals, it was always the classical Venus, not the biblical Mary, who captured the artist, and doing so every bit as expertly as she had done centuries earlier in ancient lore, when she took the heart of the Trojan warrior Paris.[37]

Venus first appears in Cranach's artwork in the company of Paris and her peers, Juno and Minerva, in *The Judgment of Paris* (1508). In his first woodcut debut the viewer beholds the famous warrior as he awakens in a dream-world after returning home from the Greek-Trojan wars. Ex-hausted and befuddled, he opens his eyes to discover Jupiter standing over him in the company of the three slick Greek goddesses.

Before the passage of a year, Venus appeared again, now standing side by side with her son Amor (a.k.a. Cupid) in a new woodcut depiction of the ancient "Venus Shrine" in the city of Magdeburg, titled *Venus and Amor* (1509). During these years Cranach developed his own fantasy fig-ure of Eve, whom he progressively modeled on his fantasy figure of Venus, while Eve's consort, Adam, acquired the familiar features of the classical god Apollo.

The story of Paris and the goddesses was well established in humanis-tic literature and decorative art, and Cranach would continue to address it

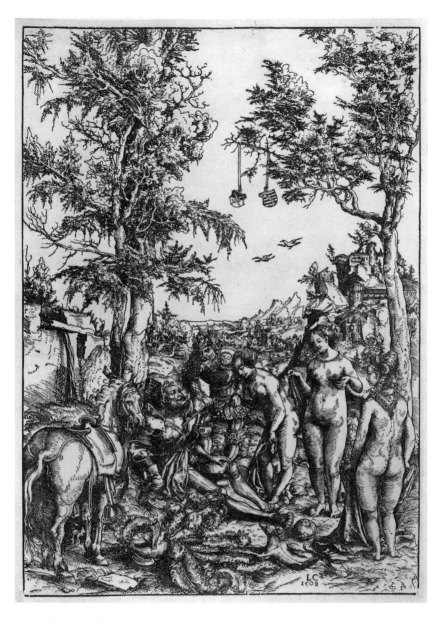

Lucas Cranach the Elder, *The Judgment of Paris,* 1508. Woodcut, 14⁷⁄₁₆ × 10 in.
(Kupferstichkabinett, Staatliche Museen, Berlin, Germany;
Photo: Jörg P. Anders, Bildarchiv Preussischer Kulturbesitz/Art Resource, New York)

well into the 1530s. When, in mid-November 1513, the future Saxon elector John the Constant married Margarete of Anhalt, the newlyweds spent their wedding night in a new bed decorated with classical stories by Cranach. Those stories addressed the relationship between the sexes, with Paris and the Greek goddesses prominent among them. Other gems decorating the bed were the tragic-comedic scene of Hercules swooning under the sweet "whip" of Queen Omphale, and last (and least) the trembling Lucretia, whose grief and shame over the loss of self and family honor moved her to suicide.[38]

Whether historical or mythological, such stories served the Saxon court's political need to document the regime's origins and legacy dating back to antiquity. In his early years in Wittenberg, Cranach turned substantial slices of that history into free-standing paintings for the first time.[39]

In representing Venus, he did not have a competing Dürer portrayal of the classical goddess to address and contest. Dürer did conjure a northern Alpine "Frau Venus" named Nemesis, or Large Fortune (1501–3). A brainy, outsized, winged heroine, she is seen traversing the globe as she pontificates on such subjects as metrics, proportionality in art, vanity, and temperance.[40]

It is inconceivable that such a figure might appear in Cranach's intuitive, untamed Eden wherein a sensuous Venus reigns over water nymphs and frolicking forest folk, who run about naked and cavort without shame. Cranach's Venus contests the beauty of her peers in the presence of Paris and accompanies her son, Amor, in the mischief of carnal love. Rather than teaching metrics and proportionality in the pursuit of an artistic career, she practices the virtues of measure and restraint as she seeks success in the art of love!

Smitten by her pluck, Cranach early admired and embraced Venus as a soul mate. Among Renaissance artists, he was the first to break the old church taboo on presenting biblical saints and holy women nude. It had forever been the law of the medieval church that the bodies of saints whose hagiography required nudity be covered from head to toe with a thick coating of fur, thereby preventing any bare skin to be seen.

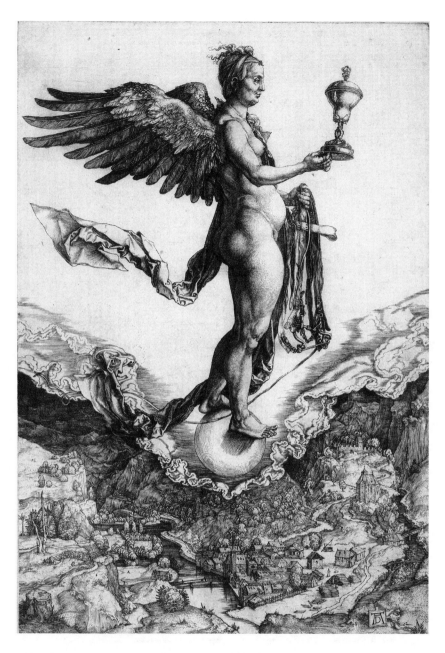

Albrecht Dürer, *Nemesis, or "The Large Fortune,"* 1501–2. Engraving, 13 × 9 1/16 in.
Beneath the figure is a landscape depicting Chiusa, near Innsbruck.

Lucas Cranach the Elder, *The Rapture of St. Mary Magdalene,* 1506. Engraving.
(Kupferstichkabinett, Staatliche Museen, Berlin, Germany;
Photo: Bildarchiv Preussischer Kulturbesitz/Art Resource, New York)

Cranach's alleged first holy nude appeared in a woodcut wilderness scene set against a quiet landscape watched over by the royal shields of electoral Saxony and its Wettin mother dynasty.[41] Titled *The Rapture of Mary Magdalene* (1506), the scene shows the prayerful saint as she is gently escorted heavenward on the batting wings of seven hardy, robed putti, which also cover and conceal and protect her private parts.[42]

Adam and Eve, and Venus Too!

Cranach's earliest representation of Adam and Eve was a busy woodcut (1509–10) in which the first humans appear as a contented rustic couple in a teeming bestial forest. Dwarfed by free-ranging, noble forest beasts, the fateful pair cast their lot with the devil, who appears in serpentine guise, gazing darkly upon them.[43]

In Cranach's first painting of the pair, a year later (1510–12), the constant viewer sees that they have moved front and center in their fallen world, asserting their dominance over the verdant landscape and wildlife refuge that was God's original creation.[44] That Cranach was borrowing again from Dürer is confirmed by a quick glance at Adam's feet, which appear in the exact position Dürer had painted them in 1508! True to his artwork, Cranach presents an awkward and unattractive Eve at the side of Adam, her rubbery legs asymmetrically crossed in the artist's typical shorthand treatment of human appendages.[45]

Guessing that artists, like their artworks, also imitate reality, it may not be coincidental that Cranach was at this time also moving out of his bachelor's quarters in Wittenberg Castle and into a house of his own in the city center. There, not only did he purchase and rebuild the city's largest mansion, but over the years he also gained a leading role in the city's governance, courtesy of his new adjunct careers in politics and private businesses.

As for the progress of his artwork, this bold changing of his circumstances seems to have been emancipating. By the mid-1510s, he was pairpainting Adam and Eve and Jesus and Mary romantically! Each pair appears bright, attractive, and better proportioned, demonstrating what

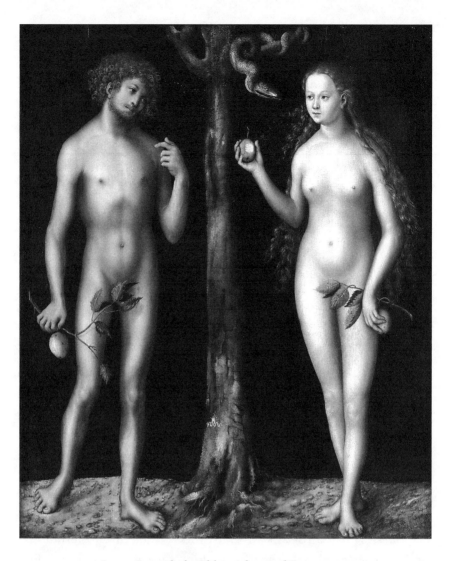

Lucas Cranach the Elder, *Adam and Eve*, 1513–15
(Photo: Hans Hinz/ARTOTHEK)

the passage of time and the medium of paint can do for the artist and his artwork. His portrayals of Adam and Eve now become hybrids of biblical iconography and classical anatomy. Eve, originally born of Adam's rib in the creative hands of God, is now reborn of Venus in the loving hands of Cranach, while Adam continues to acquire the round head and curly locks of the sun god Apollo.[46]

In the years between 1513 and 1515, Cranach's figure of Venus triumphs over that of his Eve. He now debuts a classical, Venus-like Eve in the moment of the Fall, a fetching figure and a future, hybrid model for his nudes.[47]

The new Eve holds an apple in each of her hands, one of which shows a clean, lethal bite. As the venomous sin of disobedience spreads throughout her body, her consort Adam gingerly holds a broken branch from the forbidden tree to which an intact apple is still attached. Dazed, but still game, Adam motions Eve to step toward him as the damaged pair forswears Paradise. Leafy twigs cover their genitals, calling attention not only to their disobedience and shame, but also to their newfound "classical" sexuality: a gift from Venus to Eve through Cranach.

As she savors her sin, Eve's eyes are beady and alert like those of the Serpent, while Adam's eyes remain languid and unfocused, a Cranach commentary on which really is the weaker sex. Locked both with each other and with the Serpent in a mesmerizing stare, their original innocence and obedience turns to selfish lust and desire, marking the point of no spiritual return.

HISTORY AND MYTH: THE MAGDEBURG VENUS

In remembrance of Rome's good fortune, Julius Caesar (ca. 101–44 BC) erected an enduring shrine to Venus on a plot of land in Roman-occupied Germany. Many centuries later the city of Magdeburg was built on that same spot, henceforth to be known as "Little Rome." With four times the population of Wittenberg, yet wielding only a quarter of its military power, Magdeburg came under Saxony's protection centuries later.[48] In the age of Cranach and Luther, the "Magdeburg Venus" still documented and confirmed the Saxons' sacred bond with ancient Rome and Troy. Therein lay the importance of the two Venus woodcuts (1508–9) Cranach created early in his career.

More pertinent to the modern story is his portrayal of Venus and Amor together for the first time in a work of art. In larger-than-life images the nude mother and child stand before the "foundation tree,"

attesting the "Magdeburg Venus" as a powerful, reigning goddess who still protects Saxony. With her son accompanying her, the new pair, goddess and godchild, authenticate electoral Saxony's ancestry all the way back to Julius Caesar.

Hanging prominently from the "foundation tree" are the two coats-of-arms of the new electoral Wittenberg regime created in 1485. One displays the crossed swords of the new (electoral) Saxon state, the other, a garlanded rhombus, is the mother shield of the Saxon (Wettin) dynasty.[49] After the division of Saxony into "electoral" (Ernestine) and "ducal" (Albertine) regimes, the two lands continued to proclaim their golden pedigree all the way back to pristine Rome.

In his first *Venus and Amor* scene (painted in 1509 but dated 1506 in the work), Cranach claims a piece of that pedigree for himself and his family. Between and below the two royal shields he hangs his recently awarded coat-of-arms (1508). He also adds his initials, and dates the woodcut falsely (1506 rather than 1509). The backdating was an effort to assert his prominence in the development of the German chiaroscuro (black-white) technique. Having employed the technique as early as 1506, he evidently thought it just and proper to assert a date that credited his authorship.[50]

Another kind of "backdating" appears in the verses accompanying the scene. Pretending to be words spoken from the lips of Venus herself, they allege not only a deep Saxon bond with the cult of Venus, but also infer electoral Saxony's rightful ownership and faithful stewardship of its acclaimed ancient and present-day lands.

> Although there are many great lords
> In lands far and wide
> Still I [Venus] can say without boasting:
> All are subject to me.
> For no man can be found
> That I, Lady Venus, do not rule.
> Many a hero wins a battle
> And becomes a child of Venus

Henceforth, destined to win many battles
And to remain my captive
For my son [Amor] can plunge love's arrows
Into a heart with great speed.[51]

Here the mythical pair is presented in the heroic Italianate-Düreresque style, to which Cranach did not again subject his fond Venus. The naïveté of mother and child complement their tender interaction, while giving the regime some relief from its obsessive pursuit of certifiable links to classical antiquity.[52]

The Bright Light of "Dark Venus"

In these early years of infatuation with Venus, Cranach also painted her life-size for the first time in northern European art, a minor masterpiece of the period.[53] Long known as the "Leningrad/St. Petersburg Venus" after the museum where the work hung for centuries, she is today known as "Dark Venus," after her olive-colored skin and the dark background she appears against.

Praised as a "blooming woman [and] a sample of progressive human-ism," she restrains her son as he begins to draw his bow and send fatal "love arrows" into the hearts of unsuspecting passersby. Critics have de-scribed "Dark Venus" as more a pagan than a Christian figure, adding another novel dimension to the scene.[54] As in all of his early works Cranach again demonstrates that he is unreliable on anatomical details and proportionality. Nor does he bestow on his subject a flattering, extra-terrestrial physical beauty, as did the High Renaissance Italian painters and their northern peers.

A true original, "Dark Venus" is a measure of Cranach's artistic prog-ress after five years as court painter. Although it is a magnificent work of art, closer scrutiny uncovers a jarring specimen of womankind. She pre-sents a short, compact, slender upper torso with modest, high-set, signa-ture Cranach breasts. Her opposing lower torso is massive, her hips and thighs Romanesque. Her small head does not quite fit her large neck, nor

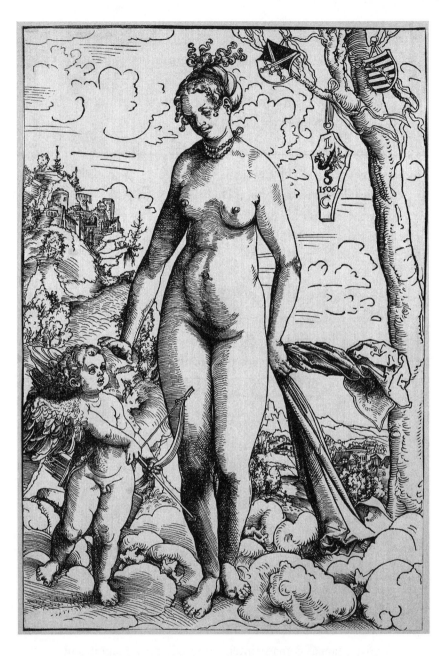

Lucas Cranach the Elder, *Venus and Amor*, 1509 (dated 1506). Etching.
(Kupferstichkabinett, Staatliche Kunstsammlungen, Dresden, Germany;
Photo: Erich Lessing/Art Resource, New York)

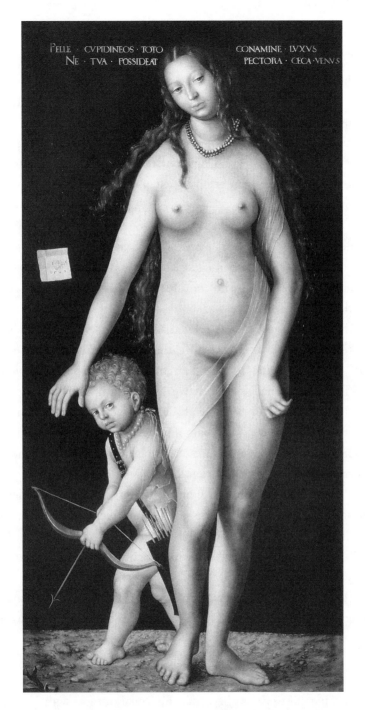

Lucas Cranach the Elder, "Dark Venus" (*Venus and Cupid*), 1509
(Hermitage, St. Petersburg, Russia; Photo: Scala/Art Resource, New York)

her thighs her shanks. And there is little symmetry between her restraining right arm and her apparently recessed left.

Yet for all that, a palpable air of mystery surrounds her, particularly about her face, as she exudes a Cranach womanhood never before seen. A major transitional figure in the artist's portrayal of women, "Dark Venus" opened the door to a style that conveyed a figure's "aura," or "emanation," not the impossible human reality itself, but a life force beyond mere pigment and canvas.

A closer comparison with the early woodcuts of Mary Magdalene, Eve, and Venus discovers a painted "Dark Venus" who distills and improves on the best features of each. Looking forward, she points to the bright, lithe, erotic figures who continue, Venus-like, to steal the scenes of Cranach's 1520s and 1530s artworks.

Although arch-critics Max J. Friedländer and Heinz Lüdecke insisted that Cranach's best works were his earliest works, each man gave "Dark Venus" fulsome praise, and neither could find anything remotely approaching it in Cranach's later artworks. Tracking the evolution of the Cranach woman from first Venus to last, Lüdecke harshly ridiculed his 1530 "Frankfurter Venus" as "a pampered, feudal . . . skinny courtesan."[55] By such total dismissal, he gave lesser critics his leave to apply their own harsh judgments throughout Cranach's entire body of art.

Still "Dark Venus" certified Cranach's ability to paint a broader spectrum of women with unusual insight and appreciation. Almost single-handedly she sent Cranach away from the gloomy, ponderous, heroic High Renaissance model of womankind to a brighter, lighter, truer-to-life portrayal of Saxon women. Rather than an "anomalous peak" in his art production (thus Friedländer), "Dark Venus" confirmed the continuity between Cranach's early and late representations of "fascinating women."

WERE CRANACH'S WOMEN TRAMPS?

Cranach's harshest critics allege that his collaboration with Luther and the princes reduced the artisans in the cities and the peasants on the land to "mere objects of cabinet politics," commodities without power and

rights. If that were not petty criticism enough, others point to the "squandering" of his talent on redundant altarpieces and recumbent nudes. As commentaries on the status of women in the "patriarchal age" of Luther, Cranach's women are said to appear in his post-1525 artworks as "mere instruments of play and entertainment for gentlemen." Gone is the "progressive content" of his previous principled artworks that had bravely condemned political and social injustice.[56]

As for countering such prudish and ideological criticism of Cranach's painted women, some clarity and caution may be gained by a closer look at just who those women were and why they engaged the painter's attention so. While not denying the personal and mercenary sides of Cranach's erotic artworks, his painted females give every appearance of having been local women of good standing. Through the artist's imagination they received the celebrated roles of revered characters in contemporary society's distant biblical and classical past, and for more than Andy Warhol's famous fifteen minutes.

A comparison of Cranach's erotic figures with portraits he made of known Wittenberg women makes it obvious that his nudes were not just figments of his imagination; his models clearly were women he knew or passed on the streets in the city, as can be seen in the pairing of *Lady with an Apple* and *Nude Venus,* as well as in *Young Lady Clothed* and *Venus in a Landscape.* In the hands of the painter these women role-played the ancient narratives that linked present-day history to that of the past. Both clothed and nude, in their own skin and in that of the goddess Venus, to all appearances each juxtaposed pair is one and the same person.

More instructive still are the portrayals of loving mothers attending their children in domestic scenes titled *Charity* [Caritas]. A stock figure in late medieval and early modern art, Charity personifies devoted motherhood. Here, a daughter, perhaps four years of age, cradles a doll in her arms as her toddling brother clings to their mother's leg, while her infant sibling suckles at mother's breast.

The scene is one Cranach witnessed often for at least a decade in his own household of five children born between 1513 and 1520. The soft nudity of the scene is enhanced by the artist's draping the mothers with

Lucas Cranach the Elder, *Lady with an Apple*, 1527

(Photo: Nationalmuseum, Prague, Czech Republic)

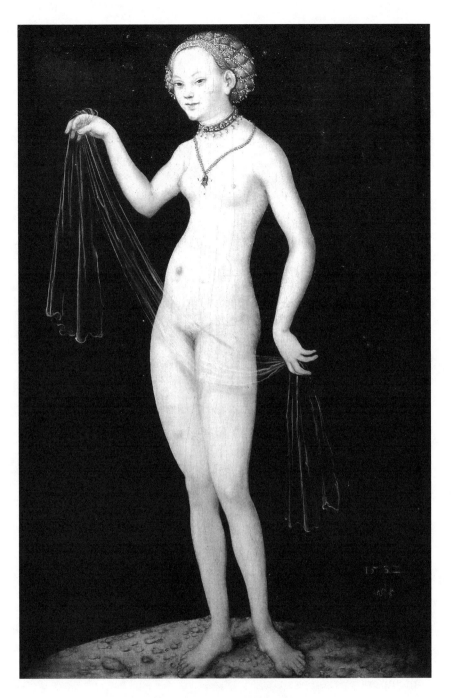

Lucas Cranach the Elder, *Nude Venus*, 1532
(Photo: Städel Museum/ARTOTHEK)

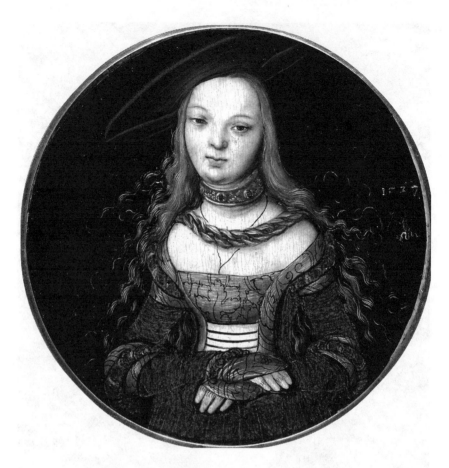

Lucas Cranach the Elder, *Young Lady Clothed*, 1525
(Photo: Staatsgalerie Stuttgart, Germany)

jewelry, suggesting burgher women of means who also had lives of their own beyond the nursery. The contrapuntal veil defines the scene emphatically as chaste and familial. It could be an early kitchen breakfast, the gathering of the children for an afternoon nap, or the bedtime roundup at the end of the day. With a few turns of Cranach's brush, the devoted mother might be Venus, Eve, Lucretia, or any other classical, biblical, or contemporary Saxon woman.

The diaphanous veil covering the mother's body without concealing it is an artifice with both chaste and erotic connotations. Metaphorically, it establishes a moral-religious boundary not to be transgressed.

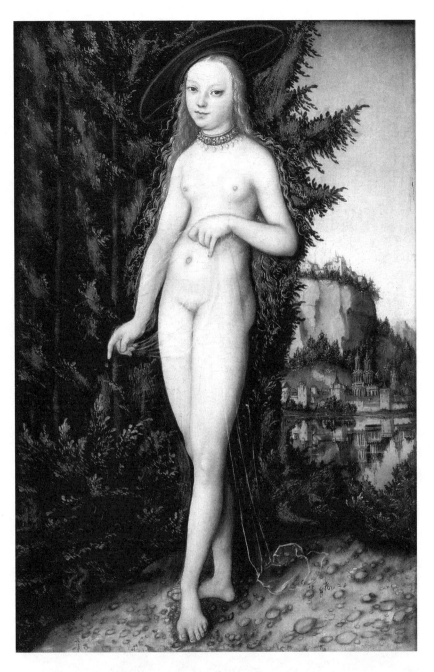

Lucas Cranach the Elder, *Venus in a Landscape*, 1529.

Oil on wood, 14^{15}⁄$_{16}$ × 9^{13}⁄$_{16}$ in.

(Louvre, Paris, France; Photo: Jean-Gilles Berizzi,

Réunion des Musées Nationaux/Art Resource, New York)

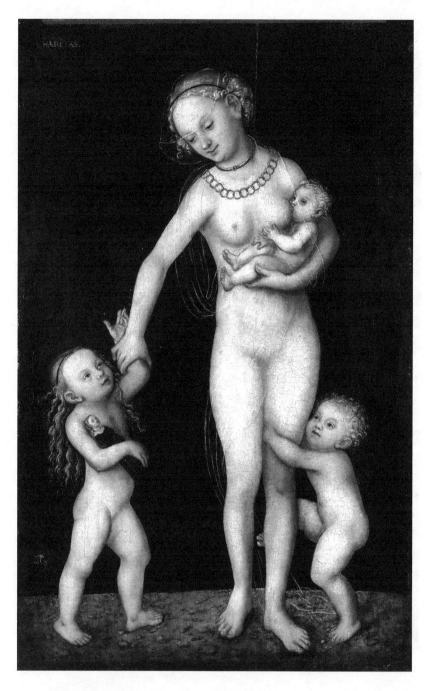

Lucas Cranach the Elder, *Charity*, 1537–50. Oil on beech, 22³⁄₁₆ × 14¹⁄₄ in.
(Presented by Rosalind Countess of Carlisle, 1913, National Gallery, London, Great
Britain; Photo: © National Gallery, London/Art Resource, New York)

Although an evocative nude, Charity is no courtesan. In the context of a loving mother and dependent child, total nudity conveys total maternal self-sacrifice. This Saxon mother was deemed to be as great a heroine on the home front as were the biblical and classical women who gave their bodies and often their lives to save their tribes from their mortal enemies, and their family's good name from dishonor. Examples are Judith in the Old Testament and the classical Lucretia.[57]

Still another portrayal of Charity (1534), arguably Cranach's best in the genre, catches a proud, doting mother as she sits on a stone bench with her four children in a scene of innocent nakedness. Her legs firmly crossed and her head and shoulders veiled, she signals to all who approach her that she is a sworn, chaste wife and a devout mother unto death.

Beginning in 1529, Cranach created a dozen versions of this domestic scene: a nude artwork epitomizing the Protestant gospel.[58] Known to contemporaries as the "the Lutheran parable of faith," the figure of a transparently devout and utterly self-sacrificing mother represents the freedom and charity of faith.

Charity's antitype is that of the flamboyantly dressed figure of melancholy, who gives nothing to others and thinks only of herself. In a test scene borrowed from the Italian painter Andrea Mantegna, Cranach surrounds the selfish, melancholic figure with no fewer than sixteen singing, dancing, music-making putti! The strong presence of children, song, and dance was Luther's first and sure remedy against the malady of melancholy and the stricken person's best hope for a speedy recovery and return to faith and charity.[59]

Like the figure of Charity, that of Justice (*Iustitia*) also has nothing to hide and everything good to give to righteous supplicants who stand before the bar. Hence, she, too, appears in a diaphanous veil of righteousness. Stripped of all duplicity and self-interest she holds forth in her hands both the scales of justice and its great punishing sword.[60]

Behind such personifications lay intertwined humanistic and Protestant reasoning. In 1523, Wittenberg's Philipp Melanchthon asked Cranach to create an "almost naked *Sophrosyne*" for him. Sophrosyne was a female

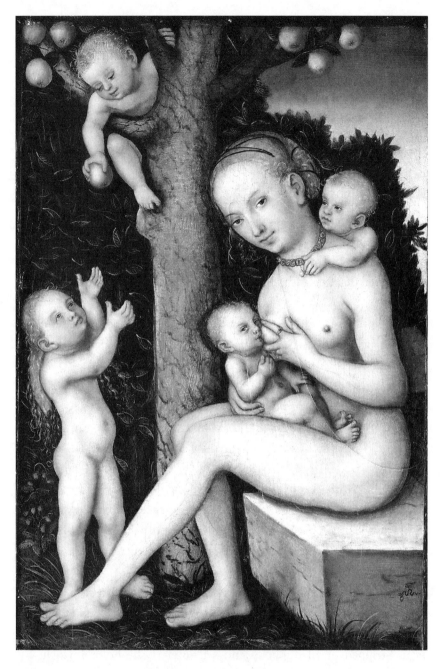

Lucas Cranach the Elder, *Charity with Four Children*, 1534

(Photo: Christie's Images/ARTOTHEK)

model of the highest virtue chastely draped with a certifying diaphanous veil. This graphic image was to be the title page of the professor's primer for beginning students: The *Enchiridion Elementorum Puerilium*.

A personification of one of the four cardinal virtues, the figure of *Sophrosyne* embodied reason, discipline, and measure. For both humanists and Lutherans these internal restraints were vital to the development of faith-based piety, freedom, and brotherly love, hence, the sum of a godly life: "Faith with its fruit . . . faith as the receptor organ of God's mercy, the source, life, and guide of charitable works."[61]

Cranach's nudes were not modeled on Wittenberg's courtesans and prostitutes, but on Saxon women Cranach knew, observed, conceptualized, and chose to portray. The same painted female figures who excited and satisfied the sensuous appetites of gentlemen also personified society's most vital professions: motherhood, jurisprudence, and education. The core message female nudity conveyed to these guardians was transparency, fidelity, and self-sacrifice to family and society.

Other female figures, both clothed and unclothed, who appear regularly in his stories were ad hoc compositions from the workshop's "beauty formula." Pressed into supporting, or even starring, roles, these women personified city laws, values, and virtues, while role-playing the grand history lessons of biblical and classical antiquity.

That there were also live models in the Cranach workshop cannot be denied and dismissed. From the popularity of Cranach's art, one surmises that opportunities for modeling, nude or clothed, were always there. Among Cranach kin, it is conceivable that Barbara Cranach might have been tapped for such scenes. She, with other relatives, had made earlier appearances in her husband's representations of *The Holy Family* and *The Holy Kinship*. In *The Wittenberg Altarpiece* (1547), members of the Cranach and Luther families, both living and dead, appear together with Jesus and the twelve Apostles in Cranach's grandest and most celebrated altarpiece.

Although it is highly unlikely that Cranach's painted misbehaving women were modeled on the city's courtesans and mistresses, such women

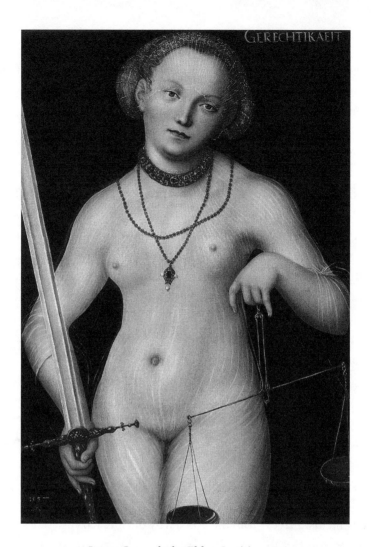

Lucas Cranach the Elder, *Iustitia*, 1537
(Photo: Fridart Stichting, Amsterdam, Netherlands)

did exist at court, and Cranach did indeed paint scenes of their mercenary play with gentlemen. They were a comparatively small cohort of his artworks and he depicted them with grotesque faces and in crude acts of sexual groping, both suggesting his disapproval.[62] As the first major German artist to apply all of his skills to lowbrow scenes of "ill-matched couples," he may be forgiven for that. In the moralizing scene of *Three*

Lucas Cranach the Elder, *Sophrosyne*, 1523
(Photo: By kind permission from Das Evangelische Predigerseminar Wittenberg,
Bibliothek, Germany)

Lovers, the third couple on the right represents what Cranach and his contemporaries believed a good, prudent, and successful marriage required: maturity and experience, close proximity in age, independent means, and a sincere desire for true and lasting companionship.[63] If such high-quality attention was given to such low-life characters for reasons other than commercial, the token presence of courtesans and mistresses suggests the artist's desire for inclusiveness in his artwork, a rounded view of all the people he knew and observed in his lifetime.

Lucas Cranach the Younger (1515–86), *Three Lovers*, after 1537.
Oil on beech wood.

(Gemäldegalerie Alte Meister, Staatliche Kunstsammlungen, Dresden, Germany;
Photo: Elke Estel/Hans-Peter Klut, Bildarchiv Preussischer Kulturbesitz/Art
Resource, New York)

ANTIQUING SEX: THE POLITICS OF ART AND NUDITY

Looking beyond his first biblical and classical women (1506–13), Cranach
shook up his contemporaries with a new artistic surge of buck-naked,
shiny-white, svelte-perky, ephemeral-flirtatious women, whom he pa-
raded on canvas and wood during the mid-1520s and 1530s.[64] Set against
these clever heroines and sleek goddesses, his earlier, heroic pre–"Dark
Venus" women seem a far cry from the Renaissance gentleman's fantasy
escort. And one might also say the same about his early portrayals of the
brokered mates of the royals and the companion wives of the humanists
and reformers.

From the Cranach woman's derring-do and liberties taken, these
clever, sleek, and comely women were every bit the product of the classical

Renaissance, bold figures risen from the deep archives of the humanists to be tempered for proper society by Cranach's fast brush. Had Cranach and Luther not become friends and allies in the early 1520s, pulled together by Luther's reforms and Cranach's commission to portray him, the divide between the German Renaissance and Reformation might never have been bridged, making religious reform more difficult and leaving humanistic values more shallow and unengaged.

Yet, having once made reform their common cause, each side, independently and conjointly, pored over and shared the storied wisdom of both the biblical and classical past. And joining them, Philipp Melanchthon planted the dual humanistic and religious heritages firmly in Wittenberg University and the German schools, thereby putting the treasure troves of timeless exemplars and wisdom directly in the service of both religious and domestic reform.[65]

What made the issues of marriage, sex, and family so pressing at this time was the reformers' urgency to bestow on the clergy and the religious the same freedoms and rights of ordinary laity. The ultimate goal was to secure marriage, sex, and family within the protective walls of the divine estate of marriage. Barring such protections, Protestants believed that family and society could not survive the licentiousness of the street and Rome's punitive interventions into family life.

In the pursuit of those goals, the reformers turned a remarkable part of their world upside down. No longer would the cloister be the last, best refuge of unmarried, or unmarriageable, girls and women. With Luther and Von Bora leading the way, a legal, companionate, married life, recognized by both church and state, would give former nuns and monks, and otherwise marriage-deprived laity, new security and opportunity. The appeal of those measures was confirmed by the flight of the religious from their cloisters within transitioning Protestant lands.

Although the most progressive contemporary and modern critics have never forgiven the Reformation for not embracing the rebellious zeitgeist of the 1520s (the Peasants' Revolt), history has not judged Cranach to be a completely unsympathetic figure of the times. Like Luther

and the vast majority of his peers, he had neither deep sympathy, nor an effective panacea for the common man's revolution against the reforming and thriving polity and society that was Saxony in the 1520s. Neither a betrayer of his fellowman nor a squanderer of his native talents, Cranach appears today to have been one of those "mighty men" who become a true "hinge of history" against his will and largely unawares.

8

Women on Top

DEFENDERS OF THE FATHERLAND

I n his painted biblical and classical stories, Cranach remembered women who acquitted themselves well in the face of challenge and peril. They are women who died at the hands of men, committed suicide out of shame for what men had done to them, and dispatched despots who threatened their tribes and dishonored their families. Cranach portrays them as having fought the good fight, holding their own against the physical powers and professional advantages of men. For any who doubted that, Cranach's women had their stories of conquests, both sexual and homicidal, to document it.

Devoting as much of his artwork to women as to men, Cranach came to know women well. Whatever contemporary viewers may have made of his depictions, there is no doubting that they disarmed the doubting male.[1] His animated stories were primers in the cunning of women and the gullibility of men, vital knowledge for both sides in the battle of the sexes.

Politics was the lifeblood of courtly life. All officers and servants of the court existed to exalt the regime to the heavens and defend it there to the death. In an age of strong dynastic rivals, political regimes had no better protection than a well-documented history grounded in ancient legal and political precedent, and appealingly presented by the court painters of the age.

The electoral Saxon court prided itself on being a devout Christian

regime, the counterpart of history's fallen, immoral "Borgia courts." From that righteous perspective Frederick the Wise sang his regime's praises with moral-religious fervor. A man of many mottos, he turned one of them into an acronym that was in turn embroidered on the official uniforms of his court servants, proclaiming: "*The Word of God Endures Forever.*"[2]

Hired to refresh and project Saxony's public image, select biblical and mythological figures became powerful links in the regime's pedigree.[3] From this perspective, the court painter may appear to have been just another "company man," a glorified "scribe" whose artworks were propaganda links in a long historical chain. Yet, although raw politics was everything to the state, it seldom exhausted a work of art, or defeated the artist's urge to expose the pedestrian and horrific sides of political life.

Both in life and in art Cranach was well acquainted with "political expediency." His numerous artworks served the political goals of both church and state. Yet, among those works, one also finds much storytelling that could only ennoble a ruling prince and lift up his subjects. In no genre was that truer of Cranach's artwork than in his painted stories of biblical and classical women.

His portrayals drew on the literary works of the court humanists, who also addressed subjects beyond politics and war. They, too, conjured and projected new worlds and opportunities beyond cold historical fact. Paid to introduce his fellow Saxons to their distant historical forbearers, Cranach's artistry bounced his viewers from past to present and back again. In doing so art put the hot issues of celibacy and marriage, gender and sexuality, family and society, directly before the electoral court.

Although the Saxon elector always exalted the moral fiber of his court over those of his rivals, his Saxon subjects dearly wanted to have their own vices and depravity. At the time of his death, Frederick confirmed a poorly kept secret by leaving behind legacies for two out-of-wedlock children of his own. Also among the decorative scenes that drew the eyes of royal visitors to the hidden walls of Wittenberg Castle was "the incredibly rich catalog of both exemplary and foul stories" to be found there. A

keeper of the common touch, Cranach was the first German painter to take seriously such plainspoken decorative castle art that remained embedded in old tapestries, hidden in out-of-the-way cabinets, and otherwise scattered about the castle in aged wall graphics.[4]

In such matters, Cranach went where other artists feared to go, and in doing so he created more "firsts" in the art of his age than any other contemporary artist. Historian Ingrid Schulze singled him out among his peers as the Renaissance artist who knew women best and helped them most. She credits him with "having grasped the erotic nuances of a woman's body with greater sensitivity than any other contemporary artist," concluding that he was the right artist to address the issues of gender in a transformational age.

> One should not forget that the age's top tier of burghers within humanist ranks were anything but prudes. Visual pleasure and a zest for life played a big role in their lives, moving them to embrace classical antiquity as the bearer of an ideal of physical beauty emphatically bound up with sexuality.[5]

Before the workshop started turning out high-quality paintings of nude women in unprecedented quantity, Cranach had made his artistic peace with the female body. He rejected the larger-than-life heroic portrayals popular in High Renaissance circles. In full flight from the era's ill-painted, ponderous women, the new "Wittenberg style" presented a spare, lyrical, silhouetted woman, henceforth to become the "Cranach woman." For all the present-day criticism and cartooning of this lithe, willowy female, she was then, as is her modern counterpart today, a true artistic evolution of womankind.

Upon first seeing the new Cranach woman, the viewer is struck by nothing so much as the absence of "volume." Compared with the heroic High Renaissance nude, the Cranach nude presents reduced breasts and a deemphasized derriere. As a rule, he neither diminished nor exaggerated the gender-specific features of the female anatomy. If ever he erred in such matters, it was on the side of understatement. By excising the external

Wallpaper designed by Cranach, St. Nicolai Church, Coswig,
Sachsen-Anhalt, Germany

girth of the High Renaissance woman, he set free her inner mirth. The result was more engrossing than the direct touching of skin and flesh. Whether clothed or naked, the stylish and savvy Cranach woman enchanted the viewer with a radiant, transparent persona.

In stories retold from antiquity, Cranach's biblical and classical women beguiled both their male suitors and tormentors. More often than not these women did with men as they wished, serving them up their just deserts. Whether the foils were kings or philosophers, tyrants or prophets, they were no match for a beautiful, clever, and determined woman.

Together with their own marriages and household companionships, it was in biblical stories and classical myths that the reformers confirmed womankind's inner powers. Those powers began with the ability to create and deliver new life, thereafter to feed and nurture it, discipline and protect it, educate and send it out into the world, there to build and to serve: all empirical "truths" of observed human nature.

Thus enlightened and armed, the reformers assailed Rome's efforts to bottle up the divine seminal fluids and stamp out the primordial sparks of human life with the rules of celibacy, chastity, and preemptive church interventions into lay life. For the reformers there existed only one safe refuge from papal harassment and only one sure harness to hold human sexuality to its intended purpose and proper end: the divine estate of marriage, household, and family.

THE BIBLICAL STORIES

Following the example of the Trojan warrior Paris, Cranach also chose Venus over the now expanded competition, which for him included the classical rivals (Hera and Athena), the biblical mother of humankind (Eve), and the mother of God (Mary). Having earlier been swept off his feet by the women of classical antiquity, Cranach plunged into the Old Testament stories, finding them every bit as riveting as those of classical antiquity.

After the story of Adam and Eve, the Old Testament presented numerous characters, both male and female, royal and plebeian. The rich

biblical archive gave the reformers just what they needed to frame their civic-domestic and moral-religious reforms. And making it all the easier for the workshop, the Old Testament stories, like those of classical mythology, were filled with sexuality and the war between the sexes.

David and Bathsheba

In the story of David and Bathsheba a great king arranges the death of one of his top generals so that he might take the general's wife for his own. The story is one of several paradigmatic tales of lust as only biblical women can arouse it. Both Cranach Sr. and Cranach Jr. sketched, or painted, scenes of the voyeuristic King David as he ogled Bathsheba during her bath on a riverbank near the king's castle retreat.[6]

Both Cranachs present this biblical story as a commentary on the Sixth Commandment: "Thou Shalt Not Commit Adultery." In the mid-to-late 1520s and during the 1530s, father and son interpreted the story independently of each other. In the end both expressed ambiguity, if not doubt, about placing primary blame on Bathsheba.[7]

Cranach Sr.'s sketch of the story shows Bathsheba hiking her dress up to her knees, while her eyes, and apparently those of one of her maidens, searched for those of King David. This was the "locking of the eyes" in the "fateful [sexual] stare" that sowed the seeds of the pair's mutual adultery and the king's murder of her husband.[8]

In his 1526 painting of the same scene, Cranach Sr. changes the earlier storyline by portraying Bathsheba and her attendants as having been utterly oblivious of the king. As one of her servants washes Bathsheba's feet, the king feasts his eyes upon her. Again, she and her attendants do not reciprocate his "penetrating gaze," eye contact as lethal as Amor's arrows of love. Thus was King David marked as the sole aggressor.

In Lucas Jr.'s renderings of the scene circa 1537, Bathsheba is both blamed for the affair and exonerated of it. The son's substantial painting of his father's earlier etching (1526) catches Bathsheba sitting on a riverbank with her servant washing her feet in a pool of still, clear water, into which she gazes. Upstream, the king and his servants sit in a befogged

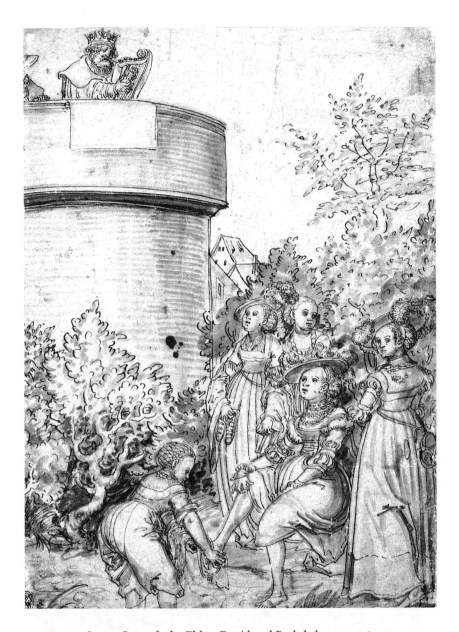

Lucas Cranach the Elder, *David and Bathsheba,* ca. 1526.
Pen and brown ink, gray wash, 10⅝ × 7¾ in.
(Kupferstichkabinett, Staatliche Museen, Berlin, Germany;
Photo: Jörg P. Anders, Bildarchiv Preussischer Kulturbesitz/Art Resource, New York)

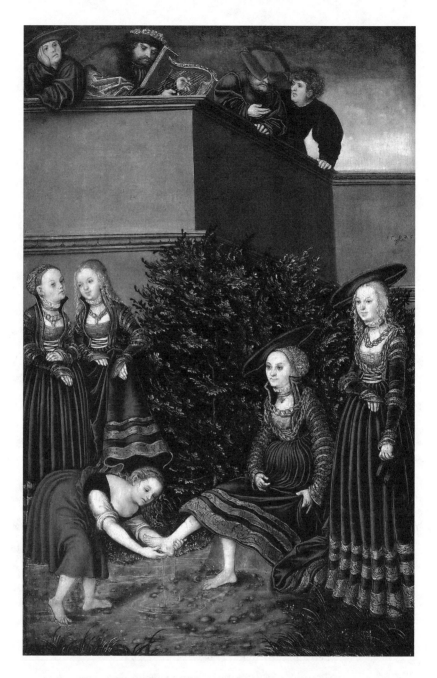

Lucas Cranach the Elder, *David and Bathsheba,* 1526.

Oil on red beech wood, 15 ¼ × 10 ⅛ in.

(Gemäldegalerie, Staatliche Museen, Berlin, Germany;

Photo: Jörg P. Anders, Bildarchiv Preussischer Kulturbesitz/Art Resource, New York)

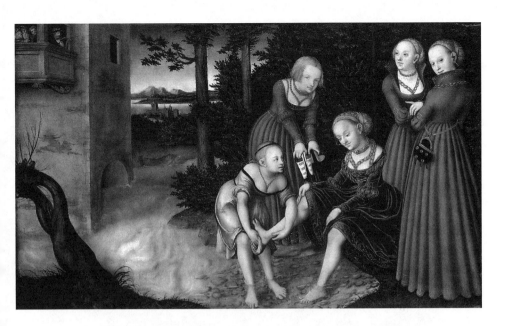

Lucas Cranach the Younger, *David and Bathsheba*, ca. 1537
(Kunstsammlungen Chemnitz, Dresden, Germany;
Photo: Klut; by kind permission from Gemäldegalerie Alte Meister, Dresden)

parapet extending out from the castle wall into the surrounding moat. Compared with Bathsheba's tame riverbank bath scene, the king's balcony rather suggests a netherworld.

Bathsheba's eyes are fixed on her feet, not on the king, again eluding the "sinful stare." However, two of her attendants (on the right) seductively cast their eyes at the king, one giving the viewer a come-hither stare, while the other points a stiff finger at the king, as if to say: "I'll take that one!"

Whatever sympathy Lucas Jr. may have harbored for Bathsheba, he, unlike his father, did not exonerate any of the women from predatory flirtation. That conclusion is suggested by the post-1537 watercolor of the scene, adapted from his father's circa 1526 copper etching. Whereas the father's etching depicts Bathsheba and her maidens looking up and away from the king, Lucas Jr.'s watercolor of the same scene shows her throwing her head back and staring directly at the parapet, apparently searching for the face of the king. If such positioning is not enough to incriminate her, it may be noticed that her legs are agape and her dress is rolled up above

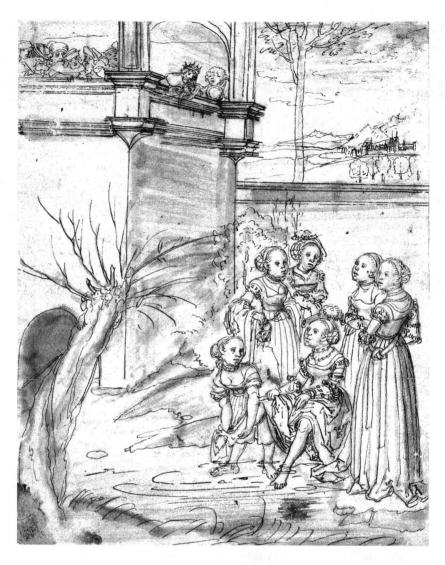

Lucas Cranach the Younger, *David and Bathsheba*, ca. 1537. Oil on wood.
(Staatliche Kunstsammlungen, Dresden, Germany;
Photo: Bildarchiv Preussischer Kulturbesitz/Art Resource, New York)

her knees, revealing bare skin all the way up to the kneecaps with a promissory peek beyond![9]

In these various portrayals, King David personifies the age's presumed universal male response when confronted with feminine beauty. Having begun with a mere flash of ankle, the greatest king of the Old

Testament is incrementally and uncontrollably drawn into Bathsheba's web. For Cranach's contemporaries this was predictable behavior whenever the eyes of a male fell on a beautiful female.[10]

Samson and Delilah

Samson, the last Israelite judge before Samuel (Judges 13–16), was renowned for having single-handedly killed a thousand Philistines with the jawbone of an ass. Yet, his judicious mind and Herculean strength were no match for the charms of Delilah. Having been told early in the relationship that his enemies had promised Delilah 1,100 pieces of silver to discover and deliver the secret of his strength, the infatuated biblical strongman blurted it out on her first request: "My secret? I am a Nazarene of God, and my uncut hair makes me invincible!"

Cranach was the first artist north of the Alps to paint this Old Testament story, all earlier versions of it having been either etchings or woodcuts. In the biblical account, Delilah summons a Philistine to shave away Samson's locks after she has caressed him into a deep sleep. In the contemporary telling of the story, it was Delilah herself, not a Philistine, who gave mighty Samson his first and last haircut. Convinced that women held the advantage in the battle of the sexes, Cranach's audience would have found it absurd had Delilah not finished what she started, hence her starring, if not quite biblically accurate, role in Samson's destruction.

HOMICIDES AND SUICIDES

Salome

Throughout history one finds examples of wise, holy, and powerful men stripped of their powers by women they thwarted, scorned, or otherwise alienated. In Cranach's world women settled their scores with the opposite sex in various stages of dress, or undress, some impeccably attired from head to toe, others taking down their prey naked, "undressed to kill."

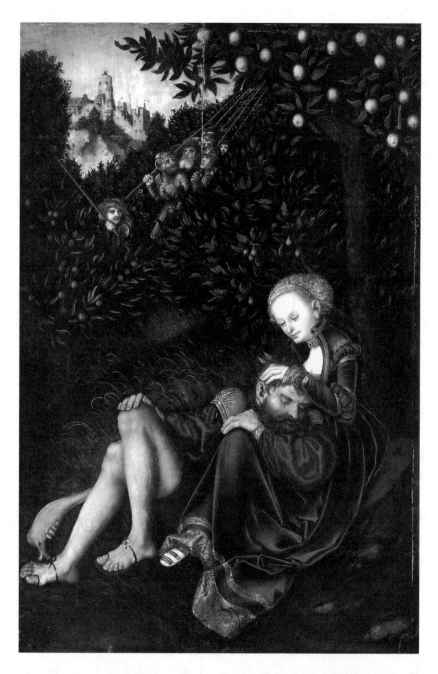

Lucas Cranach the Elder, *Samson and Delilah*. Oil on wood, 22½ × 14⅞ in.
(Bequest of Joan Whitney Payson, 1975 [1976.201.11], The Metropolitan
Museum of Art, New York; Image copyright © The Metropolitan Museum of
Art/Art Resource, New York)

One such clever, vindictive woman who successfully took the life of a perceived family enemy was the youthful stepdaughter of Tetrarch Herod Antipas. Her name was Salome, and her family included the supreme rulers of the age. Yet, for all their great power, a prominent man of God exposed the tetrarch's failings and thwarted his will when he defied the laws of God. That brave man of God was the prophet John the Baptist.

Taking the high moral and religious ground, John had condemned Herod's illegally contrived marriage to his sister-in-law, Herodias. For John, the marriage was made in hell and possible on earth only by a double adultery: Herod having put away his lawful wife by fiat, while Herodias abandoned her lawful husband, the king's half-brother, Philipp, to become Herod's wife.

Deeply affronted and harboring grudges as only royals can do, Salome and her mother plotted to rid themselves of the righteous Baptist. But for Herod's fears of the holy man and a concurrent revolt by the Jews, he would in all likelihood have preemptively executed John and married Herodias outright as he pleased.

As the biblical story tells it, Salome and her mother laid their own death trap for the Baptist. After an erotic veil dance celebrating the king's birthday, Salome's besotted stepfather swore a public oath to fulfill her fondest wish, whatever it might be. Before the king could catch himself and give the matter a second thought, Salome demanded the head of John the Baptist. Publicly bound to his sworn oath, and aware of the threat to his rule if he failed to keep it, Herod granted Salome her morbid wish.

At the conclusion of the story, a triumphant Salome nonchalantly approached her stepfather's table with her trophy kill on a pewter platter, as if she were serving up the first dinner course. Upon viewing his enemy's head, the now rueful king waved the deathly plate away as he recoiled from the horror before him.

In the end, the severed head of the Baptist became a daughter's gift to her masterminding mother, who is seen at the table fighting off smirks and glee, as the family celebrated its cruel success.

If there is a moral in this story it must surely be this: There *is* a wrath

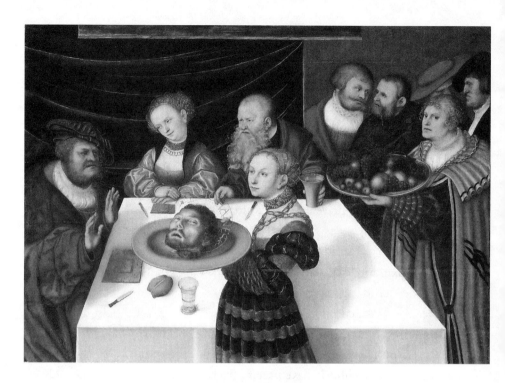

Lucas Cranach the Elder, *The Feast of Herod*, 1531
(Photo: Städel Museum/ARTOTHEK)

greater than that of a woman scorned. It is the wrath of *two* women thwarted, one of whom has a fan dance like no other.[11]

Judith

The apocryphal story of the Hebrew widow and heroine Judith is set in the reign of the Babylonian king Nebuchadnezzar (605–562 BC), an era when the Hebrews and the Babylonians battled one another to the death. The story revolves around the king's field general, the tyrant Holofernes, who besieged Judith's city of Bethulia and proceeded to cut off its water supply.

Under that dire threat, Judith plotted to bring down the famous general single-handedly by her lethal womanly charms. Accompanied by her handmaiden, she made her way to the tyrant's field camp, where the two of them presented themselves as defectors from the Hebrew faith. By

that bold strategy, Judith gained the only advantage a clever, beautiful, and determined woman requires to undo a powerful tyrant: close proximity to him.

Upon their meeting, Holofernes was captivated by her beauty and derring-do. As was the wont of such a man, he invited her to join him at his table. According to her plan, no sooner was the meal finished than he forcibly took her to his bed and ravished her. In the wee small hours of the morning as the tyrant swooned in a drunken sleep, Judith took his great sword in hand and beheaded him, as she knew she would. Bagging the severed head to be taken back home as a trophy to rally her people, she and her handmaiden quickly fled the camp undetected.

In later paintings (1530) of the story, Cranach depicts Judith's direct "engagements" with the field general: the sharing of his table and his bed, and her taking of his head in return. In the late 1520s and 1530s the Cranach workshop produced a dozen scenes of the heroine as she outmaneuvered and killed her prey.[12]

For the story's death scene (1526–30), he presents Judith in an extravagant dress, her hands tightly gloved in silk, displaying eight outsized rings of gold and silver, three on one hand and five on the other. She holds the sword of justice in one hand while maintaining a mauling grip on the tyrant's thick black hair with the other. Calmly tilting back his severed head, she shows the viewer his bled-out neck. Her placid face and penetrating eyes proclaim the triumph of the just, as the general's rolled-back eyes present the death mask of the unrighteous.[13]

The 1531 portrayal was also a commemoration of the founding year of the Schmalkaldic League, the first confessional alliance of Protestant lands and imperial cities created for the defense of Evangelical Christendom. Over the 1530s and '40s, the alliance sporadically engaged imperial forces in the buildup to the siege of Wittenberg in 1547, when the combined imperial armies defeated the league and occupied the city.

In the upper left background of the 1531 scene a dark, middle-aged Cranach appears behind a tree, dressed in a pelt coat. His face and hands point to Judith as she sits at the table with the king in what was the artist's personal gesture of support for both Judith and the new Protestant

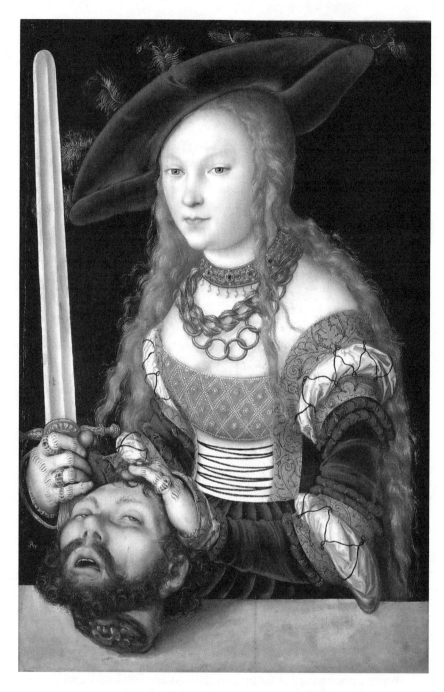

Lucas Cranach the Elder, *Judith with the Head of Holofernes*, ca. 1530
(Kunsthistorisches Museum, Vienna, Austria;
Photo: Erich Lessing/Art Resource, New York)

league. Also appearing in the same scene is Landgrave Philipp of Hesse, who joined Elector John Frederick of Saxony at the helm of the new league. Standing at the far end of the table, his eyes ablaze, Prince Philipp holds in his hands a great pike that reaches up beyond the picture frame into the heavens, an apparent boast of Protestant righteousness and in- vincibility.[14] The inference is that the league, like Judith herself, is a bearer of divine authority and justice, and will ultimately be no less triumphant.

Lucretia

Unlike the stories of Salome and Judith, that of Lucretia ends not with a stealthy murder of her tormentors, but with her own quiet suicide. Hers is a story of self-imposed guilt and familial-societal shame brought on by irretrievable loss of self-respect and honor that was no fault of her own. Over the late 1520s and through the 1530s, Cranach painted eight-plus representations of Lucretia, each a different shape and size, age and social standing, all brave women telling the same story of irreparable male brutality.[15]

The core, classical Roman story of Lucretia is that of an attractive, virtuous daughter of a patrician family who became the wife of an army commander. For reasons unexplained, but readily surmised, the eldest son and successor of King Sextus Tarquinius Superbus, called Sextus, became infatuated with Lucretia and began a sustained campaign to co- erce her into having sex with him. When she rebuffed his every overture and demand, he resorted to blackmail.

The unyielding Sextus told her bluntly that he would kill her and posi- tion her body alongside that of a slain slave if she did not submit to him. And, he continued, when the two bodies are found entangled together, he would swear an oath to the authorities that he came upon them as they were making love, and given the great outrage of such foul mixing of the social classes, he could not restrain himself from killing them both on the spot, thus leaving Lucretia shamed forevermore in both life and death.

As Lucretia weighed her options, she convinced herself that there was no escaping the ruination of her honor by young Sextus. Having thus far

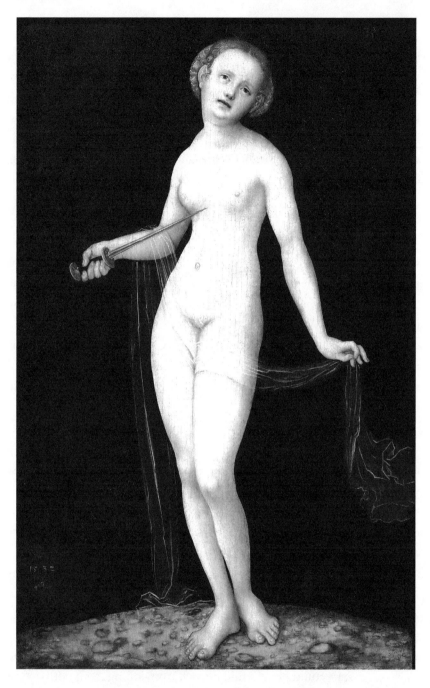

Lucas Cranach the Elder, *Lucretia*, 1532. Distemper on wood, 14¾ × 9⅝ in.
(Akademie der Bildenden Künste, Vienna, Austria;
Photo: Erich Lessing/Art Resource, New York)

tormented his victim with impunity, Sextus took the final step by forcibly raping her. Soon after the event, she told her husband and father everything. Shattered by personal embarrassment and family disgrace, she concluded that her only honorable course was to take her life in the hope that a better one awaited her.

Cranach depicts her as a tortured and broken woman. Each portrayal shows her alone with a dagger poised under her sternum just touching her skin, but not yet drawing blood.[16] The pain of dishonor and approaching death contorts her face as she prepares to push the dagger into her heart. Unknown to her, in what may have been a small moral victory in the aftermath of her suicide, her powerful family proceeded to resist the Tarquinian monarchy, and by doing so contributed to its eventual demise and replacement by the Roman Republic.

Lot and His Daughters

The story of Lot and his daughters may be the strangest of all biblical cautionary tales. It is set in the godless city of Sodom at its moral-spiritual nadir, a time when one could not find ten good men within the city walls. Regretting that he ever created the Sodomites in his own image, God proceeded to wash his hands of them altogether. Cranach's retelling of the story is a curious, even incredulous account of idealized teenager incest in a successful attempt to save a family tree and, possibly, the entire human world beyond.

Compared with the residents of Sodom, Lot's family was righteous, so God spared it the death by fire and brimstone he visited upon the godless city. However, during their flight from Sodom, Lot's wife put them in no less jeopardy by succumbing to the mortal sin of Eve. Against God's emphatic command, she looked back on the burning city as the family fled, for which willful disobedience she was famously reduced to a pillar of salt.

Now the last remnants of their family, and for all they knew all of human life, the three of them, father and two daughters, found themselves completely alone in a desolate world (Gen. 19:12). With a sudden, strained idealism, Lot's youthful daughters resolved to save at least their

family's progeny from impending extinction. As the girls were in their mid-teens and had recently been engaged to men who perished in the Sodom firestorm, a happy picture of marriage, sex, and family still lingered in their saddened hearts.

In such dire straits, they came face to face with the fate of never having proper husbands to give them proper offspring and perpetuate their clan. Whether their pondering was long or short, it dawned on the daughters that the only proven fertile man in their lives was their father, whom the daughters now looked on as the family's last, best hope of longevity: Lot would provide the seed to continue the family line and possibly all of humanity. As Eve had been born of Adam, Lot's grandchildren would be born of their grandfather in a similar miracle of new birth and creation.

With such desperate hopes the daughters resolved to pursue an unlawful means of procreation: they would bear children incestuously by taking the seed of their father.

How that might come about is as complicated as only a biblical story can be. In the months before their exodus from Sodom, Holy Scripture tells us, a male mob reportedly burst into Lot's family home in search of two rumored visiting angels, whom the mob intended to ravage. To save the blessed angels from such a fate, Lot, in an instinctively proper, yet arguably misguided, display of hospitality, offered his virgin daughters up to the mob in the place of the two angels. In doing so, he put his obligation as a host above his paternal duty to protect his children. Between the mob's intentions and their father's "hospitality" the Lot daughters understandably had to take their destiny into their own hands. They were spared the ordeal of the mob at this time, as it had greater interest in the angels from on high than in Lot's lowly daughters.

Whatever the reasoning behind Lot's "hospitality," his willingness to turn his daughters over to a mob could only have confirmed their desire to take their lives into their own hands. Becoming mothers by the seed of their father was preferable to falling into the hands of the mob.

Fearing that their father would not voluntarily inseminate them, the daughters increased the odds of his compliance by plying him with wine.

In Cranach's portrayals, the reclining daughter's legs are spread in antici-
pation, while the father's legs remain crossed awkwardly in what looks
like a tentative gesture meaning: "No, thanks, please!"[17]

The ending and moral of this story are also of great biblical com-
plexity. Both daughters were impregnated by their father and delivered
healthy boys who grew up to be leading Hebrew tribesmen. By its silence,
the Old Testament implies that God took no offense at the daughters' and
the father's transgression of the incest taboo. Apparently the daughters'
benevolent desire to salvage the future of their family, and perhaps of all
humankind, made their gamble forgivable in the eyes of God.

At this time and place in Wittenberg's history, however, Cranach's
contemporaries would not have joined the author of the Book of Genesis
in excusing acts of incest, no matter the motives of Lot's daughters and the
stakes at hand. Not only had these young virgins been contemplating
their wedding night for months, their own father had also recently offered
them up to be gang-raped! Libidinous thoughts of first sex and fears of
illicit, or forced, sex were surely resonating in their impressionable minds.

Despite the upbeat biblical ending, in the judgment of contemporary
Wittenberg citizens, the daughters' worst fears were realized in the mo-
ment their drunken father inseminated them.

The reader may well ask: how did such biblical art advance the Protes-
tant Reformation, and what does it tell us about the Wittenberg court
painter? What is arguably the strangest of all Old Testament stories, that
of Lot and his Daughters, exposes to the viewer the awesome power of the
human sex drive, which, in the guise of the "divine estate of marriage,"
Luther would have the reader believe was also the main force behind the
Reformation. Under the stresses that befell Lot's family, the incest taboo
proved to be a paper tiger. And if the deeply internalized and honored
incest taboo cannot command and restrain the human sex drive, how
much more presumptuous must Rome's rules of clerical celibacy and
lay chastity be? From the reformers' perspective, Rome's rules of "sex-
ual modification" in domestic marriage had deeply frustrated and frag-
mented the sovereign estate of marriage as God had ordained it.

Cranach's art and Luther's sermons warn time after time against

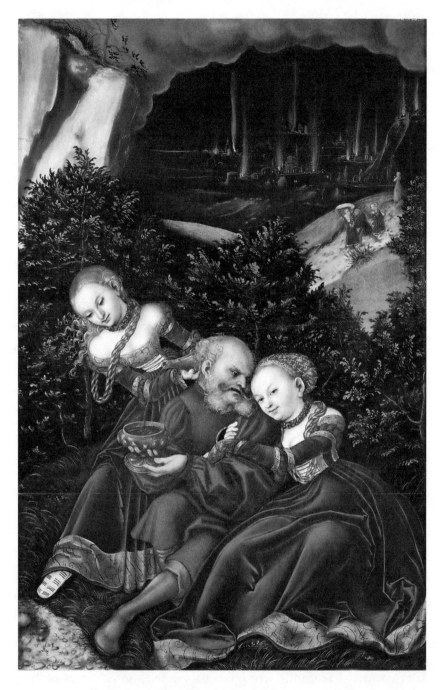

Lucas Cranach the Elder, *Lot and His Daughters*, 1528
(Kunsthistorisches Museum, Vienna, Austria;
Photo: Erich Lessing/Art Resource, New York)

misguided repression of the sex drive, which permeates human nature and is godlike in its ability to create and maintain human life. In keeping it on a proper course, it requires and responds best to the internal pressures and pleasures that only the intimacy and privacy of the estate of marriage can properly deliver.

TESTING TESTOSTERONE

In proving the sex drive to be unconquerable this side of eternity, the challenge Cranach's women posed for contemporary viewers is nowhere more powerfully delivered than in his portrayal of *The Sleeping Nymph of the Fountain* (1530). For the age, she was a true sextet of temptation. She is utterly naked, alone in a wood, transparent, but not completely disenchanted, sumptuously feminine, conveniently supine, and presently sound asleep. If that were not vulnerability enough, she also has the company of two partridges "drilling" the ground around her with their beaks. The partridges are symbols of both Satan and the church. They steal eggs from other birds, as Satan takes souls away from God. Although more often than not they bode ill, they may also protect and save souls. Taken together with the bow and quiver of arrows that hang from a nearby tree, the signs rather favor moral danger.

The nymph's protective measures are a translucent veil and tightly crossed legs (badges of loyalty and purity). There is also an engraved request to passersby, which pleads: "I AM THE NYMPH OF THE SPRING, DO NOT AWAKEN ME." For her male viewers she poses a conflict between self-indulgence ("Shall I?") and self-control ("No!"). Those who stop and stare soon find themselves aroused and tempted, while those who hurry by her are spared the character-building crossroads of moral confrontation and decision.

Without the embedded request, a passerby might well think himself free to take advantage of the situation. In this test of gallantry and virtue, that request awakens the passerby's conscience, alerting his better self. Will the viewer heed her plea and take the higher road, or will his lust convince him that her plea is just a titillating "dare," thus urging him on?

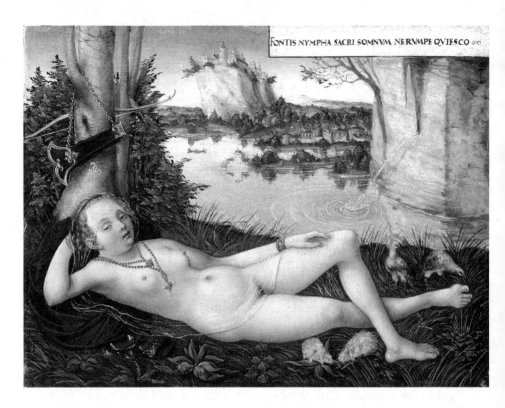

FONTIS NYMPHA SACRI SOMNVM NE RVMPE QVIESCO ᚙᚙ

Lucas Cranach the Elder, *The Sleeping Nymph of the Fountain* (Nymph of the Spring), 1530. Oil on beech panel, 6 × 8 in.
(Robert Lehman Collection, 1975 [1975.1.136], The Metropolitan Museum of Art, New York; Photo: Schecter Lee, Image copyright © The Metropolitan Museum of Art/Art Resource, New York)

In evaluating erotic artworks in a deeply religious era, one discovers that the most sacred religious images are conveyed to audiences by the very same formulas and techniques that deliver alleged "pornography." Completely *asexual* representations, images no viewer in his right mind would associate with *eros,* also draw the same carnal-minded, sensation-seeking viewers to Cranach's grotesque crucifixion scenes. Presumed to be uplifting, the blunt image of Christ's death on the cross has a raw, depressive effect on the viewer, both attracting and repelling him. In horrifying scenes of Christ's beaten and bloodied body hanging limp upon the cross, seemingly held together only by his feisty loincloth, Cra-

nach is not addressing the viewer's libido, but rather testing his spiritual mettle by making the viewer share the death throes with his Savior to the bitter end.[18]

The purpose of such religious art was no different than that of a Cranach nude's moral challenge. Both artworks powerfully confront the viewer, one erotically, the other religiously. Yet the intent of both is to shake up the viewer and force a self-examination in a hoped-for promise of moral awakening.

Despite completely different iconographies, both Cranach's nudes and his religious images succeed by the self-same artistic process. His representations of the nude body of Venus and the semi-nude body of the crucified Christ stopped sixteenth-century viewers in their tracks, leaving them to ponder their own lives before a work of art as if they were looking directly into the truest of mirrors. The sexual element in the one and the grotesque element in the other are the "hooks" that bring their viewers into the scene, there to behold and rediscover themselves morally and spiritually.

THE JUDGMENT OF PARIS:
STILL JUDGING AFTER ALL THIS TIME

Years after the founding of the electoral Saxon state in 1485, even in the late 1520s and throughout the 1530s Wittenberg's brain trust pored over the ancient texts and medieval chronicles of the contiguous lands of Saxony, Thuringia, and Meissen. They did so in a constant quest for historical precedents (political, genealogical, legal, literary, and not least artistic) that might boost the regime's prestige in diplomacy with both allies and adversaries. As a rule of thumb, the older and surer a documented lineage, the more confident, secure, and bolder the land.

Compared with the many late-medieval German cities that began their local histories with Adam and Eve, these proclaimed distant bonds with biblical and classical antiquity were not so far-fetched. The Saxon regime and its rivals did not dismiss their ancient counterparts as merely mythical and allegorical. They rather embraced the heroes and heroines

of antiquity as if they were their immediate forebears, a true distant mirror in which the "old" can be seen seeding the "new." By tracing their land's lineage back to the Trojan warrior Paris and his son, Francus, the reputed founders of the kingdom of France, the electoral Saxon regime claimed a historical pedigree that gave pause to both friends and foes in neighboring lands.[19]

Cranach first portrayed the story of Paris in a court-commissioned woodcut celebrating Saxony's historical link with the shrine of the "Magdeburg Venus." In 1512–14, and again in the decade between 1527 and 1537, the artist presented the scene in more appealing versions. As its popularity grew in courtly circles over the years, the scene of *The Judgment of [the Trojan Warrior] Paris* became a popular, "private best seller."[20]

There exist today eight late paintings of Paris with Venus and her sister goddesses, each more artistically engaging than the original woodcut dating back to 1508, while still faithful to the story's plot. Throughout the subsequent portrayals, Cranach's signature landscape remains intact, and so do the dramatis personae. With the passage of time, however, the story was elaborated and fleshed out. By the 1530s it featured a (now plucky) horse, the god Jupiter, and the three goddesses Venus, Juno, and Minerva, along with Paris.[21] The prominent late addition to the scene, missing in earlier versions, is the presence of Amor, the son of Venus. Armed with his lethal bow and quiver of arrows, Amor patrols the scene in flight from on high, unrestrained by his erstwhile cautious mother, a major reinterpretation of the famous pair.

Remembering his earlier representation, Cranach picks up the story of Paris at the moment Jupiter comes upon the lone warrior, recently returned from fighting, still fully armored and presently lost and wandering about in a wood. In the classical story line, the chief god was searching Paris out at the request of the three goddesses, who had importuned him to choose among them the fairest—a chore that Jupiter, in his great wisdom, had already planned to impose on the mortal human Paris.

Thus did Paris awaken to find himself in a mythological dream world facing a true enough challenge. In the famous scene the lightly armored Jupiter introduces Paris to the queued, nude goddesses so eager to win his

blessing. With their egos and hopes as fully in view as their naked bodies, the goddesses give the appearance of teenagers preening as they join Jupiter in persuading Paris to referee their beauty pageant.

According to a text by the ancient rhetorician and historian Lucian of Samosata, it was Darius Phrygius, the historian of the Trojan wars, who passed down the information that Paris asked the goddesses to remove their clothes so that he might judge them "truly and thoroughly."[22] That the goddesses were judged in the buff was not a strict requirement of either the ancient classical story or Cranach's retelling of it. His existing model for the scene was a 1502 woodcut by an unknown master, who presented the three goddesses fully clothed. Cranach apparently got the idea of presenting them nude from an etching of the scene by his Wittenberg predecessor, the Italian painter Jacopo Barbari.[23]

In his new, 1530s renderings of *The Judgment of Paris* Cranach exercised the greatest possible artistic freedom in search of the strongest possible customer response. He knew a painting that featured naked, flirtatious goddesses, led by Venus, would be a roaring success for the workshop. In portraying the three eager goddesses as being quick to strip (they actually appear on the scene naked!), Cranach affirmed what he, with them, also knew well, namely that their nudity and flirtatiousness would bend Paris's will immediately to theirs. Despite his pivotal role, the goddesses had the upper hand. Indeed, from the very start Paris's judgment was compromised and skewed by the charms of Venus, the goddess of love.

In Cranach's late revival of the story, each goddess lusted to be the fairest, not in virtue but in physical appearance, to which end each offered Paris a bribe. Juno promised him dominion and riches in Asia, and Minerva, untold new powers and luck in war. It was Venus, however, who read the male heart best. She promised the prince of warriors the love of the world's most beautiful woman, Helen of Sparta, daughter of Zeus and Leda (a.k.a. Nemesis) and the wife of the Spartan king Menelaus.

Taking up Jupiter's chore, Paris passed over Juno and Minerva, scorning two powerful goddesses. Having judged Venus to be the fairest, with her help Paris abducted Helen, an act that started the Trojan wars and

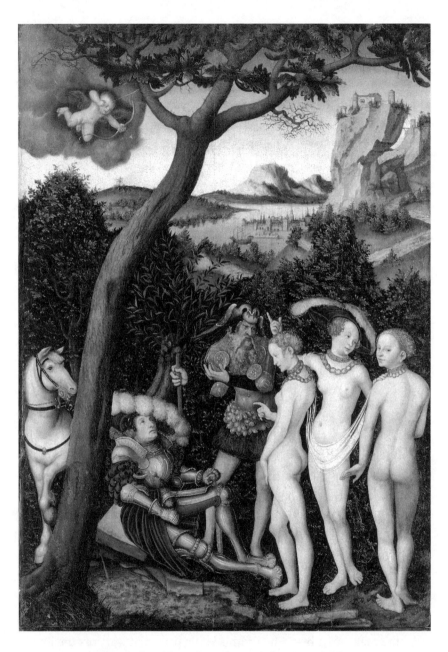

Lucas Cranach the Elder, *The Judgment of Paris,* possibly ca. 1528.

Oil on wood, 40⅛ × 28 in.

(Rogers Fund, 1928 [28.221], The Metropolitan Museum of Art, New York; Photo: Schecter
Lee, Image copyright © The Metropolitan Museum of Art/Art Resource, New York)

changed the ancient world. Despite, or perhaps because of, the story's meandering back and forth from wars and politics to nudity and sexuality, it fulfilled all expectations, both courtly and popular. The court was pleased because Paris again, through Cranach, confirmed Saxony's ties to antiquity. And Cranach and Luther, too, were pleased because the new artwork engaged the viewing public in the battle of the sexes, which promoted the reformers' now prioritized domestic-civic agenda.

By choosing Venus to gain the love of Helen, Paris again advertised the classical lessons of Cranach's nude repertoire and Luther's theology of courtship and marriage, namely, that the physical and rational powers of males are no match for female beauty and cunning in the battle of the sexes.

Still following a steep learning curve, the love-struck Paris and Helen quickly discovered the woes their extramarital love had created, and not just for themselves. There in the story was the murderous revenge of the Spartan king whom the pair had cuckolded, and thereafter more of the same interventions from the jealous goddesses Paris had passed over. The lovers' willful transgression of the estate of marriage (Helen's abduction and adultery) also turned a sizable part of the ancient world into the battlefield of the recurrent Greek-Trojan wars.[24]

Beyond the artistic confirmation of the court's historical pedigree, Cranach's *Judgment of Paris* (1530) also put a new moral-religious test before the conscientious lay viewer. Standing with Paris at the crossroads of (self-denying) virtue and (self-gratifying) lust, will the viewer run the gauntlet with him?[25] Will he lose his heart to "goddesses," succumb to their powers, take their bribes, and let them have their way with him, as he would then have in return? *Or* will the viewer keep his moral dignity and spiritual faith, outlast the temptation of lust, heed the divine imperative, appeal to God's mercy, and in the end find himself delivered from the bondage of carnal sin?

If the story of Paris's judgment was an admonition to rulers and lands to prioritize military readiness over all else in the hope of gaining peace, Venus's complementary message was one of individual restraint of passion sufficient to lead a well-measured life. In those combined lessons

from antiquity Elector Frederick the Wise found the true, basic elements of his regime's success: military prowess, moral-religious character, a just political rule, and an always open mind and ear for diplomacy, be it with allies or rivals, and near or far away.[26]

VENUS WANING, AMOR RISING:
CRANACH STEALS THE SCENE

Belatedly learning from the literary humanists that the third-century poet Theocritus had compared Venus's son Amor to a bee (both Amor and bees were "little guys" with big "stingers"), Cranach seized upon that image to sensationalize the traditional scene of Venus once again, this time at Amor's physical and poetic expense. Having already elaborated on the original story by placing mother and son in the same frame, he now updated their roles by turning them upside down.[27]

In a new pairing of the temperate mother and her rowdy son under the title *Venus and Amor as "Honey Thief"* (ca. 1531), the reckless Amor is stung by a swarm of bees while raiding a honeycomb. The bratty god-boy, widely known for his promiscuous arrows of painful love, finally gets his comeuppance. Although the pain of the honeybee's sting was a good lesson learned, it did not end the perpetrator's passion for honey, nor did it stop Amor's assault on unsuspecting lovers-to-be.

The inflicted pain did, however, inject a bit of Schadenfreude and comedy into a long, serious Venus story. Within the frame of his latest improvisation, Cranach encapsulated the lesson of the bee sting with an embedded summary: "When Cupid steals honey from the honeycomb, a bee stings his finger; likewise, the brief, passing lust we indulge leaves us with wounds that also cause us bitter pain."

Those words and the image remind the viewer of the wages of sin and the rewards of reason and discipline. In restating that received truth, the artist's intent was subversive: Cranach here *lightens* harsh judgments on erotic love. As the bees attack Amor, the personification of recklessness, the little fellow stands ever so tall. He clutches the stolen honeycomb in his hand to the very last drop, no matter the number of bee stings that

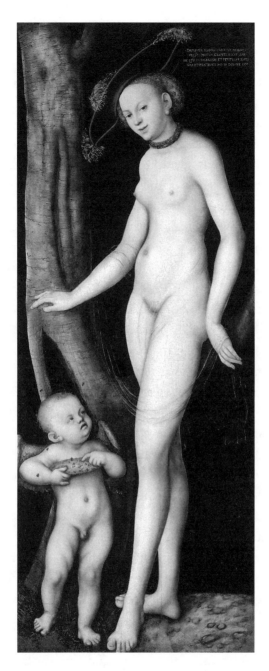

Lucas Cranach the Elder, *Venus and Amor as "Honey Thief"* (Venus and Cupid
Bearing Honeycomb), ca. 1531. Oil on wood, 66½ × 26⅜ in.
(Galleria Borghese, Rome, Italy;
Photo: Mauro Magliani for Alinari, 1997, Alinari/Art Resource, New York)

might be inflicted. Here Cranach asks the viewer a pertinent question: if the indulgence of "passing lust" is so treasured and sought after, how painful can its punishment really be?!

Making the story of Venus and Amor all the more his own, Cranach turns Venus into her reckless son's accomplice. By doing so he mitigates her classical role as restrainer and disciplinarian in matters of the heart. Although still willful and free, Amor becomes the more sober of the two, as his mother becomes all the more adventurous. Appearing Eve-like, apple tree and all, Venus seems to have "fallen" from her pedestal. She now joins Amor at the bow, targeting unsuspecting viewers with her own intoxicating love "arrows," namely, powerful come-hither stares. With her son, she now fans the fires of erotic love rather than dampen them down in good conscience. To put it succinctly, in matters of sex and love, Cranach and Venus lighten up and become Lutherans!

By 1530 Cranach had been married for eighteen years, and Luther for a still eye-opening five. Both men were well acquainted with carnal love, as Luther attests in the multiplying hours of his *Table Talk* and Cranach shares with the viewer in his proliferating nude repertoire. For at least two decades, both men battled medieval theologians and Renaissance philoso- phers over matters of courtship and marriage, sex and progeny, thereby displacing ecclesiastical-clerical sovereignty with domestic-parental in all matters of child-rearing and the household economy. Viewing life from within the Protestant estate of marriage, Cranach and Luther gave *eros* their imprimatur.

From his very early couple paintings of the Cuspinians and the Reusses to those of the Luthers in the mid-1520s and 1530s—not to mention the good fathers and mothers, uncles and aunts, that he also depicted the Saxon electors and other royals to be—Cranach portrayed marriage, par- enthood, and child-rearing in the most down-to-earth and pragmatic ways. In his mythological scenes of Venus and Amor, he hymns the mother and her child just as he had done the magic circle of companionship and family that was the blessed estate of marriage.

Cranach's late innovations on the story of Venus and Amor were part of that celebration and they appear to have no contemporary parallel. Be-

ginning with a 1509 woodcut of Venus and Amor and extending the scene through the 1530s, the mythical pair caught the attention of nineteenth- and twentieth-century painters, who were drawn wide-eyed into Cranach's world, by none other than Pablo Picasso.

The four of them, Cranach and Picasso, Venus and Amor, are now part of the centuries-old Venus story as it stands today. Cranach's abrupt new twists in that story were twofold and confirm Venus's conquest of him. The first was the imposition of poetic justice and comic relief on Amor's long string of mischief: "the great stinger at last stung!" The second twist was Venus's loss of will in restraining her son. In this turn of the story, the spirited disciplinarian and guardian of the classical "mean" became the "classical Eve," who now, with some help from Cranach, eased up on *eros,* erotic love. No longer begrudging the god-boy's raids on unsuspecting hearts, or lapses in disciplined lives, the carnal pleasures mortal souls so yearn for were now there for the taking, both the indulgence and the pain!

THE WORLD WE HAVE LOST

Inasmuch as Cranach was Martin Luther's best friend and most effective ally during the Reformation's birth and maturation, it may seem belittling that so many modern artists and art historians remember him most for his painted nudes. If that latter appreciation is intended to praise the painter's portrayal of life in the round, leaving no part of it off his canvas, one may forgive the critics' narrowness. Luther may also claim a share of that rude repertoire's success inasmuch as no other cleric of the age wrote more often or more openly about the bodily life, particularly his own. Who but Luther could denounce Rome's rule of clerical celibacy and related impediments to lay courtship, sex, and marriage as "selling vulvas and genitals"—and get away with it![28] He also wrote as graphically about carnal bliss in the marital bed as Cranach painted it there.

Upon the approach of court secretary Spalatin's wedding day in 1525, a recently married Luther wrote to his friend about what the two of them now had in common, which was, as Luther put it: "a Katherine." Spalatin's

bride-to-be, like Luther's wife, was also named Katherine. As Luther was at this time traveling and away from Wittenberg, he could not attend the Spalatins' wedding. However, he promised his friend that he and Katie would be with them in both body and soul on their wedding night.

And just how might that occur? Although far away from the newlyweds, Martin and Katie pledged to celebrate their wedding vows at the very same time and in the very same way they knew the Spalatins would be celebrating theirs. As Luther put it: "I will make love to my Katherine / while you are making love to yours / and therein [the four of us, together at one and the same time] / will be united in love."[29] Here were romantic words and carnal actions worthy of Venus and Amor!

As Cranach had done in his lifetime with the works of Dürer, modern artists, from time to time, also broaden and sharpen their skills by paraphrasing the works of artists they admire, or envy, in their own chosen style. Among the old masters frequently chosen for such exercises Cranach has been a modern favorite. Beginning in 1942, Picasso seized upon a number of his artworks, among them the figures of Venus and Amor, which he quickly rendered in his own expressive style.[30] In doing so the most famous artist of the twentieth century brought Cranach's quietly embedded sexuality howling to the surface in a pen-and-ink drawing. The result, some would say, personifies Venus and Amor as infected, grotesque sexual organs in painful full cry, the modern artist's way of sharing his dark perception of his own world by comparison with that of the German Renaissance and Reformation.[31]

In Cranach's portrayal of Venus and Amor five centuries ago, the artist discovered that erotic love was not so fearsome and condemnable as the medieval clerical world alleged. Luther and Cranach rather believed that self-indulgent erotic love (*eros*) and self-denying spiritual love (*agape*) had cohabited in the human body and soul, perhaps uncomfortably, but not necessarily unrewardingly, since Adam and Eve. Advanced by the sixteenth-century reformers, this biblical-classical image of man and woman still today has great currency in the world, mostly positive. Unlike modern voyeurs who quest only after self-gratification, their sixteenth-century counterparts, upon beholding a Cranach nude,

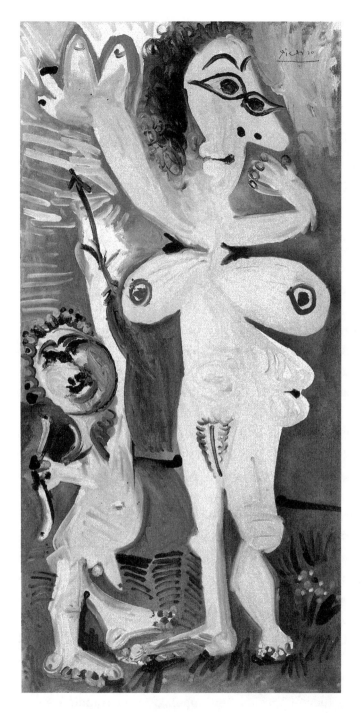

Pablo Picasso (1881–1973), *Venus et Amor*, 1968

(Photo: © Succession Picasso/VG Bild-Kunst, Bonn 2010)

could at one and the same time experience base erotic desire and engage in a heartfelt spiritual struggle whose outcome was neither dark nor forever.

By contrast, Picasso's ugly stripped-down paraphrases of Venus and Amor have no room for a kinder, transcendent vision of humankind, which earlier civilizations and quite a few people still today embrace eagerly. In the modern artist's paraphrase of Cranach's artwork, Amor's bee sting becomes a metaphor for syphilis, a disease that progressively riddles the body, mind, and soul, leaving behind a grotesque image of what lies ahead for all humankind.

At the height of the Reformation in 1520s Wittenberg, syphilis was also a scourge. As it spread through the city, Luther warned his students to stay away from the prostitutes they were accustomed to meeting at the Elbe River. Six centuries ago Cranach could have made the same association while painting *Venus and Amor as a "Honey Thief"*: thrown up his hands and left the matter fatally there.[32]

That neither he, nor Luther, took such a course suggests the greater complexity, opportunity, and resolve within the intertwined moral-religious, domestic-familial world of the European Renaissance and Protestant Reformation. Rather than succumbing hopelessly to a syphilitic plague, Cranach, Luther, and Venus too gathered their assets and challenged the viewer to learn from their pluck, faith, and stunning beauty.

Parading smart, strong, and sexy women in countless artworks, the Cranach workshop nurtured a romantic, familial consciousness congenial to the Reformation's organization of society around marriage and sex, progeny and family, work and prayer. Cranach's women successfully liberated Rome's shackled libidos from the dark prisons of celibacy, chastity, and the cloister.[33]

In Cranach's developed nude repertoire, classical and biblical women swept the world's most learned and powerful men off their feet. Notwithstanding a pandering, materialistic side, his nude repertoire was truer to Judeo-Christian "anthropology" and common-sense classical empiricism than were ever Rome's constructed notions of human sexuality and free will. Lovely nudes as Cranach painted them, so desired by

Lucas Cranach the Elder, *Venus in a Landscape,* 1529, detail
(Louvre, Paris, France; Photo: Erich Lessing/Art Resource, New York)

Saxon gentlemen in the 1520s and 1530s, had for fifteen centuries been the forbidden, hidden fruit of the celibate religious and lay penitents.

In the not so distant age of the Church Fathers, the ascetic religious claimed to see in the shadows of the fires of their hermit caves tempting, tormenting visions of naked, dancing girls upon the walls. In the reformatory atmosphere of the early sixteenth century, Cranach's nudes also confirmed the private desires of Everyman and Everywoman for companionship and intimacy with the opposite sex. In doing so, art helped to create a world in which the laity could freely desire and fantasize, ear-

249

nestly court and marry, joyfully make love and raise families without doubt, shame, and "Big Brother's" cold oversight and intervention.

Looking back to the Cold War East German historian and Cranach biographer Heinz Lüdecke, we find a man who dismissed Cranach's nudes as totally frivolous. Yet, he also cited approvingly Heinrich Heine's witty assessment of Cranach and Luther's roles in the Protestant assault on Rome: "The loins of Cranach's Venus," he wrote, "are far more substantial theses than those the German monk placed on the door of the church in Wittenberg."[34]

Whatever else one may make of Heine's wisecrack, the idea that Cranach's women carried the Reformation forward more effectively than Luther's *Ninety-five Theses* contains two true statements about Protestant success. The first is the old truism that a picture is worth a thousand words. The second, which was Heine's main point, acknowledges the power of human emotion over human reason. The blended visual-visceral impact of Cranach's altar paintings, portraiture, and broadsheets was every bit as powerful as Luther's sermons, pamphlets, and catechisms, not a few of whose covers were also decorated by Cranach.

Recent studies of sixteenth-century popular culture also echo Heine.[35] In ways straightforward theological argument cannot do, Cranach's alluring images of women drove home the awesome power and divine blessing of human sexuality in and through which new life is created. From the sex drive comes the vital human need for intimacy and companionship, progeny and family, upon which the foundations of entire cities, states, and nations are laid. In this regard, Cranach's images were incomparable couriers of history and the gospel.

9

Remembering Cranach and Luther

CRANACH IN EXILE

Upon the death of Elector John the Constant (1532), John Frederick, the last of the Wittenberg electors Cranach and Luther served, succeeded his father. He did not, however, receive his validating electoral title from the emperor until 1535, a delay caused by the formation of the Protestant Schmalkaldic League in 1531, a united front of Lutheran princes and free German cities sworn to defend the Protestant faith to the death.

By the late 1530s, the imperial army and the new Protestant league were foreshadowing the great religious wars still to come. Led by John Frederick and the Hessian Prince Philipp, the league gained the support of French Catholics, who were then engaged in their own bitter war with the imperial Catholic Hapsburgs. Also at this time the threat of a Turkish invasion of Christian Europe impeded the emperor's ability to engage the Protestant league fully, again delaying the inevitable.

The long standoffs ended after Martin Luther's death in October 1546. Six months later (April 1547) the imperial army, fresh from its victories on the battlefields of Franken and Saxony, crossed the Elbe River and engaged the Protestant league in the Lochau Moor near Mühlberg. Here, in the Saxon elector's favorite game preserve, Hessian and Saxon soldiers were easy prey for the mighty imperial army. Under the command of the Italian-Spanish Duke of Alba, short shrift was made of the Schmalkaldic League.[1]

Luther's Death Mask, 1546

(Photo: By kind permission from Marktkirchengemeinde Halle an der Saale, Germany)

A besieged and defeated Wittenberg capitulated to the emperor on May 19, 1547. Within a week John Frederick was stripped of his electoral title and placed under house arrest. With that loss, the court painter's position was also vacated, taking away Cranach's title, salary, and perks. In the aftermath of the city's subjugation, the remnants of John Frederick's court moved to Weimar. At the meeting of the Augsburg Reichstag in 1548, rival Duke Maurice of (Albertine) Saxony was awarded the electoral Saxon title that had been the possession of the (Ernestine) Saxon dynasty since 1485.

Departing Wittenberg as the hostage of Emperor Charles V, the defrocked John Frederick began an exile and house arrest that would extend throughout the greater part of his remaining years. He now accompanied and served the emperor in his several royal residences in the Netherlands, Germany, Switzerland, and Austria.[2]

In the years leading up to war (1545–47), the Cranach workshop busied itself with war preparations, much of their work being done in Torgau. There, halberds were lacquered and brightly colored troop flags and coats-of-arms sewn for the soldiers of the Schmalkaldic League. In the aftermath of the long delayed war, the league was in tatters and the city occupied. The artworks of the previous electoral regime, those of the Cranach workshop and other painters, were now sought out as reliable "currency" for the dispersing electoral Saxon court. The best-sellers were portraits of noblemen and royals, tempera portrayals of Venus and Lucretia, and the ever popular jousting scenes.[3]

Other grand popular art objects, such as the stone sculpture of John Frederick in the Castle Church, were carefully packed and stored away in Cranach's house at the initiative and generosity of Cranach.[4] By taking those steps Cranach saved the exiled John Frederick and his sons a sizable amount of their propertied wealth that would otherwise have fallen into the hands of the new imperially appointed, Saxon elector, Maurice.

The dethroned John Frederick and his sons wrote often to Cranach during the early years of their exile, instructing him to ship paintings from the electoral collection to their private hunting lodge in Wolfersdorf deep in Thuringia and to the cities where the exiled John Frederick was

forced to go. The artworks requested were prized by private owners both for viewing and as tokens of ready cash. In 1550, John Frederick sent Cranach a list of favored artworks to be shipped to him, including his wife's request for a copy of *The Seven Virtues,* a Cranach artwork "printed in quince juice."[5] Among the art treasures in the exiled elector's collection was Dürer's *Martyrdom of Ten Thousand Christians,* a presumed work of some attachment for the Wittenberg princes, as Dürer had painted it years earlier for his friend and benefactor, Frederick the Wise. Before Cranach rescued it, it had been on public display in Castle Church.

Some fine paintings were also shipped to Antwerp in the war years, where John Frederick received and passed them on to the emperor in Brussels. Such ransom by any other name was just as sour to the hostage as it was sweet to his keeper. With Cranach's productivity and high-end artworks, John Frederick hoped quickly to leverage himself at the emperor's court and thereby gain the earliest possible release from his captivity.

After all the efforts Cranach made to safeguard and ship the artworks requested by his lord to Weimar, the House of Saxony's gratitude was completely hollow. The good deeds were ruled "under present circum-stances" to be *un*official and *non*-remunerable.[6]

For the first time in forty-two years, an aged, weary, and angry Cra-nach saw his annual salary and the perquisites of the court painter dis-appear. The uncertainty of the present "regime change" kept him on pins and needles. Ever resourceful in finding solutions, he continued to create and ship his artworks to patrons and customers. However, with Witten-berg on a war footing, he could no longer could count on prompt pay-ment, or even payment at all.

At the time the opposing imperial and Protestant armies were posi-tioning themselves for battle, John Frederick pressed the Wittenberg no-tables to advance him hard cash. Cranach was already covering quite a bit of unpaid electoral debt, yet he nonetheless "lent" John Frederick the largest sum of all: five thousand gulden. It was an investment only a most loyal and generous man would have made, given the odds of recovery. Gregor Brück, who managed to remain rich in both fat and lean years,

lent the elector only two hundred taler, the same amount Cranach's far-from-rich son-in-law, pharmacist Casper Pfreundt, contributed. With the folly of the loan unveiled within a few weeks, Cranach beseeched the elector, quite in vain, to repay him.[7]

After the imperial soldiers besieged Wittenberg, the university intellectuals, led by Philipp Melanchthon, quickly fled the city, while Cranach and the artists loyally hung on. One historian describes Cranach at this time as having been "too conscientious a citizen to flee." Other historians surmise that his age, now seventy-five, kept him both there and out of prison during the years of the city's occupation (1547–50).[8]

Despondent in the wake of defeat and occupation, Cranach deplored John Frederick's arrest at the hands of Duke Albert of Prussia, an imperial ally. Among the gathering of eyewitnesses at the stripping of John Frederick's title, Cranach told the duke straight to his face that God's wrath would soon bring him down:

[Sir, he interjected] there is a proverb: "When you tighten the string too much, it breaks." God himself will now break you because [the emperor and his army] have assaulted mercy and honor.[9]

A cousin's eyewitness account of Cranach's actions in the aftermath of Protestant defeat (1547) gives the modern reader a credible picture of the aged artist's character and state of mind during Wittenberg's political demise. Matthias Gunderam (d. 1564) was both a Cranach relative and an intimate of the Saxon electors. He held a master's degree in liberal arts and philosophy from Wittenberg University and later served its faculty as dean. During the harsh years of occupation, he was the live-in private tutor of Cranach Jr.'s children.

Before his death, Gunderam deposited Latin notes written from memory in 1556 and other memorabilia in a copper "time capsule" placed in the south tower of St. Mary's Church.[10]

Opened in 1760, those notes told the story of Cranach's private meeting with Emperor Charles V in the aftermath of the city's defeat. According to those records, the meeting materialized after the emperor, while touring the defeated city, overheard the mention of Cranach's name and

immediately began to seek him out. He still remembered the day, thirty-nine years earlier in 1508, when he, then an impressionable boy of eight, met the great artist in Mechelen (Malines) in the Netherlands, then a member of a Wittenberg diplomatic delegation.

In the intervening years, the emperor had received Cranach paintings as gifts from the Saxon electors and was also aware of the productions of the Cranach workshop. Recalling their meeting and remembering what an interesting man the Saxon painter had been, the emperor asked the captive John Frederick to confirm Cranach's presence and whereabouts in the city.

Summoned thereafter to the field camp of the emperor near the village of Piesteritz on the outskirts of Wittenberg, the painter and the emperor spent the evening reminiscing about their first meeting four decades earlier. Gunderam's memoirs included a summary of their conversation recorded by the Rostock theologian David Chrythaeus, another Wittenberg graduate who at the time was the emperor's biographer.

The theologian described the meeting of the two as polite and respectful. It began with the emperor immediately telling Cranach that the small wooden panel on which he had painted his portrait so long ago was still in his room in Mechelen. Most of all, however, the emperor wanted to know everything about their first meeting and what he had been like as an eight-year-old. Cranach did not disappoint him. He described with detail how the then emperor Maximilian I had taken his grandson, the young archduke Charles, by his right hand and led him through the Belgian estates as the assembled representatives paid homage to the future Emperor Charles V.

As for the boy's behavior at the time, Cranach recounted his incessant fidgeting during his portrait painting and how he successfully stopped it. Having learned that the boy was fascinated with weapons of war, he requested that a painted iron projectile be positioned on the opposing wall and targeted directly at the boy's eyes. From that moment on young Charles was frozen in place, and Cranach hurriedly finished the portrait![11]

Cranach's stories very much pleased the emperor, who pledged his

generosity. Before decamping he sent Cranach a silver plate filled with Hungarian-German ducats as a show of his appreciation. Cranach, however, wanting neither to be compromised by the enemy, nor to lose the emperor's favor in such a situation, reportedly took only a token of the gift, a mere "two forefingers worth."[12] Also in response to the action, again according to Gunderam, Cranach fell to his knees before the emperor and foreswore any favors for himself, while pleading with him "to show both his grace and the mildest of punishments to John Frederick." Thereupon the emperor assured Cranach that no harm would befall his defeated prince. That having been said, the painter returned to his house in the city, where he refused to take an oath of allegiance to the emperor, in a show of loyalty to Saxony and its defrocked and exiled elector.

A second retrospective of Cranach's behavior in the wake of Protestant defeat, at odds with Gunderam's, appeared in Dresden in 1609.[13] Its seventy-two-year-old author, Valentin Sternenboke, claimed his account was based on stories told him directly by Lucas Jr.

Sternenboke's account of the meeting depicts a terrified Cranach convinced that his association with the Saxon elector would bring him a sure death sentence. Upon meeting the emperor Cranach fell immediately to his knees, only to be quickly pulled up and assured that no harm would befall him. Contrary to Gunderam, Sternenboke portrays the emperor as having no clear recollection of their meeting in 1508. He rather opened the conversation by inquiring after the origin of Cranach's name, and went on to ask whether he was the Cranach who had been in the Netherlands in 1508 and painted his portrait as a young master (*herrlein*). With Cranach confirming, the emperor went into his tent and returned with the very portrait in his hand, again asking for the painter's confirmation. The emperor was also keen to know why he had painted him staring at a wall, which was the cue for Cranach to retell the story of the young archduke's frustrating lack of self-control and the artist's inspired remedy of it.

Asked by the emperor if he had any special requests, Cranach, as Gunderam also reported, fell to his knees and begged him to show mercy to John Frederick. Upon hearing those words, the emperor deadpanned,

rather darkly: "I wish it were something else you wanted from me," suggesting that he might not be so inclined. At the end of the meeting Cranach was escorted to his lord's place of confinement. Upon seeing each other the two men embraced and cried together over all they had lost.[14]

Critics view Sternenboke's account as exaggerated and romanticized, particularly with regard to the degree of danger Cranach then faced. It is, however, also true that the emperor had initially used terror tactics against John Frederick in an effort to force his early surrender and shorten the war. To that end, he directly threatened an immediate court sentence of death should his captive refuse to profess the creed of the Council of Trent, a sentence subsequently commuted to exile and house arrest.[15]

It was not in the emperor's interest to execute a Saxon elector, and there was certainly no reason whatsoever to remove the electoral Saxon painter. In all likelihood the emperor saw in both men powerful and effective, charming and inventive "Renaissance men," who were best kept alive as pawns on short leashes and under his watchful eyes.[16]

CRANACH GOES TO THE MOUNTAIN

From that day in 1547 when John Frederick departed Wittenberg as the emperor's hostage, Cranach had a standing invitation to join him in exile. Although loyally disposed to do so, he was initially stricken with vertigo and declined. During the passage of the postwar years (1547–50), the correspondence between the two men was continuous and often urgent. By early 1550, there were good reasons for Cranach to leave Wittenberg and only a few for him to stay. The city was no longer his town, and what was still there professionally for him was now in the good hands of Lucas Jr.

Cranach's Wittenberg life was now fraught with new rivalry and conflict. He was again caught up in a lawsuit over his apothecary privilege and right to purchase spices for his son-in-law's pharmacy—litigations pressed on him by the vengeful new Saxon elector Maurice. Maurice also intervened in the Cranachs' property interests and taxes, on one occasion

conferring with the tax collector about a meadow they had shown an interest in purchasing. At the same time John Frederick, writing from Augsburg in his very best "siren prose," continued to pummel his court painter with requests for artworks and increasingly the presence of the artist himself.

Demoralized by disputes over law, land, and art, Cranach resolved to leave Wittenberg. His initial plans were to go to Weimar where his son-in-law, Chancellor Christian Brück, Jr., and daughter, Barbara, had settled with their family after leaving Wittenberg. From that firm family base, he would then travel south to Augsburg, there to join his erstwhile lord for the duration of his captivity. On June 12, 1550, John Frederick, now three years into his exile, received Cranach's plans from their mutual friend Brück. Joyful over the decision, his sons volunteered to send a carriage to take the aged painter from one city to the other.[17]

As Cranach was well into his late seventies, the big questions on the minds of family and associates were whether the legendary "fast painter" could survive the journey, hold his own in the brutal give and take that was Augsburg politics, and still have the stamina to meet the high expectations of his art production, which John Frederick counted on to grease his release.

Those questions were quickly answered by Cranach's son-in-law. Then in Wittenberg visiting his aged father for several weeks, Christian Brück also kindly looked in on his father-in-law as well. From his own observations of the artist's daily routine, Brück had no doubt whatsoever that he was fully up to the challenge. "Despite his years," he wrote to all, "neither in body, nor in spirit did I find any trace of diminishment, and as always he still cannot spend an hour sitting alone, or being idle." Also, in his own words, Cranach assured Christian that he was able and ready to "go wherever and however so far" as John Frederick commands him.[18]

Before leaving Wittenberg, Cranach wrote and filed his final testament. Therein, he reiterated Lucas Jr.'s proper ownership of the family workshop; resigned all of his positions in the city council; and charitably remembered the servants of the church and his own poor relations.

After three-plus years as a captive, John Frederick was still relying on

Cranach's artwork and diplomacy to assist his campaign for release from imperial house arrest and reinstatement as the Saxon ruler. For his part, Cranach was confident that his lord's reinstatement would also lead to his own engagement in a new world of art and politics. Although both men could see the cautionary clouds on the horizon, each harbored in his heart a reprise, however brief, of the golden Wittenberg years, with John Frederick returning to political rule and the Cranach workshop mixing pigments again.

Following his plan, Cranach went first to nearby Weimar, while in distant Augsburg John Frederick awaited their reunion and return to power. If the dream came true Cranach would have both his family and the rump of the old electoral Wittenberg court circled around him once again, but now in Weimar, where family and exiles from the Wittenberg court stood ready to welcome the return of their erstwhile elector and court painter. Not least enticing for both men was the time to be spent in Augsburg, where the ardor of national political debate could still make old men young.

On July 23, 1550, Cranach and John Frederick were reunited in Augsburg. There Cranach remained with his former lord until February 1551, during which interim the Reichstag was also in session. In these months Cranach was again a very busy painter, albeit informally and in a freelance capacity, no longer wielding the "fast brush" that had changed his world, but also no slow dabbler either. As always he made the very most of his artistic and entrepreneurial opportunities. His new artworks in Augsburg were on the high end: portraits of the emperor, the imperial court servants, and aging patricians. Among the latter were Cardinal Grandvelle and the portraitist Titian (1477–1576), who had painted John Frederick in the middle of his exile (1550). Although no match for Cranach's productivity and variety of subject matter, Titian, now in his late seventies, exceeded Cranach's eighty-one-year lifespan by a full eighteen![19]

In 1552, John Frederick arrived at the emperor's residence in Innsbruck with Cranach in tow. There the defrocked elector received his imperial pardon and release from captivity, henceforth to bear the solid title of "Duke" (*Herzog*). Although no longer one of the seven elec-

tors, after his cleansing "reconciliation"—a formal, penitential forswearing of all previous failings and misdeeds—John Frederick became a voting member in the second chamber of the empire.

For all of Cranach's good artwork and loyal service to his lord, he had less to do with John Frederick's reinstatement to high rank than did the ambitious Saxon elector Maurice, who had taken his title and place. Maurice had recently alienated the emperor by joining the French in a grab for control over the German bishoprics of Metz, Toul, and Verdun. In a search for a Saxon counterweight to the treasonous Maurice, the emperor restored the lost Ernestine Saxon lands to their previous ruler, the new duke, John Frederick. Armed with a pardon and an adjusted title, he and Cranach returned to the old (Ernestine) Wittenberg court now seated in Weimar. Although it was another time and place, 1550s Weimar, not 1530s Wittenberg, the dream of the elector and the court painter did have a brief reprise.[20]

THE MONEY TRAIL TO THE GRAVE

Cranach's fate was now completely tied to John Frederick's, whose reinstatement also opened new opportunities for his court painter. But as with Cranach's earlier safeguarding of the electoral Saxon artworks, the House of Saxony would give its faithful servant still another hollow thanks for his selfless efforts fourteen years earlier.

The issue was belated payment of salary for services rendered in war-interrupted pay periods, a conflict forced to the surface by Cranach's reunion with John Frederick. In a memorandum dated October 8, 1551, it was agreed that Cranach's long due lost salary for the period between autumn 1546 and spring 1547 would be immediately paid "after the records were checked." By agreement, there would be no salary for the period between Easter 1547 and July 23, 1550, the day Cranach rejoined John Frederick in Augsburg.

From that latter date on, however, he was officially in John Frederick's service again. The conditions of his rehire were twofold: that he settle in Ernestine territory and restrict his services to John Frederick and his sons.

For such willing obedience he was to receive an annual salary of one hundred florins for life, the first payment due on July 23, 1551, the second after July 23, 1552.[21] With the return of the title of court painter came also his lost perquisites: winter and summer clothing, board at court, and two apprentices sharing in both. Yet, just as he had earlier been denied payment for safeguarding the court's artworks in time of war, no immediate reimbursement of the promised war-interrupted salary was forthcoming.

Despite the new ducal arrangements and promises, very little money appears to have crossed Cranach's hands. In July 1552, John Frederick refused his request for 150 gulden, which Cranach urgently asked for to pay off the debts of his son and son-in-law. Defending his denial of payment, the restored elector told him that his money had to be put aside for the days when he could no longer paint.[22]

To all appearances the lord he had served faithfully for twenty years was withholding salary and other payments due his court painter. Writing with a visibly shaky hand in the same year (1552), Cranach submitted a detailed bill for thirty-one itemized artworks created in Augsburg, for which he received a total sum of one hundred gulden.[23]

Conscience also recoils at the continued hold on his war-interrupted salary dating back to 1546–47, especially after John Frederick's assurance in black and white (a note dated October 8, 1551) of its imminent payment. Not until March 1554 was that princely debt finally paid—but not to Cranach, who was then a full year into his grave!

One suspects that the House of Saxony's posthumous "final package" of 250 gulden, when carefully broken down, contained Cranach's remuneration for two years of service in Weimar at 100 gulden each, to which was added his half-year war-interrupted salary of roughly 50 gulden. That sum was delivered to his son-in-law as "payment in full for the services of Lucas Cranach, the Elder."[24]

Cranach died on October 16, 1553, at the age of eighty-one, in the Weimar home of his son-in-law and daughter, reportedly in the latter's arms. He was buried in St. Jacob's cemetery, and his tombstone is today displayed in the Church of St. Peter and St. Paul, an identical copy of which covers his grave.[25]

Cranach's Tombstone, 1553

(Photo: Dr. Peter Moser)

CRANACH AND LUTHER UPON THE ALTARS

In the same year in which the imperial army defeated the Schmalkaldic League and occupied Wittenberg (1547), Cranach put the finishing touches on his long-developing *Wittenberg Altarpiece,* also known as *The Reformation Altar* and still to be seen in St. Mary's Church today. A memorial to Luther and the Reformation, the work is Cranach's most personal and ambitious altarpiece and also the longest in the making.

In preserving the Protestant history of salvation, *The Wittenberg Altarpiece* joins the Cranachs' equally famous *Weimar Altarpiece* (1555) in a climactic tribute to both the reformer and the artist. Together, the two altars remain the definitive German memorials to the life and work of both men.[26]

The Wittenberg Altar

The centerpiece of the Wittenberg altar reprises the last day of Christ's life on earth by bringing the Savior and the Twelve Apostles into the Church of St. Mary to celebrate Luther's life and work with the contemporary Wittenberg congregation. In the surrounding scenes the work of the church continues at its everyday pace. The viewer beholds the preaching of the gospel, the baptism of infants, the lay confession of sin, and the latter's "reconciliation" with God. Princes and clergy also mix into the crowd with their wives and children, as present-day Christians commune with the very first Christians, doing so as if they were next-door neighbors rather than distinct Christian generations living sixteen centuries apart.

In the center panel the Apostles converse with one another and with the Wittenbergers. At the head of the table the Apostle John has thrown himself upon his Savior's lap and is embraced by him in return. At the same time Christ confronts an aggressive Judas, on his right, whose pocketbook bulges with ill-begotten silver, and whose bare feet suggest an imminent quick dash away from the Lord's table. With the two forefingers of his right hand Christ pushes a morsel of food into his betrayer's already full mouth, thereby sealing his lips and also the eternal futures of both men.

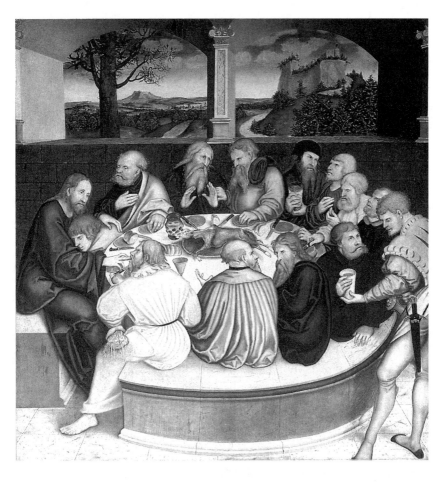

Lucas Cranach the Elder, *The Wittenberg Altarpiece*, 1547, center panel
(Marienkirche [St. Mary's Church], Wittenberg, Germany;
Photo: The Bridgeman Art Library/Getty Images)

Luther sits at the Lord's table among the twelve Apostles in the center scene as if he were the thirteenth. He appears in his early 1520s disguise as the bearded Junker Jörg, a reminder to the viewer of his months in Wartburg Castle in Thuringia, where he translated the New Testament into German at the birth of the Reformation.[27]

In remembering Luther, Cranach recalls the early days when stealth and deceit were necessary tools for the Protestant cause. In 1522, Luther returned to the city in the same disguise to dethrone his rival, the icono-clast Carlstadt. Whether boasting or jesting, he claimed at the time to have

fooled even Cranach with the Wartburg disguise! Here, in the altarpiece, Cranach reprises those exciting times by having Luther fool Christ and all the Apostles with the same disguise. Turning away from the Lord's table, Luther gives the beholder nothing less than a full frontal view of himself as Junker Jörg.

The cupbearer serving and conversing with Luther is apparently Lucas Jr., or perhaps a younger Lucas Sr.[28] Given the presence of several deceased figures in the altarpiece, however, most of them from Luther's family, the cupbearer may in fact represent neither Lucas, but rather the prematurely deceased Hans Cranach, eldest son of the painter.

In the predella beneath the centerpiece, Cranach Sr., now seventy-five, is seen as an attentive graybeard at the outer end of the congregation. His eyes are trained on Luther, who stands in a deep stone pulpit extending from the opposing wall. Filling the space between pulpit and congregation, an emaciated, crucified Christ hangs in isolation at mid-scene, accompanied both in dying and in death by his animated, watchful, and protective loincloth. At the end of Luther's outstretched arm two fingers single out Christ and the elder Cranach, as the two men search out the other in and through the crucified Christ.

The scene shows the painter's advanced age, and in sympathy with the broken hands and body of Christ, also Cranach's shrunken, arthritic hands that hang motionless like crippled rabbit paws. Only the expressionistic Cranach could get away with such an eccentric touch in so solemn a moment in the history of salvation.

Clustered together in the front row of the congregation are selected members of the Luther family, both living and dead. Prominent in the foreground scene is his son Johannes, called Hans, the reformer's first-born and Cranach's godson. He appears in a bright red coat, seated between his mother's legs with an outstretched arm across her lap, which she firmly holds to keep him still. The bright red color of his coat exactly matches his father's slightly visible "cardinal collar," a thin red decoration suggesting a direct Cranach salute to his great, good friend, Martin. It is also a declaration of what Wittenbergers had then long since known: Martin Luther was the consensus bishop of the new Protestant Church.[29]

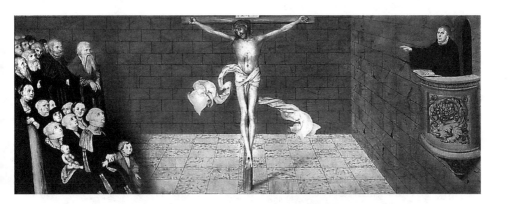

Lucas Cranach the Elder, *The Wittenberg Altarpiece,* predella
(Marienkirche, Wittenberg, Germany; Photo: The Bridgeman Art Library/Getty Images)

Directly behind the widow Luther's left shoulder the viewer sees an-
other turned head with bright, popping eyes. It is the appealing round
face of a young woman who has been seen before in Cranach's portrayals
of Saxon women.[30] She looks neither at Christ nor at Luther, but rather
stares blankly at the viewer, a figure who is there, yet not there.

Who might she be? A good guess is Luther's prematurely deceased
daughter, Magdalena, called Lenchen ("Darling Lena"). Her sudden death
at thirteen, in 1542, was as traumatic a blow to the Luthers as the Cranachs'
sudden loss of their eldest son, Hans, at twenty-four in 1537. Shattered by
their children's deaths, both men loyally attempted to console each other,
but all of their efforts were in vain. For a while, Luther claimed to have
given up on God. In his grief he asked a friend to "thank God" for taking
his beloved daughter away to a better world, even though he and her
mother had wanted so very much to keep her with them for a longer time.
Writes a stricken Luther:

> The force of our natural love is so great that we are unable to do this
> ["thank God"] without crying and grieving in our hearts [and]
> experiencing death in ourselves. . . . The features, the words, the
> movement of our living and dying daughter, who was so very obe-
> dient and respectful, remain engraved in our hearts. Even the death
> of Christ . . . cannot take all this away, as it should. You [the unnamed
> friend], therefore, must please give thanks to God in our place.[31]

267

Lucas Cranach the Elder, *The Wittenberg Altarpiece*, predella,
detail of Magdalena Luther
(Marienkirche, Wittenberg, Germany; Photo: The Bridgeman Art Library/Getty Images)

Although more succinctly phrased in Luther's eloquent words, Cranach's grief over the premature death of his son, then traveling in Italy with his father's leave, was no less a bitter cry from the heart: "Almighty God," he opined, "wants to make me completely weary with the world," suggesting thoughts of taking his own life in due penance for his loss.[32]

Described as a "thin, dry, two-dimensional, inert" Christ, Cranach's crucified figure in the predella has been held up as the prime example of the "negativity of Protestant art."[33] And in a totally different iconography, that of the classical nude, the same critics have also declaimed Cranach's "Protestant negativity" in portraying the female body.[34]

Such criticisms notwithstanding, the scene in the predella could not be more positive and celebratory. At the center of the scene is faith in a Savior who, within an eternal divine plan, takes upon himself the sins of the world, a biblical "Catcher in the Rye," sacrificing everything he was and possessed in his short lifespan on earth, letting himself be degraded for one big, selfless reason: that all humankind might be safe and share a new spiritual life in eternity.

The Christ of the predella is eminently Luther's Christ interpreted. Far from Friedländer's "impoverished" Protestant art, and Koerner's "spent Christ" of the altarpieces, contemporary laity saw in the figure a true, appealing Savior and Redeemer. By the religious-theological calculus of the age, it was Christ's becoming "thin, dry, two-dimensional, and inert" that assured the faithful a full, refreshing, three-dimensional, anchored life in eternity: redemption and salvation one could believe in!

In the left wing of *The Wittenberg Altarpiece* the viewer sees the professor of Greek, Philipp Melanchthon, who, though no ordained minister, conducts the rite of infant baptism. Standing before a baptismal pool large enough to receive an adult, the professor appears to ladle the water out of the great basin onto the newborn with his bare hand: a sprinkling rather than total immersion.[35]

On Melanchthon's right, the aged Cranach makes a second appearance in the altarpiece. Armed with a towel, he stands ready to take in hand both the newborn and his new duties as godfather. Those duties were to receive, nurture, and instruct a new Christian life in the way of the Lord.

Lucas Cranach the Elder, *The Wittenberg Altarpiece*, left wing

(Marienkirche, Wittenberg, Germany; Photo: The Bridgeman Art Library/Getty Images)

On Melanchthon's left, Elector John Frederick stands as co-godfather of the newborn. Like Melanchthon, he too has a drying towel, and holds in his hand an open Bible, or perhaps Luther's prayer book, as he repeats his god-fatherly vows.

Thickly ringed around the baptismal pool are some of Wittenberg's most important women, there from the ranks of both the living and the dead. Mixed into the throng are the wives of the city's theologians and pastors: Katherine Luther and the late Barbara Cranach, the living Katherine Jonas and Walburga Bugenhagen.

The most prominent, yet least seen, of those women is surprisingly Barbara Cranach (d. 1541). The viewer beholds only her imposing, center-front backside clothed from neck to toe in the brocade and furs of a rich person. If local gossip is to be believed, she earned this anonymous cameo by repeatedly complaining that her husband had "never painted her." Whatever the truth of the story, her nagging seems to have brought her both more of what she did not want (anonymity and girth) and less of what she desired (visibility and appeal). Whatever expectations Frau Cranach had, her husband's blunt portrayal as a clothes-horse left her still not properly seen in a work of art, and thus not truly painted by her husband.[36]

In the right wing of the altarpiece as the viewer beholds the scene, Johannes Bugenhagen, the pastor of St. Mary's Church and Luther's confessor, is seen hearing open confessions. In 1525, he conducted the Luther–Von Bora marriage ceremony, and twenty-one years later he eulogized Luther at his gravesite (1546). Seen here holding the "key to heaven" in his hands, he appears in his role as confessor. He is seen pardoning the sins of a truly penitent burgher by placing the key to heaven upon his head, and withholding absolution from an impenitent rich man, whose hands are visibly bound. The one falls gratefully to his knees, while the other exits angrily from the church.[37]

Luther and Cranach Sr. appear more than once in the Wittenberg altar, as the two of them are revered and celebrated as living links between the biblical Apostles and the sixteenth-century lay congregation of St. Mary's Church. Viewing the altarpiece in its entirety, one sees the still

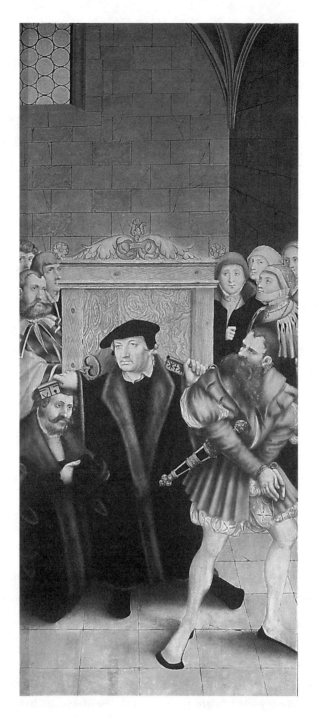

Lucas Cranach the Elder, *The Wittenberg Altarpiece,* right wing
(Marienkirche, Wittenberg, Germany; Photo: The Bridgeman Art Library/Getty Images)

living figures of Professor Philipp Melanchthon, Elector John Frederick, Pastor Johannes Bugenhagen, and the court painters Cranach Sr. and Jr. Joining them both in art and present-day memory are three members of Luther's family: the reformer himself, his wife Katherine, and their deceased daughter Magdalena, who are joined by Cranach's long-buried wife, Barbara (d. 1541).

The Weimar Altar

In 1555, Lucas Jr.'s masterly *Weimar Altarpiece* (1555) joined *The Wittenberg Altarpiece* in still another celebration of the life and work of Luther and Cranach Sr. Praised as "the single most important visual monument of the German Reformation," the painting is the supreme artwork of Lucas Jr.'s career, with some assistance from his father in the last years of his life.[38]

As the viewer scans the altarpiece he immediately beholds the familiar figures of Cranach, Luther, and John the Baptist, John being the biblical wilderness prophet who pointed out and authenticated Jesus as the Messiah at the birth of Christianity. Once focused on the scene, the viewer's eyes jump immediately from Christ's side-wound to the groomed head of Cranach, who appears not as a religious prophet, or reformer, but as a solitary penitent, his hands folded in prayer. He stares impassively at the viewer, who is surprised to discover that only Cranach among the three is actively receiving the Savior's redemptive bloodstream.

In this novel iconography Cranach is cast in the role of Adam, that is, "Everyman," a stand-in for the whole of fallen humankind. Widely known in his lifetime to have been a wealthy entrepreneur and painter of nude women, a powerful part of the righteous Christian community may well have perceived him as aloof from religion, a man without a cause beyond himself. Throughout his professional life as an artist and entrepreneur, Cranach did business with both Rome and Wittenberg, no questions asked. He consistently treated the confessional spectrum from Rome to Wittenberg and Halle as a lucrative market for his altar panels and other decorative art. Yet *The Weimar Altarpiece* memorializes him as

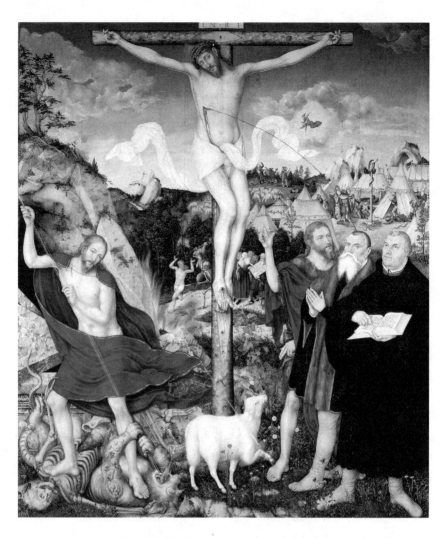

Lucas Cranach the Younger, *The Weimar Altarpiece*, 1555, center panel

(Photo: Kirchengemeinde Weimar, Herderkirche)

the artist of the Reformation and the man who confessed Christ belatedly on his deathbed.[39]

No matter how belated, or shallow, Cranach's deathbed confession may have been—whether truly from the heart and always privately kept there, or just another beguiling brushstroke exercise for the admiring public, there is no denying that the painter was the captain of his own life and ended it with the same affirmative note on which he had lived it.

The image of Cranach that appears in *The Weimar Altarpiece* is actually an earlier original self-portrait from the hand of Cranach Sr. himself, *sans* a confession of faith and a redemptive bloodstream. After his father's death, Cranach Jr. transplanted the self-portrait to the altarpiece, wedging his father in between John the Baptist and Luther, the two "bookends" of Christian salvation history then to date. He also added the Christ-centered bloodstream to the scene, reprising a gothic blood motif shared by both father and son. In doing so, Cranach Jr. was to all appearances fulfilling a "legacy wish" of his father, who in the last years of his life had wanted only comfort, respect, and remembrance: altogether a son's remarkable tribute to his father!

Taking a closer look at *The Weimar Altarpiece*, the viewer beholds on one side of the cross the risen, victorious Christ clad in a light, bright cardinal cape literally stamping out sin, death, and the devil. On the other side, a select and well-aligned "triumvirate" stands a silent vigil for the crucified and dying Christ. In concert those mighty men of God—John the Baptist, Luther, and Cranach Sr., in that order—represented and connected primitive first-century Christianity with its new sixteenth-century Protestant revival.

In the Cranachs' artistic presentation of them, they become trans-historical custodians and protectors of original, pristine Christianity, beginning with Christ's appearance on earth in the first century AD and extending to Luther's sixteenth-century rescue of the gospel from Rome. In the year of the Lord 1555, Cranach Jr.'s *Weimar Altarpiece* proclaimed these three men the alpha and omega of sixteen centuries of unbroken Christian faith.

Among these triumvirs, John the Baptist was first in line inasmuch as he had been the first to recognize the man who was the Messiah. Sixteen centuries later, with the help of the Cranachs, John the Baptist again points his discerning fingers at both the crucified Messiah high upon the cross and the Lamb of God who represents him at its base.

Next in line after John the Baptist comes the ecumenical Cranach Sr., who is there because he, like John the Baptist upon seeing Christ, also recognized in Martin Luther no less a mighty man of God for his own

times. It was Luther, in concert with Cranach, who exposed the failings of the Roman church and returned sixteenth-century Christians to the true foundations of their faith. As the "painter of the Reformation," Cranach was Luther's most intimate friend and mentor over the critical years that made the Reformation. During their years together it was very often Cranach's advice that kept Luther's reforms viable and constructive, appealing and on track.

The third triumvir was the age's incomparable religious reformer, Luther. A prescient "swashbuckler" in the mold of John the Baptist, he, too, recognized a godly man when he saw one. In this regard, Luther was also quick to point a knowing finger straight back at Cranach. Devoted men both, neither could take his hands off the proverbial plow in the vital years of the 1520s. Like Cranach's workshop, Luther's brain trust was a gold mine of talent and innovation. Both men also brought the distant worlds of the ancient philosophers, the Hebrew prophets, and the Christian evangelists to fortify their task.

Standing in *The Weimar Altarpiece* before the cross with a wide-open Bible in his hand, Luther mirrors a background scene that appears dead center behind the cross of Christ, showing Moses presenting the tables of the law to the Hebrews. Reaching beyond the Mosaic Law in the Book of Exodus, Luther is seen pointing to the New Testament stories of Christ's crucifixion and resurrection as they were prophesied by John the Baptist.

Of the three men, Luther is given the lion's share of physical space in the altar panel, almost equal to that of the combined figures of John the Baptist and Cranach. Cranach Sr.'s spatial representation is also diminished by his belated, artificial insertion into the finished work. Therein lies also a measure of Luther's gravitas within the age.

At this juncture in European history, the peaking of the European Renaissance and Reformation, Luther, more so than any other contemporary figure, determined the future course of reformed Christendom a full sixteen centuries after John the Baptist had pointed his discerning finger at Jesus. At Luther's death in 1546 and Cranach's in 1553, a Protestant legacy was already racing across Europe and beyond. It brought a needed

cleansing of the medieval church and a painful division and realignment of Western Christendom, both religiously and politically. These reforms recovered the New Testament core of historical Christianity, while at the same time opening the door to a nuanced plurality of Christian confessions, replete with deep classical and Hebrew influence.

An Inconvenient Question?

Luther's teaching portrayed the faithful Christian as being ever in need of Christ's sacrifice. In classic Lutheran theology, the faithful Christian is always sinful in himself, yet righteous by his faith in Christ. So why, one may ask, does the Savior's bloodstream not also fall upon the mortal heads of John the Baptist and Martin Luther, neither of whom, by their own measure, was a man without sin?

One possible explanation is that John the Baptist and Luther had in their lifetimes confessed the faith in a timely way and thus identified themselves as being solidly within the fold. To all appearances Cranach had not originally been scheduled to appear with the Baptist and Luther in *The Weimar Altarpiece*. Only after his deathbed confession of faith and a loving son's artful wedging of his father's self-portrait into the finished work did Cranach steal the scene from John the Baptist and Luther.

Adding to the possible intrigue, powerful churchmen perceived Cranach to have been religiously *un*committed for the far greater part of his life. He was also known to have painted a great number of nude women over his lifetime, a creator of worldly, erotic, libertine art. Luther, who surely loved him, once described him as a "rough painter [who] could have spared the female sex for the sake of God's creation and our Mothers. He could have painted other images suitable to the pope, i.e. more devilish ones. But you judge for yourself."[40]

There can be no doubt that the Cranach painters, father and son, and their many admirers wanted Cranach Sr. to share the spotlight fully with Luther in the altarpiece, a position they believed he had rightfully earned and was worthy of such remembrance. And by all indications Cranach Sr.

confided to his son that he wished to join his posthumous peer, his colleague and friend Luther, in *The Weimar Altarpiece,* if only for history's sake.

Was then Cranach's deathbed confession the occasion, or perhaps the "price," of his appearance in the altarpiece? If Cranach Jr. had not inserted his father's portrait into the scene, would we today see only Luther standing there with John the Baptist as witnesses to sixteen centuries of New Testament Christianity, absent Cranach and the Savior's bloodstream?

Cranach Jr. surely understood and deeply believed that his father was as much a "witness" to a new Protestant Christian faith as was Luther. Thus did he put his father in the place of Adam and added the Savior's bloodstream to the scene, a parallel gesture to Luther's replacement of Moses and his taking of God's Word from his hands.[41]

It was again Luther's formulaic teaching that the Christian soul was a mixed and warring soul this side of eternity, both righteous and sinful at one and the same time. For Rome's clerical brain trust, there could not have been a more contradictory and unfathomable Christian doctrine. Because the Protestants were true to that belief and teaching, the mighty Cranach was put forth as the model, humble, confessing Christian sinner-saint, henceforth to be washed, both literally and forevermore on scene, in the eternal bloodstream of humankind's Savior: Cranach, the constant-inconstant Protestant Christian.

Not only is *The Weimar Altarpiece* the "supreme visual monument of the German Reformation," it is also the most incisive and succinct artistic expression of the Protestant gospel of faith alone. Therein, the viewer beholds an alternating, ecumenical Cranach, sometimes Protestant, sometimes Catholic. By all measures he was the best example the Protestants had of a "mixed" Christian soul evidently at peace with itself. And that also made Cranach the most eligible sinful-righteous Christian the Wittenberg painters could offer up to the redemptive bloodstream of their Savior.

The bloodstream motif immediately draws the viewer's attention to Cranach rather than to Luther. Clearly there was an effort on the part of the Cranach painters to leave a strong Cranach legacy behind in the formi-

dable shadow of Luther. Confessed of his sins and washed in the blood of the Lamb, the aged Cranach becomes not only "the new Adam" but also the supreme personification of Luther's movement and the new gospel.

Lifelong, Cranach had created an "ecumenical bloodstream" of his own, a mixture of artworks, political and domestic services, entrepreneurial wealth, and a faith without boundaries. Those he served expressed their appreciation, but only grudgingly paid their bills. And when the lean years came, particularly in the wake of Wittenberg's defeat and occupation, the former recipients of his largesse left the septuagenarian painter largely on his own and in arrears.

No matter though—his life was never a pity. In the year before his death, the aged painter who had been called "fast brush" at the height of his powers still created sixteen new artworks. They were not the best of his career, but he painted them anyway because he still had the stories of God and man to tell.

Notes

CHAPTER 1. CRANACH IN HISTORY, ART, AND RELIGION

1. The exhibitions took place in Dresden-Chemnitz (November 2005–March 2006), Aschaffenburg (February–June 2007), and Frankfurt (November 2007–February 2008). The Frankfurt exhibit moved to London (February–July 2008) on the heels of a previous showing of Cranach and Dürer in Madrid (October 2007–January 2008).

2. Displaying a sizable seventy paintings, the Dresden-Chemnitz exhibition was a revealing account of the state of Cranach's existing works. Quite a few of the exhibit's works were borrowed from the collection in the Dresden Museum's Old Masters Gallery, whose limited wall space left many paintings languishing in underground storage and rarely seen. Fifty of the exhibited works were ascribed conjointly to the workshop, the remaining twenty authenticated to Cranach's hand. Although the master's blueprint and emendations may still be seen in these collections, by the mid-1520s the greater part of Cranach's artwork had ceased to be the product of one man. Cf. Dieter Koepplin and Tilman Falk, *Lukas Cranach: Gemälde, Zeichnungen, Druckgraphik; Ausstellung im Kunstmuseum Basel, 15 Juni bis 18 September 1974* (Basel, 1974), vol. 1, pp. 12–13.

3. Berthold Hinz, *Lucas Cranach d.Ä.* (Reinbeck bei Hamburg, 1993), p. 17.

4. E. G. Schwiebert, *Luther and His Times* (St. Louis, 1950), pp. 81–85.

5. Although long thought to be first in burgher wealth, more recent scholarship places him second or third.

6. Hinz, *Lucas Cranach d.Ä.*, p. 52. On jousts and hunts, see ch. 2 and 3.

7. "Eine Form zum Pfefferkuchen meine gnedigen jungen Herlein bestalt." Rainer Hambrecht, "Die Kursächsischen Rechnungsbücher im Staatsarchiv Coburg und ihr Quellenwert für die Person Lukas Cranachs d. Älteren," *Jahrbuch der Coburger Landesstiftung* 32, no. 165 (1987): 90.

8. Ernst Ullmann called Cranach's mannerism a peculiarity and dated it from his first (1518) painting of *The Nymph of the Spring*, which, when set beside his 1509 Venus, confirmed a major transformation in his artistic style. Ullmann, "Lucas Cranach d.Ä., Bürger und Hofmaler," in *Lucas Cranach: Künstler und Gesellschaft*, ed. Cranach-Komitee der DDR (Wittenberg, 1973), pp. 59–65.

9. Franz Kugler, *Geschichte der Malerei* (1847), cited in Susanne Heiland, "Cranach im Urteil der Kunstgeschichte," in *Lucas Cranach der Ältere: Der Künstler und seine Zeit*, ed. Heinz Lüdecke (Berlin, 1953), p. 150.

10. Heiland, "Cranach im Urteil," pp. 151–52.

11. Friedrich Lippmann (1895), cited in ibid., p. 151.

12. H. Janitschek (1890), cited in ibid., p. 150.

13. "Biedermännische Schicksalslosigkeit [the fate of the petty bourgeois]." Wilhelm Worringer (1908), cited in ibid., pp. 151–52.

14. Max J. Friedländer (1902), cited in ibid., pp. 151–52.

15. Max J. Friedländer and Jakob Rosenberg, *The Paintings of Lucas Cranach* (Ithaca, N.Y., 1978), p. 16.

16. Richard Muther held Cranach's true legacy to be not Reformation altars and portraits but magical forest landscapes, art scenes that pointed forward to the nineteenth-century romantic paintings of Caspar David Friedrich. Muther, *Lucas Cranach* (Berlin, n.d.), pp. 40, 46, 49.

17. Ibid., pp. 12, 31–32; Koepplin and Falk, *Cranach*, vol. 1, figure 82.

18. With Muther's defense of Cranach as a *modern* artist, other scholars of the era insisted that he, more than most, led the forward developments in sixteenth-century art. "Nun ein Mitgehen mit der allgemeinen Stilentwicklung." Kurt Glaser (1921), in Heiland, "Cranach im Urteil," p. 153.

19. Their rivalry was also a hot topic in modern German historiography, with Dürer being profiled first in a scholarly monograph (1726). Cranach did not receive a legitimating scholarly study until 1761. Heiland, "Cranach im Urteil," pp. 143–45.

20. Heinz Spielmann, "Cranach als Parameter," in *Lucas Cranach: Glaube, Mythologie und Moderne*, ed. Werner Schade (Hamburg, 2003), pp. 6–11.

21. Friedländer and Rosenberg, *Paintings of Lucas Cranach*, pp. 15–20.

22. Hinz, *Lucas Cranach d.Ä.*, pp. 14, 16.

23. Peter Blickle, *The Revolution of 1525: The German Peasants' War from a New Perspective* (Baltimore, 1981), pp. 155–62; Steven Ozment, *Protestants: The Birth of a Revolution* (New York, 1991), pp. 118–48.

24. Heinz Lüdecke, ed., *Lucas Cranach der Ältere im Spiegel seiner Zeit: Aus*

Urkunden, Chroniken, Briefen, Reden, und Gedichten (Berlin, 1953), and *Lucas Cranach der Ältere: Der Künstler und seine Zeit* (Berlin, 1953). Joseph Koerner also sees Cranach's art faltering prematurely after he joined Luther and the Reformation.

25. Lüdecke dated the painting to 1518, but more recent research has pegged it as 1510–11. *Cranach: Eine Ausstellung der Staatlichen Kunstsammlungen Dresden und Kunstsammlungen Chemnitz, 13 November 2005–12 März 2006*, ed. Harald Marx und Ingrid Mössinger (Chemnitz, 2005), p. 319.

26. Lüdecke, ed., *Der Künstler und seine Zeit*, p. 105. Closer to home in sixteenth-century Augsburg, "the Fuggerei" was a charitable workers' compound benevolently built and administered by the Fuggers.

27. *Trade and Usury* [Von Kaufhandlung und Wücher] (1524), *Luther's Works*, vol. 45, ed. Walther I. Brandt (Philadelphia, 1962), pp. 231–38.

28. Lüdecke, ed., *Der Künstler und seine Zeit*, pp. 105–6. Ullmann saw in Cranach a "disposition" to Luther themes: "he expresses hatred of mercenary greed and seems to anticipate Luther's war on indulgences." Ullmann, "Lucas Cranach, Bürger und Hofmaler."

29. Jane C. Hutchison, *Albrecht Dürer: A Biography* (Princeton, 1990), pp. 181–82.

30. Dismissing the works of art historians and art critics as gibberish ("Kunstschriftstellerei"), Lüdecke singled out the works of Worringer (1908), Eduard Heyck (1908), Muther (1914), and Heinrich Lilienfein (1942) as the worst of the Cranach batch. Lüdecke, ed., *Cranach im Spiegel seiner Zeit*, pp. 5–7.

31. Ibid., pp. 282–83.

32. Blickle, *Revolution of 1525*, pp. 195–201; Steven Ozment, *The Age of Reform, 1250–1550* (New Haven, 1980), pp. 260–89.

33. Ozment, *Age of Reform*, p. 287.

34. Lüdecke, ed., *Der Künstler und seine Zeit*, pp. 121–22.

35. E. G. Schwiebert, *Luther and His Times* (St. Louis, 1950), pp. 81–85.

36. Werner Schade, *Cranach: A Family of Master Painters*, trans. Helen Sebba (Erfurt, 1980), German edition (Dresden, 1974), p. 8.

37. Steven Ozment, *A Mighty Fortress: A New History of the German People* (New York, 2004).

38. "A modern Anglican—or even a modern Roman Catholic—is likely to be more like a sixteenth-century Anabaptist in belief than a sixteenth-century member of the Church of England." Ibid., p. 682.

39. Ibid., pp. 103–7, 612–53.

40. Hans-Jürgen Goertz, *The Anabaptists* (London, 1996), pp. 68–84. On Luther and the Jews, see Johannes Wallmann, "Reception of Luther's Writings on the Jews from the Reformation to the End of the Nineteenth Century," *Lutheran Quarterly* 1 (1978): 75–78.

41. A radical strain of Anabaptists did, however, try to turn the world upside-down in the city of Münster. Cf. James M. Stayer, *Anabaptists and the Sword* (Lawrence, Kans., 1972), pp. 203–28.

42. John C. Olin, ed., *Desiderius Erasmus: Christian Humanism and the Reformation, Selected Writings* (New York, 1965), p. 113.

43. For the Roman Christians, saving faith was baptismal faith exercised and "shaped" by a lifetime of charitable works (*fides caritate formata*). For the Anabaptists, saving faith was the fruit of a higher, adult "believer's baptism," not that of a clueless infant. As biblical literalists, the Anabaptists followed the example of Jesus' baptism upon reaching the age of reason and being fully aware of the divine covenant he was entering. Bodo Brinkmann, ed., *Cranach der Ältere*, exhib. cat., Städel Museum, Frankfurt am Main, November 23, 2007–February 17, 2008 (Frankfurt am Main and Ostfildern, 2007), pp. 214–15; cf. Christine O. Kibish, "Lucas Cranach's *Christ Blessing the Children:* A Problem of Lutheran Iconography," *The Art Bulletin* 37 (1955): 196–203.

44. Koepplin and Falk, *Cranach*, vol. 1, p. 14.

45. Dieter Koepplin, "Ein Cranach Prinzip," in *Lucas Cranach: Glaube,* ed. Schade, pp. 144–65.

CHAPTER 2. CHASING DÜRER

1. A master craftsman (*Handwerksmeister*) rather than a fine artist (*Kunstbeflissener*). Hinz, *Lucas Cranach d.Ä.*, p. 7.

2. His gravestone in Weimar dates his birth in October 1472, but others argue 1473. Rainer Hambrecht, "Lucas Cranach in Coburg," in *Lucas Cranach: Ein Maler-Unternehmer aus Franken,* ed. Claus Grimm (Regensburg, 1994), pp. 52–58. Suzanne Heiser, *Das Frühwerk Lucas Cranachs des Älteren: Wien um 1500–Dresden um 1900* (Berlin, 2000) p. 44; Jutta Strehle, *Lucas Cranach d.Ä. in Wittenberg* (Wittenberg, 2001), pp. 6–7.

3. Hinz, *Lucas Cranach d.Ä.*, p. 7.

4. Grimm, ed., *Ein Maler-Unternehmer,* pp. 105, 236; Schade, *Family of Master Painters,* pp. 12–13.

5. See court records for years 1495–98, in Schade, *Family of Master Painters,* pp. 401–2.

6. Elisabeth Shepers, "Die Maler von Kronach," in *Ein Maler-Unternehmer,* ed. Grimm, pp. 45–51, 244; Schade, *Family of Master Painters,* p. 12.

7. Grimm, ed., *Ein Maler-Unternehmer,* pp. 220–64 (catalogue).

8. Hambrecht, "Lucas Cranach in Coburg," p. 52.

9. Ibid., pp. 53–56.

10. Heiser, *Frühwerk Lucas Cranachs,* p. 49.

11. Schade, *Family of Master Painters,* pp. 402–3.

12. On hunts, see Claus Grimm, "Cranach als Hofmaler," in *Ein Maler-Unternehmer,* ed. Grimm, pp. 309–13; Schade, *Family of Master Painters,* pp. 209–11.

13. These were apparently the first paintings he made of his lords.

14. Heiser conjectures that Cranach may have been in Vienna as early as 1498 before departing in 1504, *Frühwerk Lucas Cranachs,* p. 51.

15. Lüdecke, ed., *Cranach im Spiegel seiner Zeit,* pp. 10–11. For Cranach's Viennese works, see Koepplin and Falk, *Cranach,* vol. 1, pp. 130, 55ff (artworks), which began with the couple portraits of the Cuspinians and the Reusses.

16. Friedländer and Rosenberg, *Paintings of Lucas Cranach,* pp. 12–29.

17. Hinz, *Lucas Cranach d.Ä.,* p. 16; Heiser, *Frühwerk Lucas Cranachs,* pp. 34–43. Cf. Koepplin and Falk, *Cranach,* vol. 1, p. 12.

18. Friedländer named this work "The Seated Lovers." Friedländer and Rosenberg, *Paintings of Lucas Cranach,* pp. 13–15.

19. Ibid., pp. 15–16.

20. Ibid., pp. 12–15; Koepplin and Falk, *Cranach,* vol. 1, p. 114.

21. Friedländer and Rosenberg, *Paintings of Lucas Cranach,* no. 5, p. 66.

22. Among contemporary artists, Dürer and Martin Schongauer were born into noble families, yet their inherited family coats-of-arms did not appear in their artwork as did Cranach's shield, which, for all the de facto equivalence it bestowed on the Cranach family, remained a lesser pedigree, more a contemporary honoring of the person rather than an "ennobling" of his bloodline. Cf. Hinz, *Lucas Cranach d.Ä.,* p. 14; Koepplin and Falk, *Cranach,* vol. 1, no. 131, p. 238.

23. "Wherever we may look, nowhere in the age can we find anything to compare with Cranach's shattering *Passion* in Munich, the vivid immediacy of the Cuspinian portrait, and the lyrical landscape of *The Holy Family Resting on the Flight into Egypt.* Here Cranach is completely independent of Dürer and

seems to have thrown off the shackles of tradition and convention sooner than Altdorfer, even sooner than Grünewald." Friedländer and Rosenberg, *Paintings of Lucas Cranach*, p. 16. "Taken as a whole, Cranach's *Passion* series represents a personal triumph over Dürer, whose *Albertina Passion* remained a comparative fragment . . . with only seven scenes finished. . . . Using a medium-sized format well-suited to his narrative talent, Cranach outstripped his rival." Schade, *Family of Master Painters*, p. 36; Max Geisberg, *The German Single-Leaf Woodcut, 1500–1550*, ed. Walter L. Strauss (New York, 1974), vol. 2, p. 36.

24. Dürer's praise was conveyed by Johannes Strigel. For Philipp Melanchthon's ratings of the artists, see ch. 3.

25. Koepplin and Falk, *Cranach*, vol. 1, p. 132. The Dürer woodcuts and engravings that influenced Cranach most were *The Apocalypse* and *The Large Passion*, and within the latter the scenes of *The Agony in the Garden* and *The Crucifixion, Samson and the Lion, The Holy Family with Hares*, and *St. Jerome in the Wilderness*. Schade, *Family of Master Painters*, p. 15.

26. Heiser, *Frühwerk Lucas Cranachs*, p. 26.

27. Koepplin and Falk, *Cranach*, vol. 1, p. 121.

28. In the early 1520s Cranach adapted religious art to Luther's preferred "minimal art" in an effort to protect religious images in the wake of iconoclasm. Hinz, *Lucas Cranach d.Ä.*, pp. 14–16; Grimm, ed., *Ein Maler-Unternehmer*, pp. 294, 296–97.

29. See especially the *Schächer am Kreuz* [Thief on the Cross] (ca. 1502), in Grimm, ed., *Ein Maler-Unternehmer*, p. 303.

30. Geisberg, *German Single-Leaf Woodcut*, ed. Strauss, vol. 2, p. 525; Grimm, ed., *Ein Maler-Unternehmer*, pp. 307–8, no. 128.

31. Grimm, ed., *Ein Maler-Unternehmer*, p. 297, no. 114b.

32. Friedländer and Rosenberg, *Paintings of Lucas Cranach*, pp. 15–16.

33. To communicate to the viewer the rapidity of the artist's strokes, Koepplin and Falk displayed *Christ on the Mount of Olives* in reverse imagery. *Cranach*, vol. 1, pp. 134–37; Geisberg and Strauss, ed., *German Single-Leaf Woodcut*, vol. 2, p. 509.

34. Cf. Koepplin and Falk, *Cranach*, vol. 1, p. 120; Heiser calls this "the expressive exponent." *Frühwerk Lucas Cranachs*, p. 112.

35. Ernst Rebel, "Lucas Cranachs Porträitkunst," in *Ein Maler-Unternehmer*, ed. Grimm, p. 131.

36. Originally, the painting was anonymously titled. Ibid.; Heiser, *Frühwerk Lucas Cranachs*, pp. 123–24.

37. In re Herr Reuss's melancholy, Heiser points out that his book is wide open on his lap, yet his face remains impenetrable, the very reverse of Cuspinian, whose book is closed, yet his face is "wide open" and seemingly blessed. Arguably, Reuss's face can be read as negatively as Cuspinian's can be interpreted positively, suggesting that the two couples are true opposites. Heiser, *Frühwerk Lucas Cranachs*, pp. 123–25.

38. Cf. ibid., p. 126.

39. Koepplin and Falk, *Cranach*, vol. 1, pp. 164, 168.

40. Cf. Grimm, ed., *Ein Maler-Unternehmer*, p. 132.

41. Gerald Strauss, *Law, Resistance, and the State: The Opposition to Roman Law in Reformation Germany* (Princeton, 1979), pp. 3–30.

42. Grimm, ed., *Ein Maler-Unternehmer*, pp. 131–33; Koepplin and Falk, *Cranach*, vol. 2, pp. 163–64.

43. Friedländer and Rosenberg, *Paintings of Lucas Cranach*, plates 3–4.

44. Heiser, *Frühwerk Lucas Cranachs*, p. 53; Schade, *Family of Master Painters*, plate 7.

45. Koepplin and Falk, *Cranach*, vol. 1, p. 149.

46. Also titled *Braunschweiger Liebespaar-Zeichnung "Oberdeutsch"* (1503). Heiser calls it *Liebespaar am Brunnen* [Lovers at the Fountain]. The portrait is in the Herzog Anton Ulrich-Museum, Braunschweig. Heiser, *Frühwerk Lucas Cranachs*, p. 34.

47. Possible precedents can be found in Dürer and Israhel von Meckenem. Koepplin and Falk, *Cranach*, vol. 1, pp. 150–51.

48. Lüdecke, ed., *Cranach im Spiegel seiner Zeit*, p. 11.

49. Schade says it was inspired by Dürer's woodcut of the *Holy Family with Three Hares* (1496–97), in Schade, *Family of Master Painters*, p. 20. Cf. Koepplin and Falk, *Cranach*, vol. 2, no. 375, p. 528. Hinz calls it "a new theme of Christian art" and describes Cranach's signature on it as "capricious," apparently because of the earlier experimentation (1503) he made with a cryptogram; *Lucas Cranach d.Ä.*, pp. 14–15 (n.b. there is no "boxing up" of the author's initials here). Friedländer and Rosenberg, *Paintings of Lucas Cranach*, plate 10.

50. In Cranach's later versions of the scene, the numbers of putti double and even quadruple: twenty-two in 1509, fifteen in ca. 1520. Geisberg and Strauss, ed., *German Single-Leaf Woodcut*, vol. 2, pp. 506–7.

51. Heiser, *Frühwerk Lucas Cranachs*, pp. 115–18.

52. Koepplin and Falk, *Cranach*, vol. 1, p. 168.

CHAPTER 3. THE COMPLEAT COURT PAINTER

1. "He found the stimulus that enabled him to assimilate Dürer's pictures and master them in his own way." Schade, *Family of Master Painters,* pp. 14–15.

2. Heinrich Kühne, *Lucas Cranach der Ältere in Wittenberg* (Wittenberg, 2004), p. 5; David Steinmetz, *Misericordia Dei: The Theology of Johannes von Staupitz in Its Late Medieval Setting* (Leiden, 1968), p. 11; Harald Marx, "Dresden als Cranach-Palast und der 'Moderne' Cranach," in *Cranach,* ed. Marx and Mössinger, pp. 88–111.

3. Koepplin and Falk, *Cranach,* vol. 1, pp. 48–51, 61; Hutchison, *Albrecht Dürer,* p. 66; Grimm, ed., *Ein Maler-Unternehmer,* pp. 297–98. The altar was severely damaged in 1988 when a disturbed person doused it with acids. Today, it is safeguarded in Munich's Alte Pinakothek.

4. Paul M. Bacon, "Art Patronage and Piety in Electoral Saxony: Frederick the Wise Promotes the Veneration of His Patron, St. Bartholomew," *Sixteenth-Century Journal* 39 (2008): 973–1001.

5. Hinz, *Lucas Cranach d.Ä,* pp. 16–17.

6. Ibid., pp. 14, 16–17; Schade, *Family of Master Painters,* p. 15; Lewis W. Spitz, *Religious Renaissance of the German Humanists* (Cambridge, Mass., 1963), pp. 81–109.

7. Dieter Koepplin, "Lucas Cranachs Heirat und das Geburtsjahr des Sohnes," *Zeitschrift der Deutschen Verein für Kunstswissenschaft* 20 (1966): 79–84. On Conrad Mutianus Rufus, see Spitz, *Religious Renaissance of the German Humanists,* pp. 130–54.

8. Koepplin and Falk, *Cranach,* vol. 1, pp. 19–20, 45; Cornelius Gurlitt, "Die Künst unter Kurfurst Frederick der Weise" (1897); R. Bruck, *Friedrich der Weise als Förderer der Kunst* (Strassburg, 1903); Edgar Bierende, *Lucas Cranach d.Ä. und der deutsche Humanismus: Tafelmalerei im Kontext von Rhetorik, Chroniken und Fürstenspiegeln* (Munich, 2002), pp. 182–88.

9. Hutchison, *Albrecht Dürer,* p. 72.

10. Schade, *Family of Master Painters,* p. 22.

11. Grimm, ed., *Ein Maler-Unternehmer,* p. 318.

12. Koepplin and Falk, *Cranach,* vol. 1, pp. 41–42, 45.

13. Bierende, *Lucas Cranach d.Ä. und der deutsche Humanismus,* p. 234.

14. Strehle, *Lucas Cranach d.Ä. in Wittenberg,* p. 7.

15. Hinz, *Lucas Cranach d.Ä.,* p. 17; Hutchison, *Albrecht Dürer,* pp. 114–16.

16. Koepplin and Falk, *Cranach*, vol. 1, no. 9, p. 47; Geisberg and Strauss, ed., *German Single-Leaf Woodcut*, vol. 2, p. 576.

17. Koepplin and Falk, *Cranach*, vol. 1, no. 9, p. 46.

18. Steven Ozment, *Magdalena and Balthasar: An Intimate Portrait of Life in Sixteenth-Century Europe* (New York, 1986).

19. Hinz, *Lucas Cranach d.Ä.*, p. 23; Koepplin and Falk, *Cranach*, vol. 1, pp. 50–51.

20. Friedländer and Rosenberg, *Paintings of Lucas Cranach*, p. 19. Grimm calls it a "master work with powerfully modeled three-dimensional figures." Grimm, ed., *Ein Maler-Unternehmer*, p. 299. Dürer's large woodcut of 1497–98 is the model for the middle panel. Lüdecke, ed., *Cranach im Spiegel seiner Zeit*, p. 15; Koepplin and Falk, *Cranach*, vol. 1, no. 12, p. 49.

21. Since her martyrdom, Catherine has been the patron saint of Christian philosophers and other learned Christian professions.

22. Friedländer and Rosenberg, *Paintings of Lucas Cranach*, no. 11.

23. Hinz, *Lucas Cranach d.Ä.*, p. 23; Koepplin and Falk, *Cranach*, vol. 1, p. 89. For the present-day progress in reuniting the pieces of this famous work, presently divided between Dresden and London museums, see Marx, "Dresden als Cranach-Palast," pp. 98–100.

24. Marx and Mössinger, eds., *Cranach*, pp. 99–105. On the debate over "who's who" among the body parts, see Lüdecke, ed., *Cranach im Spiegel seiner Zeit*, p. 15; Koepplin and Falk, *Cranach*, vol. 1, p. 49; Hinz, *Lucas Cranach d.Ä.*, pp. 19–20; L. Kämmerer, "Die Bildnisse auf Cranachs Katharinenaltar in Dresden," *Zeitschrift für bildende Kunst* 65 (1931–32): 193–94, discussed by Friedländer and Rosenberg, *Paintings of Lucas Cranach*, pp. 68–69.

25. Bierende, *Lucas Cranach d.Ä. und der deutsche Humanismus*, p. 160.

26. Hopelessly smitten by Cranach's Danube-Viennese works, Friedländer, while not totally dismissive of Cranach's later work, faults *The Martyrdom of St. Catherine* for its "poor construction" and inauguration of the "stiff" Wittenberg style. Friedländer and Rosenberg, *Paintings of Lucas Cranach*, p. 68.

27. Thomas Maissen and Gerrit Walther, eds., *Funktionen des Humanismus: Studien zum Nützen des Neuen in der humanistischen Kultur* (Göttingen, 2006), pp. 229, 237 (Sibutus), pp. 226, 229–33 (Cranach); Schade, *Family of Master Painters*, p. 27.

28. Koepplin and Falk, *Cranach*, vol. 1, pp. 214–17.

29. Some have equated the coat-of-arms with true ennoblement: "erhob ihm in den Adelsstand." With the passage of generations, Cranach's latter-day

relatives were also tempted to treat it as such. Lüdecke, ed., *Cranach im Spiegel seiner Zeit*, pp. 59–60, 107.

30. Ibid., p. 14; cf. Grimm, ed., *Ein Maler-Unternehmer*, 226; Hinz, *Lucas Cranach d.Ä.*, pp. 29–31; Strehle, *Lucas Cranach d.Ä. in Wittenberg*, p. 9; Koepplin and Falk, *Cranach*, vol. 1, figure 96.

31. Cf. the Moorish figureheads of the Scheurls and the Dürers, among others, in Eugen Schöler, *Fränkische Wappen erzählen Geschichte und Geschichten* (Neustadt an der Aisch, 1992), pp. 12, 94–95; Steven Ozment, *Flesh and Spirit: Family Life in Early Modern Germany* (New York, 1999), p. 55.

32. According to Schade, the winged serpent "symbolizes a rapid improviser on whom time confers a well-deserved prize [viz. talent and success]." The original image is said to be an "artistic device" of Erfurt painters known as a basilisk, "a dragon that kills by [flaming] breath and glance." Schade, *Family of Master Painters*, pp. 27–28.

33. Some speculate that the coat-of-arms was bestowed on Cranach because he, as court painter, was to accompany the elector on a planned expedition to Italy, a journey that appears never to have occurred. Grimm, ed., *Ein Maler-Unternehmer*, p. 226. If such accreditation was needed for diplomatic missions, then Cranach's journey to the imperial court in the Netherlands, also in 1508, may have been the occasion for his new shield.

34. See Joseph Leo Koerner, *The Moment of Self-Portraiture in German Renaissance Art* (Chicago, 1993).

35. In 1485 the Wettin dynasty was divided into ducal (Albertine) and electoral (Ernestine) Saxony, henceforth, lethal rivals.

36. Marx and Mössinger, eds., *Cranach*, p. 594.

37. Grimm, ed., *Ein Maler-Unternehmer*, pp. 226–27.

38. See Hinz on Scheurl's "November *Pomprede*," in *Lucas Cranach d.Ä.*, p. 26.

39. In the published version of Scheurl's salute (Leipzig, October 1509) similar praise was appended by other admirers, among them future Luther rival Andreas Bodenstein von Carlstadt, who collaborated with Cranach on the first Protestant broadsheet against Rome in 1519–20. Koepplin and Falk, *Cranach*, vol. 1, pp. 95ff; Lüdecke, ed., *Cranach im Spiegel seiner Zeit*, pp. 49–58.

40. Lüdecke, ed., *Cranach im Spiegel seiner Zeit*, pp. 49–50, 54 (emphasis added); Hinz, *Lucas Cranach d.Ä.*, p. 26.

41. Lüdecke, ed., *Cranach im Spiegel seiner Zeit*, p. 53.

42. Ibid., pp. 51–52.

43. Ibid., pp. 53–54; Koepplin and Falk, *Cranach,* vol. 1, p. 14.

44. Strigel prepared a consolatory poem upon the death of Cranach's eldest son Hans, giving the reader some vital internal family history. He also reports Dürer's private praise of Cranach's mythological women, noting their "appealing charm and agility . . . the best in the genre of all artists of the age." Hinz, *Lucas Cranach d.Ä.,* p. 44; Grimm, ed., *Ein Maler-Unternehmer,* p. 228.

45. Melanchthon, for example, was not present at Luther's wedding and apparently unhappy about it, whereas Cranach was there as both best man and stand-in father of the bride.

46. Cranach's art "auf eine einschmeichelnde Wiedergabe einfacher, volkstüm-licher Sachverhalte gerichtet . . . Dürer . . . malte alles grossartig, differenziert durch vielfältige Linienführung." Grimm, ed., *Ein Maler-Unternehmer,* pp. 227–28.

47. Frederick apparently incurred such scorn from the emperor by failing to negotiate a successful treaty with the French on his behalf. Bernd Stephen, "Kul-turpolitische Massnahmen des Kurfürsten Friedrich III, des Weisen, von Sach-sen," *Lutherjahrbuch* 49 (1982): 55–56; Bierende, *Lucas Cranach d.Ä. und der deutsche Humanismus,* pp. 161–62.

48. Grimm, ed., *Ein Maler-Unternehmer,* p. 318; Schade, *Family of Master Painters,* p. 28.

49. See Christoph Scheurl's "Oration to Cranach" (1509), in *Cranach im Spiegel seiner Zeit,* ed. Lüdecke, p. 50; Koepplin and Falk, *Cranach,* vol. 1, no. 139, pp. 241–42.

50. Schade, *Family of Master Painters,* pp. 28–30.

51. "Je nicht in diese Lande." Georg Spalatin, "Friedrichs des Weisen, Leben und Zeitgeschichte," in *Georg Spalatins historischer Nachlass und Briefe* (Jena, 1851), vol. 1, pp. 60–62.

52. Matthew 10:2–3, 27:56; Mark 3:18, 15:40; Luke 6:15; John 19:25; Acts 1:13.

53. Joseph Leo Koerner, *The Reformation of the Image* (London, 2004), p. 73; Koepplin and Falk, *Cranach,* vol. 1, pp. 75–77; Friedländer and Rosenberg, *Paint-ings of Lucas Cranach,* no. 18, p. 70.

54. Schade, *Family of Master Painters,* p. 40; Friedländer and Rosenberg, *Paintings of Lucas Cranach,* nos. 18, 20, p. 72. Hinz notes the influence of Quentin Massys, whom Cranach met in the Netherlands, and whose painting of *The Holy Kinship* had in turn been influenced by Leonardo da Vinci. Hinz, *Lucas Cranach d.Ä.,* pp. 32, 34.

55. Most critics agree that those enhancements peaked in a startling new portrayal of Venus, known as "Dark Venus" (1509).

56. Schade, *Family of Master Painters,* p. 40; Hinz, *Lucas Cranach d.Ä.,* pp. 37, 40; Geisberg and Strauss, ed., *German Single-Leaf Woodcut,* vol. 2, pp. 509–19.

57. Luther's authenticating, protective shield "the White Rose" was not awarded until 1518.

58. Grimm, ed., *Ein Maler-Unternehmer,* no. 362, p. 189.

59. Friedländer and Rosenberg, *Paintings of Lucas Cranach,* nos. 29–30, 36–39, 20, 40, 46, 50–51, 54, 67, 80–82, 85–89.

60. *Against the Idol at Halle* (1522). See Heiko A. Oberman, *Luther: Man Between God and the Devil* (New Haven, 1989), pp. 68–70, 74ff, 187–90; Grimm, ed., *Ein Maler-Unternehmer,* p. 318. Earlier (1514) Luther had lectured against indulgences, while numerous reform-minded humanists, following Erasmus, ridiculed them as well. On the Halle indulgence, see *Luther's Works,* vol. 39, pp. 247–99.

61. By 1520, the forces of reform in Wittenberg were strong enough to persuade the elector to purge his relic collection, then topping out at nineteen thousand pieces. By most accounts, the bulk of the collection ended up in the hands of Spanish collectors. Hinz, *Lucas Cranach d.Ä.,* p. 35; Koepplin and Falk, *Cranach,* vol. 1, pp. 187–88, 190.

62. Koepplin and Falk, *Cranach,* vol. 1, p. 207. In Cranach's woodcut portrayal of Sibutus, Koepplin and Falk discover the artist's general view of life and "constant character trait" that sets him apart from Renaissance philosophers and artists. When an active Cranach figure emerges self-consciously "in the spirit of Humanism," he confronts something contradictory, or conflicting, and feels constrained or tied down, a bondage of the will. In the example of Sibutus, "the figure's lips remain closed and the look on his face expresses great anxiety rather than the consciousness of a great orator—a feeling of being tied down . . . a stirring helplessness of human actions." See n. 75 below.

63. Ibid., pp. 112, 207–8, 214–17. On sprezzatura, see Castiglione's *The Book of the Courtier,* ed. Daniel Javitch (New York, 2002), first written in 1508, first published in 1528, so expressing a contemporary attitude. (Thanks to Margaret Arnold.)

64. "If the figures depicted by Cranach stand out as active and assured, Cranach nevertheless seems to be approaching something contradictory: a developing awareness of being bound, a loss of self-control and weakness in the face of superior powers. The image of Sibutus expresses a corresponding religious statement because the viewer expects something different from an imperially-crowned poet, whose crown seems here to grow together with his hair and to

disappear into it. A heroic monument this is not!" Koepplin and Falk, *Cranach,* vol. 1, pp. 196, 207. Thanks to Christopher Brown.

65. Koepplin and Falk rather see Sibutus taking the first tentative steps at rebuilding his will: "Willensbildung, the next modest step into humanistic manhood." Ibid., vol. 1, p. 208.

66. See Romans 7 and St. Augustine, *The Confessions.*

67. "Epitaph des Heinrich Schmitburg" (1518), no. 121, in Ullmann, "Lucas Cranach, Bürger und Hofmaler," p. 61.

68. Lüdecke, ed., *Der Künstler und seine Zeit,* p. 117.

69. "Ablass Pallia Bisthumbs lehen": "indulgence granted by the Pallia of the bishopric [of Rome]." Marx and Mössinger, eds., *Cranach,* no. 12, p. 322.

CHAPTER 4. WORKSHOP WITTENBERG

1. Kühne, *Lucas Cranach in Wittenberg,* pp. 12–13.

2. Monica and Dietrich Lücke, "Lucas Cranach in Wittenberg," in *Ein Maler-Unternehmer,* ed. Grimm, p. 59; Schade, *Family of Master Painters,* p. 45.

3. Koepplin, "Ein Cranach Prinzip," pp. 144–65.

4. "He lived in Cranach's house for some time after October." Koepplin and Falk, *Cranach,* vol. 1, pp. 160, 238.

5. "Nr. 1 Schlossstrasse am Markt, Schlossstrasse und Elbgasse." In these years Cranach bought and refurbished a property at 3 Market Square. Today, four properties occupy these spaces: 2, 3, 4, and 6 Market Square. Cf. Hinz, *Lucas Cranach d.Ä.,* pp. 46–47.

6. Ibid., p. 44.

7. Schade, *Family of Master Painters,* pp. 41–42.

8. Lücke, "Cranach in Wittenberg," pp. 59–65.

9. Ibid.; Schade, *Family of Master Painters,* pp. 41–45. A surviving tax notice indicates that Cranach first rented 1 Castle Street from a co- or second owner after Teuschel. Schade, *Family of Master Painters,* p. 407, no. 102.

10. Ownership of the pharmacy would extend through the Cranach female line well into the nineteenth century. Lücke, "Cranach in Wittenberg," p. 62.

11. "Wohn- und Geschäftshaus." Ibid., p. 60. After Cranach departed Wittenberg for good in 1550, surviving son Lucas Jr. inherited 1 Castle Street and remained there with his family and directed the Cranach workshop for the next forty-two years. Strehle, *Lucas Cranach d.Ä. in Wittenberg,* pp. 16–19; Kühne, *Cranach in Wittenberg,* p. 16; Schade, *Family of Master Painters,* p. 41.

12. Lücke, "Cranach in Wittenberg," pp. 60–62, ranks him third in total wealth.

13. Dieter Koepplin, "Lucas Cranachs Heirat und das Geburtsjahr des Sohnes Hans," *Zeitschrift des Deutschen Verein für Kunstwissenschaft* 20 (1966): 79–84 n. 42. Lücke dates the marriage as early as 1510–11.

14. "Die poetisch umspielte Leibelei nach humanistischer Mode." Ibid., pp. 82–83.

15. The epigrams are said to illustrate freedom in erotic and artistic affairs that prevailed in the humanistic milieu. Schade, *Family of Master Painters,* pp. 31.

16. *The Rapture of St. Mary Magdalene* (1506) and *Venus and Amor* (1509).

17. Hinz, *Lucas Cranach d.Ä.,* pp. 45–46; Koepplin, "Cranachs Heirat," pp. 83–84, citing the diary report of Valentin Sternenboke (1609).

18. Koepplin, "Cranachs Heirat," pp. 82–84; Friedländer and Rosenberg, *Paintings of Lucas Cranach,* no. 34, pp. 75–76.

19. *The Princes' Altarpiece* (1510); Friedländer and Rosenberg, *Paintings of Lucas Cranach,* no. 18, p. 20.

20. Schade, *Family of Master Painters,* p. 45, no. 56; Koerner, *Reformation of the Image,* p. 73; Friedländer and Rosenberg, *Paintings of Lucas Cranach,* no. 20, pp. 71–72.

21. Friedländer believed Cranach adorned the figure of Mary Cleophas with the face and bearing of his bride, while Koepplin, who commands the more recent research, argues the case for Maria Salome as the truer to history figure of Cranach's wife. Friedländer and Rosenberg, *Paintings of Lucas Cranach,* no. 34, p. 75; Koepplin and Falk, *Cranach,* vol. 1, pp. 74–78.

22. On this issue: Koepplin, "Cranachs Heirat," pp. 79–84; Hinz, *Lucas Cranach d.Ä.,* pp. 41–45, who agrees with Koepplin. Friedländer and Rosenberg, *Paintings of Lucas Cranach,* no. 34, p. 75.

23. *Treuhandemblem* [trustee emblem].

24. Koepplin and Falk, *Cranach,* vol. 1, pp. 74–76; Hinz, *Lucas Cranach d.Ä.,* pp. 45–46.

25. Hinz, *Lucas Cranach d.Ä.,* pp. 44–45; Koepplin, "Cranachs Heirat," pp. 82–84; Schade, *Family of Master Painters,* pp. 30–32.

26. *Luther's Werke in Auswahl* 8, no. 3530 (1536): 100–101, no. 5524 (1542–43): 318–19.

27. For the marriage boom of the late fifteenth and sixteenth centuries: Anthony F. D'Elia, *The Renaissance of Marriage in Fifteenth-Century Italy* (Cambridge, Mass., 2004); Heide Wunder, *He Is the Sun, She Is the Moon: Women in*

Early Modern Germany (Cambridge, 1998); Steven Ozment, "Inside the Pre-industrial Household: The Rule of Men and the Rights of Women and Children in Late Medieval and Reformation Europe," in *Family Transformed: Religion, Values, and Society in American Life*, ed. Steven M. Tipton and John Witte, Jr. (Washington, D.C., 2005), pp. 225–44.

28. Their children were Hans, born March 15, 1513, died October 4, 1537; Lucas Jr., born October 4 or 6, 1515, died in 1586; Ursula, born in 1516 or 1517, not known when she died; Barbara, born 1517–18, date of death unknown; Anna born in 1520, died in 1577. Schade, *Family of Master Painters*, p. 118; Koepplin, "Cranachs Heirat," pp. 79–84; and Kühne, *Lucas Cranach in Wittenberg*, pp. 24–27.

29. Hinz, *Lucas Cranach d.Ä.*, p. 43–44; Schade, *Family of Master Painters*, p. 118; Koepplin, "Cranachs Heirat," pp. 79–84; and Kühne, *Lucas Cranach in Wittenberg*, pp. 24–27.

30. Friedländer cites "a form of oratory and painting that can be taught and learned." Cited in Koepplin and Falk, *Cranach*, vol. 1, p. 13.

31. Lüdecke, ed., *Cranach im Spiegel seiner Zeit*, pp. 104–5.

32. Ibid., pp. 17–18.

33. Marx and Mössinger, eds., *Cranach*, pp. 92–93, 424–25, 595.

34. Lüdecke, ed., *Cranach im Spiegel seiner Zeit*, p. 21 n. 9; Hinz, *Lucas Cranach d.Ä.*, p. 50.

35. Lücke, "Cranach in Wittenberg," p. 64; Strehle, *Lucas Cranach d.Ä. in Wittenberg*, p. 42.

36. Hinz, *Lucas Cranach d.Ä.*, p. 51.

37. Kühne, *Lucas Cranach in Wittenberg*, p. 38.

38. Lüdecke, ed., *Cranach im Spiegel seiner Zeit*, pp. 65–68; Strehle, *Lucas Cranach d.Ä. in Wittenberg*, p. 68.

39. Lüdecke, ed., *Cranach im Spiegel seiner Zeit*, pp. 65–66.

40. Ibid., pp. 21, 65–66, 109–10; Strehle, *Lucas Cranach d.Ä. in Wittenberg*, p. 68.

41. Lüdecke, ed., *Cranach im Spiegel seiner Zeit*, pp. 66–67.

42. Hinz, *Lucas Cranach d.Ä.*, pp. 47–49; Lüdecke, ed., *Cranach im Spiegel seiner Zeit*, pp. 31, 62–65, 108.

43. Martin Luther, *Three Treatises* (Philadelphia, 1960); Spitz, *Religious Renaissance of the German Humanists*, pp. 110–29.

44. Kühne, *Lucas Cranach in Wittenberg*, pp. 33–34; Hinz, *Lucas Cranach d.Ä.*, p. 49.

45. Strehle, *Lucas Cranach d.Ä. in Wittenberg*, p. 26; Lüdecke, ed., *Cranach im Spiegel seiner Zeit*, p. 108.

46. Grimm, ed., *Ein Maler-Unternehmer,* p. 231; Schade, *Family of Master Painters,* pp. 43–44; Germanisches Nationalmuseum, ed., *Martin Luther und die Reformation in Deutschland: Ausstellung zum 500; Geburtstag Martin Luthers* (Frankfurt am Main, 1983), pp. 275–83.

47. The biblical stones were jasper, sapphire, agate, emerald, onyx, carnelian, chrysolite, beryl, topaz, chrysoprase, jacinth, and amethyst (Rev. 21:19–21).

48. "Names given according to all shades of color." Lücke, "Cranach in Wittenberg," p. 231; Koepplin and Falk, *Cranach,* vol. 1, pp. 221ff.

49. Brinkmann, ed., *Cranach der Ältere,* p. 201; Grimm, ed., *Ein Maler-Unternehmer,* p. 231.

50. Brinkman, ed., *Cranach der Ältere,* pp. 200–201.

51. Kühne, *Lucas Cranach in Wittenberg,* pp. 33–35; Hinz, *Lucas Cranach d.Ä.,* p. 49; Lücke, "Cranach in Wittenberg," p. 63.

52. Lücke, "Cranach in Wittenberg," p. 49; Strehle, *Lucas Cranach d.Ä. in Wittenberg,* p. 26. Away from Wittenberg, Lotter later developed a very successful career as a printer in Dresden and Leipzig.

53. Luther: "I did not want to give the press any more books at all. . . . But Lucas's press needed support and for that reason I have now given him my thoughts on the emperor's Imperial Mandate, together with my Annotations on the seventh chapter of Corinthians. In doing so I have become a slave to profit and greed." Lüdecke, ed., *Cranach im Spiegel seiner Zeit,* p. 32.

54. Ibid., pp. 32–33.

55. Spalatin, "Friedrichs des Weisen."

56. Lüdecke, ed., *Cranach im Spiegel seiner Zeit,* pp. 63–64.

57. Ibid., pp. 63–64, 108–9; Martin Brecht, *Martin Luther: The Preservation of the Church, 1532–1546* (Minneapolis, 1987); and Schwiebert, *Luther and His Times.*

58. Schwiebert, *Luther and His Times,* pp. 644–45.

59. John Witte, Jr., *From Sacrament to Contract: Marriage, Religion, and Law in the Western Tradition* (Louisville, 1997), pp. 70–73.

60. On Apel, see ibid.

61. Lüdecke, ed., *Cranach im Spiegel seiner Zeit,* pp. 113–14.

62. Compare and contrast the treatment of the subject by German historian Peter Blickle, *The Revolution of 1525* (Baltimore, 1978), and English historian Diarmaid MacCulloch, *The Reformation: A History* (New York, 2003).

63. Hinz, *Lucas Cranach d.Ä.,* p. 49.

64. Schade, *Family of Master Painters,* pp. 44–45, 414, nos. 237, 253.

65. Ibid., p. 438, no. 320, p. 441, no. 364.

66. Ibid., p. 443, no. 401, p. 444, no. 409.

67. Ozment, *Protestants,* pp. 147, 246. "Because there is no hope of getting another government in the Roman Empire . . . it is not advisable to change that government. Rather let him who is able to darn and patch it [flicke und pletze dran] and do so as long as we live; let him punish the abuse and put bandages and ointment on the smallpox." "Exposition of Psalm 101," in *Luther's Works,* vol. 13, p. 217.

68. Schade dates the arrival of the apothecary privilege on December 6 from Lochau, *Family of Master Painters,* p. 410, entries 161, 162, 166. Grimm is more comprehensive: *Ein Maler-Unternehmer,* pp. 228–31, nos. 11, 17; Kühne, *Lucas Cranach in Wittenberg,* pp. 35–37; Lücke, "Cranach in Wittenberg," p. 62.

69. No sales could be made when the city's wine cellar was fully supplied and operating; all sales of wine carried a user tax payable to the city; and as with medications, wine had to be sold by a university-trained and licensed apothecary. Lüdecke, ed., *Cranach im Spiegel seiner Zeit,* pp. 61–62, 107; Hinz, *Lucas Cranach d.Ä.,* pp. 46–47; Koepplin and Falk, *Cranach,* vol. 1, p. 22.

70. Kühne, *Lucas Cranach in Wittenberg,* pp. 35–39.

71. Lücke, "Cranach in Wittenberg," pp. 62–63.

72. Schade, *Family of Master Painters,* pp. 42–43; Lücke, "Cranach in Wittenberg," p. 60.

73. Lüdecke, ed., *Cranach im Spiegel seiner Zeit,* pp. 61–63, 107.

74. Ibid., p. 107.

CHAPTER 5. MARKETING LUTHER

1. Oberman, *Luther,* pp. 113–50; Schwiebert, *Luther and His Times,* pp. 145–49.

2. Hinz has them meeting for the first time in 1517 and Cranach illustrating Luther's writings in 1518. Hinz, *Lucas Cranach d.Ä.,* pp. 64–66. Koerner cites scholars who found the two working together in 1516 on *The Ten Commandments* panel in Wittenberg's town hall, moving their first collaboration up several years: Joseph Leo Koerner, "Luthers Beziehung zu Kunst und Künstlern," in *Leben und Werk Martin Luthers von 1526–1546,* ed. Helmar Junghans (Frankfurt am Main, 1984). Koerner, *Reformation of the Image,* pp. 76–77.

3. On the volatility and vulnerability of Germany at this time, see "The Grievances of the German Nation" (1521), in Gerald Strauss, *Manifestations of Discontent in Germany on the Eve of the Reformation* (Bloomington, 1971), pp. 52–64.

4. Thomas Müntzer was the most lethal of Luther's rivals and a leader of the Peasants' Revolt of 1525. Shortly after his rejection by the princes Müntzer lost his life while commanding a peasant militia during the revolt. *Sermon Before the Princes: An Exposition of the Second Chapter of Daniel (Allstedt, July 13, 1524)*, in *Spiritual and Anabaptist Writers*, ed. G. H. Williams (Philadelphia, 1957), pp. 47–70; Hans-Jürgen Goertz, *Thomas Müntzer: Apocalyptic Mystic and Revolutionary* (Edinburgh, 1993), pp. 193–207.

5. Schwiebert devotes fifty-three pages to the *Leipzig Debate* (1519) between Luther and John Eck, the no-return point of Luther's venture into religious reform. Schwiebert, *Luther and His Times*, pp. 384–437. Artist Wolfgang Stoeckel's crude portrayal of Luther on a reform pamphlet at this time also documents the reformer's forward movement. Martin Warnke, *Cranachs Luther: Entwürfe für ein Image* (Frankfurt am Main, 1984), pp. 9–11.

6. "Pioneer of the Protestant aesthetic." Hinz, *Lucas Cranach d.Ä.*, pp. 64–66; Schwiebert, *Luther and His Times*, pp. 536–38; Charles Garside, *Zwingli and the Arts* (New Haven, 1966), pp. 28–33.

7. Andreas Bodenstein von Karlstadt, *Der Himmelwagen und Höllenwagen* (1519), with Hans Schäufelein's woodcut illustration of Hans von Leonrodt's "Hymelweg, etc.," in Koepplin and Falk, *Cranach*, vol. 2, no. 351, p. 504.

8. Hutchison, *Albrecht Dürer*, pp. 124–26.

9. See the copper engravings of Frederick and his brother John in *Martin Luther und die Reformation in Deutschland: Ausstellung zum 500*, ed. Germanisches Nationalmuseum, p. 118.

10. Luther as "a revolutionary Professor." Strehle, *Lucas Cranach d.Ä. in Wittenberg*, pp. 75–76; Warnke, *Cranachs Luther*, pp. 17–20.

11. Hinz suspects the unflattering "sleepy features" of Cranach's 1519 portrayal of Albrecht of Brandenburg reflect Reformation polemic, or Cranach's "dispirited effort at copying" a representation imposed on him by Dürer. Hinz, *Lucas Cranach d.Ä.*, p. 83. Lüdecke reports Friedrich Engels's famous comment upon his first beholding of Cranach's 1520 Luther. He claimed to see in Luther "both the poet of the Marseillaise and the bloodthirsty enemy of the revolutionary peasants." "Lüdecke, ed., *Cranach im Spiegel seiner Zeit*, p. 24.

12. Warnke, *Cranachs Luther,* pp. 32–33.

13. Ibid., p. 52. See also *Martin Luther und die Reformation in Deutschland: Ausstellung zum 500,* ed. Germanisches Nationalmuseum, p. 228, no. 287.

14. Ozment, *Age of Reform,* pp. 290–302 (Erasmus and Luther), pp. 235, 238–30, 244 (Ockham and Luther).

15. "Whereas in 1522, Luther had . . . wished all images gone . . . he [now] suggested that images were salvific, necessary for salvation [because] faith takes place in the image-filled machinery of the human heart." That change of mind, from *adiaphoron* to *sine qua non,* attests the artist's strong influence on the reformer. Koerner, *Reformation of the Image,* p. 161. Cf. Carlos M. N. Eire, *War Against the Idols: The Reformation of Worship from Erasmus to Calvin* (Cambridge, 1986), pp. 54–73.

16. Cf. Koerner, *Reformation of the Image,* pp. 9–11, 28, 32, 34, 45–49.

17. For Luther, to control content and meaning, the image had to be a "simple, clear, transparent 'text.'" Hanne K. Poulsen, "Fläche, Blick und Erinnerung: Cranachs Venus und Amor als Honigdieb im Licht der Bildtheologie Luthers," in *Lucas Cranach: Glaube,* ed. Schade, pp. 134–35.

18. Hajo Holborn, *A History of Modern Germany: The Reformation* (New York, 1959), p. 149.

19. Ibid., pp. 24–25, 111; Strehle, *Lucas Cranach d.Ä. in Wittenberg,* p. 88; Schwiebert, *Luther and His Times,* pp. 513ff.

20. Schwiebert, *Luther and His Times,* pp. 148–52.

21. On the character and independence of the reformer, see Oberman, *Luther,* pp. 298–312.

22. Lüdecke, ed., *Cranach im Spiegel seiner Zeit,* pp. 68–69.

23. Ibid., p. 538.

24. Koerner, *Reformation of the Image,* pp. 83–84, 102, 136.

25. A primary narrative of the Wittenberg iconoclastic movement is Nikolaus Müller, *Die Wittenberger Bewegung 1521 and 1522: Die Vorgänge in und um Wittenberg während Luthers Wartburgaufenthalt: Briefe, Akkten und dergleichen und Personalien* (Leipzig, 1911).

26. Schwiebert, *Luther and His Times,* p. 540.

27. "Eight Sermons at Wittenberg, 1522," in *Luther's Works,* vol. 51, pp. 70–91, with direct remarks on "images" (pp. 81–83). See also Oberman, *Luther,* pp. 301–4; Schwiebert, *Luther and His Times,* pp. 536ff, 542–43.

28. Garside, *Zwingli and the Arts,* pp. 28–33.

29. Hermann Barge, *Andreas Bodenstein von Karlstadt* (Leipzig, 1905), vol. 2, pp. 12–14, cited in Koerner, *Reformation of the Image,* pp. 83–84, 90–92.

30. Ibid., pp. 153–56.

31. Luther: "Image breakers misread Scripture, violate [Christian] freedom, scandalize the weak, and undermine political authority [etc.], and they do so all in vain because] whether [one] wants to or not, when he hears the word Christ, there delineates itself in his heart the picture of a man who hangs on the cross." Luther, *Against the Heavenly Prophets,* cited in Koerner, *Reformation of the Image,* pp. 157–61, 166, 171.

32. By "arresting the iconoclast's blow [against the churches]" Luther is said to have inaugurated "confessionalization," the pervasive, organizing power of religion within society. Koerner, *Reformation of the Image,* pp. 158–59.

33. Ilonka Egert, "Erzbischof Albrecht von Mainz, 1490–1545," in *Kaiser, König, Kardinal: Deutsche Fürsten, 1500–1800,* ed. Rolf Straubel and Ulman Weiss (Leipzig, 1991), pp. 64–73.

34. Letter to Spalatin (November 11, 1521), in *Luther's Works,* vol. 48, ed., Gottfried Krodel (Philadelphia, 1963), p. 326.

35. Letter to Albrecht of Mainz (December 1, 1521), in *Luther's Works,* vol. 48, p. 342. Halle was Albrecht's new residence.

36. "Why the Books of the Pope and His Disciples Were Burned," *Luther's Works,* vol. 31, ed. H. J. Grimm (Philadelphia, 1958), pp. 381–95.

37. Egert, "Erzbischof Albrecht von Mainz," pp. 66–68.

38. Spalatin, "Friedrichs des Weisen," pp. 40–41, 57–62.

39. Martin Brecht, *Martin Luther: Shaping and Defining the Reformation, 1521–1532* (Minneapolis, 1990), pp. 189, 201.

40. Andreas Tacke, *Der katholische Cranach: Zu zwei Grossaufträgen von Lucas Cranach d.Ä., Simon Franck und der Cranach Werkstatt, 1520–1540* (Mainz, 1992), p. 11.

41. Ibid.

42. Ibid., pp. 14–15.

43. Eamon Duffy, "Spiritual Surrender," *The Guardian* (March 1, 2008).

44. Tacke, *Der katholische Cranach,* pp. 12–21, 32–33.

45. Ibid., pp. 13–14.

46. Benjamin J. Kaplan, *Divided by Faith: Religious Conflict and the Practice of Toleration in Early Modern Europe* (Cambridge, Mass., 2007).

CHAPTER 6. GOSPEL ART

1. The iconoclasts were outclassed by the new religion. Cf. Koerner, *Reformation of the Image*, pp. 77–78, 92–93, 102, 114.

2. Warnke, *Cranachs Luther,* p. 36.

3. Cf. Christopher Boyd Brown, *Singing the Gospel: Lutheran Hymns and the Success of the Reformation* (Cambridge, Mass., 2005). Brown makes a good argument that Luther's numerous tuneful, transparent hymns for children laid a powerful and lasting foundation for the recruitment of new Protestants.

4. *Passional Christi und Antichristi,* Lüdecke, ed., *Cranach im Spiegel seiner Zeit,* p. 25; Koepplin and Falk, *Cranach,* vol. 1, no. 218–20, p. 351.

5. Hinz, *Lucas Cranach d.Ä.,* p. 51.

6. Koerner, *Moment of Self-Portraiture;* Koerner, *Reformation of the Image.*

7. Koerner, *Moment of Self-Portraiture,* pp. xviii, 39–43.

8. Ibid., pp. 188, 191.

9. In 1520, convinced that Luther's capture and execution by the church was imminent, Dürer intervened on Luther's part with Spalatin. Thereafter he contacted Erasmus, urging him also to come to Luther's defense, thereby proving himself (Erasmus) to be in "the likeness of [his] master Christ." Appealing directly to God, he went on to compare the church's persecution of Luther with Christ's Passion, praying: "But Lord, before you judge [Luther's fate], we pray that you will it that as your son Jesus Christ had to die at the hands of the priests and rise from the dead and afterward ascend to heaven, so too in a like manner it should be with your follower Martin Luther, whose death the pope with his money and against God [now] contrives: him [too] you will quicken again." Cited in Koerner, *Moment of Self-Portraiture,* pp. 76–77.

10. Luther saw images working "neither by miracle, nor by volition, but automatically and for everyone to whom an image appears: whether I want to or not, when I hear the word Christ, there delineates itself in my heart the picture of a man who hangs on the cross." Ibid., pp. xviii, 8–9, 40–42, 122.

11. Ibid., pp. 40–41, 55–56, 67.

12. The exception is *The Weimar Altarpiece* (fig. 9.8).

13. Duffy, "Spiritual Surrender."

14. Lutheran art is said to "reduce the image in favor of didacticism." In the eyes of art historians, the "tragedy of Martin Luther" was just such disenchantment: he "unwrapped and internalized what Christian images dialectically revealed and concealed" (Hegel). In a word, Lutheran theology and art were

terminally handicapped by their aggressive disenchantment of the message! Koerner, *Reformation of the Image,* pp. 32–37, 40, 364–66.

15. Koerner, *Moment of Self-Portraiture,* ch. 16.

16. On the wages of iconoclasm and "secular satisfactions," see Michael Baxandall, *The Limewood Sculptors of Renaissance Germany* (New Haven, 1980), pp. 69–94.

17. "Imagistic ascesis." Both artists and their images are said to be deconstructed into sinners and signs, no longer the Christ-like genius of Dürer. Koerner, *Moment of Self-Portraiture,* p. 382.

18. Ozment, *A Mighty Fortress,* ch. 5.

19. *On Temporal Authority* (1523). By this argument Luther was continuing to protest Carlstadt's recent and greatly resented success in persuading the city council to remove art from Wittenberg's churches, which Luther believed to be an abiding "issue of the soul," hence, not under the state's jurisdiction.

20. Mitchell B. Merback, *The Thief, the Cross, and the Wheel: Pain and the Spectacle of Punishment in Medieval and Renaissance Europe* (Chicago, 1999), on the godless artists of Nürnberg, who were Dürer associates with non-conforming sexual behaviors.

21. Hutchison, *Albrecht Dürer,* pp. 181–82. Such a monument of victory over the peasants was built in Mainz in 1626.

22. "From the start I had two fears. If the peasants became lords, the devil would become abbot; if these tyrants became lords, the devil's dam would become abbess. Therefore, I wanted to do two things: quiet the peasants and instruct the lords. The peasants were unwilling, and now they have their reward. The lords too will not hear, and they shall have their reward also." *An Open Letter Concerning the Hard Book Against the Peasants* (July 1525), *Works of Martin Luther,* vol. 4, p. 264.

23. Ozment, *A Mighty Fortress,* p. 102.

24. H. C. Erik Midelfort, *A History of Madness in Sixteenth-Century Germany* (Stanford, 1999), pp. 23, 140, 154. "Die Melancholie," in *Cranach der Ältere,* ed. Brinkmann, pp. 316–19.

25. Fernando Checa, " 'What Cannot Be Painted': Ideas, Approaches, and Themes in German Painting at the Time of Dürer" (a summary of Panofsky's interpretation of Dürer), in *Durero y Cranach,* ed. Fernando Checa (Amsterdam, 2007), pp. 462–78.

26. Ibid., p. 469. On this subject, cf. Midelfort, *History of Madness,* pp. 154–57.

27. Harking back to Dürer's Christ-like *Self-Portrait* from 1500, Koerner sees *Melencolia I* as another of Dürer's prescient "pivotal moment[s] in the history of subjectivity."

28. Why Dürer might have painted Melancholy in the person of his wife, Agnes, is no mystery. Their marriage was childless and unhappy, and rumors describe each partner as tormenting the other: Agnes was a shrewish young wife who made her husband's life miserable. Albrecht gave back as good as he got, driving her mad by the sheer neglect of her. See Erwin Panofsky, *The Life and Art of Albrecht Dürer* (Princeton, 1955), pp. 6–7, and Hutchison, *Albrecht Dürer*, p. 51. One might also venture a mischievous question: could Dürer's all-male representation of melancholy be another of the great artist's precocious "modern moments," here, the modeling of the first bisexual, or androgynous, melancholic?

29. Hutchison, *Albrecht Dürer*, p. 117.

30. Ibid.; cf. "Lament for Luther" in ibid.; Koepplin and Falk *Cranach*, vol. 1, 268–70; cf. the story of Sibutus, ch. 3.

31. Erasmus, "De Libero Arbitrio," trans. E. Gordon Rupp, and Luther, "De Servo Arbitrio," trans. Philip S. Watson, in *Luther and Erasmus: Free Will and Salvation* (Philadelphia, 1969).

32. Brinkmann, ed., *Cranach der Ältere*, pp. 316–19.

33. Against Melancthon's defense of astrology, Luther commented: "Es ist ein dreck mit iher kunst." Cited in Koepplin and Falk, *Cranach*, vol. 1, pp. 368–69.

34. Brinkmann, ed., *Cranach der Ältere*, pp. 316–17.

35. Compare Christ's loincloth as protector of the dying Jesus and the sacred space surrounding the cross.

36. Brinkmann, ed., *Cranach der Ältere*, pp. 318–19.

37. Ibid., pp. 316–17, 319; J. C. Smith, *New Perspectives on the Art of Renaissance Nürnberg: Five Essays* (Austin, Tex., 1985), p. 33.

38. Art historian Erwin Panofsky connected the melancholic shaving of sticks with the devilish "witch squad" [Hexenschar] in the sky: "It was bound together with every art of magic and the devil's work." He deemed it "improbable" that the intense whittling of sticks was just a leisurely way for an unsettled mind to pass the time. It was the making of "some kind of magical root [Zauberrute] darkly connected with the wild ride of the witches." Erwin Panofsky and Fritz Saxl, *Dürers Melencolia, I: Eine Quellen- und Typen-geschichtliche Untersuchung* (Leipzig, 1923), pp. 149–50.

39. Midelfort, *History of Madness*, p. 104.

40. "He who sees through the devil no matter how fine he appears overcomes him." Brinkmann, ed., *Cranach der Ältere*, p. 318. Midelfort, pp. 105–6.

41. Midelfort, *History of Madness*, p. 104.

42. Schwiebert, *Luther and His Times*, p. 150.

43. Koepplin and Falk, *Cranach*, vol. 1, pp. 268–69; Brinkmann, ed., *Cranach der Ältere*, p. 318.

44. Midelfort, *History of Madness*, p. 105; Bugenhagen's remedy, *Luthers Werke in Auswahl*, 8, *Tischreden*, ed. Otto Clemen (Berlin, 1950), p. 209.

CHAPTER 7. CRANACH'S WOMEN

1. Steven Ozment, *The Reformation in the Cities* (New Haven, 1975), pp. 47–120; Steven Ozment, *When Fathers Ruled: Family Life in Reformation Europe* (New Haven, 1983), pp. 1–49; D'Elia, *The Renaissance of Marriage*, pp. 117–34; Marc R. Forster, "Domestic Devotion and Family Piety in German Catholicism," in *Piety and Family in Early Modern Europe: Essays in Honor of Steven Ozment*, ed. Marc R. Forster and Benjamin J. Kaplan (Burlington, Vt., 2005), pp. 97–114.

2. On concubinage, out-of-wedlock births, and family formation, see Ozment, *Reformation in the Cities*, pp. 35, 37, 59–61, 113–14, 150; Jeffrey R. Watt, "The Impact of the Reformation and the Counter-Reformation," in *Family Life in Early Modern Times, 1500–1789*, ed. David I. Ketzer and Marzio Barbagli (New Haven, 2001), vol. 1, pp. 123–54.

3. Wunder, *He Is the Sun, She Is the Moon*, pp. 44–62; Ozment, "Inside the Preindustrial Household," pp. 225–43.

4. Martin Luther, *The Estate of Marriage* (1522), in *Luther's Works*, vol. 45, ed. Walther I. Brandt (Philadelphia, 1962), pp. 17–49.

5. *On Temporal Authority: To What Extent Should It Be Obeyed?* (1523) in *Luther's Works*, vol. 31, ed. Harold J. Grimm (Philadelphia, 1957), pp. 27–30.

6. *To the Councilmen of All Cities in Germany That They Establish and Maintain Christian Schools* (1524), in *Luther's Works*, vol. 45, p. 368.

7. *Ordinance of a Common Chest* (1523), in *Luther's Works*, vol. 45, pp. 159–75; Carter Lindberg, *Beyond Charity: Reformation Initiatives for the Poor* (Minneapolis, 1993).

8. Ozment, *Reformation in the Cities*, pp. 52–54.

9. Luther, *Estate of Marriage*, p. 18; Ozment, *Reformation in the Cities*, pp. 37, 59–61, 100–101. In 1532, upon hearing about a eunuch who regretted his castra-

tion, Luther commented: "Yes, indeed, eunuchs are more ardent than anybody else, for the passion doesn't disappear, only the power [to perform]. For my part I'd rather have two [testicles] added than one pair cut off!" *Luther's Table Talk*, in *Luther's Works*, vol. 54 (Philadephia, 1967), p. 177, no. 2865b.

10. Oberman, *Luther*, pp. 273–74.

11. Luther, *Estate of Marriage*, pp. 18–19.

12. For a similar challenge to sectarian Protestants seeking to change their confession, Goertz, *The Anabaptists*, chs. 1, 5; Lyndal Roper, "Sexual Utopianism," *Journal of Ecclesiastical History* 42, no. 3 (1991): 394–418; and Stayer, *Anabaptists and the Sword*.

13. Oberman, *Luther*, pp. 272–83; for details, Schwiebert, *Luther and His Times*, pp. 581–602.

14. Richard Friedenthal, *Luther* (London, 1970), pp. 431–33. On Von Bora see Kirsi Sjterna, *Women and the Reformation* (Oxford, 2009), pp. 51–70.

15. The last category describes "ill-motivated" marriages between the too old and the too young, false unions in which one seeks lifelong security and care while the other wants only an early inheritance and security.

16. "Her sensual qualities exceed every natural skin test." Anne-Marie Bonnet, "Der Akt im Werk Lucas Cranachs," in *Ein Maler-Unternehmer*, ed. Grimm, pp. 143–44.

17. "Lust of the eyes and sensuous joy played a central role in affirming antiquity's role as the messenger of a physical ideal of beauty that was bound emphatically with sexuality." Ingrid Schulze, "Lucas Cranach und die Universität Wittenberg," in *Lucas Cranach: Künstler und Gesellschaft*, ed. Cranach-Komitee der DDR (Wittenberg, 1973), p. 73.

18. Susan Foister, "Cranachs Mythologien, Quellen und Originalität," in *Lucas Cranach: Glaube*, ed. Schade, p. 116; Bonnet, "Der Akt im Werk Lucas Cranachs," pp. 143–44.

19. Bonnet, "Der Akt im Werk Lucas Cranachs," pp. 141, 143; Foister, "Cranachs Mythlogien," pp. 116–29. Cf. Cranach's 1510s portrayals of Jesus with a young Mother Mary, ch. 2, 3.

20. For a comparable biblical example, in *David and Bathsheba*, Bathsheba's eye-popping attendants seek to draw King David's and the viewer's attention to themselves.

21. "The coy charms of a young maiden, a sensuous stare, thick, full, negroid lips, womanhood in full bloom of passion—many were the ways [Cranach]

strove to combine the sensual and the spiritual, the individual and the typical in her." Friedländer and Rosenberg, *Paintings of Lucas Cranach,* p. 21.

22. Ibid., p. 23.

23. As in Cranach's poetic flirtations with and paintings of his mysterious "girlfriend" Anna and Gesa Bloch, the consort of Wittenberg rector Dietrich Bloch.

24. *Luther's Table Talk,* in *Luther's Works,* vol. 54, no. 49, p. 8.

25. Ibid., no. 3508, p. 218.

26. Ibid., no. 1658, p. 161.

27. Ibid., no. 5513, p. 444.

28. Hinz, *Lucas Cranach d.Ä.,* pp. 89–91.

29. Ibid., p. 176.

30. Merback, *The Thief, the Cross, and the Wheel.*

31. Cf. Lüdecke, ed., *Cranach im Spiegel seiner Zeit,* ch. 1; Friedländer and Rosenberg, *Paintings of Lucas Cranach,* ch. 6.

32. Michael Carter, "Cranach's Women: A Speculative Essay," *Australian Journal of Art* (1989–90): 49–77.

33. His "general thesis" holds that a subsection of Cranach's painted women (*Venus, Fountain Nymph,* etc.) "lies within the reconfigurations of the erotic [then] taking place amongst the sub-culture of . . . wealthy and powerful males, in which . . . certain of those nude paintings were used as accompaniments to masturbation." Ibid., pp. 69–70.

34. Hinz, *Lucas Cranach d.Ä.,* p. 178.

35. Ibid., p. 97.

36. Ibid., p. 100.

37. The thirty-plus Eves appeared in eighteen different formulations. Bonnet, "Der Akt im Werk Lucas Cranachs," pp. 140–43.

38. Lüdecke, ed., *Cranach im Spiegel seiner Zeit,* pp. 56–57. See Friedländer and Rosenberg, *Paintings of Lucas Cranach,* plates 272–75, 235–39.

39. For the several versions of the story of Paris as it appears in literature, history, and contemporary *Fastnacht* plays, see Koepplin and Falk, *Cranach,* vol. 2, pp. 613–16.

40. Koepplin and Falk, *Cranach,* vol. 2, pp. 631, 642, 645, 650. "Eine durch die konstruierten Proportions-formen gezügelte sinnliche Leiblichkeit vorführt." Bonnet, "Der Akt im Werk Lucas Cranachs," pp. 141–44, 148. According to Hutchison, the proportions of "Frau Venus were based on a mathematical scheme of measurement similar, but not identical to, the one outlined by Vitruvius."

Hutchison, *Albrecht Dürer: A Biography*, pp. 71–139; Bonnet, "Der Akt im Werk Lucas Cranachs," pp. 143–44.

41. Cf. Dürer's earlier Magdalene (1504–5), which pales by comparison. Geisberg and Strauss, ed., *German Single-Leaf Woodcut*, vol. 2, p. 667.

42. Brinkmann, ed., *Cranach der Ältere*, pp. 222–23; Hinz, *Lucas Cranach d.Ä.*, p. 24; Friedländer and Rosenberg, *Paintings of Lucas Cranach*, nos. 191–99.

43. Foister, "Cranach's Mythologien," p. 118; Geisberg and Strauss, ed., *German Single-Leaf Woodcut*, vol. 2, p. 503.

44. Friedländer and Rosenberg, *Paintings of Lucas Cranach*, nos. 43, 44.

45. On Dürer's influence, Hutchison, *Albrecht Dürer*, p. 98; Friedländer and Rosenberg, *Paintings of Lucas Cranach*, plate 43.

46. For scenes of this progression, see Friedländer and Rosenberg, *Paintings of Lucas Cranach*, plates 43, 44, 191 (1526, the *Desperate Housewives* version), 199 (ca. 1530), 357 (after 1537), pp. 78, 107, 109, 140.

47. This is the *Desperate Housewives* selection from among Cranach's more than twenty-five portrayals of Adam and Eve.

48. Schwiebert, *Martin Luther and His Times*, pp. 117–18.

49. Bierende, *Lucas Cranach d.Ä. und der deutsche Humanismus*, pp. 217–18. The "garlanded rhombus" is an equilateral parallelogram.

50. "Wettstreit um Erfindung der Clair-Obscur-Tecknik den zeitlichen Vorrang seiner Arbeiten von dessen Burgmairs zusichern." *Venus Cupido Mässigend*" (pre-dated 1506/1509). Cranach had produced such works as early as 1506. Koepplin and Falk, *Cranach*, vol. 2, pp. 644–45.

51. In the original:

> Wievol fiel sind der grossen Herrn/
> In allen Landen weit und fern/
> Doch (welchs ich on rhum sagen kan)
> Sind sie mir [Venus] all unterthan/
> Denn kein Mensch nicht erfunden wird/
> Den ich Fraw Venus nicht regiert/
> Offt mancher Held ein Schlacht gewindt/
> Der nachmals wird ein Venus kind/
> Und der vorhin viel Schlacht gewan/
> Das kan mein son ingrosser eil/
> Der ins hertz scheust der Liebe pfeil.

Geisberg and Strauss, ed., *German Single-Leaf Woodcut*, vol. 2, p. 583.

52. Hinz compares this early Venus to Dürer's corpulent witches: "Four Witches," *Lucas Cranach d.Ä.,* p. 40; Koepplin and Falk, *Cranach,* vol. 1, p. 253, Tafel 15; Friedländer and Rosenberg, *Paintings of Lucas Cranach,* no. 22.

53. Elke Anna Werner, "Die Schleier der Venus: Zu eine Metapher des Sehens bei Lucas Cranach d.Ä.," in *Cranach der Ältere,* ed. Brinkman, p. 103.

54. Lüdecke, ed., *Cranach im Spiegel seiner Zeit,* pp. 122–23.

55. "In the place of a blooming young woman, there steps a pampered, twiggy courtesan." Ibid., pp. 37, 122.

56. Ibid., pp. 122–23. Cf. Carten-Peter Warncke, "Picassos Werkparaphrasen zu Cranach," in *Picasso Trifft Cranach: Pablo Picasso Litographien zu Lucas Cranach,* ed. Marlies Schmidt (Cranach-Stiftung, Wittenberg, 2004), pp. 4, 14.

57. On the role of the veil, Werner, "Die Schleier der Venus," pp. 99, 101.

58. "A new spiritual body in a new picture form." Cf. Dieter Koepplin, "Cranachs Bilder der Caritas im theologischen und humanistischen Geiste Luthers und Melanchthons," in *Cranach der Ältere,* ed. Brinkman, pp. 64–66.

59. Friedländer and Rosenberg, *Paintings of Lucas Cranach,* nos. 222, 277.

60. Koepplin, "Cranach's Bilder der Caritas," pp. 62–63, 206–7.

61. Ibid., pp. 72–74.

62. See illustrations in Friedländer and Rosenberg, *Paintings of Lucas Cranach,* plates 282–93, pp. 125–26.

63. See Steven Ozment, *Flesh and Spirit: Private Life in Early Modern Germany* (New York, 1999), chs. 1, 2, pp. 1–132.

64. See Hinz, *Lucas Cranach d.Ä.,* ch. 2.

65. Melanchthon's translation of Theocritus gave Cranach the story for his 1527–30 portrayals of *Venus and Amor as "Honey Thief."* Picasso interpreted the bee sting as syphilis: Amor sought bodily love, but rather got disease, hence his tears. Warncke, "Picassos Werkparaphrasen," p. 15.

CHAPTER 8. WOMEN ON TOP

1. Hanne K. Poulsen, "Cranachs Venus und Cupido als Honigdieb im Licht der Bildtheologie Luthers," in *Lucas Cranach: Glaube,* ed. Schade, pp. 130–39.

2. "*V.D.M.I.E.: Verbum Dei Manet In Eternum.*" Bernd Stephan, "Kurfürst Frederick III, der Weise," in *Kaiser, König, Kardinal,* ed. Straubel and Weiss, p. 33.

3. "The Saxon electors concentrated their interests above all on their long-lost dynasties and lands and thereby on a courtly-humanistic history from which

they were able to pursue their power politics, tracing their historical claims and rights, titles and lands, while implementing new social reforms and Christian-humanistic norms." Bierende, *Lucas Cranach d.Ä. und der deutsche Humanismus,* pp. 171–72, 180.

4. Koepplin and Falk, *Cranach,* vol. 1, pp. 213–14, vol. 2, p. 565.

5. Schulze, "Lucas Cranach und die Universität Wittenberg," p. 73. Cf. Ernst Borkowsky, *Das Leben Friedrichs des Weisen, Kurfürsten zu Sachsen* (Jena, 1929), pp. 6, 38.

6. These scenes first appeared in Luther's beginning translation of the Old Testament (1524), and appeared again in his *Catechism* for the laity (1529). Andreas Tacke, "Bathseba im Bade," in *Picasso Trifft Cranach,* ed. Schmidt, pp. 59–61. On fears of women's sexuality in the sixteenth century, cf. Charles Zika, "Fears of Flying: Representations of Witchcraft and Sexuality in Early 16th-C. Germany," *Australian Journal of Art* 8 (1989–90): pp. 19–46.

7. Cranach Sr.'s works reside today in the Staatliche Museum, Berlin, and those of Lucas Jr. in Dresden (a painting) and in Leipzig (a watercolor).

8. Marx and Mössinger, eds., *Cranach,* p. 226, no. 110.

9. Ibid., pp. 224–29; Tacke, "Bathseba im Bade," p. 60.

10. Lucas Jr. (ca. 1537) in Marx and Mössinger, eds., *Cranach,* pp. 224–25.

11. Mark 6:21–29; Matthew 14:1–12. Marx and Mössinger, eds., *Cranach,* pp. 297–301.

12. Brinkmann, ed., *Cranach der Ältere,* pp. 202–5.

13. Ibid., pp. 320–21, no. 99.

14. Philipp of Hesse was the suspected patron of the two paintings. Ibid., pp. 204–5, nos. 45, 46, pp. 320–21, no. 99.

15. For a spectrum of these women: Friedländer and Rosenberg, *Paintings of Lucas Cranach,* pp. 235–40.

16. Brinkmann, ed., *Cranach der Ältere,* pp. 322–24; Schade, ed., *Lucas Cranach: Glaube,* no. 81, p. 82. In an existing drawing that shows a penetrating dagger, the serpent logo and the date (1509) appear. Editor cites ca. 1525 as the true date of this version.

17. Koepplin and Falk, *Cranach,* vol. 2, pp. 566–67.

18. See crucifixion scenes in Friedländer and Rosenberg, *Paintings of Lucas Cranach,* pp. 377–85.

19. "A report on the true German historical beginnings . . . the preferred point of departure in 15th century German humanist historiography of the

German princes and their successors . . ." Bierende, *Lucas Cranach d.Ä. und der deutsche Humanismus,* p. 199.

20. Bonnet cites the 1508[09?] woodcut as "the first surviving work of humanistic content in which Cranach presented worldly nudes." Bonnet, "Der Akt im Werk Lucas Cranachs," pp. 139–43. Hinz, "Sinnwidrig zusammengestellte Fabrikate?" in *Ein Maler-Unternehmer,* ed. Grimm, pp. 174–77. For all versions of the Judgment of Paris, see Friedländler and Rosenberg, *Paintings of Lucas Cranach,* pp. 41, 252–58.

21. Jupiter, Venus, Juno, and Minerva are their Roman names. In the original Greek version of the legend they were known as Zeus, Aphrodite, Hera, and Athena, respectively.

22. Spalatin mentions this chain of information in his historical chronicle. See Bierende, *Lucas Cranach d.Ä. und der deutsche Humanismus,* pp. 204, 212.

23. Ibid., pp. 209–12.

24. According to Darius, the Trojan wars left 676,000 Trojans and 886,000 Greeks dead on the fields. Thereafter the surviving Trojan soldiers were divided into two armies, one led by Aeneas and Paris, the other by Antenor. Ibid., pp. 188–89, 212.

25. Jorg Roberts, "Lucas Cranachs Heidnische Götter und die Humanistische Mythenallegorese," in *Lucas Cranach: Glaube,* ed. Schade, p. 104. See also Koerner's discussion of late-medieval crossroads images, *Moment of Self-Portraiture,* pp. 384–400.

26. Bierende, *Lucas Cranach d.Ä. und der deutsche Humanismus,* p. 232.

27. Koepplin, "Ein Cranach Prinzip," p. 157; Poulsen, "Fläche, Blick und Erinnerung," pp. 63–64.

28. "The Babylonian Captivity of the Church," in *Three Treatises: Martin Luther* (Philadelphia, 1960), p. 226. See also Oberman, *Luther.*

29. Cited in Oberman, *Luther,* pp. 273–74, 276.

30. Among other modern artists who have paraphrased Cranach are: Ernst Ludwig Kirchner, Paul Klee, Max Beckmann, Paul Wunderlich, Alberto Giacometti, Francis Picabia, Marcel Duchamp, Brogna Perlmutter. Warncke, "Picassos Werkparaphrasen," pp. 13–21, 14–16.

31. Ibid., p. 14; Heinz Spielman, "Cranach als Parameter," in *Lucas Cranach: Glaube,* ed. Schade, pp. 6–12; Eliana Widmaier Picasso, "Picasso und Cranach der Ältere: Kunst als Lebenskraft," in *Cranach,* ed. Marx and Mössinger, pp. 6–12; Warncke, "Picassos Werkparaphrasen," pp. 13–21.

32. Mark W. Eberle, "Lucas Cranach's Cupid as Honey Thief Paintings:

Allegories of Syphilis?" *Comitatus: A Journal of Medieval and Renaissance Studies* 10, no. 1: 22–40.

33. That same familial ideal dominated the early workshop portrayals of *The Holy Family* (Joseph, Mary, and Jesus) and *The Holy Kinship* (Jesus' extended family) throughout the 1510s and 1520s.

34. Lüdecke, ed., *Cranach im Spiegel seiner Zeit,* pp. 19–20, 30.

35. Cf. Christopher Boyd Brown, who makes a strong case for both music and art in the Reformation's success, in *Singing the Gospel: Lutheran Hymns and the Success of the Reformation* (Cambridge, Mass., 2005).

CHAPTER 9. REMEMBERING CRANACH AND LUTHER

1. The Protestants had both the army and the opportunities to defeat the imperial army as soundly as the latter beat them, but they lost due to a failure of discipline and leadership. Hajo Holborn, *A History of Modern Germany: The Reformation* (New Haven, 1961), 227–30.

2. Lüdecke, ed., *Cranach im Spiegel seiner Zeit,* pp. 44–45.

3. Hinz, *Lucas Cranach d.Ä.,* p. 124.

4. Lüdecke, ed., *Cranach im Spiegel seiner Zeit,* pp. 119–20; Schade, *Family of Master Painters,* p. 441, no. 373.

5. Schade, *Family of Master Painters,* pp. 441–44, nos. 376–78, 379, 391, 396.

6. Lüdecke, ed., *Cranach im Spiegel seiner Zeit,* pp. 119–20.

7. Cranach's investment was apparently joint with Hans von Ponickau. Schade, *Family of Master Painters,* p. 441, no. 375.

8. Cranach "felt too deeply his civic duties." Lüdecke, ed., *Cranach im Spiegel seiner Zeit,* pp. 44–45, citing Joseph Heller, *Lucas Cranach's Leben und Werke* (1854).

9. Schade, *Family of Master Painters,* p. 441, no. 374.

10. Gunderam's position and respect within the Cranach clan is attested by Cranach Sr.'s granting him the power of attorney in the family lawsuit over the purchase of spices for the Cranach apothecary shop. Lüdecke, ed., *Cranach im Spiegel seiner Zeit,* pp. 83–85; Schade, *Family of Master Painters,* p. 442, nos. 380–81.

11. Lüdecke, ed., *Cranach im Spiegel seiner Zeit,* pp. 85–86, 88.

12. Ibid., pp. 44–45.

13. *Historia Valentin Sternenbokes* (Dresden, 1609).

14. Lüdecke, ed., *Cranach im Spiegel seiner Zeit,* pp. 86–89.

15. Holborn, *History of Modern Germany,* p. 230.

16. Lüdecke, ed., *Cranach im Spiegel seiner Zeit,* pp. 88–122.

17. Schade, *Family of Master Painters,* p. 442, no. 384.

18. "Frisch und gesund . . . an seinem Leibe und Gemüt kein Abnehmen gespürt . . . Kein Stunde ledig oder müssig sitzen kann." Lüdecke, ed., *Cranach im Spiegel seiner Zeit,* pp. 78–80, 117f, 144.

19. Hinz, *Lucas Cranach d.Ä.,* pp. 111, 113, 129–30.

20. Lüdecke, ed., *Cranach im Spiegel seiner Zeit,* p. 45.

21. Schade, *Family of Master Painters,* pp. 442–43, nos. 387, 399.

22. Lüdecke, ed., *Cranach im Spiegel seiner Zeit,* pp. 119–20.

23. Schade, *Family of Master Painters,* p. 444, no. 408.

24. Ibid., p. 444, no. 413.

25. Ibid., p. 444, no. 408, 412.

26. Koerner, *Reformation of the Image,* pp. 258, 264.

27. The fabled castle tower may be seen in the distant background.

28. Ibid., p. 374; Albrecht Steinwachs and Jügen M. Pietsch, *Der Reformationsaltar von Lucas Cranach d.Ä. in der Stadtkirche St. Marien Lutherstadt Wittenberg* (Leipzig, 1998), pp. 6–9, 15.

29. Steinwachs and Pietsch, *Reformationsaltar,* p. 15; Koerner, *Reformation of the Image,* p. 331.

30. Compare with the figure of Justice (*Iustitia*).

31. Ozment, *Protestants,* p. 167.

32. "Der allmächtig Gott will mich der Welt ganz müd machen." Schade, *Family of Master Painters,* p. 437; Steinwachs and Pietsch, *Reformationsaltar,* p. 15.

33. Koerner, *Reformation of the Image,* p. 237.

34. The scholar behind this critique (Berthold Hinz) points to what he calls Cranach's "shiny, diminutive, svelte child-women with tiny breasts, small derrieres, and willowy appendages." Hinz, *Lucas Cranach d.Ä.,* ch. 6.

35. Steinwachs and Pietsch, *Reformationsaltar,* pp. 12–13.

36. Strehle, *Lucas Cranach d.Ä. in Wittenberg,* p. 52.

37. Steinwachs and Pietsch, *Reformationsaltar,* pp. 12–14.

38. Koerner, *Moment of Self-Portraiture,* pp. 378–79, 382, 389. In defense of Dürer's fondness for making self-portraits, Koerner turns the table on Cranach's critics by asking: "Has there ever been a more exultant artist's [self-]portrait than Cranach's in Weimar [where the blood of the Savior falls only on his head]?" Koerner, *Reformation of the Image,* p. 250. It is also called "the most impressionable monument of Reformation art" in Friedrich Ohly, *Gesetz und Evangelium:*

Zur Typologie bei Luther und Lucas Cranach; Zum Blutstrahl der Gnade in der Kunst (Münster, 1985), pp. 28–32.

39. Ibid., p. 32.

40. *Luther's Works,* vol. 50, *Letters III,* ed. and trans. Gottfried G. Krodel (Philadelphia, 1975), p. 264.

41. Ohly, *Gesetz und Evangelium,* p. 32.

Index

Page numbers in italic refer to illustrations. Artworks by Lucas Cranach Jr. and Sr. and Albrecht Dürer are indexed under the artists' names.